MEDIEVAL ENGLAND
1066–1485

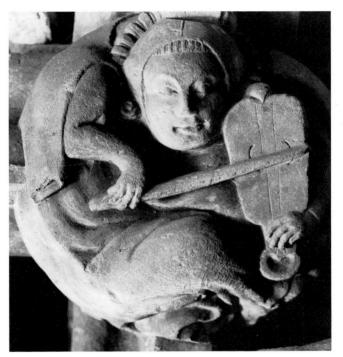

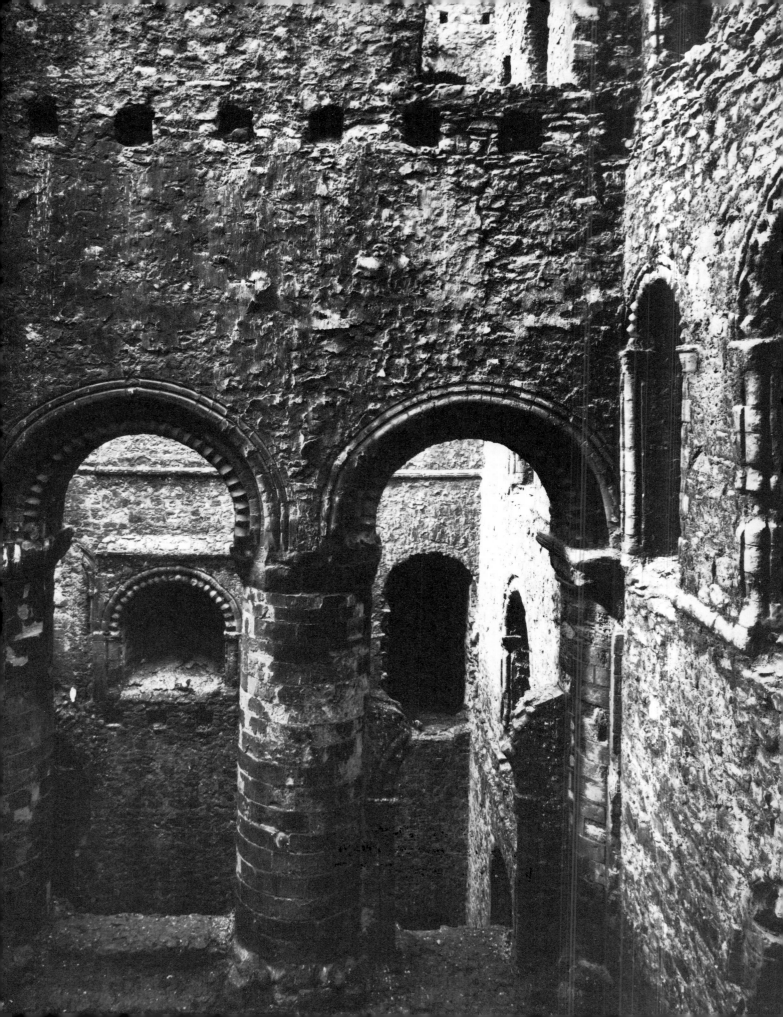

MEDIEVAL ENGLAND

1066—1485

Edmund King

· PHAIDON · OXFORD

For George and Hilda Greatwood

Acknowledgements

Reproduced by gracious permission of Her Majesty the Queen: 106, 172; Musée de la Tapisserie de Bayeux. By permission of the Town of Bayeux: 19; John Bethell: 24, 28, 35, 45, 121, 128, 132, p. 223 no. 3; Bibliothèque Royale Albert Ier, Brussels: 108; Courtesy of the Master and Fellows of Corpus Christi College, Cambridge: 69, 73, 74, 110, 118, p. 164 no. 1. p. 222 no. 2, p. 243 no. 3; Courtesy of the Master and Fellows of Magdalene College, Cambridge: 135; Courtesy of the Master and Fellows of Trinity College, Cambridge: 25, 86; Courtesy of the Master and Fellows of St John's College, Cambridge: 58; Syndics of Cambridge University Library: 81; University of Cambridge Committee for Aerial Photography, Crown copyright reserved: 20, 56, 92, 138, p. 136 no. 1, p. 201 no. 4; Courtesy of the Dean and Chapter of Canterbury: 59; C. L. H. Coulson: p. 93 no. 2; Herbert Art Gallery and Museums, Coventry: 101; National Library of Ireland, Dublin: p. 87 no. 3; Courtesy of the Dean and Chapter of Durham: 65, 129, p. 214 no. 1; E. T. Archive: 90, 127; Trustees of the National Museums of Scotland, Edinburgh: p. 165 no. 2; Reproduced by permission of the Provost and Fellows of Eton College: 174; Exeter City Council: 57; P. J. Gates Photography: 157; Lark Gilmer: 7, 17, 156, 159; The Burrell Collection, Glasgow: 116; Glasgow University Library: 55; Sonia Halliday & Laura Lushington: 43, 44, 47, 98, 99, 102; T. A. Heslop: p. 215 no. 3; A. F. Kersting: 3, 30, 63, 70, 76, 79, 105, 114, 145, p. 143 no. 4; Jorge Lewinski & Mayotte Magnus: 37, 46, 83, 96, 147, 176, p. 92 no. 1; British Tourist Authority, London: p. 207 no. 4; Conway Library, Courtauld Institute of Art, London: p. 1, 173, p. 27 nos. 3 & 4, p. 242 no. 2; The British Library Board, London: 6, 9, 13, 31, 34, 50, 52, 68, 72, 82, 84, 87, 88, 94, 119, 122, 133, 143, 146, 162, 164, 166, 167, 171, 177, p. 86 no. 1, p. 87 nos. 4 & 5, p. 137 nos. 3 & 4, p. 143 no. 2, p. 174 no. 1, p. 201 no. 5, p. 206 no. 2, p. 222 no. 1, p. 243 no. 5, p. 258 nos. 1 & 3; Reproduced by Courtesy of the Trustees of the British Museum, London: 16, 33, 54, 67, 71, 112, 124, 134, p. 61 nos. 4 & 5, p. 174 no. 2; The Corporation of London Records Office: 4; English Heritage, London: 75, 95, 123, 152, 153, 154, p. 55 nos. 3, 4 & 5, p. 110 no. 2; The Trustees of Lambeth Palace Library, London: 142; Museum of London: 51, 120, 140, p. 60 no. 2, p. 223 no. 4; Reproduced by Courtesy of the Trustees, The National Gallery, London: 149; Reproduced by permission of the National Portrait Gallery, London: 158; Public Record Office, London: 42, 60, 77, 100, 107, p. 20 no. 2, p. 21 no. 3, p. 214 no. 2, p. 215 nos. 4 & 5 (Crown Copyright material in the Public Record Office is reproduced by permission of the Controller of Her Majesty's Stationery Office); Royal Commission on the Historical Monuments of England: 14, 22, 36, 48, 66, 78, 80, 85, 111, 130, 137, 139, 155, 169, 170, p. 36 no. 1, p. 105 no. 4, p. 110 no. 2, p. 207 no. 3, p. 243 no. 4, p. 254 no. 2; Society of Antiquaries of London: p. 110 no. 1; The South Bank Centre, London. Photo Angelo Hornak: 59; The Tower of London: 90; The Board of Trustees of the Victoria & Albert Museum, London: 12, 27, 89,

104, 117, 131, 148, 158, 163, p. 60 no. 2, p. 142 no. 1; Reproduced by permission of the Trustees of the Wallace Collection, London: 168; Warburg Institute, London: 91, p. 136 no. 2; By permission of the Dean and Chapter of Westminster: 165; Norfolk Museums Service: 150; The Pierpont Morgan Library, New York: 26, 39, 40; Ashmolean Museum, Oxford: p. 60 no. 1, p. 61 no. 3, p. 206 no. 1; The Bodleian Library, Oxford: 11, 103, 125, 160, p. 104 no. 1, p. 242 no. 1, p. 259 nos. 4 & 5; Courtesy of the President and Fellows of Corpus Christi College, Oxford: 18; The Warden and Fellows of New College, Oxford: 144; Thomas-Photos, Oxford: p. 105 no. 3; Archives Nationales, Paris: 32; Bibliothèque Nationale, Paris: 15, 23, 64, 127; Philip Rahtz: p. 200 nos. 1 & 2; Salisbury and South Wiltshire Museum: 21; Wales Tourist Board: p. 86 no. 2; Weidenfeld & Nicolson Archives: 109, 112, 122, 175, 158, 165; Edwin Smith: 1, p. 21 no. 4, p. 54 nos. 1 & 2, p. 93 nos. 3 & 4, p. 143 no. 3, p. 175 no. 4; Wim Swaan: frontispiece, 29, 38, 49, 53, 61, 62, 93, 136, 161, p. 111 no. 3; Christopher Wilson: 126; ZEFA Picture Library: 151.

Phaidon Press Ltd
Littlegate House
St Ebbe's Street
Oxford OXI ISQ

© 1988 by Phaidon Press Limited

British Library Cataloguing in Publication Data

King, Edmund
 Medieval England
 1. Great Britain—History—
 Medieval period, 1066–1485
 I. Title
 942.02 DA175

 ISBN 0 7148 2359 7

Designed by Tim Higgins
Picture research by Suzanne Williams

Typeset by BAS Printers Limited, in Monophoto Poliphilus with Blado italic and titles in Romic Medium
Printed and bound in England by Butler and Tanner Ltd., Frome

FRONTISPIECE ILLUSTRATIONS: (*page 1*) Musician: roof boss, York Minster, 14th century; (*title-page*) Rochester Castle keep, *c.* 1127; (p. 7) Edward II's tomb, Gloucester Cathedral, 1330s

Contents

The picture essays are listed on the next page

Picture Essays

1 The effigy of Edward II on his tomb in Gloucester Cathedral, 1330s. See also Pl. 114

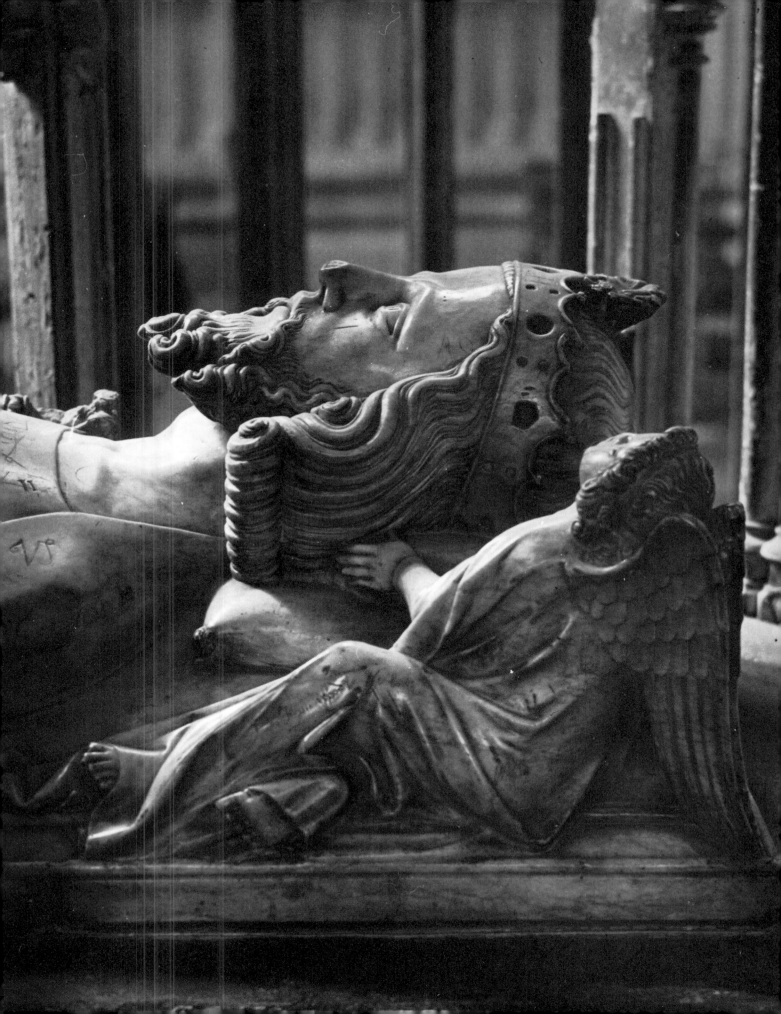

INTRODUCTION

I IMPLORE YOU, MY LORD', wrote William of York to the royal chancellor Ralph Neville in August 1227, 'to arrange matters so that I do not have to go on eyre in Cumberland. It would mean a long journey, and the climate there disagrees with my constitution.' If there was work for him to do, he said, he would much rather be sent to Cambridge and Huntingdon, for he was a bene-ficed clergyman, and had a living there, as well as property in his native Yorkshire. As this clerk looked out on Eng-land in the middle of our period he saw a series of local communities, some of which clearly he found more attrac-tive than others. Even though he was a Yorkshireman, he did not relish the journey further north. And yet he went. William was a professional lawyer. He had recently started sitting as a judge, and in due course (for this was the standard career pattern of the more able) he would become a bishop. This was at Salisbury, in 1246, and it is not likely that he protested then against his promotion to one of the most attractive sees in England (pp. 120-1). In 1227 England was still in the process of recovery from civil war. The journey to Cumberland was necessary. It made money for the king — over £240 in only nine days, William boasted in another letter — but this was a second-ary concern. It showed that the hand of the king still reached to the farthest parts of the kingdom.

Just as the English government sent out its representa-tives into the shires, so the shires sent their representatives to Westminster. They came most regularly, from the late thirteenth century onwards, to parliament. A view of a thirteenth-century parliament is represented in early sixteenth-century dress in Pl. 106. The king's professional staff, the chancellor and the judges, the successors of Ralph Neville and William of York, sit on their woolsacks. They are, quite properly, shown at the centre of affairs. Around them, each in their distinctive dress, sit the lay and spiritual lords. The painting dates from over two centuries after the events which it says that it describes, but in essence nothing was seen to have changed. This was a model of order in medieval English society, at any period. The king was placed at the centre. Parliament was his parliament. It was the king's job to provide a focus for the concerns of the local communities of England.

Just as the English kingship had its own images, which will be taken up and illustrated in this book, so too did the other main sections of English society. They can be seen in illustrations from the early twelfth century (Pl. 18) at the end of the reign of Henry I. In three of the four images the king is pictured asleep. In a dream that must have come close to being a nightmare he is shown visited by peasants, by knights, and by clergy. It was common at this time to think of society as made up of three 'orders', namely 'those who worked, those who fought, and those who prayed'. Representatives of each are shown here. Each had a distinctive office in a well-regulated world. Each carried the symbols of that office plain for all to see. Their dress helps differentiate them, but it was what they held in their hands that was really distinctive: the peasants carried spades and hoes, the knights their swords, the clergy had rings on their fingers and staffs in their hands. In life they never seem far from these symbols, in death they cannot be separated from them. The final sketch in this group of four from John of Worcester again shows the king at the centre of affairs; but this is not an image of royal mastery. His ship is about to founder in a storm, which only abates when the king promises to remit taxation. What you have in these four sketches is a view of medieval politics. In it the knights and peasants are just as important as the king and the great magnates.

A challenge, a pleasant one to the writer and I hope to the reader also, is to relate images and text. To continue for the moment with one of the orders, with those who fight. The mounted knight strides through the pages of this book, for all the world as if he owned it. We can see him, and after a while we can hear him talk. A valuable text for the early fourteenth century is the *Scalachronica* of Sir Thomas Gray of Hetton in Northumberland. He is a northern knight, at one time the custodian of Norham castle, where in 1291 Edward I had summoned the English parliament to determine the succession to the Scottish king-ship. He seems at times the archetype of the English country

gentleman. Images of the chase help realise his battle-scenes: at Byland in 1322, the English army cowered before the Scots, 'it was no otherwise between them than as hare before greyhounds'. And at another time, in another engagement, he describes a group of Scottish exiles, 'by the light of a house that was set on fire they drew together again like partridges'. His judgements are those of his order. He expected his kings to play a public role, and criticised them severely if they did not. Edward II, he said simply, was 'wholly unfitted for chivalry'. That judgement helped bring this king to an early grave; but the need for monarchy gave him a tomb in which the image of kingship remained untarnished (Pl. 1).

The events of this period are well enough recorded, and distance may help to put them in context, but the world of ideas in which medieval people moved, and by which they judged others, was very different from our own. To highlight here one last image from the many vivid images in the text which follows. Robert of Thorpe, the lord of Longthorpe near Peterborough, was one of the middle class of medieval England, another professional administrator, and probably the father of a future chief justice. He and his family took their ease in the evenings in a room in which seemingly every inch was plastered with pictures (Pl. 121). There are moral tales, scenes from the Bible, from everyday life, heraldry and grotesque, all jumbled together, all familiar images. Many of them will be found, separately, in the text which follows. They helped people at the time understand their position in the world. They may help us understand what the men and women of the day took for granted.

All authors need a break from their normal routines, and a lot of allies. Sir Thomas Gray was given nearly four years of study leave by the Scots, who captured him and between 1355 and 1359 imprisoned him at Edinburgh castle, where he found an excellent library. In happier circumstances, I was given leave for the Michaelmas Term 1986 by the University of Sheffield, and must thank both it and my colleagues in the Department of History for enabling me to pass the point of no return in writing this text. The contribution of Bernard Dod, my editor at the Phaidon Press, has at every stage been invaluable. My warm thanks go also to Dr Maurice Keen for reading a draft of the whole volume. Many of the contributors of the picture essays gave help beyond providing the text which appears over their names. I must particularly thank my colleague Dr Simon Walker for his help with the final two chapters. The customary proviso is more than usually necessary here: none of the above bears any reponsibility for my errors. My wife Jenny and children Michael and Frances have been a constant source of help and encouragement; and we all together would like to join in thanking my parents-in-law, to whom this book is dedicated.

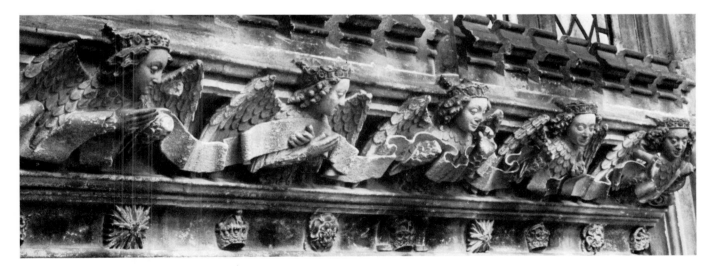

2 The heavenly choir: mouldings below the east window of St George's Chapel, Windsor. Late 15th century

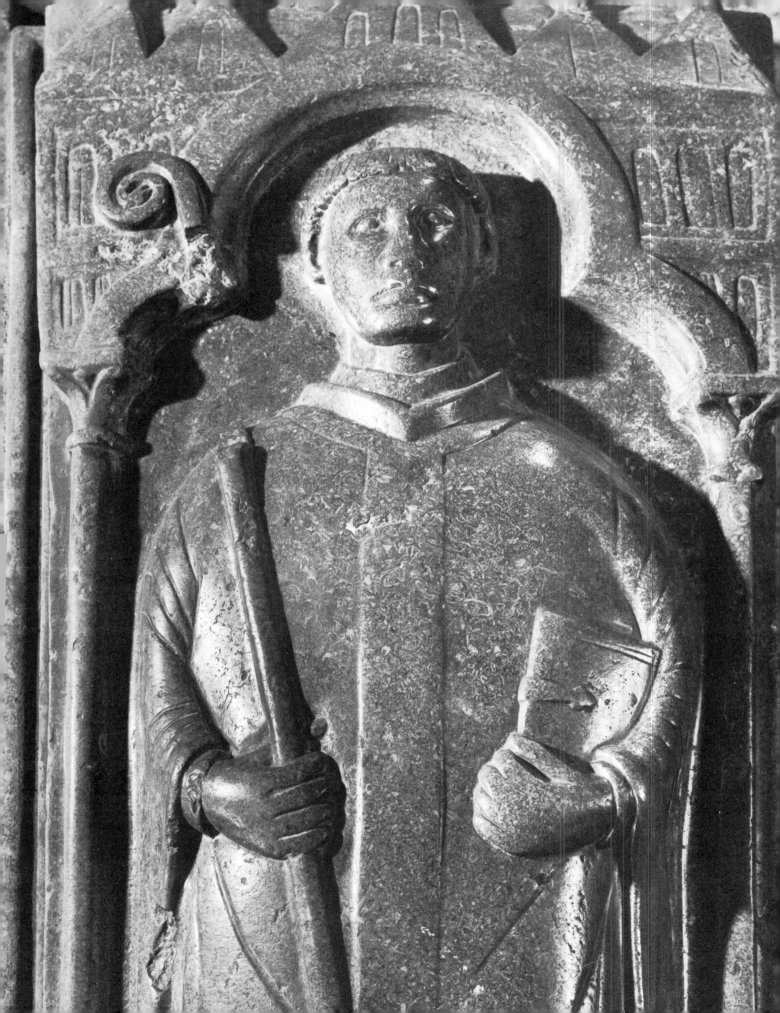

THE NORMAN CONQUEST AND SETTLEMENT

1066—1106

I N 1101 THE MONKS OF Peterborough Abbey paid King Henry 1 for permission to elect as their abbot a certain Godric. All that we know of Godric is that he was an Englishman, the brother of Brand who had been made abbot shortly after the Norman conquest, and may have been present at the battle of Hastings. Abbot Brand had died in 1069, and his brother Godric must have been an old man in 1101 – old and sour, and elected by an elderly and sour community of monks. They will have been disappointed, but they cannot have been surprised, when within a few months Abbot Godric was deposed. His crime was not that he was English but that he had paid for his election. The monks were caught on the horns of a dilemma: Henry would hardly have allowed this election without the payment of a substantial sum, yet to the new generation of churchmen, the payment of that sum and Henry's own involvement were enough to invalidate the election. The monks of Peterborough may have been sour, but they were not stupid. They knew all this very well. By electing Godric they were registering a protest at what had happened to their monastery over the past thirty-five years, at what had happened to their society. This chapter covers that period.

The New Dynasty

Duke William, when he was crowned king of England on Christmas Day 1066, stressed that he was the designated heir of Edward the Confessor. That he was so designated cannot be proved, though several modern historians feel that he was indeed the Confessor's chosen successor. Those present at Westminster would have been less worried about the title than about the content of William's kingship. He promised that every man should have the protection of 'his own law', a law which varied according to his rank and the part of England in which he lived, and that every man should be his father's heir, which meant that rights of property would be respected. To the Londoners, to whom he looked for popular recognition of his kingship and practical help, he repeated these promises in a surviving writ,

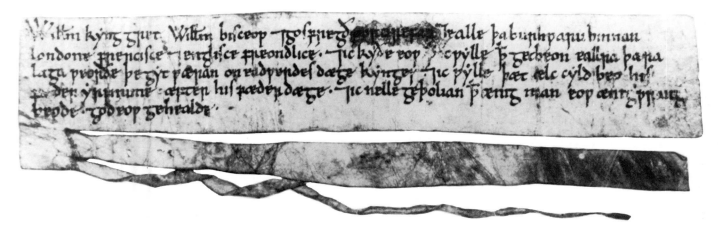

3 Abbot Benedict of Peterborough (died 1193). Peterborough Cathedral, north aisle of the choir
The abbot's effigy was made from local marble, quarried at Alwalton, Huntingdonshire; it must have been made soon after the abbot's death.

4 Writ of William 1 in favour of the city of London. 1067. City of London Record Office, charter 1a
William greets his men of London, both French and English, 'freondlice'. The use of English, and what is said in the text, is intended to emphasise the continuity of William's kingship.

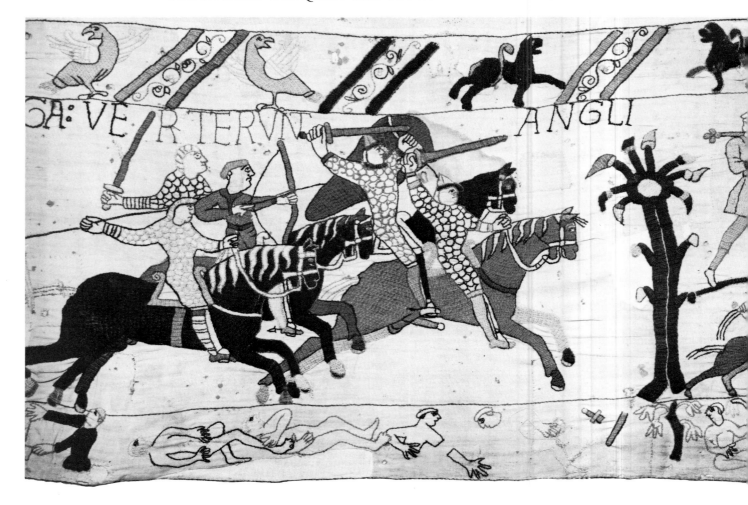

5 The English flee from the Battle of Hastings. The Bayeux Tapestry
The Battle of Hastings has become a rout. Dead English in the lower border are stripped
and mutilated; those that remain alive are pursued by Normans with swords, lances, bows and
arrows, and whips. The Englishmen carry maces, and one removes an arrow from his eye.

in their vernacular English. There was no reason to doubt
that he was sincere. Some men at least could remember
the time of Cnut, who had succeeded in 1016, founding
a new dynasty. For the first few months of Cnut's reign
England had been treated as a conquered province, but
within two years the two races had agreed upon the basis
of an Anglo-Danish state.

In 1066, and in the years which followed, the story was
very different. It is the story of the confiscation of Saxon
wealth and Saxon land. Its results are seen in Domesday
Book, the survey of twenty years of Norman rule, the
measure of the value of William's promises. Measured in
terms of the taxable assessment of land, in 1086 William
controlled a little over 17 per cent of England. Of his sub-
jects the churchmen – the bishops and the heads of religious
houses – controlled a little over 26 per cent. The estates
of both church and crown were dwarfed by the holdings
of the great laymen, comprising 54 per cent of England.
It was a small group of people, who held real power.
Twenty laymen and twelve churchmen between them held
forty per cent of England. Not one on this list was of
English descent.

The English had been expropriated. To see how this
had happened it is necessary to look first at the military
aspects of the settlement, then at the Norman attitude to
the inheritance of land. It is in the interaction between these
two things that the key to the Norman settlement may be
found. An excellent witness is the Norman monk Orderic
Vitalis, whose chronicle is the most important source for
the history of England and Normandy between the Con-
quest and 1141. Orderic was of mixed parentage: his
mother was English, his father a Norman clerk, one of
the professional staff who followed Roger of Montgomery
into his English estates.

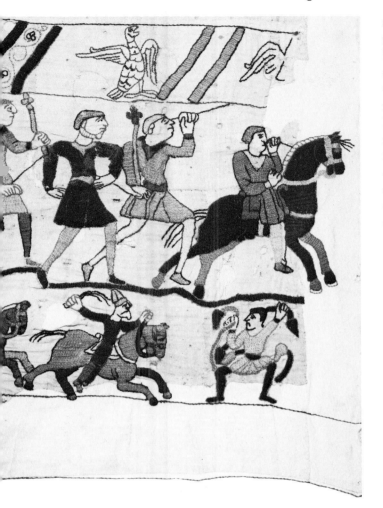

Oderic's story of the Conquest is the story of the English reacting against 'the injustice and tyranny of the Normans'. It is the story of one rising after another, only with difficulty put down, and then only because the Normans had a secret weapon.

*The king rode to all the remote parts of the kingdom and fortified strategic sites against enemy attacks. For the fortifications called castles (*castella*) by the Normans were scarcely known in the English provinces, so that the English — in spite of their courage and love of fighting — could only put up a weak resistance against their enemies.*

The earliest Norman castles were essentially very simple, a ditch and stockade surrounding an enclosure, in part of which was placed a defensive motte and elsewhere domestic buildings. These castles could be used not only for defence 'against enemy attacks', but also as centres for controlling and colonising the surrounding areas.

This will explain why many of the earliest Norman castles were fortified on sites well away from existing settlements. They show 'the fighting units in the Norman armies taking up positions for further advance'. The quotation,

and the approach, is that of John Le Patourel, who insisted that the Norman Conquest should be seen not as a single battle but as a long process of settlement, by no means complete when the Conqueror went to his grave in 1087. On this analysis, the dates of the castleries represent stages in the Norman settlement. When the king returned from Normandy in 1067, said Orderic, 'he gave away every man's land' to his own followers and kinsmen. In truth it was only the south of England that could be immediately disposed of. Kent was given to Odo of Bayeux; the Isle of Wight to William fitz Osbern; and the five divisions of Sussex to Robert count of Eu (Hastings), Robert count of Mortain (Pevensey), William de Warenne (Lewes), William de Braiose (Bramber), and Roger of Montgomery (Arundel). These were some of the most powerful magnates of the pre-Conquest years. They all acquired considerable estates elsewhere. The great Midland estates (Shrewsbury, Tutbury, the Peak) were created in the 1070s; and those in the north (Pontefract, Richmond, Conisbrough) were put together in the 1080s.

If settlement was slow, this was of necessity. William had promised that every man should be his father's heir. Some of the English who counted on this promise were heirs to great estates and had great expectations. Several English earls were not compromised by events in 1066, because they were too young. They looked to the king for marriages suitable to their rank. Waltheof, for example, the son of Siward earl of Northumbria, was lucky: he was given in marriage the Conqueror's niece Judith, with the earldom of Huntingdon/Northampton — a grant made 'in the name of peace' between the two communities. The brothers Edwin of Mercia and Morcar of Northumbria, on the other hand, were not so lucky. According to Orderic, the rebellion which destroyed them resulted from a breach of promise. The king had promised Edwin his own daughter in marriage. 'But later, listening to the dishonest counsels of his envious and greedy Norman followers, he withheld the maiden from the noble youth, who greatly desired her and had long waited for her. At last his patience wore out and he and his brother were roused to rebellion.' The result of that rebellion, in 1071, was Edwin's death and Morcar's capture. Their lands went to these same 'greedy Norman followers'.

The year 1075 saw the last serious rebellion against William's rule of England. It took place while he was on the Continent, and seems to have turned on a marriage which took place without his agreement. This was between Emma, daughter of William fitz Osbern, and Ralph earl of East Anglia, whose mother was a Breton and whose father was English. The mixture, taken with a lot of drink at the 'bride-ale' at Norwich, proved explosive. The bride's

brother, Roger earl of Hereford, plotted with his new brother-in-law to rise against the king. Earl Waltheof of Huntingdon, who had been made earl of Northumbria also in 1071, was at the wedding-feast, and privy to their discussions. The rebellion was easily put down, with neither earl able to get beyond his home base. Wulfstan bishop of Worcester and Aethelwig abbot of Evesham, two English churchmen, raised their Norman knights and tied the earl of Hereford down in his lands beyond the Severn. Odo of Bayeux and Geoffrey of Coutances, two Norman bishops, acting with William of Warenne, led the English *fyrd* to defeat earl Ralph's forces near Cambridge. The rebel earl of East Anglia was beseiged in Norwich castle, and then escaped to Brittany. The 'revolt of the earls' showed how the resources of the Anglo-Norman monarchy could be used to put down local revolt. The two leaders who came into William's power were treated severely. Roger of Hereford was imprisoned,

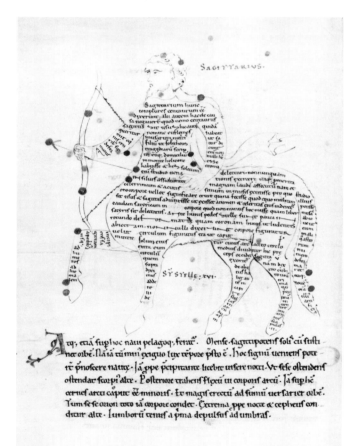

6 Sagittarius. London, British Library, Cotton MS Tiberius C.I, fo. 25v, 1120s, from Peterborough Abbey
A copy of a 9th-century manuscript of a text by Cicero describing the constellations. It was from such texts that pictorial images of the gods and mythical creatures were transmitted to the middle ages.

and Earl Waltheof was executed. His execution provided Orderic with the setting for one of his best set pieces. The last English earl made an admirable end. His final wish was to be allowed to recite the Lord's Prayer. He broke down in tears before he had finished; the guards would wait no longer; Waltheof was beheaded. 'Then all who stood around heard the head say, in loud and clear voice, "but deliver us from evil, Amen". This was the way Earl Waltheof met his death.' Orderic had this story from Crowland, where Waltheof was buried. They did not quite manage to make a saint of him, but had a good try.

William's Norman followers, it is clear, were suspicious of English males. With females it was another matter; marriage of Norman barons and knights to English women of property is a major theme of the Norman settlement. English heiresses were much sought after. The Countess Lucy, the heiress of Aelfgar of Mercia, brought an estate centred on Bolingbroke in southern Lincolnshire to a succession of three Norman husbands, Ivo de Taillebois, Roger fitz Gerold de Roumare and Ranulf le Meschin, to the confusion of later historians but to the profit of each of them and their successors. The castellan of Oxford married the daughter of Wigot of Wallingford. There were many marriages of this kind. It may be no accident that the few Englishmen who appear in the Domesday survey as major landholders left only daughters to succeed them. The most famous of these was Colswain of Lincoln, whose daughter married Robert de la Hay (from La Hague near Cherbourg in Normandy). These women conveyed legitimacy, in their offspring, in their title to land. In Norman eyes at least, these marriages went a long way to legitimising the Conquest.

The Normans, it is now argued by historians, were in no sense a separate 'race'. Though originally, as their name implies, of Norse descent, their Viking blood was much diluted and they had little trading contact with the Viking world. They were Frenchmen. These Frenchmen from Normandy brought with them to England, so it is also argued, no particular aptitude for war, and no carefully organised feudal hierarchy. What was distinctive about Normandy before 1066 was a well-preserved administrative structure, dating back to Carolingian times. The duke had vassals in every part of Normandy, some of them men of great rank. The most important of these, and the most important men in England immediately after the Conquest, were William's own kinsmen. Of the eight great lords who fitted about sixty or more ships for the invasion fleet of 1066, only one seems to have been unrelated to William. At the top of the list were his half-brothers Robert of Mortain and Odo of Bayeux (see picture essay). Odo was in feudal terms the richest man in England in

7 St John's Chapel, the White Tower, Tower of London. *c.*1070–*c.*1090
For an external view of the White Tower, and further comment, see Pl. 17.

1086: his estates were valued at £3240, though 75 per cent of his land, a very high figure, was held by his tenants. He was one of the two men who stood in the king's place as regent when he returned to Normandy early in 1067, when the Normans, 'bursting with the wealth of England', brought Lent to a premature end. The other regent was William fitz Osbern. The most powerful magnate in central Normandy, William fitz Osbern, was descended from the ducal house on both sides, and had served as steward of the duke's household. He was given strategic authority in England: in the south lordship of the Isle of Wight, in the Welsh Marches the earldom of Hereford, the southernmost of the three earldoms placed against the Welsh kingdoms.

Men such as William fitz Osbern consolidated their authority in England in just the same ways as they had done in Normandy. Duke William established a castle at Breteuil, the custody of which he then gave to William fitz Osbern; alongside the castle its new lord then founded an urban settlement (a *bourg*) and a priory. At his new castle at Chepstow in the Welsh Marches William fitz Osbern followed the same pattern. Castle, borough, religious house – the bastions of authority in the Normans' brave, new world – are found together time and again at what became the key centres of magnate power. William fitz Osbern died in 1071 at Cassel in Flanders, fighting in the army of the king of France. He was highly praised by Orderic: 'the bravest of the Normans, renowned for his generosity, ready wit and outstanding integrity, he was universally mourned.' Orderic did not speak in such generous terms of the Montgomeries. His own monastery of St Evroul was 'situated in barren country, and surrounded by the most villainous neighbours'. Top of the list of villains were the family of Montgomery-Bellême, formed on the marriage of Roger II Montgomery, another of William's kinsmen, with Mabel of Bellême, the heiress

to an estate of key importance on the southern frontier of Normandy. Roger fitted out sixty ships for the invasion fleet, stayed behind as regent of Normandy when it sailed, and, as we have seen, was soon given great power in England. Like William fitz Osbern he was given a large estate in the fertile south – the region of Sussex dependent on Chichester and Arundel – and then sent to the Welsh Marches to defend a new sector of the Normans' expanding frontier. He was made earl of Shrewsbury, and almost the whole of what is now Shropshire was placed under his sole control.

The Beginnings of Feudalism

The reader of Orderic Vitalis's chronicle will find in it much more about fighting than about feudalism. The Norman Conquest seems all very matter of fact. 'William appointed strong men from his Norman forces as guardians of the castles, and distributed rich fiefs that induced men to endure toil and danger to defend them.' But behind that there was a structure, one that William inherited and that he changed. The structure of public obligation in late Anglo-Saxon England was based on what was termed 'the threefold obligation' (*trinoda necessitas*) imposed on all men of free rank: bridge work, borough work, and military service. Debate has centred particularly in the last of these; on what changes, if any, the Normans introduced into the structure of military obligation. Some changes there had to be. The castles were new. They had to be garrisoned.

The knight's obligation of castle-guard for forty days each year evolved from this need. The knights who held of the great barons served at their lord's castle; those of Alan of Brittany, for example, served at Richmond in Yorkshire. The common service, which was later described as the 'honour' of Richmond, supplied an identity to these men. Royal castles were garrisoned, in part at least, by the tenants of nearby honours; the sixty knights of Peterborough served at Rockingham castle.

No dispute surrounds the obligation to perform castle-guard. It is quite otherwise when we come to consider the obligation to serve in the royal army. Did the Conqueror impose on his great vassals, in return for their 'rich fiefs', quotas of knights whom they had to supply for the royal army? It now seems that he did, for this is the clear reading of a writ sent in the 1070s to Aethelwig abbot of Evesham telling him to join the king at Clarendon with his quota of five knights and to see that the other major tenants of the West Midlands obeyed the royal summons. (The abbot's part in putting down a revolt in 1075 has already been noted, p. 14.) There seems no good reason not to take this letter at its face value. There were quotas imposed, the majority of them fixed well before 1100. They should be seen, urges J. C. Holt, whose view is followed here, as 'some guarantee that the recipients would contribute to the successful maintenance of the Conquest'. The quota of service due meant just that. What was owed might not always be required, though a scrupulous man or one unsure of his standing with the king, might feel it prudent to make

8 Preparations for battle. The Bayeux Tapestry
The logistics of medieval warfare. It takes two strong men to carry a suit of chain mail; spears and swords are everywhere, and helmets are carried on the sides of the cart. More domestic details appear in the wine barrels (with bungs), and the pig slung over a man's shoulder.

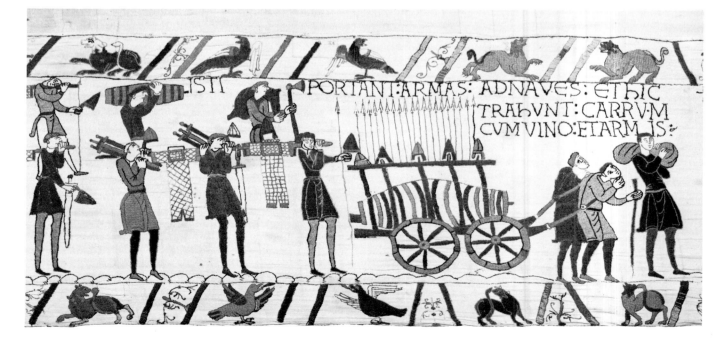

9 William I. London, British Library, Cotton MS Domitian A.II, fo. 22r, early 12th century
The initial comes from the chronicle of Battle Abbey, where it is explained that the house was founded on the site of the Battle of Hastings, in fulfilment of a vow William had made on the battlefield.

arrangements to raise the full number. The earliest list of knights of an individual barony comes from Peterborough abbey around 1100. The time may be no coincidence. Henry I in the first months of his reign was in need of all the men he could muster, and the monks of Peterborough were, as we know, in disgrace (see page 11). The list shows the abbey trying as best it can to raise the full, and very heavy, quota of sixty knights. It proved something of a stretch. Vivian of Churchfield had a hide of land, and claimed a quarter-hide more: 'he shall be a knight in the army with two horses and his own arms, and the abbot will provide him with any other necessities.' He was not the only tenant to need support from the abbey to meet the minimum obligations of military service. Another entry in this very valuable Peterborough list distinguishes between service, 'in the army and in guard-duty and in musters'. The muster here was the local militia, the *fyrd* of the pre-Conquest period, which continued to be important after 1066. The bulk of any such militia must have been English. In the rising of 1075, which culminated in earl Waltheof's death, the *fyrd* was used, and William's rule was maintained with English support.

William's own security came first from a strong base in land. His 17 per cent of England represented roughly double what the house of Wessex had held; that is the single most important reason why his kingship was stronger than theirs. In 1086 the king held land in all counties save Cheshire, Shropshire and Middlesex. The first two of these, where land values were in any event not high, were delivered almost in their entirety to earls established in those counties; Middlesex was the rural appendage of London. Elsewhere in England, in the twenty-nine other counties surveyed in 1086, the king had a landed base. It was at its strongest in central southern England, Wessex, since it was built up from (though much larger than) the estates which the rulers of Wessex had held. It was because of the concentration of their own estates, as well as because of the proximity of Normandy, that the Norman kings of England travelled by routine over an area which seldom extended west of Bath or north of Northampton.

The routine itineration of lordships merged with the routine displays of kingship. For this was William remembered: 'He kept great state. He wore his royal crown three times a year as often as he was in England: at Easter at Winchester, at Whitsuntide at Westminster, at Christmas at Gloucester.' And 'on these occasions all the great men of England were assembled about him.' These feasts were organised to allow scope for what the great men most liked doing: plenty of eating and drinking, plenty of hunting, and lots of political gossip. The churchmen, who enjoyed all of those things, would often take counsel at the same

time. But the focus of the event was the day of the festival. First the king bathed in the royal tub, which travelled around with the court; its attendant received 4d. for each bath, 'except on the three great feasts of the year'. Then the king and queen processed to the church, and were greeted by acclamations (the *laudes regiae*), which had been introduced from Germany and had a distinctly imperial air: 'to the most serene William, crowned by God, the great and pacific king, life and victory'. The queen, the clergy, and 'the whole army of the Christians' were each in turn acclaimed. This is kingship at its most sacral. After the ceremony the king and queen would appear before the people, very likely on a balcony on the west front of the church. A great feast followed at which some of the magnates had a ceremonial role, for instance as butler at the royal table. These duties symbolised their close relationship with the king, and were jealously guarded (thus the story from the following century on p. 89).

The Making of Domesday Book

If any single text sums up William's achievement, and that of his men, it is Domesday Book. This was a cooperative effort, for which both the initial discussions and the effective conclusion were noted by the *Anglo-Saxon Chronicle*. There were two meetings of the great court just described. The first was at Gloucester over the twelve days of Christmas 1085, which were very busy, for 'the king held his court there for five days, which was followed by a three-day synod held by the archbishop and the clergy'. There, after discussions, the orders were given for a survey (in Latin *descriptio*) of the whole of England, and men rode out to make it. Less than seven months later, on 1 August 1086, the council came together again at Salisbury, and along with them 'all the landholding men of any account throughout England', and, whether or not they were already his vassals, they all bowed before King William, 'and became his men, and swore oaths of fealty to him'. This was a particularly solemn meeting of the council, and it took place outside the normal run of meetings. It was summoned to put the seal on a remarkable achievement, the making of Domesday Book.

After the Gloucester council meeting, 'the king sent his men into every shire'. This brief statement must conceal some complicated discussions. England was divided into groups of counties or circuits, each the responsibility of a different set of commissioners. The map above shows the most important information the council had in making its dispositions, the counties into which England was divided, and within them the royal castles and the centres of dioceses. The map suggests the divisions that were made.

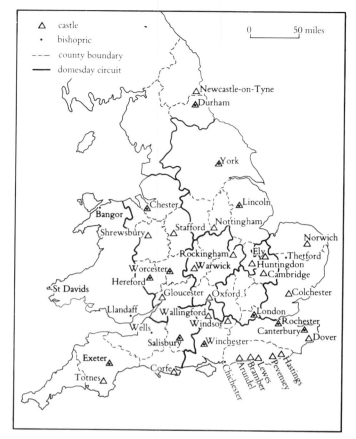

10 Domesday England
The main centres of authority, and the circuits of the Domesday commissioners as they rode between them, are shown

They can be identified with a fair degree of certainty, for each set of commissioners and their clerks, though working to a common plan, left their fingerprints on the folios of Domesday Book. The names of one set of commissioners are known. Those who toured the west Midlands were Remigius bishop of Lincoln, Walter Giffard, later earl of Buckingham, Henry de Ferrers, whose descendants became earls of Derby, and Adam, brother of Eudo Dapifer. We may imagine the commissioners for northern England mustering at Huntingdon on the Great North Road. There they had preliminary discussions, summoned English monks from the neighbouring monasteries to serve as clerks and interpreters, dealt with the Huntingdon Domesday, and then set off north. They had a long way to go, but after this they had only three ports of call, at Lincoln, at York, and at Nottingham (where the joint county-court of Nottingham and Derby met). At each county court there came together, 'the sheriff of the shire, and all the barons and their Frenchmen and the whole hundred'. The making of the Domesday Book was a polyglot achievement. If Latin was the language of the official reports, and French that of the commissioners as they took

their ease in the evenings, for day after day in court English must have been the language most frequently used. The court sessions played an important part in the making of Anglo-Norman England. The great men knew England well, but they cannot before have stopped so long, or listened so hard, as they had to do in the early months of 1086.

Domesday Book was in every sense a remarkable effort of concentration. What induced the great men to undertake it? The question has recently been put, more insistently than before, by J. C. Holt. His answer is that what they gained in return was a confirmation of their lands, a formal recognition of their tenure. It was for the lands recorded in Domesday Book that they performed homage at Salisbury. And after this, the *Anglo-Saxon Chronicle* relates, William took from his men 'a very considerable amount of money where he had any pretext for this, just or otherwise'. At the end of several county sections of Domesday Book there are lists of disputes which came up in court, and these offer clues as to how the commissioners operated, and why so many of William's men had to pay heavy fines. The following is one of the disputes recorded in Lincolnshire: St Guthlac's land is that of Crowland Abbey, and Hereward is Hereward 'the Wake'.

The men of the wapentake say that St Guthlac's land, which Oger the Breton holds in Rippingale, was the monk's demesne farm, and abbot Ulchel let it to Hereward to rent, as might be agreed between them each year; but the abbot took possession of it again before Hereward fled the county, because he had not kept the agreement.

If the facts were as the men of the hundred claimed, Crowland Abbey would have been entitled to reclaim the land from Oger the Breton. The clergy entered many claims before the commissioners, and recorded some gains. They did not win every time, however. The bishop of Durham claimed the land of a priest against Gilbert of Ghent; 'the men of the riding say they never saw the bishop's predecessor seized of it, either by writ or deputy; and they testify in Gilbert's favour'. The emphasis on what they had *seen* is important: this is an oral and a visual culture. What the barons gained was to have all their lands given this public ratification, to have their tenures seen and heard by the whole county, thence to be registered in William's great survey.

Domesday Book was the achievement of a man who saw his work in England as secure. But no medieval ruler, however secure, ever exhausted his claims to territory, his pursuit of lands which at one time his ancestors had held. The capital of Normandy, the port whose growth went hand in hand with the growth of the duchy itself, was Rouen. Only seventy miles separated Rouen from Paris,

the seat of the Capetian kings of France. The two cities lay on the river Seine, one of the great thoroughfares of northern Europe. Between Normandy and the region of Paris, the Île de France, lay the Vexin, an area whose boundaries were defined in terms of the tributaries of the Seine. The Normans put forward a claim, which went back to the early years of the eleventh century, to 'the whole Vexin from the river Isère to the river Epte'. After twenty-one years of his rule of England William felt strong enough to pursue his claim. At the end of 1086 he crossed to France via the Isle of Wight. His campaign in 1087 was aimed at giving him control of the crossing of the Seine at Mantes and of the Epte at Pontoise. The sack of Mantes in July 1087 was long remembered, but it was the immediate cause of the Conqueror's death. 'The king, who was very corpulent, fell ill from exhaustion and heat.' He lay ill for six weeks and died at Rouen on 9 September.

The Church after the Conquest

The story of the English church immediately after the Conquest mirrors very accurately the changes that have already been described. English churchmen could not easily be deposed, but as they died they were replaced by Normans: Stigand was replaced as Archbishop of Canterbury in 1070 by Lanfranc, previously prior of Bec and then abbot of Caen, a man with a fine reputation for learning. In the same year the Conqueror gave the abbey of Peterborough to Turold, earlier a monk of Fécamp, who had a fine reputation as a fighter. When he arrived at Peterborough with a hundred men-at-arms the abbey's tenants, led by Hereward 'the Wake', rebelled, for they knew that

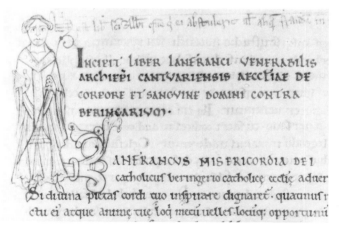

11 Lanfranc, archbishop of Canterbury. Oxford, Bodleian Library MS Bodley 569, fo. 1r, c.1100; text made in Normandy, acquired by St Albans Abbey
The text is of Lanfranc's treatise on the Eucharist.

Domesday Book

NOTHING LIKE DOMESDAY BOOK survives for any other European country in the middle ages; few governments even today could carry out a detailed inquiry into landholding and produce the results for scrutiny within a matter of months. Yet that is what happened in late eleventh-century England. Having spent Christmas 1085 at Gloucester, William the Conqueror 'had much thought and very deep discussion with his council about this country – how it was occupied or with what sort of people'. The inquiry that followed had two major aims: to

ers composed of lay magnates and ecclesiastics were allotted to groups of counties. The speed with which they worked indicates that much of the groundwork must have been conducted beforehand. The inquiry proceeded by taking evidence in court from juries made up of the priest, the reeve, and six men from each village, who verified the information demanded for their locality. The use of juries for such purposes was not novel, but the scale of their employment in a government inquiry in this way was certainly unprecedented.

The masses of detail collected then had to be digested and arranged. Drafts were drawn up for groups of counties; in all but three counties the drafts were revised and further compressed into volume one of Domesday Book. This was arranged by county, and in each county the returns for the king's lands were followed by those of his vassals, the tenants-in-chief. The volume is thought to have been largely the work of one scribe, and it is just possible that one man could have written so much during the time available before King William's death. It has

investigate the resources first of the king, and then of his most important subjects. Such information was always useful, but particularly so in 1085 when the king had been expecting an invasion from Denmark and had quartered a huge army on his vassals in England, each according to their means. The costs of such an operation may have prompted a desire on William's part to know exactly what he was entitled to expect, and how much land had been distributed to his vassals.

Most if not all of the inquiry was carried out in 1086, and its results shown to the Conqueror. Teams of commission-

1 (ABOVE) Writ of William I for Westminster Abbey. Westminster Abbey Muniments, XXIV This writ is important because, as the text says, it was issued 'after the description of the whole of England' yet before the death of King William in 1087, thus indicating that the survey was substantially complete before the Conqueror's death.

2 Index to Domesday account of Northamptonshire. London, PRO Near the start of each county there is an index of landholders beginning with the king, and followed by tenants-in-chief of the crown.

recently been discovered that a second scribe corrected and annotated the work of the first, and it is possible to speculate that this second scribe was the man in charge of the whole survey. Various candidates have been suggested for this role including two royal clerks, Samson, later bishop of Worcester, and Ranulf Flambard, who became the chief financial minister of William Rufus. Volume I does not cover the whole of England. Surveys of London and Winchester are missing, though space was evidently left for them. The survey peters out in the north, as though the commissioners were not able to discover much about this region, and indeed Normans were few and far between north of Lancashire and Yorkshire. The three counties of Essex, Norfolk, and Suffolk were surveyed but not included in volume I, probably because there was not enough time to digest the returns and enter them up; instead the more detailed provincial draft was separately bound and forms volume II of Domesday Book.

Much is said in both volumes about geld, a national tax assessed on land, and it is likely that one of the aims of the inquiry was to record liability for this tax, possibly even to revise assessments. Revision would have been a mammoth

4 Typanum at Ely Abbey, c.1135
Domesday Book acquired its familiar name because it conjured up to medieval man the image of Christ in majesty on the day of judgement, seated, and holding a large book.

task, however, and was evidently abandoned. William also wanted to find out about the wealth of his vassals, not least as a guide in assessing their obligations to the crown. It can hardly have been coincidental that in the same year as the survey King William took oaths of loyalty 'from all the landholding men of any account' in a ceremony at Salisbury. A vast transfer of land had taken place over two decades; the results were being set down and the beneficiaries confirmed their loyalty. Such a revolution had not occurred painlessly, and the survey was able to record many disputes over land.

The results of the inquiry were useful to the great men as well as to the king. Copies were made for some great landholders of the sections dealing with their own estates. The volumes themselves were in the treasury at Winchester by the early twelfth century, where they were kept with other financial records. There are a few references to them being consulted at that time, though not so many as might be expected. Domesday Book must soon have been regarded as a work of reference and not a source of up-to-date information of the kind needed in routine administration. By the later twelfth century the volumes had acquired their familiar name, for, 'as the sentence of Judgement Day could not be evaded or set aside' neither could the results of an appeal to Domesday Book.

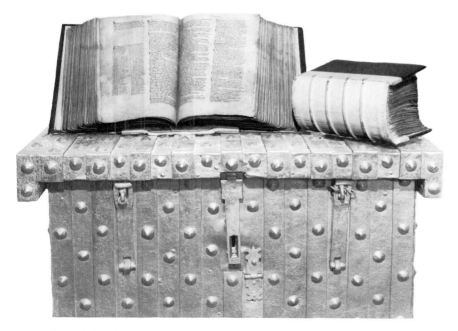

3 Domesday Book, London, PRO
The two volumes of Domesday Book on the chest in which they were kept during the seventeenth and eighteenth centuries. They have been rebound on several occasions.

JUDITH GREEN

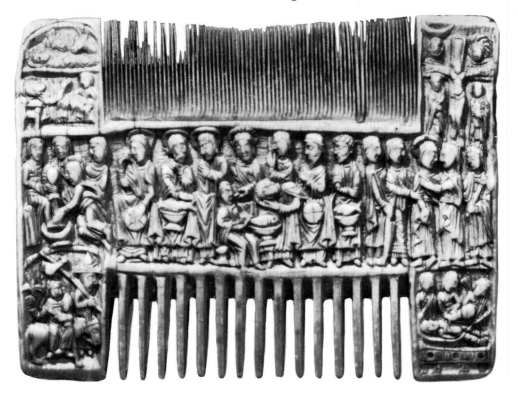

12 Scenes from the life of Christ. *c*.1120. Ivory. From St Albans. London, Victoria and Albert Museum.
Liturgical combs were used in the liturgy, during the Mass and in other services.

these Normans had come to take their land. In the small enclosed monastic communities the racial divide in Anglo-Norman England appears in sharp focus. A monk of Canterbury, Eadmer, describes the confusion there in 1076, when an English monk went mad: some of the monks spoke excitedly in French, which the English could not understand. Often the new Norman lords were not impressed by the buildings they found, or the saints whose tombs they enshrined. Athehelm of Abingdon refused to allow the feasts of St Ethelwold and St Edmund their previous dignity in the liturgical calendar, 'for he said the English were peasants'. At several centres, mostly notably at Peterborough, the English annals (the *Anglo-Saxon Chronicle*) were kept up to date. The two nations, living together under the one Rule, were eventually forced to come to terms. The new abbey churches and cathedrals, built by English craftsmen in a style imported from the Continent, provided a permanent record of their partnership.

The Norman monks and clerks who were promoted to rule the vast dioceses of Anglo-Saxon England could afford to be a little less accommodating. It was a provision of the canon law that 'episcopal sees in small townships' were to be discouraged. At a meeting of bishops convened by Lanfranc in 1075, three sees were moved – Sherborne to Salisbury, Selsey to Chichester and Lichfield to Chester. A little earlier Bishop Remigius, another prelate who had earlier been a monk of Fécamp, had moved his see from Dorchester in the Thames valley to Lincoln. These changes had been made 'by the generosity of the king and the authority of the synod'. The bishops here had an eye to the main chance; in moving to a larger centre in their diocese they could more easily tap its wealth. It is only by the indulgence of church historians that these moves are not seen as a further example of Norman greed. The Norman churchmen, as the laymen, came accompanied by a household, dependants both clerical and lay. The laymen could be given knights' fees: Abbot Turold at Peterborough made two of his nephews substantial grants of land in knight-service. The clerks might do even better. Before 1092 Remigius of Lincoln had instituted seven archdeaconries in his diocese, the largest in England – from south Oxfordshire to north Lincolnshire was 160 miles. The rank of archdeacon was known in Normandy before the Conquest but not in England. It was a powerful position, the archdeacon was responsible for both clerical discipline and temporal administration in a designated area of the diocese, which often conformed to a county boundary. He was wealthy: the archdeacon of Lincoln, observed Henry archdeacon of Huntingdon with a mixture of pride and envy, was the richest archdeacon in England. And, inevitably, he was unpopular: 'can an archdeacon be saved' was a popular conundrum in clerical circles from the twelfth century onwards.

The law which the bishops made and the archdeacons

executed was canon law. The canon law was the law of local churches, made by churchmen in their own assemblies, such as that which Lanfranc had summoned in 1075. Over these local churches was set the enormous but largely latent spiritual authority of the pope at Rome. Under one of the greatest publicists of the middle ages, Pope Gregory VII (1073–88) and his successors, the papacy would harness some of that authority. Their weapon would be the law they made in their own synods, which they would come to insist overrode the decisions of local tribunals and the 'customs' of the local churches. During the reigns of the Conqueror and his sons this added a complication, rather than a major constraint, to relations between king and church. For the most part the papacy and the local churches were agreed as to their objectives. They wished, so far as possible, to make the clergy a separate estate, under their own law and free of secular entanglement. For the English parish clergy in Norman England, as for those elsewhere in the western church, this came to involve celibacy. The Norman monks who ruled the English church in the late eleventh century were a world apart from their parish clergy. When bishop and priests did come together the sparks might fly on this issue. At Rouen in 1072 Archbishop John was stoned by his clergy, and forced to flee his church; there were similar scenes in 1119, only this time it was the 'incontinent' clergy who were driven out. The English bishops kept their distance, and repeated their prohibitions. The clergy grumbled, but were ground down.

The canon law created much more difficulty in the provisions it made regarding appointments to ecclesiastical office. The bishops and abbots of Anglo-Norman England were in every sense the equals of their lay counterparts. They had similar wealth, and the Conqueror insisted that in return for it they performed similar obligations. And so, at Peterborough (see p. 17) and elsewhere, bishops and abbots had quotas of service to perform: this meant that they held of the king by knight-service, and similarly their tenants held of them. This applied to men of English descent as well as to Normans. Wulfstan, the first bishop of Worcester (1062–95), is recorded by his biographer as dining sometimes with his knights and sometimes with his monks; he was the head of two households, that lived very different lives. The same point can be made by looking at the seal of Odo of Bayeux. On one side it is that of any powerful baron (p. 26, no. 2), an equestrian figure who bears the sword of secular power. On the other there is the tonsured clerk, with the ring and the staff, the symbols of a bishop's office, which he took with him to the grave. How were such men to be appointed, and how disciplined? Willaim and his sons took it as axiomatic that

they should appoint bishops, who were their vassals, and many of these were key agents in royal government. The king 'gave' the bishopric; this was the standard language of the day. It found visible expression in the granting of the ring and staff. To churchmen, however, this came to look wrong, particularly when (as often) it was accompanied by a payment of money. Lay investiture (the granting of ring and staff by the king) was condemned by a series of papal councils in the late eleventh and early twelfth centuries. A compromise was reached, in England in 1106 and in the German Empire at the Diet of Worms in 1122, in which each party yielded ground. In England the new bishop first did homage to the king for his lands; after this was done, other bishops handed over the ring and staff. The king's remained the dominant voice, though not the only one, in appointments to bishoprics for the remainder of the middle ages.

The Legacy of the Conqueror

One unfortunate fact of William the Conqueror's life, for which he can hardly be held responsible, was that he spent far too long in dying. When he was first taken ill in France, the professionals moved in. 'Bishops, abbots and monks stood at his bedside, and gave counsel of eternal life to the dying prince', as Orderic put it. To England and Normandy this counsel was to bring chaos. William had three surviving sons, Robert, William and Henry; a fourth, Richard, had died shortly after the Conquest. Robert, the eldest son, was originally intended as his father's heir for all his lands, both in England and in Normandy. He had been publicly recognised as such on several occasions; the baronage of each province had sworn fealty to him, and so had his younger brothers. But the position of an eldest son was never easy. Robert had sought, and been denied, an independent estate such as so many of his contemporaries had achieved. In a quarrel of 1078–9, resulting in an engagement fought at Gerberoi in the Vexin, he is reported as having unhorsed his father with his own hand. He was reconciled, but not forgiven; he was not one of those who gathered around his father's death-bed. It seems likely that the Conqueror wished to disinherit his eldest son, and give his whole inheritance to his second son William Rufus, but the clergy dissuaded him from this course of action. Robert was given Normandy, his father's inheritance; William Rufus was given England, his father's acquired land; and Henry was given 5,000 pounds of silver, which he weighed carefully, 'to make sure nothing was withheld', and locked up. William Rufus was crowned by Lanfranc at Westminster on 26 September, a little over two weeks after his father died.

Orderic had a vivid image of the bystanders' reaction when they saw that the king was dead: 'the wealthier among them quickly mounted horse and rode off as fast as they could to protect their properties.' Their reaction is understandable. The division of the Conqueror's inheritance, on which the clergy had insisted, threatened the laymen with problems of allegiance. They had lands in England and in Normandy which they now held of two different lords. King William II and Duke Robert were men of very different temperament, and each aimed to reunite their father's possessions. 'How', Orderic imagines the magnates asking, 'can we provide adequate service to two lords who are so different and live so far apart?' The answer, at least from some of them, was that Rufus should be deposed. Whether they or Robert took the initiative, there was rebellion in the spring and summer of 1088, led by the great men of Normandy: Odo of Bayeux, Robert of Morain, Roger of Montgomery and Geoffrey of Coutances. They held important castles at Rochester and Pevensey in the south of England, which could easily have been supplied from Normandy, but these supplies failed. Robert could not mobilise the resources of his duchy. By contrast the structure of William Rufus's authority held firm: the sheriffs, the English militia, the greater churchmen of England, all stood by him. The rebellion collapsed, and when this happened the pressures leading to a unification of England and Normandy fell on Duke Robert. Early in 1091 William Rufus crossed to Normandy, and in an agreement with Robert had confirmed to him certain territories he had seized in upper Normandy. It was agreed that each brother should be the other's heir, excluding Henry from the succession.

Within the British Isles William Rufus's comparatively short reign is most notable for the extension of Norman power in the marcher regions towards Scotland and Wales. He made common cause with his great barons, and co-ordinated their efforts. The Conqueror had been more concerned with the security of his frontiers than with their extension. He had come to an agreement with Malcolm king of the Scots in 1072 at Abernethy, by which the king of the Scots did homage, gave hostages, and promised not to support the king's enemies. This agreement was renewed in 1080. In the following year the Conqueror in person had marched at the head of an army into south Wales. The new ruler of the province of Deheubarth, Rhys ap Tewdwr, seems to have done the English king homage and to have paid tribute. With these agreements the Conqueror seems to have rested content. It is not stated what if anything the Welsh and the Scottish kings gained in return, but it may be that they were promised some security from the aggression of William's Norman followers. William left his men to fend for themselves. Their tenures as confirmed in Domesday were because of these agreements understated. Yorkshire was the northernmost county surveyed; the county that would become Lancashire appears in two sections; the south, 'between the Ribble and the Mersey', was an appendage of Cheshire, while lands north of the Ribble appear as little more than a list of settlements in the Yorkshire section. South of Chester the Montgomery earldom of Shrewsbury was set against central Wales, and that of Hereford, originally held by William fitz Osbern, along with the king's town of Gloucester, controlled access to south Wales. It is clear from other evidence that the Normans had penetrated some way beyond these frontiers. Castles such as Chepstow in the south, Montgomery (named after the earl's Norman seat) in the centre, and Rhuddlan in the north marked stages in the Normans advance not the limit to their ambition. Recently-found coins of William the Conqueror struck at Cardiff show the future Welsh capital an important Norman base earlier than had previously been recognised. The 'new castle' on the north of the Tyne, founded in 1080, would grow into a major port.

In the 1090s the Normans went beyond these limits and these agreements, and in so doing provoked a reaction. The key event in the north was the re-foundation of Carlisle

13 Seal of William Rufus. 1087–92. Red wax, diam. 86 mm. London, British Library, MS loan no. 1 (from the Provost and Fellows of Eton College)
The king is shown seated in majesty, with orb and sceptre; he wears a cape-like cloak with a clasp at the front. This is a double-sided seal; on the other side the king appears on horseback, armed for war, like any of his magnates (Pl. 32).

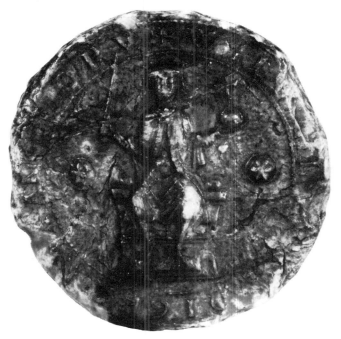

as an English borough early in the 1090s; not only was a castle built there, but the king sent into the district 'very many peasants with their wives and livestock to settle there and till the soil'. Malcolm king of the Scots was clearly perturbed by the implications of Rufus's policy. In 1092 he came south to Rufus's court, stopping along the way to lay a foundation stone for the new cathedral at Durham, expecting to have his lordship over the new settlement recognised. It was not. This precipitated a raid early in 1093, which may be taken as a revolt, and which led to the death of the Scottish king and his eldest son. Over the next forty years, four other of Malcolm's sons succeeded him, and Northumbria came securely under Norman rule. A similar extension of Norman authority, and a similar though more successful native reaction, took place in Wales. 'And then the French seized all the lands of the Britons', said a Welsh chronicle in 1093. In the north the Norman advance reached the Isle of Anglesey in 1098, in the south Cardigan, Pembroke and Carmarthen were founded in the same decade. Rufus gave active encourage-ment to his followers' ambition.

William Rufus secures his Position

While Rufus's followers were challenging the bases of Norman power on the Scottish and Welsh marches, the structure of authority within Normandy was threatened. Some of Orderic's finest passages were given to describing the disintegration of Normandy under the lax rule of Robert Curthose.

He would not give up the society of harlots and buffoons, but shamefully encouraged them, and so wasted his means that in spite of the wealth of his wide duchy he was often penniless, and so much in want of clothes that he lay in bed until 12 o'clock, and could not go to church to hear mass because he had nothing to wear; for the idle scamps and loose women, with whom he was constantly surrounded, knowing his weakness, frequently robbed him with impunity of his breeches and hose and other articles of dress.

A court so deranged could not protect its authority very far. A ruler who neglected mass would not long retain God's support.

Orderic sought a moral explanation for events that we must try to explain in political terms. After the 1091 agree-ment both King William and Duke Robert had a power base in Normandy. Rufus's was in upper Normandy, where to the townships gained in 1091 he added greater security in an agreement made with Robert count of Fland-ers in 1093. Though it was expressed in terms of feudal service, this agreement was purely a mercenary one. It set out, in some detail, the terms on which the count of Fland-ers would make troops available in England to help the

king, and would serve in person. The agreement foresaw either invasion, by the French king or another people, or rebellion, by an English count or another vassal so serious that the control of the country was at risk. A thousand troops were to be made available, the English king to be responsible for their support. Similar provisions covered Normandy and Maine. As a retainer, the English king was to pay the count of Flanders 400 marks a year. Com-pared with the revenues of Normandy this was a small sum; and it was control of Normandy, the capture of the duchy from his ineffective elder brother, that was Rufus's over-riding ambition. An attempt at a direct attack on Normandy in 1094 failed when the French king came to Robert's assistance.

Then Rufus had a stroke of luck — the preaching of the First Crusade. The preacher was Urban 11, who had become pope in 1088. His first pulpit was at Clermont Ferrand, where he had summoned a council, but from there he went north, to Le Mans, to Tours and to Blois. The message everywhere was the same. The Saracens had captured the Holy Places, the scenes of the Passion, and western pilgrims were there being abused by the heathen. The knights of western Europe had a duty to go at once to their aid. The papacy offered protection to their secular concerns, and an indulgence for their sins. It proved a seductive package. The crusading idea was to enter the consciousness of the western aristocracy. All were called, though few had the opportunity of being chosen. Nearly fifty years after this Brian fitz Count the lord of Wallingford became involved in an acrimonious correspondence with his bishop, Henry of Blois. Brian's men were robbing those taking goods to the bishop's highly lucrative fair at Win-chester. The bishop delivered the usual sermon; he got in return a very unusual history lesson. He was told in detail about the First Crusade. The pope had come to Tours — this was the venue that Brian remembered — and many had left their wives and families in answer to his call. Brian and men of his kind in spirit had gone with them. They needed no sermons from the bishop. They too had their Christian vocation.

Duke Robert took the cross in February 1096. Rufus lent him money for his expenses, 10,000 marks cash down, and in return was given custody of Normandy while Robert was away. He had raised the money by September, and Robert left immediately. William purchased from the abbey at Caen all his father's coronation regalia, the crown, the sceptre and the rod. He now had the symbols of his father's authority, and control over the full range of his possessions. Inherent in that authority were the ancient claims of his house, in particular over two areas, Maine and the Vexin. In the Vexin he prepared the ground

Odo of Bayeux

BISHOP ODO OF BAYEUX represents in the most extravagant way the ambitious and restless spirit which runs through the eleventh century Norman expansion into Britain and southern Europe. Odo was born at an unknown date in the mid-1030s. He was the son of Herleva, the mistress of Duke Robert I of Normandy and by him the mother of William the Conqueror, and of Herluin de Conteville, to whom she was married after the affair with Robert ended. While still in his teens Odo was appointed to the bishopric of Bayeux in either late 1049 or early 1050 at the instigation of his half-brother William. He was present at the battle of Hastings and became earl of Kent soon after the Conquest. Until his dramatic fall from power he often acted as William's regent in England during the long periods when the king was preoccupied with problems in Normandy. As a result Odo played a major part in organising the Norman land settlement in conquered England. But late in the year 1082 William imprisoned him for recruiting knights as part of an attempt to obtain the papacy for himself. The king only released him – and then reluctantly – when on his death-bed in September 1087. Thereafter Odo played a turbulent part in the politics of Normandy and England before departing with the Norman army which took part in the First Crusade. He died en route for the East in January 1097 at Palermo in Sicily.

Orderic Vitalis provides some valuable comments on Odo's character: 'frivolous and ambitious, devoted to delights of the flesh and to deeds of great cruelty . . . not a bishop, but a tyrant' and 'a man of eloquence and statesmanship, bountiful and most active in worldly affairs. He held men of religion in great respect, readily defended his clergy by words and arms, and enriched his church in every way with gifts of precious ornaments'. These excerpts pin-point exactly the apparent paradoxes of Odo's career: on the one hand a successful bishop well regarded in his diocese; on the other, in England the unacceptable face of the Norman Conquest. At Bayeux he organised the construction of a new cathedral, patronised poets, scholars and aspiring administrators throughout northern France, and founded an abbey dedicated to St Vigor on the edge of the town. But in England he was an immensely wealthy landowner whose activities provoked widespread complaints. In the chronicle of the abbey of Evesham he was 'a ravening wolf', while in the year 1067 the *Anglo-Saxon Chronicle* noted that 'Bishop Odo and Earl William stayed

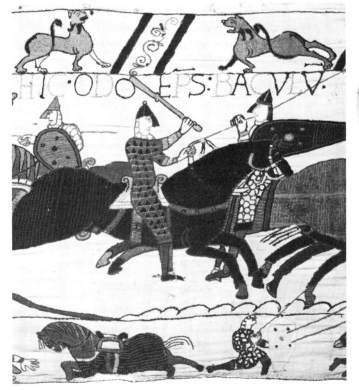

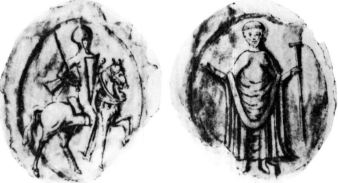

2 (ABOVE) Bishop Odo's Seal. From Sir Christopher Hatton's Book of Seals, ed. L. C. Loyd and D. M. Stenton (Oxford, 1950), Pl. VIII
This seventeenth-century facsimile shows the double-sided seal of bishop Odo. The two sides represent his two dignities of bishop and earl. The document to which the seal was once attached survives in the British Library, but the seal itself is lost.

1 Odo in battle in 1066. Bayeux Tapestry, c.1077
Odo is shown here wielding a mace and encouraging young Norman warriors to return to the fray. The bishop is represented wearing only a haubergon, rather than full armour, which suggests that he did not actually fight and shed blood.

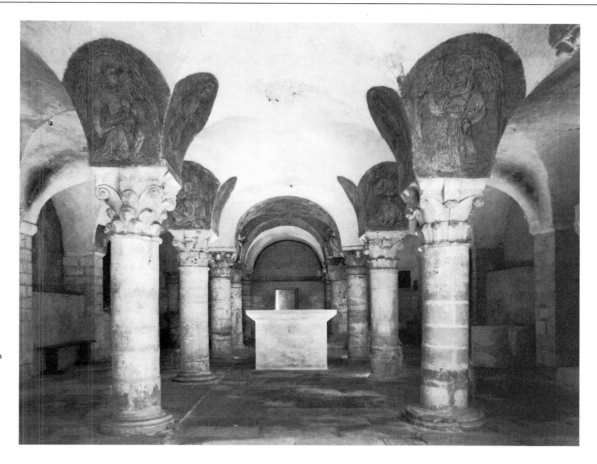

3 Crypt of Bishop Odo's cathedral, Bayeux, c.1077
This is the major surviving part of the cathedral built for Odo at Bayeux, and consecrated on 14 July 1077. The capitals are typical 11th-century productions, although the paintings above them are of later date.

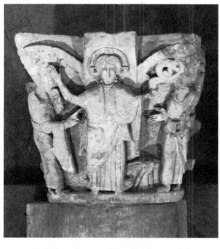

4 Capital from the crossing of bishop Odo's cathedral, c.1077
One of four capitals discovered beneath later Gothic masonry in the mid-19th century.

behind and built castles far and wide throughout this country, and distressed the wretched folk'.

The connecting thread in Odo's career is an extreme ambition and love of display which sometimes led him into inexcusable irresponsibility and injustice. His character is perhaps aptly illustrated by a scene on the Bayeux Tapestry (which he commissioned), where he, William and their brother Count Robert of Mortain are shown in council before the battle of Hastings. It is Odo who is doing the talking; whoever designed the Tapestry wanted to present him as the brains behind the operation. His achievements at Bayeux reflect worldly pomp rather than any profound spirituality; a beneficiary of his patronage commented tartly that the bishopric had become wealthy enough to support three bishops. In England Odo had to do much of the dirty work of the Conquest; in the Evesham case already mentioned, he had to conduct an inquiry into land-holdings dubiously acquired by a former abbot,

and was criticised by the abbey's chronicler for the way he did this. On occasions he behaved with generosity and a concern for justice. He made a number of grants to the abbey of St Augustine at Canterbury, and he even organised the translation to the abbey of some saintly relics. He protected the landed interests of Rochester cathedral against Picot, the new Norman sheriff of Cambridgeshire, by unravelling Picot's efforts to intimidate a jury. In no way was he crudely anti-English, although he was certainly greedy and heavy-handed. His bid for the papacy reveals a man whose ambitions were ultimately not to be satisfied even in conquered England. His range of achievements and interests can, and still do, make him an object of wonder. We and his contemporaries may dislike him, but what he did and what he was is central to an understanding of the Norman Conquest.

DAVID BATES

thoroughly. He sought to win support from the churches by gifts: a precious chasuble was taken from Battle Abbey and given to the church of St Germer of Fly. He had some allies among the great barons of the region, most notably the Beaumonts, who took their comital title from Meulan. He started building a new castle at Gisors, which Orderic thought 'almost impregnable'. The Vexin would have been a great prize, and this was the time to take it, for the trade of the Seine valley was beginning to boom and the balance of economic and feudal advantage was moving towards Paris. Rufus was forced to withdraw, having made no substantial gains. His barons had advised him that his prospects would be better in Maine, and so indeed it proved. Maine was the county immediately to the south of Normandy, small but very important strategically. Its capital Le Mans was one of the key road junctions of north-west France. Its control was disputed with the house of Anjou. That control had to be indirect, exercised via the local nobility, and the two powers in Le Mans itself, the citizens (who had formed a commune in 1070, asserting their right to govern their own affairs) and the bishop and higher clergy. As in the Vexin, it was the nobility who at this stage were fearful of the expansion of Norman lordship. They had a leader in Helias de la Flèche, who had a claim to the county of Maine, which the Angevins naturally supported. The capture of Helias early in 1098 gave Rufus the initiative. The Angevin garrison of Le Mans after a short siege came to a negotiated settlement. It gave Helias his freedom, and left the status of the parties as they had been in the Conqueror's day. Rufus asked no more. He was afforded a ceremonial entry into the city. His prestige was at its height.

With the church William Rufus was able to do little more than mark time. Lanfranc had died in 1089. After an interval of two years during which the king pocketed most of the revenues of the archbishopric, the king turned again to the abbey of Bec, and appointed its prior Anselm as archbishop of Canterbury. Anselm was a scholar of European reputation. He was to become a saint. He was also a scrupulous defender of ecclesiastical privileges, at a time when those privileges were being defined. The points of contention between him and William Rufus show very clearly the difficulties faced by both parties when the great churchmen were both spiritual leaders and counsellors of kings, and their feudal vassals at the same time. King and archbishop quarrelled several times, and on what look to us like very secular subjects. The first came soon after Anselm's appointment, when he offered the king £500 towards his expenses in Normandy and declined a request for more, fearing that such a payment, immediately after his appointment, might be reckoned simony. The king,

treated to a homily on forced exactions, dismissed Anselm peremptorily: 'Keep your money. I've got enough of my own. Clear off.' Anselm then gave the money to the poor. A few years later, in 1097, Anselm was to go into exile, after a quarrel which seems to have originated in a dispute as to the quality of the troops sent from his diocese to the Welsh expedition of that year. Anselm was well received at the papal court, and learnt at first hand that lay investiture (as had happened at his consecration) was now prohibited. Once told, he followed the letter of the law. William Rufus, and later Henry I, lost little in practical terms from the quarrel with Anselm, but the moral authority of English kingship was weakened for a decade or more, and it would make no secure gains until that conflict was settled.

The Death of William Rufus

William Rufus did not marry. His court was condemned by churchmen as a centre of vice. It is easy, and it is usual, to go on from these propositions to state that the king was homosexual. This is very far from certain. What Orderic criticises as the king's 'obscene fornications and repeated adulteries' might cover a multitude of perfectly conventional misdemeanours. It is likely that in 1093 he was considering marriage with Edith, the daughter of Malcolm king of the Scots; he came to Wilton nunnery on a pretext to see her, and a nice story is told of the king walking in the gardens discussing affairs of state while at the same time keeping a close watch on the ladies. He may not have wanted to marry, or he may just have been impatient of the hassle, and the many sermons, that marriage would involve, and have thought that he had plenty of time.

If the king did indeed think that, he was to be proved wrong. The manner of his death was described very simply in the *Anglo-Saxon Chronicle*. On 2 August 1099, 'in the morning after Lammas, King William when hunting was shot by an arrow by one of his own men.' That account has been much embroidered. It has been suggested that this was no accident, but the result of a plot designed to place Henry on the throne before Robert of Normandy had returned from crusade. Several arguments have been produced for the king's death having been the result of a plot, but none stand up to examination. Rumours were circulated that the king's death had been foreseen in prophesy. Orderic reports one such, from a monk in Gloucester, and there are others. But none of them mention premeditation, and the fall of great men was a part of the preacher's stock in trade. It is true that Henry moved swiftly to secure the succession. His brother was killed on 2 August, and on 5 August he was crowned king in Westminster Abbey.

14 St George. *c.*1100. Fordington church, Dorchester, Dorset
One group of knights (LEFT) prays for aid, which is given, the saint putting stirrups
and lance to most effective use against their enemies (RIGHT).

But speed would always have been essential, and had
Robert been back in Normandy the situation would not
have been greatly altered. The fatal arrow was most prob-
ably fired by Walter Tirel, but here also the trail goes dead,
for there is nothing to turn one of Rufus's chivalrous com-
panions, the lord of Foix and castellan of Pontoise, riding
in the New Forest on a fine summer's day, into an assassin.
The king's death was an accident.

William Rufus was a man who captured the imagina-
tion. The story of his death was only the last of many anec-
dotes about him. The archbishop of Canterbury,
according to the monk Eadmer, was told to 'clear off!'
With laymen the king was even less restrained. When
Helias de la Flèche first offered the king his allegiance in
1098, and when rebuffed threatened to recapture his posi-
tion in Maine, he was sent back, according to the monk
William of Malmesbury, with these words ringing in his
ears: 'Do you think I care what you do? Go away! Get
out! Sod off! Do what you like!' The stories may be
improved, but the language is consistent, the speech direct
and colloquial. The style was the man. He had a short

temper but a short memory. Men felt secure in his service,
and his success brought his servants profit. This was the
model of good lordship in feudal society. Rufus was a big-
ger man, and a better king, than the clerical historians give
him credit for.

Henry I's Early Years

The Conqueror's youngest son, Henry, aged thirty-two,
was now king of England. He was to become a king of
great power, but in his early years his position was more
than usually precarious. He issued a charter at the time
of his coronation, appealing for support, as a king who
would reform abuses, and rule in the traditional way.
Anselm was in exile: Henry would need to make his peace
with the archbishop, and with the church generally. But
his immediate need was for the support of the great laymen,
and it was to redress their grievances that the charter was
aimed. Reliefs, the sums of money paid for entry to a feudal
holding, were to be 'just and proper'. The king's permis-
sion for a tenant's daughter to marry was not a matter of

29

routine, but when given should not be charged for. Widows could, if they chose, remain single. The relatives, not the king, were to have the custody or 'wardship' of a child under age. Forfeitures were to be governed by the custom of the Conqueror's predecessors, 'the laws of King Edward'. The word custom is the key to the whole exercise. William Rufus had a great reputation as a quartermaster; for Abbot Suger of St Denis he was 'that great paymaster and provider of knights'. The charter of 1100 suggests that many felt that under Rufus all feudal relationships had become mercenary relationships. Henry knew their feelings well enough. Most younger sons of medieval kings did, for to be senior members of the baronage was the limit of their aspirations.

So promises were made, and it has been estimated that had they been kept they would have cost the king between £4000 and £5000 a year in revenue. Behind the promises there lay a fear of invasion – by a claimant whose title to rule Normandy Henry did not then dispute, and whose title to rule England many thought superior to Henry's own: his elder brother Robert of Normandy. Robert's case was stronger in 1100 than it had been in 1087, more strongly supported and more actively pursued. In July 1101

he landed in England in pursuit of Henry's crown. The rival armies met at Alton in Hampshire, a wild place in the middle ages, a haunt of highwaymen. The barons insisted that the two rulers come to terms. And so they did. It was agreed that Henry should keep England, and pay his brother a pension of £2000 a year. Robert should retain all of Normandy except Henry's own castle at Domfront. Each would forgive their rebel vassals. The settlement reflected the balance of power in 1101, and that alone. The balance could change. And Henry was not a forgiving man.

The immediate casualties were the Montgomeries. At Easter 1102 Robert of Bellême was summoned to Henry's court to answer a long list of forty-five charges made against him. Robert of Bellême was the eldest son of Roger of Montgomery earl of Shrewsbury, who had died in 1094. Robert had inherited his father's lands in Normandy (the 'patrimony' in the language of the day), leaving his brother Hugh to inherit what was termed the 'acquisition', his father's enormous lands in England. This was a common pattern; it allowed the claims of more than one son to be satisfied, and it avoided problems of divided allegiance if Normandy and England were ruled by different lords. But

15 Foundation charter of Lewes Priory. c.1078–1082. Paris, Bibliothèque Nationale, Bourgogne 78, no. 121
The king and a group of his magnates attest William de Warenne's grant of lands to establish Lewes Priory. Before seals were common, the visible signs of a witness's attestation were these series of crosses; the top three to the right are those of William the Conqueror, Queen Matilda and William Rufus. The charter was sent to Cluny, the mother-house, where it was preserved.

16 (OPPOSITE) Christ calling Peter and Andrew. c.1120, from Lewes Priory. British Museum
The Cluniac order had close links with the papacy, which made scenes from the life of St Peter a favourite decoration of their churches.

in 1098 Hugh was killed in Wales, and Rufus, then lord of Normandy and much reliant on Robert of Bellême for help within the duchy, granted him Hugh's lands. The reunion of the cross-channel estate was a short-term triumph for, but in the long term it was to prove fatal to, Robert and his line. For Robert of Bellême was a Norman lord by birth and inclination, a natural ally of Robert duke of Normandy, and a natural opponent of Henry, who was now king of England. The list of charges hardly mattered in 1102. Robert did not bother to attend Henry's court, and when he refused his castles and lands were declared confiscate. His castles in England were beseiged and taken one by one: first Arundel, then Bridgnorth, then Shrewsbury, and as they were taken the power of this great Norman house in England disappeared.

In place of men such as these, supporters of Robert of Normandy, King Henry in time substituted his own followers who had served him in Normandy, Robert fitz Hamon, Hugh of Avranches and Richard de Redvers among others. They came from the western part of Normandy, and it seems very likely that Duke Robert, despite the terms of the 1101 agreement, never regained control of the western part of his duchy. In 1105 Henry was able to land at Barfleur, and march south unopposed. On land that was as much his territory as that of his brother, at Tinchebrai in September 1106, the two brothers faced one

another again, and this time there was no mediation. Robert of Normandy was captured by his younger brother, and kept in honourable but close confinement, first at Salisbury and then at Bristol, until his death in 1134.

The battle of Tinchebrai is one of the key events of Henry I's reign. It unified England and Normandy and gave a single focus to the political life of both English and Normans. In the months just before and just after the battle, Henry can be seen emphasising that unity, and stressing that it did indeed derive from the support of the whole Anglo-Norman community. First there was need for a settlement with the church. Anselm had gone to Rome in 1103 to look for a compromise on the matter of lay investiture, but found neither of his principals at that time keen: the pope refused to compromise, and the king was able to retaliate by pocketing the revenues of the archbishop of Canterbury (by now the greatest barony in England, worth £1635 a year). The forthcoming showdown with Duke Robert concentrated Henry I's mind, for he would risk all by fighting a major campaign against a claimant to his throne while excommunicate. At Laigle in July 1105 king and archbishop at last sought and found a common ground. The king offered to abandon the practice of investiture if he could retain the homage of his bishops. The pope now agreed, and the bargain was struck. It was not ratified until after, but it was a necessary prelude to, the battle of Tinchebrai. The ratification, in August 1107, was a public one, in Westminster Hall, before an assembly of 'bishops, abbots and nobles of the realm'. Bishoprics and abbacies were now filled, 'nobody could remember so many being given at one time'; among them was Peterborough, vacant since Abbot Matthew had died in 1103. There was need also for a new administrative direction in Normandy. 'In the middle of October [1106] the king came to Lisieux, summoned all the magnates of Normandy, and held a council of great benefit to the church of God', as Orderic put it with evident satisfaction. Henry provided for peace, he protected the inheritance of 'all lawful heirs', and reclaimed his father's lands. All this was legislation for Normandy, but done 'with royal authority'. The royal title came from England. The churchmen and the English had, in the forty years which separated Hastings from Tinchebrai, come to stand firmly behind the Anglo-Norman royal house. It was the end of a chapter.

2

THE LIFE OF THE COURT
1106—1154

AFTER THE BATTLE of Tinchebrai the position of Henry I was secure. Orderic, though he was writing in the 1130s, summarised Henry's achievements at this early point in the reign. 'After becoming firmly established in his government on both sides of the channel in the eighth year of his reign, he always attempted to give peace to his subject peoples, and strictly punished law-breakers according to severe laws. Possessing an abundance of wealth and luxuries, he gave way too easily to the sin of lust; from boyhood until old age he was sinfully enslaved by this vice, and had many sons and daughters by his mistresses.' The main features of the reign can be identified in this short passage. A firm peace was established in England and imposed on her neighbours. Henry exacted the penalties of the law. He was a man of great wealth, and notably lascivious. And even in 'the sin of lust' we may detect important elements of policy.

Close neighbours are often good witnesses. They had no doubt as to Henry's power. For the Welsh author of *The Chronicle of the Princes* he was 'the man who had subdued under his authority all the land of Britain and its mighty ones'. The native rulers of north and central Wales and the Anglo-Norman lords competing for power in the south and the marches, each in different ways felt his power. The Welsh kings were forced to accept Henry's overlordship: they were tied to the court life of the Anglo-Norman world, and had to accept its obligations. Among them was the obligation of vassalage: in 1114, according to the *Anglo-Saxon Chronicle*, 'the Welsh kings came to him and became his vassals and swore oaths of allegiance to him'. The king was very careful as to which of his followers were allowed to become their neighbours. Robert fitz Hamon the lord of Glamorgan died in 1107; his daughter and heir was given in marriage to the senior and almost certainly the oldest of Henry's bastards, Robert of Gloucester. Pembroke, confiscated from Arnulf of Montgomery in 1102, was retained in the king's hands. A number of Flemings were settled in the Gower peninsula; and Kidwelli was given to Roger of Salisbury, Henry's senior administrator, none the less expected to lend a hand in southern Wales. Further west, the area around Carmarthen was feudalised in the characteristic manner of this phase of Norman expansion: castle, borough and religious house controlled every facet of secular and spiritual authority. In this area the Welsh princes, in Rees Davies's phrase, 'were reduced to the status of distressed gentlefolk'.

In Scotland also, the early twelfth century marked an important phase in the integration of the political life of the British Isles. The Normans marched north, with their distinctive views of the proper ordering of feudal society. The key figure here was King David of Scotland (1124–53). David had become an English earl in 1113 when Henry I granted him the marriage of Maud of Senlis, the daughter of the Earl Waltheof executed in 1075, and heir to his honour of Huntingdon/Northampton. David brought to Scotland a new currency of account and of relationships. He issued his own coins, modelled on the English. The first of his surviving charters gave Robert Bruce the lordship of Annandale. Robert – the progenitor of a future king of Scotland – took his name from Brix in the Cotentin, in the area of western Normandy that had been Henry's base before he became king. Robert was to hold Annandale in fief, for the service of ten knights. He built a castle, as a matter of course. His lord, King David of Scotland, thought in the same terms. New castles were put up, and new towns grew around them, those at Berwick, Roxburgh, Edinburgh, Stirling and Perth being particularly important. According to a fifteenth-century chronicler, David also 'illumined in his days his land with kirks and with abbeys'. The links with England were close. Not only did their aristocracy speak the same language, French, but their peasantry did so as well, English. The linguistic divide, which marked off the Celtic-speaking world, was north of the Forth.

17 The White Tower, Tower of London. *c.*1070–*c.*1090
The building may be firmly dated to the Conqueror's reign. A massive building by the standards of the day (90 ft high from ground level to battlements), it still dominates the later buildings constructed around it.

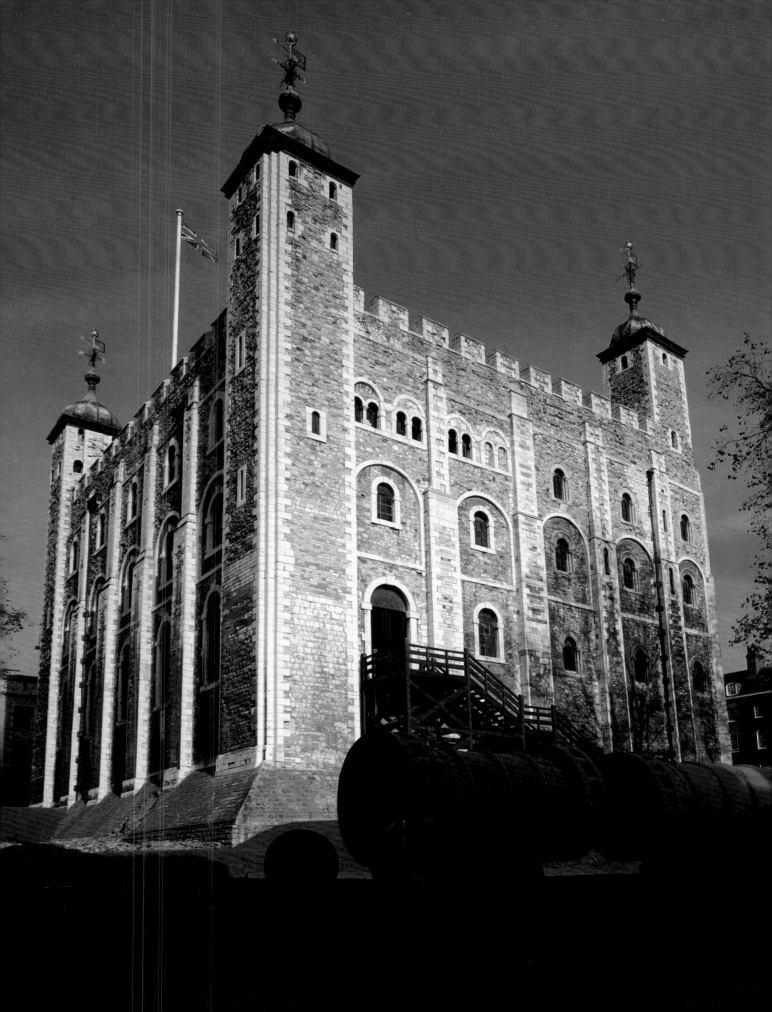

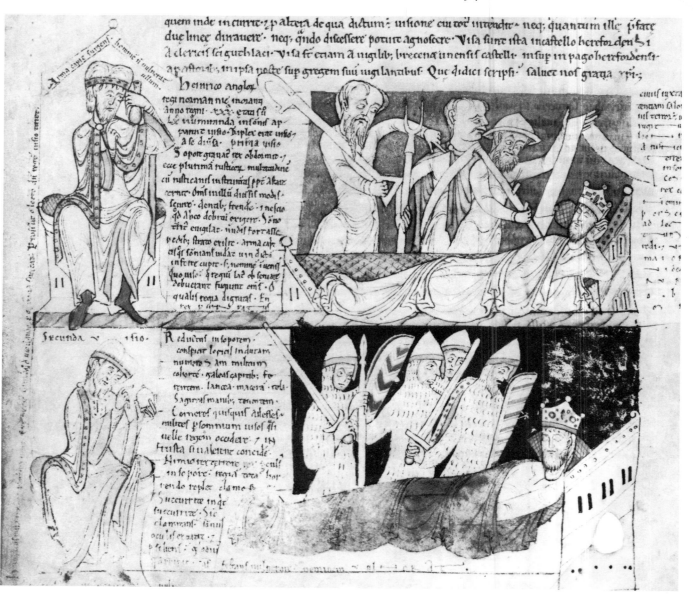

Henry I and his Servants

The court of Henry I, visited by these kings and their followers, was the true centre of the Anglo-Norman world. It was an itinerant court, but one with regular bases. Those of the king's subjects who sought his protection might have to travel some distance. At Stamford on 5 July 1110 the steward of the monks of Fécamp found Henry I and gained his confirmation of a grant of land. At Nottingham about the year 1108 the bishop of Norwich and the monks of Thetford disputed rights over 'the body of Roger Bigod', recently deceased. At Rouen, possibly in the following year, Walter Beauchamp procured writs sent to the county court of Worcester, ordering no man to take the pheasants with which he had stocked his manor of Elmley. Hugh of Ropsley in Lincolnshire was sent a writ of Henry's, issued at Brampton outside Huntingdon, ordering him to allow the monks of Belvoir in Leicestershire to collect their tithes 'at the door of his barn in peace'; 'if you don't do this, the bishop of Lincoln and Ralph Basset will see to it'. It all seems random, and yet it was not. Walter Map later in the century remembered it as a feature of Henry I's time that people knew where they were, that the king announced his itinerary in advance. A reading of the 1,500 or so charters that survive from Henry I's reign confirms this impression; there were fixed points. The most important of them the king called to mind when making a lavish annual grant to the nuns of Fontevrault in 1129: he granted them annually 100 pounds 'in the pence of Rouen', thirty

34

18 Henry I's nightmare. Oxford, Corpus Christi College MS 157, pp. 382, 383, 1140s; from Worcester Cathedral Priory (the chronicle of John of Worcester)
Henry I in Normandy in 1130 has a nightmare, in which the 'three orders' of medieval society appear before him to protest about high taxation. In the final scene the king is caught in a violent storm, which abates only when he vows not to collect danegeld for seven years. The king told his doctor, Grimbald, who is seen at top left examining the royal urine bottle.

marks from London and twenty marks from Winchester. The king never seems absent for long from one of these three centres, where 'an abundant of wealth and luxury' was to be found.

A routine needs to be worked at. It is the work of individuals, and the result of great attention to detail. Henry's routine may be confidently associated with one man above all. This was Roger, bishop of Salisbury from 1102 to 1139. A priest of the diocese of Avranches, he had been Henry's right-hand man before he became king, 'managing his private affairs and checking the luxury of his household'. According to William of Newburgh, who liked a good story to fix his chief characters in the popular mind, Roger was first noticed by Henry because of the speed with which he said mass. 'The soldiers thought that a more suitable chaplain for military men could not be found.' His career in England, where he took over the position he had once held in Normandy, shows a wider range of ability. It was with financial policy that he was particularly concerned, and his monument, set up sometime around the year 1110, was the Exchequer. He trained several of his own relatives to assist him in his work: his nephew Nigel was the first royal treasurer and later bishop of Ely, and his son Richard was educated by the monks of Ely, and became treasurer in his turn in 1158. Richard wrote the *Dialogue of the Exchequer*, which explains the workings of the institution to which he and so many of his family had devoted their lives. His preface explained that he was proud to have done so. It is perfectly proper, he asserted, for clergymen to work for kings, not just in ceremonial

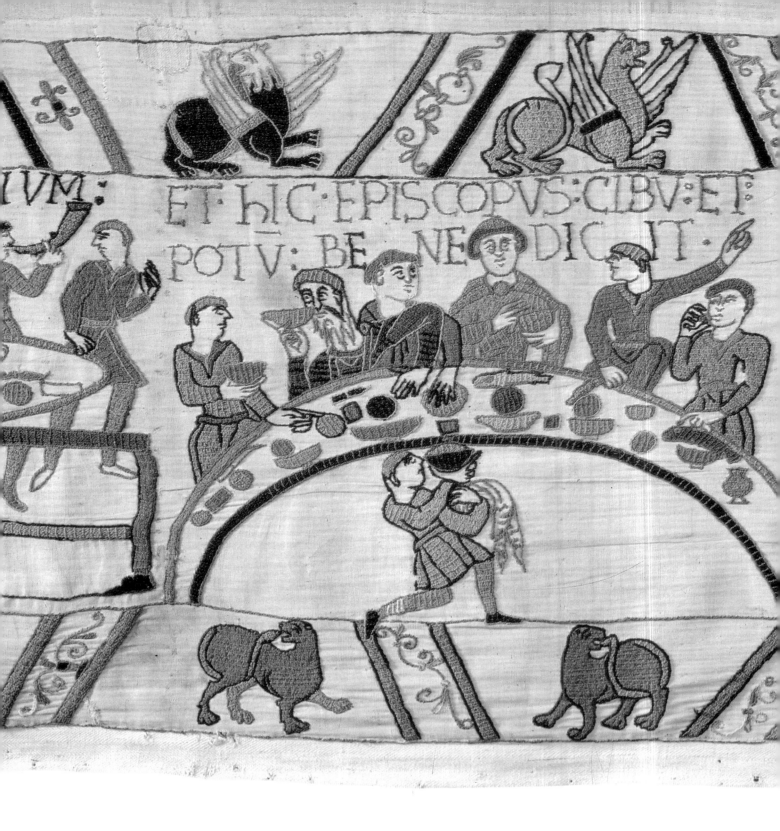

19 The eve of the Battle of Hastings. The Bayeux Tapestry

William and his nobles sit down to supper, and Bishop Odo of Bayeux says grace; the fish course has already been served. In the next scene the final preparations for the battle are made. William and his half-brothers, Bishop Odo on the left and Robert of Mortain on the right, are in a building with a tiled roof, sitting together on a settee.

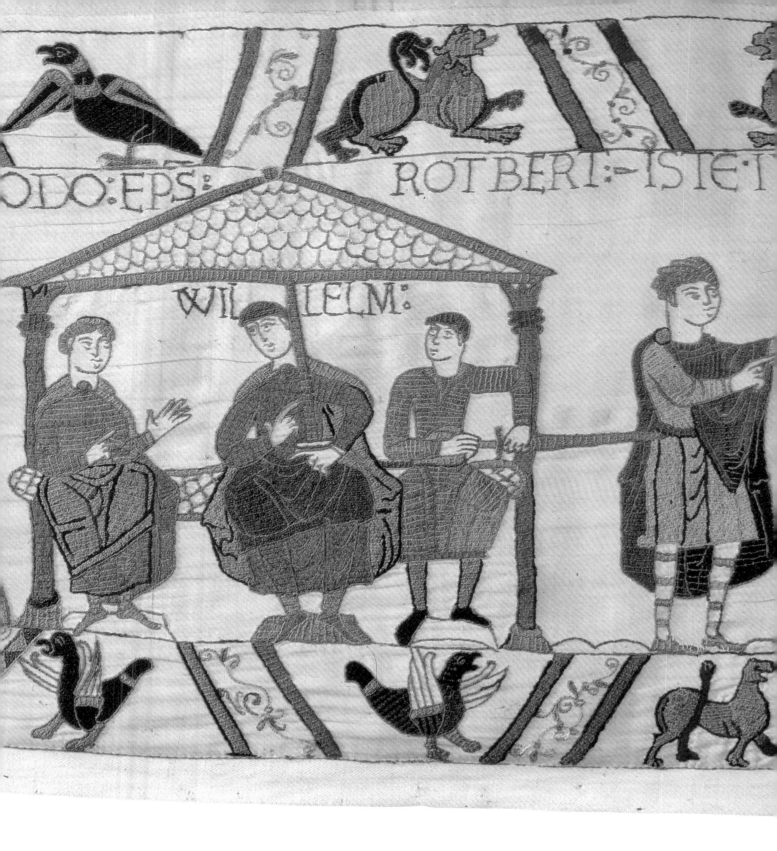

capacities but at the heart of their financial administration. No work could be more important, for the power of kings 'rises and falls as their portable wealth flows and ebbs'. This was written in the 1170s, but it is the authentic voice of Henry I's administration.

The Exchequer was the name given to a special meeting of the treasury, held twice a year to audit the accounts of the sheriffs. It took its name from the chequered board on which the treasury officials made their calculations. Not all of the royal revenue was accounted for here. Those who sought out the king for the grant of privilege, for a marriage or to turn aside the king's anger, were well advised to bring cash. This money went straight into a little bag; it was revenue 'of the chamber' (as financial historians prefer to put it), and not subject to formal account. The accounting at the Exchequer was for the more regular revenues of the crown, paid in by the sheriffs. The royal manors in the county, and the county town where the sheriff had his office (often in the royal castle), paid fixed sums of money. They made up the sheriff's farm, the word coming from the Latin

20 (BELOW LEFT) Old Sarum, Wiltshire
The settlement is given its shape by the defences of an iron-age hill-fort, which enclose an area of thirty acres. Within it, soon after the Conquest, William I built a new castle and founded a new cathedral. The site, though highly defensible, constricted settlement, and the see was transferred in 1219 to the new town of Salisbury two miles to the south.

21 (LEFT) Head of a lion. 1130s, from Old Sarum. Salisbury Museum
The stone comes from the extension of Roger of Salisbury's cathedral at Old Sarum. After the transfer of the see, the abandoned church was used as a quarry for buildings in Salisbury, where this was found.

22 (BELOW RIGHT) Bishop Roger of Salisbury (died 1139). Salisbury Cathedral
The tomb is of marble imported from Tournai, and was probably made soon after the bishop's death; the head is a replacement, of Purbeck marble, made in the 14th century.

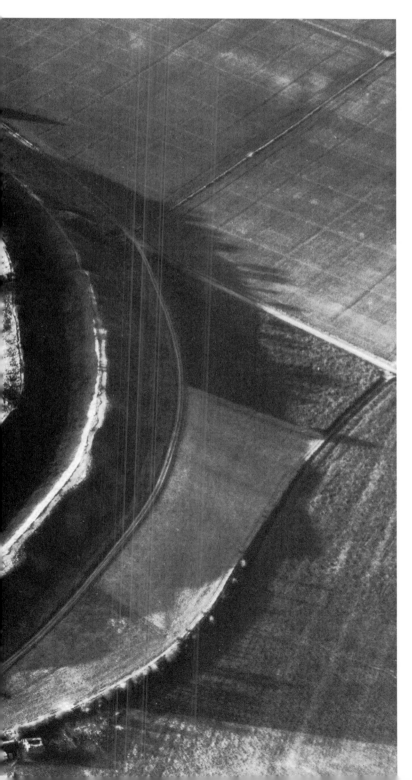

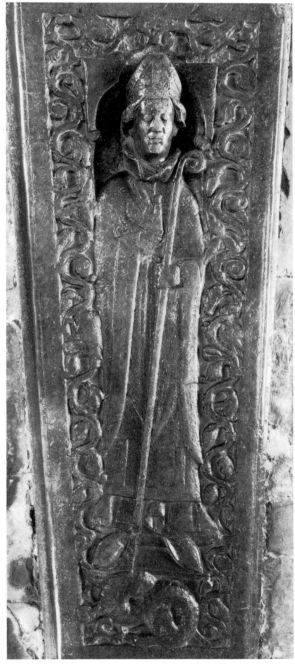

23 St Matthew. Paris, Bibliothèque Nationale, MS lat. 14762, fo. 16v, c.1080, from Exeter Cathedral
One of the earliest post-Conquest illuminated manuscripts, this shows the emergence of a characteristically Romanesque style. The figures still show the influence of Ottonian models (German: 10th century); the acanthus border decoration is Anglo-Saxon, while the flowers that grow from it are characteristic of Norman work.

24 Duke Robert of Normandy (died 1134). Mid-13th century. Oak. Gloucester Cathedral
After his death in Cardiff Castle, Duke Robert was brought for burial to Gloucester, the chief centre of royal authority in the west country. The making of this fine effigy has been associated with the claims of Henry III to Normandy, which had been lost in 1204. The coronet is not original.

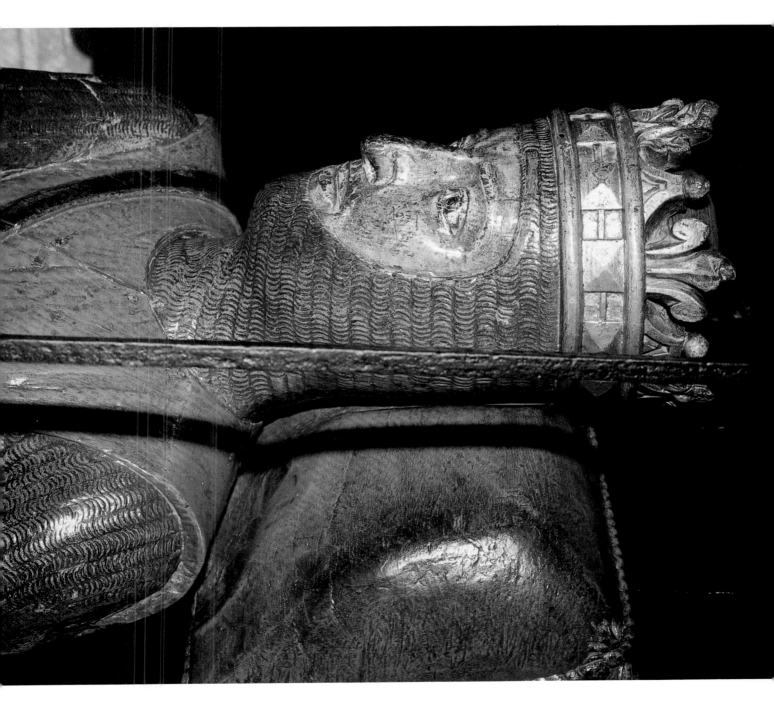

25 The Exchequer in session. Cambridge, Trinity College MS R.17.1, fo. 230r, c.1147, from Christ Church, Canterbury (Eadwine's Psalter) Coins are being weighed and assayed; the king sits in judgement; and those who have tendered the coins look on anxiously.

firma, which in a loose translation would be 'fixed' or 're-liable'. Twice a year the sheriff came to Winchester. At Easter there was a 'view' of the account, or half-term report, when he was supposed to account for half a year's farm. He would receive rents on quarter days, and so have cash in hand. At Michaelmas there was the audit proper, and a balance was struck. This was not a simple matter. The sheriff had standing-order payments to make, such as gifts of alms to religious houses, and specific mandates to dis-charge, to pay royal creditors, or to remit the property tax of favoured officials (the Exchequer officials among them). The sheriff came to Winchester with sacks of tallies and sheaves of charters; and these instruments were publicly scrutinised before any remission of the sum due was allowed. The cash which he brought would, by the end of Henry I's reign, be assayed, a sample of coins being melted down to establish the quality of the whole. The sheriff watched anxiously, and then, when he took his allotted seat around the board, was taken through his account item by item. The monks of Merton priory said that Gilbert the knight, their founder, alone of all the sheriffs, was cheerful during the Exchequer sessions.

The Exchequer must have been a record-keeping body from the beginning, but from Henry I's reign only one set of accounts survives. They cover the year which ran from Michaelmas 1129 to Michaelmas 1130. It is the first of the pipe rolls, as they were called, and a unique record. Domesday Book gives an idea of the overall resources of the whole kingdom but it is only with this pipe roll that we can ask the more precise questions, what were the resources of the English monarchy, and how much of the wealth of the kingdom could the king draw upon? It is perhaps the wealth of the king's subjects that is the most impressive feature of this pipe roll. They were prepared to pay, or at least promise, large sums when the king had any claim to share that wealth, or needed their help in collecting his own wealth. Geoffrey de Mandeville accoun-ted for 1300 marks for inheritance to an estate that in Domesday had been worth £740, and since then had been diminished. Geoffrey paid in 200 marks, and carried the balance over to the next year. William of Pont de l'Arche paid 100 marks this year out of the 1000 marks he owed for the office of chamberlain, which he had obtained through marriage to the heiress of Robert Mauduit. The land tax or danegeld was still being taken in 1129–30: this too the king shared with his subjects. £4355 was asses-sed in 1129–30, £2374 collected and £1810 pardoned. The money pardoned was still collected from the peasants, but it went into the pockets of the landowners not the king. The king had the revenues from his own villages and towns, which brought in £9000 out of his total income in 1129–30 of just under £23,000. Other large sums came from the king's rights of jurisdiction. Over £10,000 was owed in this year for legal judgements given and penalties for crimes and misdemeanours, including forest offences; of this sum just under a quarter was actually paid in. The sums due to the king, once entered on the rolls, were fixed; but payment was always discretionary. £39,000 was accounted for in this year in debts still unpaid. And £5000 was pardoned, nearly 20 per cent of the king's actual revenue. The pardons were the signs of royal favour, and rewards for services rendered.

According to Orderic, in a phrase that has stuck, King Henry I 'raised men from the dust' and 'placed them above earls and famous castellans'. The first man who came to Orderic's mind was Geoffrey de Clinton. His name comes from Glympton in Oxfordshire, a village close to the royal hunting lodge at Woodstock. It was perhaps as an efficient local agent of the crown that Geoffrey first made his mark; then he became sheriff of Warwickshire, and by the end of the reign his was a familiar face in every part of England. The 1129–30 pipe roll shows that in this and previous

years he had visited eighteen counties as a royal agent, hold-ing pleas of the crown and making sure other sheriffs measured up to his standards. The same account shows him pardoned his land tax, the danegeld, on 578 hides; if each of these was worth £2, which was roughly the Domesday valuation, he had indeed an earl's income. He could use this wealth for display. The centre of his power was at Kenilworth in Warwickshire, where he built a castle, and where he founded what was to become an important house of Augustinian canons. One of his nephews, Roger de Clinton, became bishop of Coventry in 1129, and rumour said he had paid the king £2000 for the privilege. There were men of this kind, as Orderic said, in every region of England. A similar story could be told of Ralph Basset and his son Richard, who had considerable estates in the East Midlands, of Nigel d'Aubigny in the north of England, of Payn fitz John in the west country, and of Brian fitz Count in the Thames valley. They showed a fierce loyalty to Henry I, that for some of them actually sharpened in the civil war which followed his death. In the 1140s Brian fitz Count wrote to Gilbert Foliot, bishop of Hereford, of his devotion to the memory of his lord, 'good king Henry, who brought me up, and gave me arms and an estate of land'. The bishop approved, and doubtless echoed Brian's own words when he referred to 'the good and golden days' of Henry I. It was not just a pale echo, however. It was the bishop who added the reference to gold. Brian fitz Count and his kind had done very well from their service to the king.

Law Enforcement

The king, Oderic went on to say, 'severely punished law-breakers according to strict laws'. Royal servants might suffer exemplary punishment. In 1124 'all the moneyers of England', according to the *Anglo-Saxon Chronicle*, were summoned to the Christmas court at Winchester where Roger of Salisbury presided. The king was in Normandy, and his troops had complained at the quality of the coin in which they were paid. The moneyers paid the penalty: 'When they came there, they were taken one by one, and each was deprived of his right hand and castrated.' The chronicler, elsewhere very sympathetic to the sufferings of the English, here had no pity, 'for they had ruined the country by the magnitude of their fraud'. Offences against the feudal code might also bring severe punishment. Two of Henry's own grand-daughters, the daughters of Eustace of Breteuil, were delivered to the king as hostage. When the hostage delivered in return was blinded, the boy's father was given custody of the two girls, and 'avenged his son by cruelly putting out their eyes and cutting off the tips

of their nostrils'. This was done, 'with the permission of the angry king'. This for one frontier castle, at Ivry. Luke de Barre, though not a man of the king, broke the terms of a feudal parole and compounded his crime by writing obscene verses about Henry, which were widely circulated and much admired. Luke was blinded. Members of Henry's court were threatened with blinding and loss of limbs for looting the countryside. Henry was a man very conscious of his own and his court's reputation.

The king claimed for himself 'the hunting rights all over England'. References to the severity of the forest administration are a routine part of the epitaphs of the Nor-man kings. This is not to be wondered at. Large sections of England were placed under forest jurisdiction. As the

26 The hanging of thieves. New York, Pierpont Morgan Library, MS 736, p. 36, *c*.1130, from Bury St Edmunds Abbey. A vivid image of strict justice from the reign of Henry I. The story told is of eight thieves who broke into the abbey church by night to rob the shrine of St Edmund; the saint froze them in their tracks; they were caught the next morning, and are here being executed.

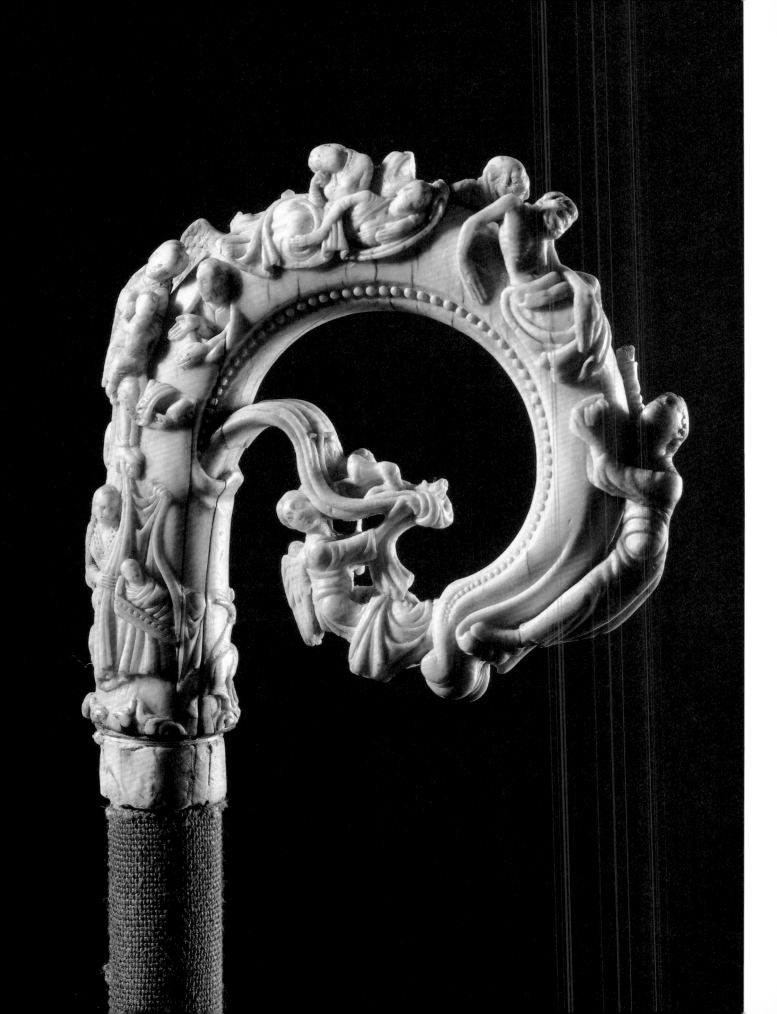

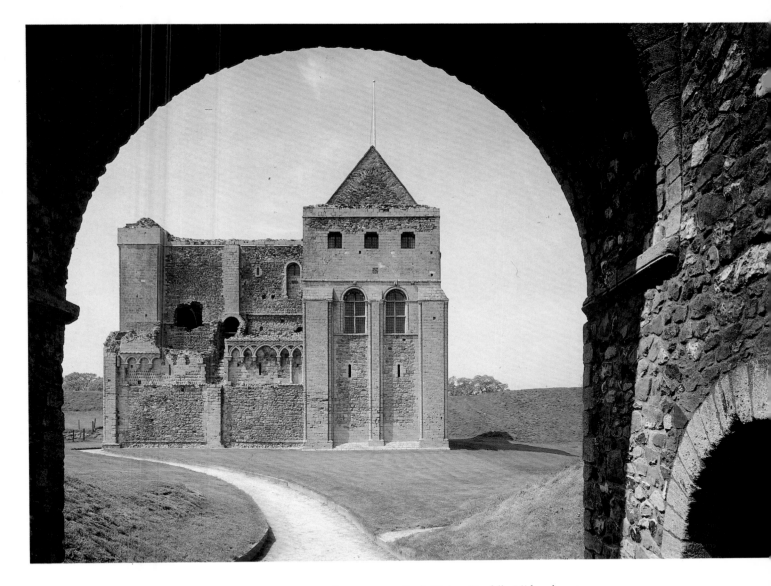

27 St Nicholas Crozier. 1150–70. Ivory, 12 cm. × 11 cm. London, Victoria and Albert Museum
Scenes from the life of St Nicholas (FROM BOTTOM LEFT): his birth; abstaining on fast days from his mother's milk, while his father looks on in amazement. The most popular saints in the middle ages developed complicated legends; the needs of artists for series of images were one factor stimulating this growth.

28 Castle Rising, Norfolk. Mid-12th century
The castle of William d'Aubigny, earl of Sussex 1141–76. The central keep is seen here from the gatehouse. The keep is 50 feet high, and contains only one residential floor above the cellars; in this were the hall and great chamber of the lord, the chapel, kitchens and garderobes.

45

economy grew, and with it the pressure of population on the land, and as the power of the monarchy grew also, the forest became the great pressure point in English political life. References to the forest proliferate in the pipe roll: twenty-two counties are mentioned in that roll, and another three in charters, as having some land under forest jurisdiction. The forest law was particularly severe. The author of the *Dialogus* puts it succinctly: 'what is done under the forest law is not called just as such, but just according to the forest law'. It embraced a wide range of matters.

It is concerned with the clearing of land; cutting wood; burning; hunting; the carrying of bows and spears in the forest; the wretched practice of hambling dogs; anyone who does not come to aid in the deer-hunt; anyone who has let loose livestock which was confined; buildings in the forest; failure to obey summonses; the encountering of anyone in the forest with dogs; the finding of hide or flesh.

It is a long list. These were the concerns of rich and poor alike. Walter of Gloucester, the king's sheriff and constable, had owed £100 at his death for a hunting offence.

The penalties of the forest law, severe as they were, must be seen as being in the defence of a working institution. It was an important part of the context of Norman and Angevin kingship. The forest provided resources. The keeper of the New Forest in 1129–30 claimed against his £25 farm the cost of transporting venison and cheeses from Clarendon to Southampton. Later in the century iron was sent from the Forest of Dean to aid Richard's continental wars. The forest also provided bases. The hunting lodges were quite as important as castles as centres of lordship, particularly in the twelfth century, For Henry I the lodge at Woodstock near Oxford was 'the favourite haunt of his retirement and privacy'. It was at Woodstock that Henry II installed his mistress, the 'fair Rosamund' Clifford. Henry I's mistresses were not worthy of remark, but William of Malmesbury notes that the king also kept at Woodstock animals sent to him from abroad, including a porcupine presented by William of Montpellier. The royal castle of Rockingham in Northamptonshire gave its name to the forest which lay around: there in 1095 Anselm had stood trial, and from there gone into exile. At Brampton, outside Huntingdon, at Christmas 1120, the king recovered from the traumas of the previous year. He had been there in 1116 when a case which concerned Peterborough abbey was heard by the *curia regis*. Nearly a century later, in John's reign, the men of the area remembered that Henry and his queen had worn their crowns three times in the wooden chapel at Brampton. And they remembered the throng: land had been set aside for lodgings for the barons. This was an important consideration. The lodges had to be able to support a considerable household, though neighbouring monasteries could be pressed into service. Henry I freed Eynsham abbey of its obligation to supply beaters for the royal hunt if parts of his household were being entertained at the abbey. All was subordinate to the hunt. And the hunt was serious business.

The Problem of the Succession

After keeping Christmas at Brampton in 1120 the king moved to Windsor, where he married Adeliza, the daughter of the duke of Louvain. This was his second marriage, and courtship had been kept to a minimum, the king being in urgent need of a son and heir. Adeliza, though she was to have children by a second husband, had none by Henry. That is not remarkable, but it is remarkable that Henry was in need of an heir. His first wife had been Edith, one of two daughters of Margaret of Scotland. She had been educated at Romsey Abbey, the best finishing school of the day, 'both in letters and in good morals'. She proved fertile, presenting the king first with a daughter and then with a son, in the two years after their marriage in 1101. The children were named Matilda and William after the great patriarch and matriarch of the Norman race. Then the line went dead. Human fertility is an inexact science at the best of times, and speculation is unrewarding, but it is odd that Edith had no more children by Henry, for he was the most fertile of English kings, He had twenty-one known bastards, the children of at least six mothers. Only Charles II, with fourteen known bastards, comes anywhere near this record. 'Throughout his life he was enslaved to lust', said Orderic, but another monk William of Malmesbury, said something different and more interesting. Henry, he said, was lord of not a slave to his passions; there was an element of policy in these unions. So it may have been. The Conqueror's empire had been rent asunder by the quarrels of his sons. Well-born bastards could be given in marriage to men and women of rank, and a single, undisputed heir left to gain the father's inheritance.

The careers of Edith's two children as they grew to adulthood indicate the most important features of Henry's policy at that time. In 1109 the German Emperor Henry V sent ambassadors, men 'remarkable for their great stature and splendid attire', to ask for Matilda's hand in marriage. They were given a magnificent reception, and in 1110 the

29 The Gloucester candlestick (detail). 1107–13, from Gloucester Abbey. London, Victoria and Albert Museum
The candlestick, one of the great masterpieces of Romanesque art, can be firmly dated by an inscription on the stem referring to abbot Peter. In this detail from the base, men are in conflict with wild beasts, and struggle upwards towards the light.

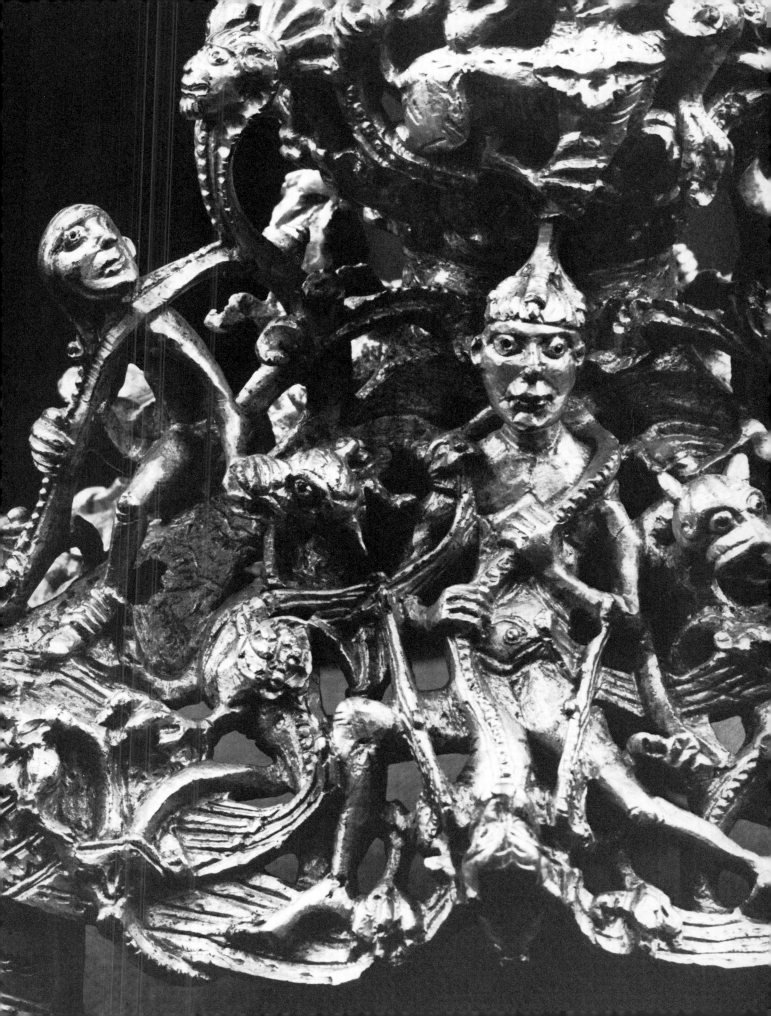

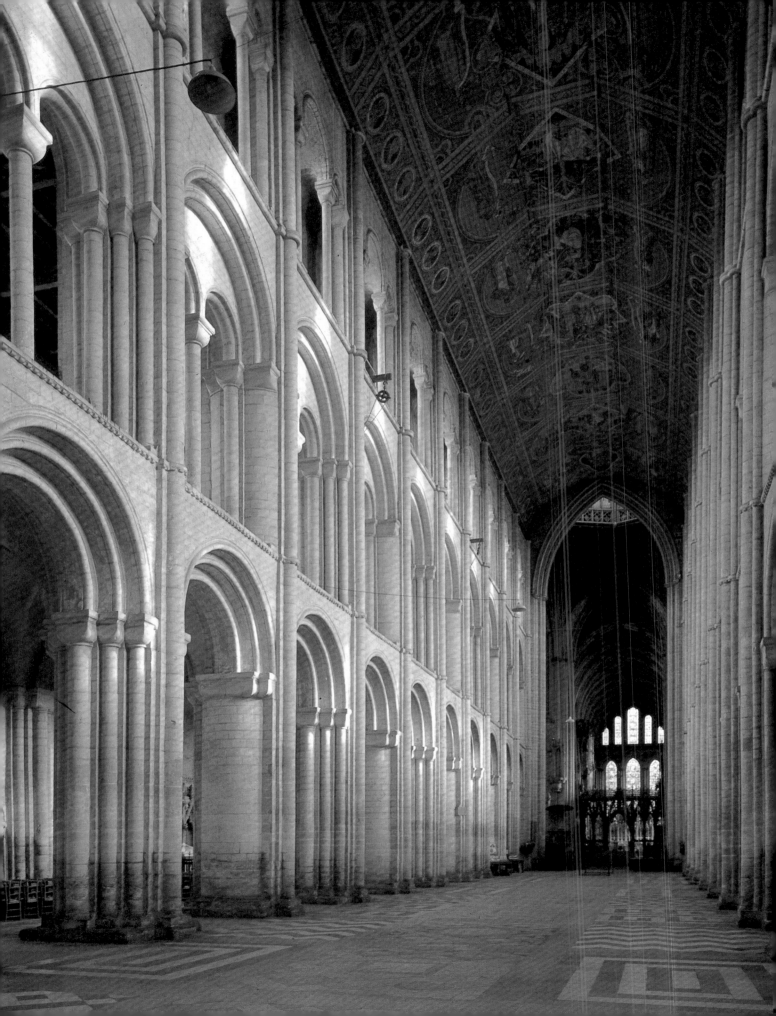

young girl was sent to Germany, where she had to learn a new language and 'the customs of the country'. In 1114 she was married. Both parties gained something from this alliance. Henry I gained status for a powerful but still new monarchy. The German emperor received with his betrothed a great pile of English silver, not less than 10,000 marks, which had been raised by levying a special land tax at 2s. on the hide. This sum was applied to the expenses of a Roman expedition whose military power forced concessions on investitures from Pope Pascal II in 1111. There still remained some credit that Henry could call in, over a decade later, when the emperor supported the king over the Canterbury election of 1123. Matilda, throughout a long life, never abandoned the title of empress. Her father was very proud of her.

It was a splendid alliance, but the focus of Henry's policy lay in France. The Capetian kings of France, prowling round their frontiers and attempting to keep in some balance the counties and duchies that lay beyond them, could only view as a destabilising force within France the power that the Anglo-Norman kings had now achieved. In trying to weaken Henry, Louis VI of France (1108–37) had several advantages. One, perhaps clearer to us now than it was then, was the stability of his dynasty. Another lay in a claimant to Normandy whose title many thought as good as Henry's own. This was Robert of Normandy's son, also christened William, known as Clito or 'the young man'; he was a young man with prospects, and the French king supported him, against Henry, at every opportunity.

Henry needed allies in France, and he sought to gain them by tying a number of comital houses to the life of his court. The count of Brittany did homage to Henry in 1106, and his son married one of Henry's bastard daughters, yet another Matilda. The lords of Brittany were tied very tightly to the Anglo-Norman court. The house of Blois proved equally firm, though their price came higher, and in time they were to undo much of Henry's work. The Conqueror's daughter Adela had married Stephen count of Blois, whose flight from Antioch in 1098 earned him notoriety throughout the western world. Their eldest son Theobald was count of Blois from 1107 to 1152. Both history and geography set him at odds with the Capetians, the other land-locked power of central northern France. Henry lavished his favours on Count Theobald's brothers. Stephen grew up at Henry's court, fought with him on campaign (with but little success), was granted

30 Ely Cathedral, the nave looking east. c.1100 and later
One of the richest communities of English monks, Ely was one of the first to rebuild in the Romanesque style. The church became a cathedral in 1109, and this supplied a further impetus to the building work.

several English lordships, and in 1125 the marriage of still another Matilda, the heiress of the county of Boulogne. Another brother Henry, a monk of Cluny, received equally lavish clerical preferment. First made abbot of Glastonbury, then and conjointly bishop of Winchester, his estate rivalled in value that of his brother Stephen, and its position was to prove equally strategic. These were men who knew exactly the roles which they had to play. King Henry himself would not have thought the price of their favour high, nor, it is likely, have been overly-impressed by them. In an interesting passage Orderic describes the meeting of Henry and Pope Calixtus II at Gisors on the Norman frontier in 1119. Reproached by the pope for his treatment of his nephew William Clito, Henry professed himself to have been ever-willing to welcome the young man. 'I even offered him three counties in England', he is reported as saying', 'so that he might govern them and grow up amongst the petititoners at my court.' That is an interesting and perhaps revealing phrase – *inter aulicos oratores* – among those who begged for favours in the royal *aula* or court. William Clito, the only son of the Conqueror's eldest son, was not impressed.

The relationship with Anjou was the most unsteady, and at the same time the most important, of Henry's frontier concerns. Here his legitimate children had an important part to play. The first serious threat to his position after the battle of Tinchebrai came after the accession of Count Fulk V in 1109. Fulk took over Maine in the following year, and refused what Henry thought to be the proper homage for it. He did not pay homage until February 1113, as part of an agreement by which his daughter Matilda was to be married to Henry's son William. Six years later, to allow the count of Anjou to go on crusade, a second period of conflict was concluded in a peace which involved the marriage agreed six years before. If Fulk had died on crusade, had his ship foundered, Henry's son would have inherited the county of Anjou. He was a single life away from a major coup. But it was the younger man, 'the focus of so many hopes', and for Orderic these hopes were for peace above all, who died. On 25 November 1120 the royal party returned from Normandy, setting sail from Barfleur in the evening when the wind changed in their favour. One of the vessels, the 'White Ship', was taken over by the younger set and was the last to sail. It foundered on a rock close to shore, but the night was dark, the sea bitterly cold, and of 200 on board only one, Berthold the butcher, survived. It was the loss of a generation: 'many lands were deprived of their lawful heirs, and great suffering followed'. Most could be and were replaced; William, 'who was considered the lawful heir of the English realm', could not be. It was Theobald of Blois, who had lost a sister of his

own in the wreck, who told the king that his son had died.

Henry never quite recovered from the wreck of his hopes on that winter night, but neither was he defeated by it. He was married again within two months, but, as has already been noted, to no avail: Adeliza did not conceive. We are told that the 1120s was a decade of increasing confidence in administration, but in the crucial matter of the succession it was a decade of difficulty and at times desperation. It was the decade of William Clito, who after the White Ship went down had good claims to be considered Henry's heir. The king of France and the count of Anjou pushed those claims as hard as they could. They were instrumental in fostering a revolt against Henry in Normandy in the years 1123 and 1124, which the uncertainty about the succession made very serious. It was concluded by Henry winning a victory at Bourgthéroulde south-east of Rouen in April 1124. The Angevin marriage described in the next paragraph then broke the alliance between France and Anjou; this was one of its chief objectives. The French king's reaction was to redouble his support for William Clito. First William was given the county of the Vexin, and then for a time he was made count of Flanders also. The latter dignity he gained after the death of Count Charles the Good, murdered on 2 March 1127 as he knelt at prayer in the chapel of his castle at Bruges. Had William Clito been able to secure his position as count of Flanders, against a number of pretenders, he would have been a thorn pressed deep into Henry's side. But now at last Henry's luck turned. William Clito was killed in July 1128 at the siege of Alost, on the eastern frontier of his county. Orderic seized on his death as one of the key events of Henry I's reign, and in recording it he went forward to note the death of Robert of Normandy in 1134.

Henry had by then settled the inheritance on his daughter the Empress Matilda. The opportunity to do so was offered by the death of her husband the Emperor Charles V in 1125. Matilda was brought back to England in the following year; she returned only with reluctance. In the discussions which followed some favoured her claim to succeed, others that of William Clito. The king had his way, and on 1 January 1127 the court swore allegiance to his daughter Matilda as heir; according to John of Worcester, associated with her was to be, 'her lawful husband, should she have one'. That husband was there-

31 Henry I grieves at the sinking of the White Ship. London, British Library, Cotton MS Claudius D.II, fo. 45v, 14th century Illustration to show the succession to Henry I, part of the early material in a group of legal texts made c.1321 for the Corporation of the City of London.

after found in the person of Geoffrey count of Anjou. Matilda was married in June 1128. The marriage was not a popular one with the Anglo-Norman baronage, even after William Clito's death the following month; both in 1131 and 1133 they had to be whipped into line, had to swear again the oaths to Matilda first sworn in 1127. The union of Matilda and Geoffrey always had the air of a marriage of convenience, but its chief objective was secured in the birth of sons to Matilda, first Henry in March 1133, then Geoffrey in June 1134.

Henry of Huntingdon represents Henry 1 in these last months of his life as a proud grandfather. He stayed in Normandy to be close to the young boys. In fact, the birth of the grandchildren was the cause of complications, and it was these that detained the king. Matilda and her husband demanded some security for their eventual succession. They asked for payment in the currency of power, for castles on the frontier between Normandy and Anjou. They may have even asked that Henry do homage to them, in his turn, 'for all the castles of England and Normandy', as the parents of his eventual heirs. Henry 1 was furious to find his son-in-law in arms on Norman soil. He had been kept waiting himself as a young man; he demanded patience in others. He would have liked, it was said, to take Matilda away from her husband by force. The chance never came. Henry was taken violently ill at one of his Norman hunting-lodges, at Lyons-la-Forêt, during the night of 25 November 1135 and died a week later. 'It must have been something he ate'; a surfeit of lampreys has always remained the most popular of the many suggestions that were made. The body was taken first to Rouen where it was disembowelled, and then to Reading, where it was buried at the Cluniac church of his own foundation. Queen Adeliza gave a rich benefaction for a light to burn permanently before the tomb of her most dear lord.

King Stephen and the Empress Matilda

Matilda, the king's chosen successor, played no part in his obsequies. She came from Anjou into Normandy with her husband to claim her inheritance, and was treated as an invader. The Norman barons met together at Le Neubourg to discuss the succession. The place was significant. It was a convenient central location, but a centre also of Beaumont power. It was the Norman barons who took the lead in offering the crown of England not to Matilda but to her cousin Count Theobald of Blois — like her, but through his mother, a grandchild of the Conqueror. They were still discussing the details however, when news arrived that Theobald's brother Stephen of Blois had already been crowned king of England on 22 December

32 Seal of Waleran count of Meulan (died 1166). c.1130. Red wax, diam. 87 mm. Paris, Archives Nationales L 893, no. 28
A typical equestrian seal of one of the great magnates of the Anglo-Norman world, here attached to a grant made c.1137 to the abbey of St Victor, Paris.

1135. On learning of Henry's death he had immediately crossed the Channel and gained the support of the Londoners. His bases were in Kent, Essex and Boulogne, giving him control of the short sea-crossing to the continent, the lifeline of the Londoners. They gave Stephen their total support. He went from London to Winchester, and there gained control of the treasury. The administrative machine, over which Roger of Salisbury had presided for thirty years, swung immediately to Stephen's side. The coup needed careful planning and a lot of smooth talking. All would have come to nothing, said William of Malmesbury, had Stephen not had the support of his younger brother Henry. The old king had appointed Henry to be bishop of Winchester in 1129. When he did so the coup of 1135 became possible. London and Winchester were the keys to power.

The election of Stephen was the work of a particular group of courtiers, but that alone does not explain his success. Medieval kings achieved their position in one, and preferably more than one, of the following ways: by being elected by various groups in the political community; by being designated as heir by the previous king; or by inheritance through a blood-link, preferably in the direct line, to the previous king. These may be taken in reverse order, as they applied in 1135. Henry 1 had originally intended to secure his line through inheritance, the throne descending to his one legitimate son. After the wreck of

33 Bishop Henry of Blois. Mid-12th century. Enamel, diam. 178 mm. London, British Museum
One of a pair of enamel plaques, made in England by a goldsmith trained in Limoges, the most famous centre of enamel working in the middle ages.

the White Ship he won no general acceptance for the view that Matilda should succeed him. He had needed to designate her his heir, and had tried to pre-empt the process of election. Designation, as with any testamentary disposition, could be changed at any time, and Stephen's party was able to produce a sworn witness, in the shape of the king's steward, to say that Henry had changed his mind. How could one be sure? One could not, and for this reason the oaths sworn to Matilda in Henry's lifetime were always the strongest part of her case. To counter this Stephen's coronation charter listed, in circumstantial detail, all those who had given him support. He had been *elected* by the clergy and people, *consecrated* by the archbishop of Canterbury, and his appointment had been *confirmed* by the pope. The election is stressed, and rightly; it is the key to Stephen's success. The election was secured, as has been shown, by a small number of men in strategic positions; but behind it lay the support of the wider political community. People liked Stephen. He was 'good natured and agreeable to all', 'affable', 'a kindly man'. He became king because he was popular.

Stephen was an accomplished courtier. He made sure that the courts of his early years were splendid occasions. At Westminster at Easter 1136 a grant to his brother's church at Winchester was witnessed by all but a few of the great men of the Anglo-Norman world: three archbishops, thirteen bishops and five earls standing at the head of a witness-list which contained fifty-five names in all. From Westminster the court moved to Oxford, where the king put in writing promises that he had earlier made to the church. In financial terms the most important of these related to the custody of churches during vacancies. Their revenues would not be pocketed by the king, nor would he take money from the man appointed, nor would he attempt to influence the process of selection of the new incumbent in any way. The cathedral chapter would elect.

All this and more was summed up in a single phrase, music to the ears of churchmen, there would be a canonical election. To this charter there was one new witness, the man everyone was waiting for, Henry's eldest bastard Robert of Gloucester. William of Malmesbury, never deceitful but always anxious to put the best gloss he could on Robert's actions, said that he did homage to the king 'conditionally'. In truth all acts of homage were conditional. Robert had no choice but to come to court. He was not inclined to press his half-sister's cause. When asked who should be king, he replied that it should be Matilda's son Henry, then only two years old.

Matilda was left isolated: 'for certain reasons', she did not cross over to England. She was pregnant again – a third son, William, was born in August 1136 – which must have impeded her. More important, crucially when compared to Stephen, she had no base in England. We can only guess how, with this disadvantage, Matilda sought to establish her claim. It made perfect sense to attack Stephen first where he was weakest – on the frontiers of his authority, and in his title to rule. Stephen's frontiers were long ones, for he inherited both England and Normandy, the first king to do so. The initial threat came from David of Scotland, the empress's uncle, who had invaded the north of England before the old king was in his grave. Stephen moved quickly against David, taking an army, chiefly of mercenaries, 'as big as any that could be remembered in England'. King David made peace. His son Henry was granted the earldom of Huntingdon, did homage for it, and was present at Stephen's Easter court. Matilda's husband Geoffrey count of Anjou was equally unsuccessful in establishing a base for her. Stephen crossed to Normandy in the spring of 1137. He purchased Theobald's support by the promise of a pension of 2000 marks a year, and that of the French king by having his own son Eustace do homage for Normandy. Stephen must

have seen these payments as a prelude to a military engage, ment with the Angevins. Before this could happen, how, ever, his army's high command fell to squabbling and recrimination. Robert of Gloucester claimed that William of Ypres, the leader of Stephen's troops from Flanders and Boulogne, had planned to ambush him. Many of the Nor, mans left Stephen's camp and made their way home. The king was widely reported as having been furious at this. 'When they have chosen me king, why do they abandon me? By the birth of God, I will never be called a king without a throne.'

In the following year, 1138, Stephen was abandoned both by Matilda's half,brother Robert of Gloucester, and by her uncle the king of Scotland, both of whom had made their peace with him in 1136. Robert, a gentleman of the old school, followed the proper form and renounced his fealty to Stephen. Stephen at this laid siege to Bristol castle, the administrative centre of Robert's west country estate. While the king was thus occupied, in what was to prove an unavailing siege, the Scots once more invaded England. Their reputation preceded them; the virtue of northern women, and the sanctuaries of northern saints, had been desecrated, and the whole position which the Normans had secured in northern England was under threat. The northern baronage took the field, led by Thurstan archbishop of York, who when young had been the 'official greeter' at Henry I's court; his task now was to turn the Scots away. The English militia, under the banners of their saints, fought alongside the Normans and won the victory. The battle of the Standard, as it came to be known, fought near the town of Thirsk on 29 August 1138, was a serious reverse for the Scots. It was followed, however, by a peace settlement which offered them several concessions, including the grant of the earldom of Nor, thumberland to the son of the Scottish king. King Stephen, said William of Malmesbury, 'always settled business with more loss to himself than to his opponents'; he may well have had this episode in mind.

The key as to why the 1138 peace was so generous to the Scots is almost certainly to be found in the presence in England that summer of a papal legate, Alberic bishop of Ostia. He was a legate of Pope Innocent II, whose authority was now unquestioned following the death of the anti,pope Anacletus II in January 1138. Alberic presided over a council which appointed Theobald abbot of Bec as archbishop of Canterbury, and was active in making the Scottish peace, but the main business of his legation was to summon the English clergy to what would become the Second Lateran Council, held in Rome at Easter 1139. Stephen could see how important this council might be, for there was the prospect that Matilda's claims

against him – that he had broken his oaths and usurped the throne – would be once and for all dismissed. He sent supporters well briefed on the concessions he had made to the English church. In charters they brought back with them those concessions, made by 'our most dear son Stephen', 'the illustrious king of the English' were several times confirmed word for word. The claims of both Stephen and Matilda were heard; and then the case was adjourned. It was not all that Stephen had looked for, but for Matilda it was a major reverse.

The Empress Bids for Power

Whatever plans Matilda had made, they had undoubtedly failed; she was in several respects worse off than when Stephen's reign began. She tried a last and desperate throw. She landed in England. The choice of landing,place was not easy. Hoping for assistance from her stepmother Adeliza, the widow of Henry I, who held Arundel in dower, Matilda landed at Portsmouth on 20 September 1139 and made for Arundel. Stephen was furious that those set to watch the coast had failed in their duty. They left him in a dilemma whose solution was more difficult than has been realised. He had isolated, but did not have in his power, two very determined women whose rank was equal to his own. Their crimes were crimes against feudal etiquette, though we can see, and Stephen could see, that the empress threatened far more. The negotiations are lost to us, but they culminated in a fatal act of indeci, sion. Stephen gave Matilda a safe conduct to join her half, brother Robert at Bristol, and his brother Henry of Win, chester accompanied her for part of the way. Men shook their heads when they heard the story, but would have thought it completely in character. For the monk of Peter, borough who wrote in the Anglo,Saxon Chronicle, the king was 'a mild man who was gentle and good, and did not inflict the full penalties of the law'; a man who 'took no reprisals'. When Baldwin de Redvers held Exeter against him early in 1136, and Geoffrey Talbot fortified Hereford in 1138, in each case the garrison surrendered and were allowed to go free. This was the king's reputation as it was broadcast through the lands he ruled. He was never feared.

The period between Robert of Gloucester's defection in the summer of 1138 and Matilda's landing in September 1139 was a time of great anxiety in England. All men of any standing thought it prudent to 'stock their castles and towns with the necessities of life, and make sure they had warriors properly armed'. This was true of churchmen as well as laymen: bishop Henry of Winchester, the king's brother, controlled six castles, and Roger bishop of

Rievaulx Abbey

IN 1131 BERNARD OF CLAIRVAUX wrote a typically forthright letter to Henry I: 'in your land there is an outpost of my Lord and your Lord. I have proposed to occupy it and I am sending men from my army who will, if it is not displeasing to you, claim, recover and restore it'. He continued by saying that he was sending messengers who would reconnoitre the site and report back. Henry was asked 'as a vassal of their Lord' to give every assistance. Early Cistercians chose and organised their new foundations with military precision; the new abbey, Rievaulx, the second Cistercian house in England after Waverley (1129), was no exception.

The tone of Bernard's letter suggests that the expedition had a site firmly in mind. The group's leader was William, a Yorkshireman and one of Bernard's secretaries, and it is likely that Yorkshire was intended as the destination and that negotiations had already been begun with Archbishop Thurstan, Walter Espec, lord of Helmsley, and perhaps with the king. Certainly Walter's foundation charter speaks of Rievaulx as established

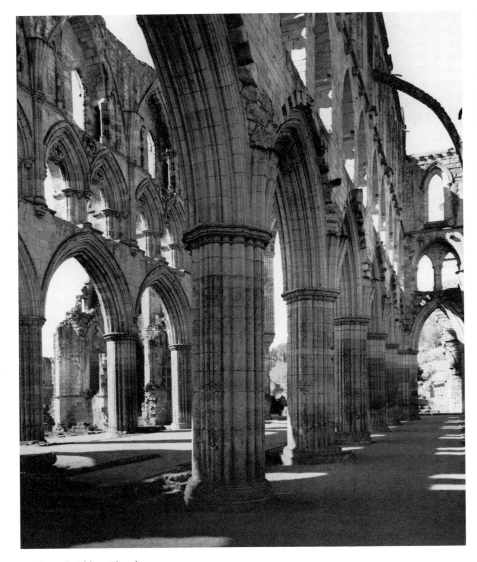

1 Chancel, Abbey Church
While comparatively little remains of the nave of the church (c.1135–40) the surviving eastern parts and parts of the transepts survive to represent Cistercian architecture of the highest quality.

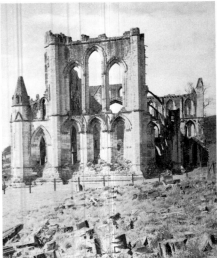

2 East End, Abbey Church
The east end was rebuilt in lavish style c.1225 and remains one of the finest examples of English Gothic architecture.

with 'the council and consent' of Thurstan and Henry. A pious (and literate) magnate, held in high regard by contemporaries for his personality and military skill, he lacked children, and this may have provided the motivation for his foundation of three abbeys: Rievaulx, Warden, and Kirkham. Archbishop Thurstan was already favourably disposed to the Cistercians and his support as diocesan was essential for the new foundation's success.

The new abbey was situated 'by a powerful stream called the Rie in a broad valley . . . high hills surround [it], encirc-

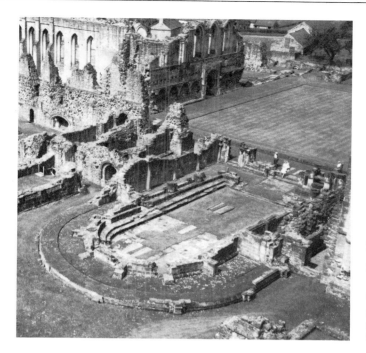

4 Scourge, Abbey Museum
This scourge of plaited chainwork, excavated from the abbey site, may have provided ceremonial correction in the chapter house for disciplinary offences.

3 Chapter House and eastern claustral range
The chapter house (FOREGROUND), originally an oblong structure, was one of the first buildings erected. The expansion of the community necessitated its later enlargement with an apse, while the decline in numbers in the late middle ages resulted in the demolition of the aisle round the apse.

ling like a crown. These are clothed by trees of various sorts and maintain in pleasant retreats the privacy of the vale, providing for the monks a kind of second paradise of wooded delight'. Another chronicler described the site as 'a place of horror and great solitude'! Shortly after its foundation Ailred joined Rievaulx as a monk, and his abbacy (1147–68) marks the apogee of the abbey's vigour and fame. According to his biographer, Ailred 'doubled all things in it . . . monks, lay brethren, servants, farms, lands and every kind of equipment'. At his death there were said to be 140 monks and 500 lay brethren and servants, making Rievaulx by some way the largest Cistercian community in England. Though it is clear that Ailred was not wholly popular in this 'home of piety and peace', Rievaulx never again achieved such fame.

The initial foundation was small, though the monks did their best to 'improve' the valley by changing the course of and partly canalising the river to improve drainage and increase pasture. However, additional grants were substantial, and the greater part of the estates had been acquired and granges (outlying farms) established by 1200. They were concentrated in the vale of Pickering, the western edge of the North York moors

and Cleveland. Pastoral farming was paramount, and by the end of the thirteenth century the abbey may have owned some 12,000 sheep.

Little is known of the later history of Rievaulx, but in 1276 it was in serious trouble, being taken into the king's hands because it was in a 'state of decay' as a result of the impact of murrain on its mainly pastoral economy. In 1288 it was again in difficulties, so much in debt to Italian merchants that the king again took charge. In 1322 a Scottish raid sacked the abbey and caused great damage to the estates. When recovery came the economic climate had changed, and from the mid-fourteenth up to the dissolution of the monasteries in the sixteenth century the abbey leased most of its

5 Windmill, Abbey Museum
This fragmentary carving from the abbey depicts the carrying of corn (perhaps by a lay-brother) for milling at a post-mill. Arable farming, as well as pastoral was vital to the Cistercian economy.

estates and largely depended on a rental income. At the Dissolution its net income was c. £278: a moderate revenue by Cistercian standards and far below that of the largest Yorkshire Cistercian abbey, Fountains.

The history of the abbey is reflected in its buildings. The original temporary structures were gradually replaced during Ailred's abbacy. The east end of the church was begun first, the remainder of the church and the claustral buildings followed. In 1225 (probably the time of the abbey's greatest prosperity) the east end of the church was rebuilt on a lavish scale. This was the final project, with the significant exception of new quarters for the abbot in the late middle ages.

An inventory of the buildings drawn up at the Dissolution gives some idea of the abbey's appearance. Besides the standard claustral buildings and offices there were the muniment room ('the house for evidence') and well-appointed abbot's lodgings, including a private chapel, dining chamber and kitchen. Outside the gate lay the 'chapell . . . garneshid for the parish'. The whole reveals something of the sophistication and comfort of a late-medieval abbey, far removed from the ascetic ideals and 'huts' of its founders.

BRIAN GOLDING

Salisbury had four, among them Sherborne and Devizes. These two castles in particular, as well as being in the latest style were now of some strategic importance. This offended some of the lay magnates, particularly those whose attitudes were formed in Normandy, for there it was a commonplace that all castles were public buildings not private possessions, and must be surrendered to the ruler in times of emergency. Was this not a time of emergency? Clearly it was. Could the loyalty of the bishops be counted upon? This was less clear. Rumours mounted, and Stephen was at length prevailed upon to take them seriously. At the royal court at Oxford in June 1139 Bishop Roger and his nephews were arrested, and the surrender of their castles demanded as evidence of good faith. Nigel bishop of Ely escaped, and most foolishly gave credence to the rumours by garrisoning Devizes. He was forced to surrender it by dire threats, in particular one to hang the chancellor, who was Roger of Salisbury's son, before the castle walls. News of this spread and was improved in the telling: one version had Bishop Roger housed in a cowshed, another introduced his mistress Matilda of Ramsbury, as castellan of Devizes, pleading for the life of her son. And there was more to come, for Henry of Winchester had his own castles, and a newly-conferred authority as papal legate. He would make 'the arrest of the bishops', as it has come to be called, a test-case. A church court was summoned, and the king was invited to explain his behaviour. It generated more heat than light, and there was no public humiliation for the king; rather 'the legate and the archbishop fell as suppliants at the king's feet in his room', and begged him 'not to allow a divorce to be made between the monarchy and the clergy (regnum and sacerdotium)'. It was really a little too late to think of that. With his own brother ranged against him, and the head of the civil service now in disgrace, the consensus which had placed Stephen in power and had sustained him up to this point had fallen apart. It was a very public break, and very widely reported. It destroyed the integrity of Stephen's court.

The court ceased to be the centre of the nation's political life. If Stephen seems hereafter a follower and not a leader of events, it is for this reason. Men went their own ways. Henry of Winchester went to France, and, after discussions with his brother Theobald of Blois and with the king of France, returned with the terms of an agreement as to the succession, 'which would have benefited the country had there been anyone to combine words and deeds'. Matilda and her supporters would have been prepared to accept them, and from this we may infer that they provided for the eventual succession of Matilda's son Henry, with Stephen offered a package of benefits which did not involve

the English crown descending to his heirs. Stephen refused, and within months there occurred the only major battle of the reign. This is no coincidence. Warfare is the last resort of those who have exhausted other means, and who have more to gain than to lose from a confrontation. It needed a focus, which was supplied by the struggle for the control of the royal castle of Lincoln. Ranulf earl of Chester and his half-brother William of Roumare had a claim to the castellanship based on inheritance, but Stephen, no less than his predecessor, was reluctant to concede the principle of inheritance of offices. It was important also for Stephen to maintain control over the main ports of eastern England, of which Lincoln, through its link via Torksey to the Trent, was one. When urged to assert his rights to the castle by the citizens of Lincoln Stephen responded promptly, and surprised Ranulf and his brother at Christmas 1140. Ranulf escaped but his wife was captured. She was the daughter of Robert of Gloucester, and to him Ranulf now appealed for help. The claims of family could not be ignored, and Robert responded promptly, bringing from the west country towards Lincoln 'a most dreadful and unendurable mass of Welsh'. Ranulf raised troops in Cheshire, some of whom must have been Welsh also, and the two earls joined forces en route, probably at Ranulf's midland base Castle Donington in Leicestershire. Stephen's own followers, his 'false and factious earls' as Henry of Huntingdon describes them, brought only small retinues, but the king could still muster a good force of household and mercenary troops. A largely infantry army was opposed to a largely equestrian army, and on ground that seems to have favoured them the infantry won the day. The king, deserted by all but a few of his men, fought valiantly but was at length forced to surrender. He was taken in captivity to Bristol.

All might now have seemed set fair for Matilda to succeed. The keys to power, in 1141 as before in 1135, were Winchester and London; the power-broker, then as before, was Henry of Winchester, who now had an extra responsibility as papal legate. He, perhaps over anxious to accommodate himself to political change, accepted Matilda's title. That title was an interesting one: from then on the empress was called domina Anglorum, 'lady of England', not queen. She now, however, began to arrogate to herself royal powers. She issued charters, and had coins struck in her own name. She asked the Londoners for a royal aid. But she was found no secure base in London. Why, with Stephen in captivity, should this have been so? For the chroniclers the reason was above all her defects of character. William of Malmesbury described her as eadem virago, which hardly needs translating, but which can be rendered as 'that woman of masculine spirit'. 'She put on

an extremely arrogant demeanour instead of the modest gait and bearing proper to the gentle sex'; she was arbitrary and headstrong in all that she did; she refused to take advice. She was tactless, without a doubt – it was tactless, for instance, to seek to invest the new bishop of Durham with ring and staff, and to take money from the new bishop of London – but there is more than a hint of sexual stereotyping in these descriptions. Matilda saw London as enemy territory, not without cause. Stephen's queen mustered troops on the south bank of the Thames, which threatened the capital no less than Matilda herself. The Londoners pealed the bells of their churches and rose to arms. The Empress was forced out.

Her position had been ambiguous all along. Did she really hope to become queen in her own right? She may once have done so, but her supporters now disillusioned her. From London she made her way to Oxford, and at Oxford she made an agreement with a rather reluctant sup-porter, Geoffrey de Mandeville earl of Essex, granting him wide powers and considerable estates in eastern England. The interest here is the security that Geoffrey asked for. Matilda had to promise that 'in so far as she could' she would ensure that her husband the count of Anjou and her son Henry would swear in person to maintain her grants; the king of France, too, if it were possible. The charter does not quite say that a woman's promises are not worth the parchment they are written on, but it comes very close to it. Events in the autumn hammered home the same lesson, that Matilda could not move far without her menfolk. Having lost London she now tried to capture Winchester. This too proved to be territory that she could not hold. She was again driven out, in her nightgown according to one account, a story accepted by a source well in tune with this reign, *1066 and All That*. In the retreat from Winchester Robert of Gloucester was captured. He was vital to his sister's success; she had no alternative but to release Stephen in exchange. There is little doubt that from now on it was the young Henry's claim to succeed as king that his mother Matilda and his uncle Robert of Gloucester tried to promote. An important stage in his eventual success was his father's capture of Normandy. The battle of Lincoln broke the resistance of the Norman baronage. Some key defections, such as that of count Waleran of Meulan, and a general apathy, meant that Geoffrey of Anjou was able to invade Normandy via Maine, take the western parts of Normandy (with Robert of Gloucester's help), and then move east. He was invested as duke of Normandy in April 1144. During this cam-paign, the Anglo-Norman empire finally fell apart, and its great chronicler Orderic Vitalis went to his grave.

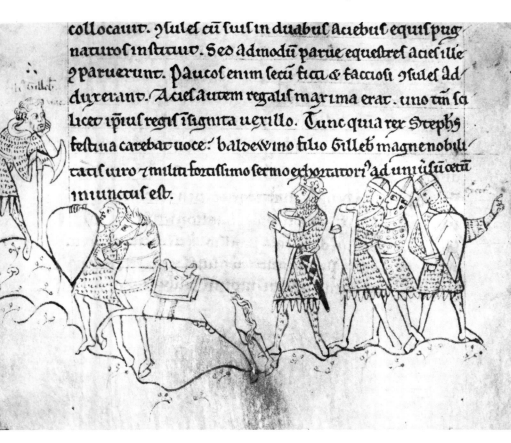

34 The Battle of Lincoln, 1141. London, British Library, Arundel MS 48, fo. 168v, *c*.1200. (Chronicle of Henry of Huntingdon) The sketch was prompted by an anecdote in the chronicle: the royal troops before the battle were exhorted to valour by Baldwin fitz Gilbert, King Stephen (CENTRE) having delegated this task because he had a weak voice.

'Christ and his Saints were asleep'

In the 1140s the lands which Henry 1 had ruled shrunk within themselves, and were under the control of three different lords. Geoffrey of Anjou was duke of Normandy; Robert of Gloucester held the west of England, with the empress more often at Devizes; Stephen remained king of England. Each offered some protection to those in their power. The author of the *Gesta Stephani* wrote that Robert of Gloucester and his supporters 'put almost half of England, from sea to sea, under their own laws and ordinances'. Robert offered that region 'the shadow of peace' but not genuine peace, for he required military service or castle-works as the price of his protection. For the writers of the day these castles were the true symbols of arbitrary power. They sprang up like mushrooms in Stephen's reign. When peace was finally concluded the demolition of the unlicensed castles was placed high on the agenda, and in one version of one chronicle the figure of 1100 such castles was supplied. 'Every great man built castles for himself and held them against the king', said the *Anglo-Saxon Chronicle* in what has become a classic description of anarchy. 'They filled the whole land with these castles', and when they were built, 'they filled them with devils and wicked men'. Men were tortured to part with their money, hung up by the feet and smoked like kippers, or placed in dungeons where there were adders and snakes and toads, 'and in these ways they were destroyed'. All went to rack and ruin. In the countryside,

you could see villages with famous names standing solitary and almost empty because the peasants of both sexes and all ages were dead, fields whitening with a magnificent harvest (for autumn was at hand) but their cultivators taken away by the agency of devastating famine, and all England wearing a look of sorrow and misfortune.

A single image summed it all up: 'It was said openly that Christ and his saints were asleep.'

The period during which the saints slept is often referred to as the 'anarchy' of Stephen's reign. In its strict sense, anarchy means a lack of government. This there was. Stephen's government in the 1140s was effective over only a very narrow area. This may be seen from the coinage (see picture essay pp. 60—1).

It does not follow that there was anarchy in a more general sense, a total lack of order in the countryside. Local order was always just as much the responsibility of the magnates as of the king. It was in the magnates' own interests to keep their ambition within bounds, and to keep control over the behaviour of their own tenants and subordinates. Their concerns can be seen in an agreement, which

was typical of many, made between the earls of Chester and Leicester between 1149 and 1153. The effect of this agreement, made in the presence of the bishop of Lincoln, was to demilitarise the county of Leicestershire. No new castles were to be built in this area (delimited in terms of its border castles) without the agreement of both parties; if any was built, the two earls together would work its destruction. They were not, however, entirely their own masters. They foresaw a situation in which they might have to fight for different lords — the earl of Leicester for King Stephen, the earl of Chester for Matilda's son Duke Henry (as he shortly became). In such a case, they promised to take a retinue of only twenty knights, and to return any goods they took in the course of the campaign. This agreement was born both of their own conflict and, just as much, of a desire to curb the behaviour of their vassals. The churchmen also had their part to play in what Ralph Davis has justly called 'the magnates' peace'. They fought with different weapons. They developed a very sharp critique of what they saw as the exactions of the lay power, the local authority which the earls in such treaties took for granted. A church council held in London in mid-Lent 1151 was concerned to 'seek out new remedies' for the malady of the body politic. They anathematised all those who sought to impose agricultural and building works and to levy taxes on their peasantry. Only royal works and royal taxes were exempted. They sought their protection in royal power, in a definition of the rights of the crown.

Henry of Anjou

The main chronicle source for the later years of Stephen's reign, whose author has so far proved elusive, is the *Gesta Stephani*. Thoroughly sympathetic to Stephen, it surprises the reader by describing Matilda's son Henry, when he came from Normandy to England in 1147, as 'the lawful heir and claimant to the kingdom of England'. It need not do so. That Stephen was rightly king, but Henry rightly his heir, was an idea that had been canvassed for a long time — not least by that indefatigible canvasser, Henry of Winchester — and was steadily gaining ground. It cut no ice, however, with Stephen, nor with his son Eustace. With Henry's landing in 1147 English politics moves on a generation. Henry was fourteen in that year, and at first had little more than youthful enthusiasm to sustain him, and a conviction of the justice of his cause. He hoped that his presence would rally his followers. It did not. He soon ran out of money to pay his troops, and neither his mother nor his uncle were prepared to help. It is not surprising that Robert refused to help. He had

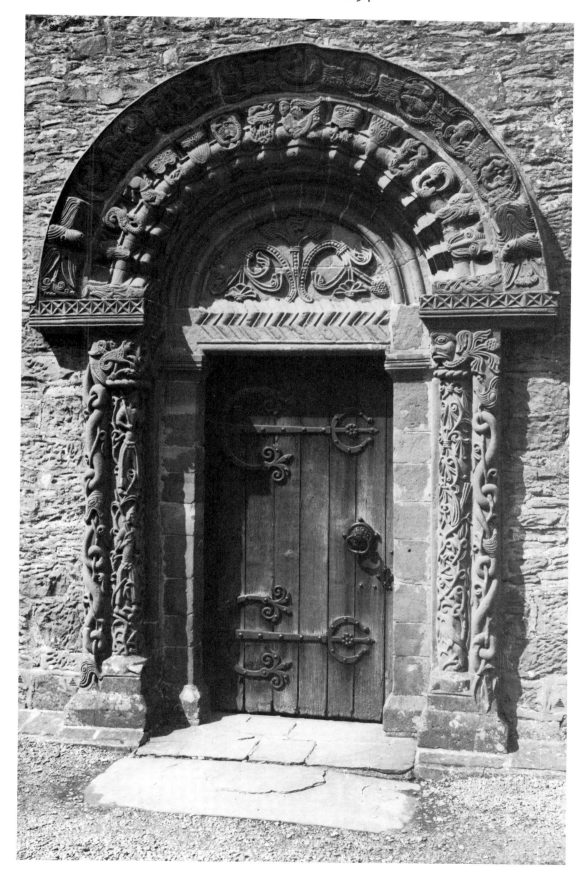

35 Kilpeck church, Herefordshire, south doorway. Mid-12th century
A priory of Gloucester Abbey was founded at Kilpeck in 1134, which helps account for the rich decoration of the parish church, built soon after this date.

The Coinage in King Stephen's reign

THE ENGLISH KINGS maintained a control over coinage which was unique amongst the monarchies of the day. Coins were minted locally, in a wide range of towns, but the dies from which the coints were struck (2) were issued centrally. Each issue of coin had some distinguishing features, from which numismatists can identify a type. Payments to the king were only accepted in coins of the current issue; this brought in most coins of the old issue, and all foreign coins, for reminting. All coins were silver pennies, 92·5 per cent fine, with a weight of around 1.39 grammes.

Coins, though they were small in size, are very precise historical documents. They bear on one side (known technically as the obverse) the king's head and his name: this was the image of kingship which circulated most widely in medieval

times. Stephen's first type shows the king with crown and diadem, holding a sceptre in his right hand. On the other side (the reverse) there was a cross, and the inscription gave the name of the moneyer (responsible for the quality of his coins) and the place of issue. From these names on Stephen's coinage it is clear that many of the twelfth century moneyers

1 Stephen Type I, struck at Oxford by the moneyer GAHAN. Oxford, Ashmolean Museum
This, and all coins with the exception of no. 5, are shown at twice actual size.

were of Saxon or Scandinavian descent – the moneyers in Hereford in Stephen's reign were Driu, Edric, Sibern and Witric, and amongst those at York were Aschil, Outgrim, Laising and Ulf.

Because of the precision of the information – the weight, the design, the places of issue – the study of types of Stephen's coinage offers one of the best

mints
• Stephen's type I
◯ Stephen's type II and/or VI
◇ Matilda and/or William of Henry
▢ Scottish coinage

Roxburgh▢ ▢Bamburgh
Corbridge▣ ▢◉Newcastle
Carlisle
Castle Rising◉
Norwich◉
Thetford◉
Bury◉ ◉Ipswich
Bedford◉
Hereford◈ Gloucester◈ ◈Oxford ◉Colchester
Cardiff◈ ◇Malmesbury London
Bristol◈ Canterbury◉
Wareham◈ Sherborne◈ Lewes◉ ◉◉◯Rye Hastings

0 ____ 100 miles

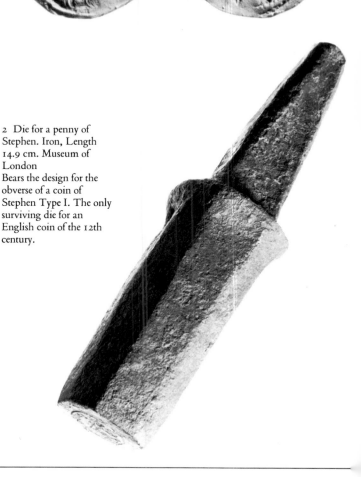

2 Die for a penny of Stephen. Iron, Length 14.9 cm. Museum of London
Bears the design for the obverse of a coin of Stephen Type I. The only surviving die for an English coin of the 12th century.

indications of the scope of his authority. The reign has received great attention from numismatists, because after the comparative boredom of a coinage tightly controlled, there was an efflorescence of different types and designs. There are many problems in their interpretation, but no dispute that the variety shows the weakness of Stephen's government in a key area of its operations. The 1140s was the one decade in English medieval history when the monarchy all but lost control over the coinage.

Only at the beginning and the end of Stephen's reign was there a single type of coin issued at a wide range of centres (these are what numismatists call 'substantive' issues). In 1972 a hoard of coins was found at Prestwich in Cheshire which was dominated by the first type of Stephen's reign. There were forty-two mints of this type previously known, and Prestwich supplied coins from all but two, a remarkable indication (granted the site) of the integration of the English economy at this date. Stephen Type I provides the base for the map, showing the authority which Stephen inherited. This type seems to have been current till c.1142.

The key date, in this area of Stephen's administration as in others, was 1141 (after the battle of Lincoln) not 1139 (the 'arrest of the bishops' and the landing of

Matilda). After this all was confusion. Some order may be introduced by looking at the main areas of lordship, as they had become established in the 1140s. The empress issued coins at Oxford, Bristol, Wareham and Cardiff. At Cardiff a remarkable hoard was found in 1980, dominated by Matilda's coins, and showing (compared with Prestwich) an economy highly localized: the 102 coins were from three mints: Bristol, Cardiff and Swansea. At adjacent centres there were struck coins in the name of Henry and William, most recently interpreted as showing moneyers striking coins in the name of dead kings, reluctant in the present to commit themselves to either side.

Just as in Bristol the moneyer Turchil who had once struck for Stephen now struck for Matilda, so in the north of England a similar adjustment was required. The two key centres of Carlisle and Newcastle came under the control of the Scots, and coins were struck for King David of Scots and his son Henry. Scottish raids came as far south as Yorkshire, and York became a frontier town. It was fiercely loyal to Stephen, but for much of the time left to its own devices, as its coinage clearly shows. Coins in Stephen's name were made from dies engraved locally, not punched dies sent up from London; some, like that of

5 Baronial figure, possibly Patrick earl of Salisbury. London, British Museum
The mint is almost certainly Salisbury. This issue was found in Wiltshire.

Stephen and his queen shown side by side (3), are thought to show the influence of a Flemish moneyer. And at York, as in south Wales, some barons issued their own coin. The symbol of authority was the sword not the sceptre, and for many chroniclers this became the symbol of the reign as a whole.

Also in the midlands engraved dies show that control from London had been lost, though here there were no baronial issues. Stephen's authority in the 1140s, as measured by his coinage, was confined to south-east England. Two smaller but still substantive types, nos. II and VI, provide the measure here. A line drawn from Castle Rising in Norfolk through Bedford and London to Lewes marks the western boundary of the group of towns that struck for Stephen between c.1142 and 1153–4. In the last year of Stephen's reign his type VII was issued (4), after peace had been agreed. Thirty-eight mints are known, a figure comparable with the first type of the reign. When peace was made, according to Ralph of Diss, the parties made a reform of the coinage a high priority. It is not difficult to see why.

EDMUND KING

3 Stephen and his queen, an engraved die with no lettering. Oxford, Ashmolean Museum
One of a variety of issues struck at York, which remained loyal to Stephen but largely out of touch with his government.

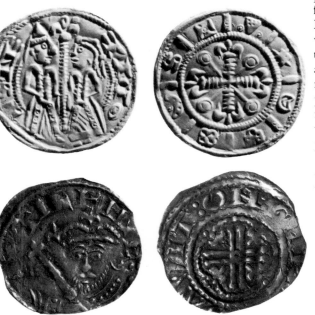

4 Stephen Type VII, struck at Ipswich by the moneyer DAVIT. London, British Museum
This coin was found at Archangel, USSR. The final issue of the reign, it shows the king bearded.

36 Castle Hedingham, Essex, interior of the great hall. c.1140; stone from Barnack, Northants
What now survives of the great keeps of the 12th-century castles is usually stronger in outline than in domestic detail (thus Pls. 37 and 38), but something of the feel of life in a magnate household can still be gained here. Castle Hedingham was a favourite residence of Stephen's queen Matilda, who died there in May 1152.

been forced to learn patience, and by now the style was the man. He was not to see the year's end, dying on 31 October 1147. Matilda left England early the following year, and settled in Rouen. She lived for another twenty years, and always liked her confessor to keep her in touch with political gossip, but from then on she was an observer. In a sense, she always had been. Henry was on his own. He was forced, in 1147, to appeal to Stephen for money, as a kinsman to whom he meant well 'so far as was in his power'. Stephen gave him the fare home. The story got around: it typified the king's good nature, but for Henry it was a humiliation. He was little more successful in 1149, when he came to be knighted by his uncle, the Scottish king. He was joined at the Scottish court by the earl of Chester, who must have done homage to him there – hence the terms of the Chester–Leicester agreement just considered. It was then the intention to mount a further attack on the north of England, but Stephen received word of this from the townsmen of York, and the threat came to nothing. Henry retreated from Carlisle through the west midlands to Bristol, with Stephen's son Eustace in hot pursuit, and returned to Normandy with nothing achieved.

During the early 1150s the balance of power changed. Henry's failure to make an impression in 1147 and 1149 had not been just because he was young, but also because he had no resources behind him. Now, and very suddenly, the resources appeared. First in 1150, when he became duke of Normandy: this was seen as his inheritance, given to him by his father when he came of age. Then in September 1151 his father, Geoffrey of Anjou, died and Henry succeeded as count of Anjou. Henry was now eighteen years old; in a few months he had gone from landless boy to great lord, and his run of luck did not end there. In March 1152 Louis VII divorced his wife Eleanor of Aquitaine. Eleanor was a great heiress: the daughter of William X duke of Aquitaine, she had brought her husband the key regions of Languedoc. But in fourteen years of marriage she had given the king only daughters. She was put aside. Within two months she had wed Henry, the marriage celebrated in Le Mans cathedral 'either suddenly or by premeditated design', as Robert of Torigny, tongue in cheek, observed. The French king was very cross when he received news of this marriage: his daughters stood to lose any rights in Aquitaine if Eleanor had sons by her new husband. A considerable alliance was put together, led by the French king, of all those who felt their position threatened by this seismic change in the balance of power within France. Events on the southern frontier of Normandy in the summer of 1152 were to prove the key to Henry's success in England. Henry went on the offensive, attacking the Vexin, and forcing the French king to make peace and accept him as his vassal for all his French territories. This recognition was crucial. Henry could now turn his attention to England. He landed in January 1153. He now had resources, augmented by some wealthy citizens of Rouen, to back his undoubted hereditary claim. Only Henry offered the prospect of a unified government of England and Normandy.

It was the best part of a year before peace was made. In general, the terms on which agreement would be reached were well enough known; they had been on the table since at least as early as 1140 (p. 56). Henry would succeed Stephen; Eustace would enjoy only the (very considerable) lands that his father had possessed before he became king of England, including the estates of the honour of Boulogne in south-east England. When it became clear that his father would be forced to accept these terms, Eustace withdrew from court. He died in August, without issue, and in the same month Duke Henry's first son was born. Stephen had another son, William, who was prepared to accept the terms that his brother had rejected, particularly when there was added to them marriage to the heiress to the great Warenne estate in East Anglia. The terms of the transfer of power were settled by November. The problem of how Henry was to inherit was solved by reference to the legal idea of adoption. Stephen saved face by making Henry his heir. He had succeeded by election; Henry would succeed by designation. For the rest of the political community, however, Henry succeeded by inheritance. Stephen was to be king for the remainder of his lifetime. 'In all England, both in those parts which pertain to me and those parts which pertain to the duke, I will exercise royal jurisdiction.' It sounded good, but there was a sting in the tail. Henry had no intention of recognising the grants of his predecessor, whom he regarded as a usurper. He did not prevaricate on this point, and so it was necessary, if Stephen was to rest in peace, for the agreement to specify that Stephen's grants to Faversham abbey would hold good. This was Stephen's particular foundation, as Reading had been that of Henry I. The main castles were granted to named custodians, while all unlicenced castles were to be destroyed. Stephen's Flemish mercenaries were to be sent home. It was a well constructed agreement, and it held for as long as was necessary, which turned out to be only a few months. Stephen died of a fever on 25 October 1154, at the age of about sixty.

3

THE ANGEVIN EMPIRE
1154—1204

ENRY II WAS a straightforward man, blessed with good health and boundless energy. His reign saw the clear exposition of a few, straightforward ideas. Those ideas he brought with him on his accession. They are to be glimpsed in the charters which he issued before he became king, and transparent in the terms of the 1153 peace settlement. He issued a charter for St Augustine's abbey, Bristol in the early months of 1153. It was here that he had been put to letters on his first visit to England ten years before. He acknowledged that the monks had protected him and his cause; in return he would protect them in their possession of any lands or rents 'pertaining to the crown of England' which they had or might acquire. He made a further grant 'for the soul of my grand-father King Henry', and promised more, 'when by the grace of God I shall have acquired my inheritance'. The exposition of the ideas in that one charter was to be a lifetime's work.

The Bones of the Kingdom

Henry would stand by those who had protected his own interests. He would safeguard the rights of the crown. He would secure the inheritance of his grandfather, i.e. all the rights that Henry I had exercised, not what had passed for royal authority over the past twenty years. And there was more. Through his wife Eleanor the hereditary claims of the counts of Poitou and the dukes of Gascony fell to Henry to pursue, and they were pursued vigorously. Henry now controlled the main lordships of western France. The journey from Newcastle in the north of England to Bordeaux in the south of France is over 700 miles (1125 km) as the crow flies. Medieval courts, following medieval roads, would find twenty miles a good day's progress. When the most difficult problems were those of communication, it was as well that ideas were kept simple.

It was as well also that the king was pragmatic in the implementation of those ideas. Nowhere was this more evident than in his choice of councillors. The 1153 peace agreement lists first among the laymen Robert earl of

Leicester and William d'Aubigny earl of Sussex (second husband of Queen Adeliza, who had died in 1152); they were the two highest-ranking of the English earls. Richard de Lucy, the witness to 135 of Stephen's surviving charters, was no less important, the guardian of Windsor and the London castles in the agreement of 1153. Within a few years the standing of Robert of Leicester and Richard de Lucy was recognised in their appointment as justiciars, which gave them executive power to act on behalf of a king who seemed always on his travels. To this list of councillors should be added Reginald earl of Cornwall, another of Henry I's illegitimate children, and last but not least, the empress herself. These five, who had been divided by the civil war, worked together in Henry's service. They were long-lived. The empress died in 1166, and the first laymen of the group was lost when Robert of Leicester died in 1168. Richard of Cornwall survived until 1175; William d'Aubigny died in 1176, and Richard de Lucy in 1179. Henry II is a rarity amongst medieval kings in working harmoniously with an older generation.

From his contemporaries, at least at first, Henry had much to fear. Stephen's second son, William of Boulogne, was the heir to all his father's lands and had acquired through marriage the East Anglian estates of the Warenne heiress, which together offered him considerable independence. But his relationship with Henry was always correct, and even shows signs of some warmth. William was killed in the Toulouse campaign of 1159, far from his own bases, fighting for Henry's ambitions. He died without issue. It was left to Stephen's daughter Mary to continue the line, not without some embarrassment, for she had earlier been appointed abbess of Romsey. The archbishop of Canterbury pronounced himself scandalised by her marriage; the pope was understanding; but of all the territory

37 Orford Castle, Suffolk, the keep. 1160s
The most important of the new castles built by Henry II, intended to strengthen his authority in East Anglia and to control an important crossing-place from the continent.

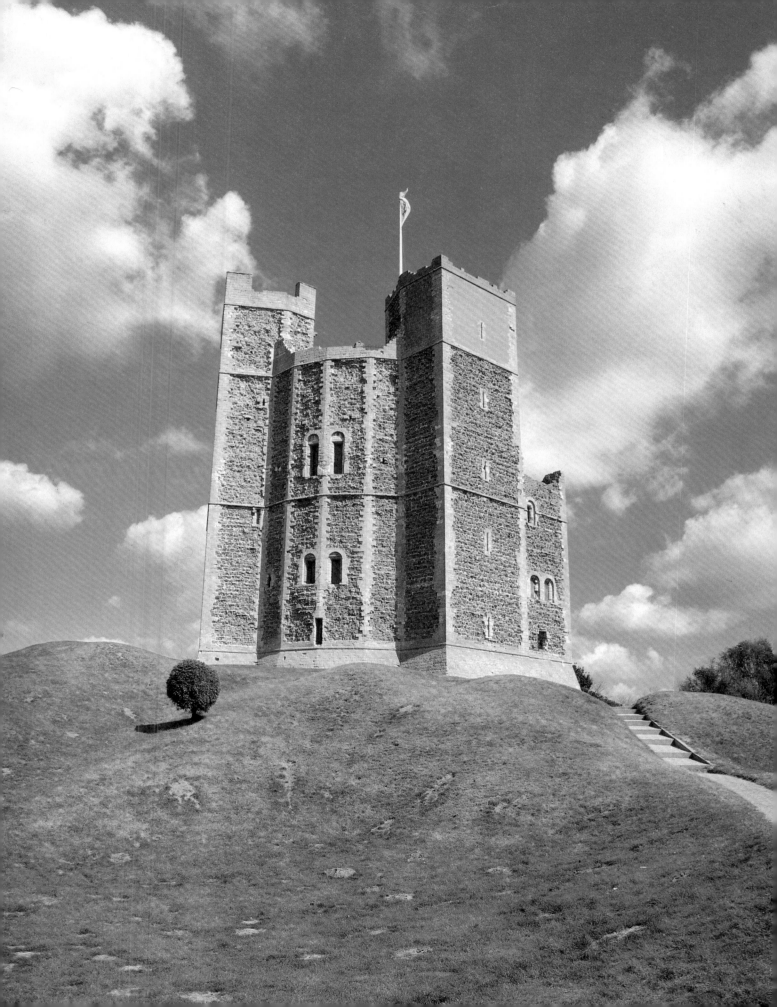

granted to William in 1153, only the county of Boulogne came to Mary's husband Matthew, brother of the count of Flanders. Henry's own brother Geoffrey was also a potential threat, for their father's will clearly envisaged some independent lordship for Geoffrey. He was denied this, and instead made count of Brittany, an agent of his brother's ambition. He too died young, and without heirs. The chroniclers take little account of these potentially powerful young men, but Henry, we may be sure, watched them carefully.

The chroniclers noted two things about the early months of Henry II's reign. The mercenary troops melted away, as the morning mist before the sun. And the king took into his own hands 'the towns, castles and villages that pertained to the crown'. Henry was particularly concerned about castles: all royal castles were to be surrendered, though they might be granted back to those who showed a proper attitude. The proper attitudes are exemplified by William d'Aubigny. He granted his manor of Buckenham to the Augustinian canons in 1151 or 1152, to found a monastery; the castle there was to be destroyed. A little later a new castle, built with royal permission, appeared at New Buckenham, a couple of miles away (Pl. 56). About the same time, in the early months of Henry II's reign, William relinquished and was granted back the honour of Arundel with its castle, and confirmed in his earldom. Not all, including the other architects of the 1153 peace settlement, spoke their lines so well. Henry bishop of Winchester refused to surrender his castles and retreated to Cluny, but saw them confiscated none the less. William of Aumale, earl of York, refused to surrender Scarborough castle. Both castle and earldom were forfeit. Consistently applied over several generations, pressure of this kind brought a considerable benefit to the monarchy. According to Professor R. Allen Brown's calculations, in 1154 there were 49 castles under royal control and 225 in the hands of barons, representing nearly five baronial castles to each royal castle. In 1214 there were 179 baronial castles to 93 royal castles, the ratio by then under two to one. (The samples are not quite the same.) This represents an important shift in the landscape of authority in England.

According to one chronicler the castles were 'the bones of the kingdom', and Henry made sure that they were strengthened with iron and with stone. Around £21,000 is recorded as having been spent on castle-works in the pipe rolls of his reign, and of this sum a few castles took the lion's share. Henry spent nearly £6500 on Dover castle, and on Newcastle-upon-Tyne, Nottingham, Windsor, Winchester and Orford over £1000 each. Orford was the only new castle of the reign, built in Suffolk where on Henry's accession there was no royal castle at all. On Scarborough the sum spent was £650, most of it on a new keep. Any barony or earl who wished to compete, and build in the new style, would have to pay similar sums. In the later years of Henry II's reign Hamelin earl of Surrey built a stone castle at Conisborough, Yorkshire, in place of the previous motte and bailey structure. The bailey was surrounded by a stone curtain wall and the keep abutted onto this. The keep was of four stories, with the entrance on the second storey. The upper floors had fire-places, latrines, a richly-decorated chapel with a small sacristy, and water-cisterns to avoid the need to continually fetch water from the well within the bailey. Henry II's reign sees a major change from wooden to stone castle-building in England.

After reclaiming many of the royal castles in England Henry crossed to Normandy in February 1156. News of his achievements had gone before him. He met King Louis of France at Chinon and did homage, in person, for Normandy, Anjou and Aquitaine. His inherited lands secured, Henry was able to look further afield. It was the desire of all feudal lords to make their neighbours their vassals, and in this way secure their frontiers. In the north of England this was not just a question of protecting a frontier but of redefining it. During Stephen's reign the Scots had come to control much of Northumbria. In May 1157 King Malcolm IV of Scots, 'considering the relative strength of the parties', surrendered Carlisle and Newcastle, and restored the historic frontier. In return he was given the earldom of Huntingdon/Northampton, conveniently vacant through the death in 1153 of Earl Simon of Senlis. As he had done with his brother and with Stephen's son William, Henry brought the Scottish king into his court, making him both symbol and agent in maintaining the integrity of his dominions.

Henry's frontiers within France presented him with more problems. The lands of his new empire marched with the Capetian crown lands at two points, in the north in the Vexin and in the south in Berry. These were to be the flash-points of the next fifty years. The Vexin was the more important: the main thoroughfare from Rouen to Paris was the river Seine itself, and several of the key bridges lay in the Vexin. The Norman Vexin had gone to the French king in the latter part of Stephen's reign; Henry wanted it back. In the summer of 1158 he sent his chancellor Thomas Becket to Paris. It was a magnificent embassy: two hundred men, eight great wagons (two of them drays, laden with best English beer), twenty-eight pack-horses (laden with more precious goods). The chancellor brought a change of clothes for each day, twenty-four new outfits in all. These, and much else, he left behind. He returned with what he sought, an agreement that the French king's

38 Newcastle-upon-Tyne,
Northumberland, the keep.
*c.*1170
The Romanesque style is seen
here at its most massive and
confident, but within a decade
in the south of England the
influence of the Gothic style
would be felt (see Pl. 53).

daughter Margaret and the English king's eldest son Henry should be betrothed. The young Henry was only three and his intended bride but a babe in arms, so no early union was looked for, but on their marriage the Norman Vexin would be the dowry of the bride. Margaret was sent to Henry II's court, to be brought up there, and the key castles of the Vexin were transferred to the Templars, to be kept in neutral custody until the marriage took place.

There remained a last and most ambitious undertaking, the pursuit of Henry's claim as duke of Aquitaine to control Toulouse. He sought the French king's support, but here found him less accommodating. And with cause; for Louis VII had daughters by Eleanor of Aquitaine – any claims that Henry had in Toulouse might be argued for Louis's daughters also. Henry tried force. A considerable army was mustered, from all his dominions, at Poitiers

39 The Story of David. *c.*1160–*c.*1180, from Winchester Cathedral
Priory. New York, Pierpont Morgan Library, MS 619 verso
A single leaf, probably made to serve as a sumptuous frontispiece to the
text of the first book of Samuel in the Winchester Bible, but not used.
Among the scenes shown here are the combat of David and Goliath
(TOP CENTRE) and Samuel anointing David (CENTRE RIGHT).

40 The Morgan ciborium. *c.*1160–*c.*1170. Copper
enamelled and gilded, height 195 mm., diam. of bowl
155 mm. New York, Pierpont Morgan Library
A ciborium contained the hosts distributed at communion
during the Mass. The function determined the scheme of
decoration, which focused on the Eucharist.

in the summer of 1159. Louis opposed him, and in the most effective way possible. He came in person to Toulouse and took charge of its defence. For Henry a direct attack on his overlord was fraught with danger, both diplomatic and practical. Bishop Stubbs called this 'feudal superstition', but in truth it was more. All Henry's gains to date, and they were considerable, were predicated on personal oaths. It was not superstition but policy that made him reluctant to attack a lord to whom he had recently sworn allegiance. Henry withdrew. After just one minor coup he would have to rest content with his gains. This coup was the bringing forward of the agreed marriage of his son and the French king's daughter. A disputed election

followed the death in September 1159 of Adrian IV (the only Englishman ever to be pope). His successor Alexander III had Henry's support, which proved crucial, and in return gave a dispensation for the early marriage of the children. The marriage was celebrated on 2 November 1160, and the castles were delivered. When in 1164 John of Salisbury visited Louis VI in Paris he sought to make polite conversation by passing on the greetings of the young bride, with whom he had recently spoken. She were better dead, her father replied: 'I scarce hope that any good can come of her.' It was a remark both pessimistic and cynical. The world had moved on. And Louis still had no son to succeed him.

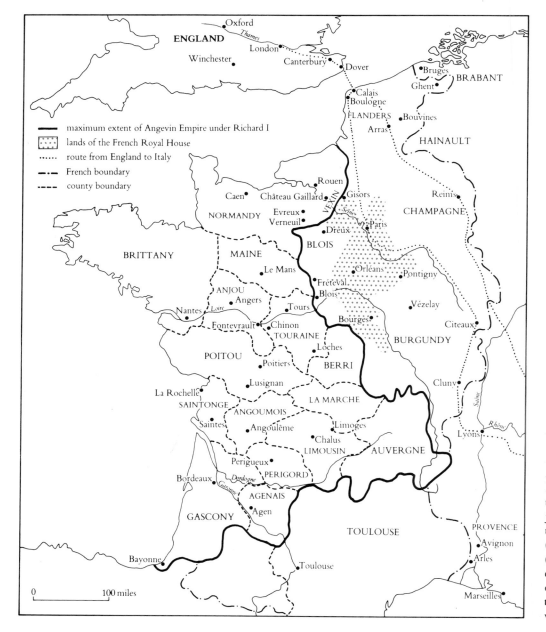

41 The Angevin empire in the late 12th century
The map shows the main centres and provinces of France, those of the west being predominantly under Angevin control

42 Judicial combat. Plea roll of 1249. London, PRO KB 26/33
A robbery in the pass of Alton, Hants, and related crimes were tried at Winchester before the justices early in 1249, and went to battle. Walter Bloweberwe (LEFT) fights Hamo Stare (RIGHT). There was an element of ritual in such combat, seen (for instance) in the fact that the men's heads were shaved.

The Government of England ·

Henry II felt strongly about proper title to land. He had come to England as a young man in pursuit of an inheritance. 'You should all know', states the preamble to a charter which comes from the last years of his reign, 'that when by God's favour I obtained the kingdom of England, I resumed many things that had been dispersed and alienated from the royal demesne in the time of King Stephen my usurper, both in knights' fees and in church endowments.' In the time of the usurper there had been civil war, the result of that disputed inheritance. What was true on the national level was true on the local scale also, a dispute over land could spill over into violence. Among the rights of the crown that Henry recovered, the responsibility for peace-keeping was pre-eminent. Both the land law and the criminal law were radically reformed during his reign.

The king's concerns can be seen in the instructions that were given to the justices who toured the country in 1166. They had questions to put, and orders to carry out; together these went under the name of an 'assise', a record of deliberations, what would be called legislation in a later age. This was the Assize of Clarendon, dealing with crime. Local juries were required to present for trial all murderers and robbers who had escaped justice since the beginning of the reign. No man, however, powerful his lord, could escape this scrutiny; all alike were cast into the net – or rather, most likely, into the pit, for the method of trial adopted was ordeal by water. The sheriff of Wilt-

shire was allowed 5s. for new pits, 'for the judgement of robbers', and a 20s. fee for the priests who blessed them. Into this doubtless rather dirty holy water the suspects were lowered. As a man's natural instinct in such a predicament is to try to breathe, and as floating was usually interpreted as a sign of guilt, it is not surprising that most who were put to this test failed it. In counties visited by the justices great numbers were condemned to death or mutilation. In Yorkshire 120 men 'perished in the judgement of water', their chattels worth in all £46 16s. od. The sheriff had done well, and was marked out for promotion. His name was Ranulf Glanville.

In a plea for right in land, and in some criminal cases, trial by battle was the procedure used. The textbook of procedure in Henry's court, which bears the name of this Ranulf Glanville, is full of references to trial by battle, which survived until abolished by statute in 1819. The clergy were against it – the sword was not their weapon – but tradition and popular support kept it going. A story from the early thirteenth century, concerning one of St Wulfstan's miracles, shows the ordeal in all its gory detail. The incident started with a tavern brawl on Whit Sunday 1217 between George of Northway and Thomas of Elder-field near Worcester. Its origins, though, were a good deal earlier, for Thomas had had a far from secret love affair with George's wife. George was wounded in the fight, and wounding was a felony; he insisted on taking the matter to court, and when the justices came round in 1221 the jury of his neighbours confirmed the facts as he reported them. The pair were ordered to fight a duel, which took place in a meadow just outside Worcester and in which the young lover Thomas was defeated. The justices sentenced him to blinding and castration. According to the Worcester account, George's family executed the judgement. Thomas's eyes were put out, not without difficulty, and his testicles cut off, and tossed to some local youths, who started a game of football. Half dead, the victim was carried into Worcester, where the saint restored the affected parts in every particular. Glanville, whose author had presided over dozens of such judicial combats, was quite clear in his own mind: 'justice was seldom arrived at by battle, even after many and long delays'.

That the ordeal and trial by battle survived for so long was for want of an alternative method of proof. This was supplied during Henry II's reign through the systematic use of the jury. The twelfth-century jury was not the impartial group of citizens of a twentieth-century American or British court. Henry II's jurors knew who the criminals were, knew who was entitled to land. That was why they were asked to serve. There were two types of jury here: the jury of presentment, as used above under the Assise

43 and 44 Stained-glass windows in Canterbury Cathedral, last quarter of 12th century. (LEFT) Adam, choir clerestory;
(RIGHT) the emperors Julian and Maurice, north-east transept
The choir of Canterbury, damaged by fire in 1174, was speedily rebuilt in the Gothic style. These panels have been identified as amongst

the earliest glass in a fine series. Each is part of a complex sequence of images. Adam appears as one of the ancestors of Christ. The emperors illustrate one of the teachings of Christ, the Parable of the Sower, where they stand for the thorns. They are seated before a mound of gold, and a text ties in the scene: 'these thorns are the rich and extravagant.'

of Clarendon, and the jury of recognition. The latter was there to answer questions, to 'recognise' publicly what were held to be material facts. In the case of novel disseisin (recent dispossession of land) three questions were put. First, had the plaintiff *A* been evicted by the defendant *B*? Second was the land a free tenancy? Third, was the eviction recent? These questions were put in court, and three 'yes' answers secured the restitution of the land to the plantiff. Matters concerning the inheritance of land and of churches were dealt with in a similar way. Reducing complicated claims to their essentials allowed them to be processed very quickly. A score of cases could be despatched in a single day in court.

The new procedures of Henry II's day were bureaucratic; they involved a lot of paper work. The key figure here, the man responsible for the local administration of the crown, was the sheriff. It was through the sheriffs in 1166 that the order came to all tenants of the crown to list the names of those who held land of them by knight-service, and the amount of that service. According to the sheriff of Yorkshire Ranulf Glanville, this was so that those who had not yet sworn allegiance to the king might now have the opportunity to do so. Some were suspicious of this explanation, for the order asked that the lists distinguish knight-holdings of different kinds: first were those created up to the death of Henry I in 1135, second those created thereafter, and third anything remaining of the service due that the tenant had to supply himself, to make up the 'quota' of knight-service owed to the crown. (As examples: Robert de Bruce owed the king the service of fifteen knights, the abbot of Peterborough the service of sixty knights.) What had the king really in mind? Bishop Henry of Winchester, King Stephen's brother, was taking no chances: both his lists, from the Winchester diocese and from Glastonbury abbey, insisted that all his men held lands granted to them or their ancestors before 1135. Others, if they had more knights' fees than their quota, suspected that they would now be assessed on the higher figure. But most who responded, becoming used to many royal commands of this kind, took the questions at face-value. Some were small tenants indeed, and the tone of their replies offers rare glimpses of their position in the world. William of Colkirk in Norfolk owed half a knight's service only, 'from the conquest of England'. 'I do not wish that my service be increased, for I do what I should do. I do homage to you, lord, and to my lord Henry your son, and I do service to your sheriffs.'

The sheriffs were the mediators of royal authority; it was the more important, therefore, that their own activities be carefully scrutinised. In 1170 justices were sent to each county, to conduct what became known as the Inquest of Sheriffs. Their inquiry involved the whole work of local government, payments made to sheriffs and their subordinates over the previous four years. This had been a busy period for them, involving them in raising troops and money for several expeditions into Wales, and taking money for the marriage of the king's daughter Matilda in 1168. The whole question of responsibility was complicated by the fact that in many areas a local landowner had the traditional right to exclude the sheriff and his subordinates, and instruct his own administration to collect taxes and carry out royal commands. The abbot of Bury St Edmunds, for instance, had this right in much of western Suffolk. The holders of these private franchises, as they were called, did not escape the 1170 inquiry: 'let the justices write down all their exactions, and their causes and occasions.' The judgements of their courts were examined. This was a very sensitive business.

The holding of their own courts was, for both lay lords and for senior churchmen, an important sign of lordship, something worth protecting if at all possible. Even the greatest of them, however, could do little more than splutter as the rising tide of royal justice engulfed them. In or shortly after 1165 Gilbert Foliot, a lord for over a quarter of a century and then bishop of London, wrote to the justiciar Robert of Leicester, whom he had known for all of that time. His old friend had changed his style. He had summoned a canon of St Paul's, 'to appear before you at Oxford at the next court, together with a man of his who is all but a rustic, to answer concerning the non-performance of an agreement made between them and (it is alleged) confirmed by charter'. This would not do. The case was trivial, and, in any event, if it were to come to court, 'it is for us if we please to hear the matter, and to show full justice to the plaintiff'. The justiciar was proposing to go over the bishop's head; this would weaken his authority in his lands, and that of the saint who protected them. 'Render to Caesar what is his, and to God what is God's. Farewell.' It is a good letter, both probing for a weakness which the bishop probably knew did not exist, and asking a favour of an old friend. There is no sign that it succeeded. The bureaucracy had a life of its own. This is the point of a delightful story in the *Dialogue of the Exchequer*, which must date from the same period. Robert of Leicester himself, who presided over the Exchequer as justiciar, had procured from the king a writ exempting him from any fines levied by the forest justices. When the writ was read out his colleagues were horrified, for they claimed that all who sat at the Exchequer board were automatically quit of such claims by virtue of their office. Once the point had been put to him, the justiciar could only apologise. 'I got the writ from the king, not

with any intention of weakening your rights, but in order more easily to escape the very pressing demands – of which the king knows nothing – of Alan and his gang.' This was Alan de Neville, the king's chief forester, and his servants, the eponymous *Alani*. Few stories in modern cabinet memoirs are quite as revealing as that.

Henry II and Thomas Becket

In the early years of Henry II's reign Theobald of Canterbury was as firmly in control of the English church as the king was in control of the state. Theobald was able to nominate one of his favoured clerks as archdeacon of Canterbury, and in 1155 this archdeacon became royal chancellor. Loyal service to the king, at a heady time when all problems seemed soluble, brought him further promotion: he was nominated archbishop of Canterbury after Theobald died in 1161, and consecrated the following year. This man was Thomas Becket, the son of a London citizen, of Norman origin but long settled in the capital. The Empress Matilda, who had now found her most convincing role as queen mother, thought this a bad appointment, but the insiders at Henry's court were happy enough.

At the enthronement the justiciar Richard de Lucy and the king's son Henry (who had been brought up in Becket's household), led the new archbishop forward to his throne. Henry of Winchester performed the ceremony, his fellow-bishops assisting. The episode provides a series of tableaux showing the unity of church and state.

After little more than a year, that unity fell apart. This was on one level a personal quarrel; two men, king and archbishop, who had once been intimate, now found themselves poles apart. It is not to take sides in the quarrel to say that it was Becket who changed, for the change from archdeacon to archbishop was a real change of life. He took charge of a great estate; he said Mass for the first time; he had a primacy amongst the English bishops; he was the spiritual father of a large community of monks. He was unprepared for any of these roles, and very much wanted to make the right impression. He asked Herbert of Bosham to keep an eye on how he behaved, and on what others thought of his behaviour. This element of narcissism is an important part of Becket's make-up. It now made him a very bad match for his king, because on several key occasions it made him ambivalent, and this ambivalence the king, a most straightforward man, inter-

45 Fountains Abbey, Yorkshire, the undercroft. Late 12th century
A Cistercian monastery, founded in the 1130s. This part of the monastic complex was used by the lay brethren (*conversi*); their sleeping accommodation was above.

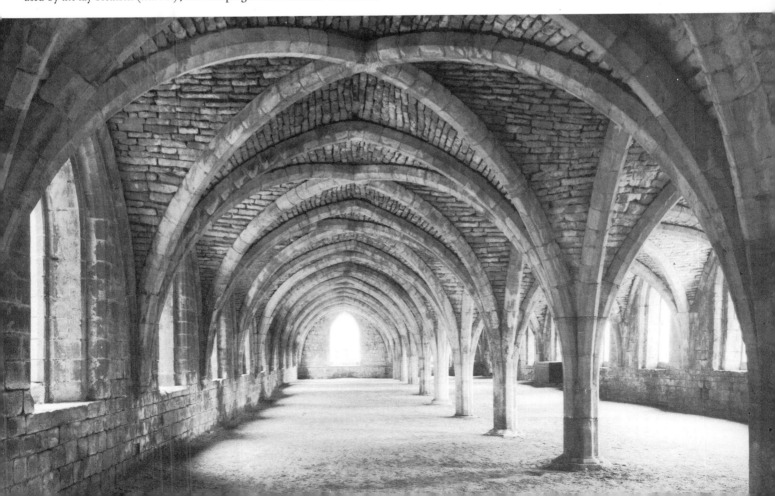

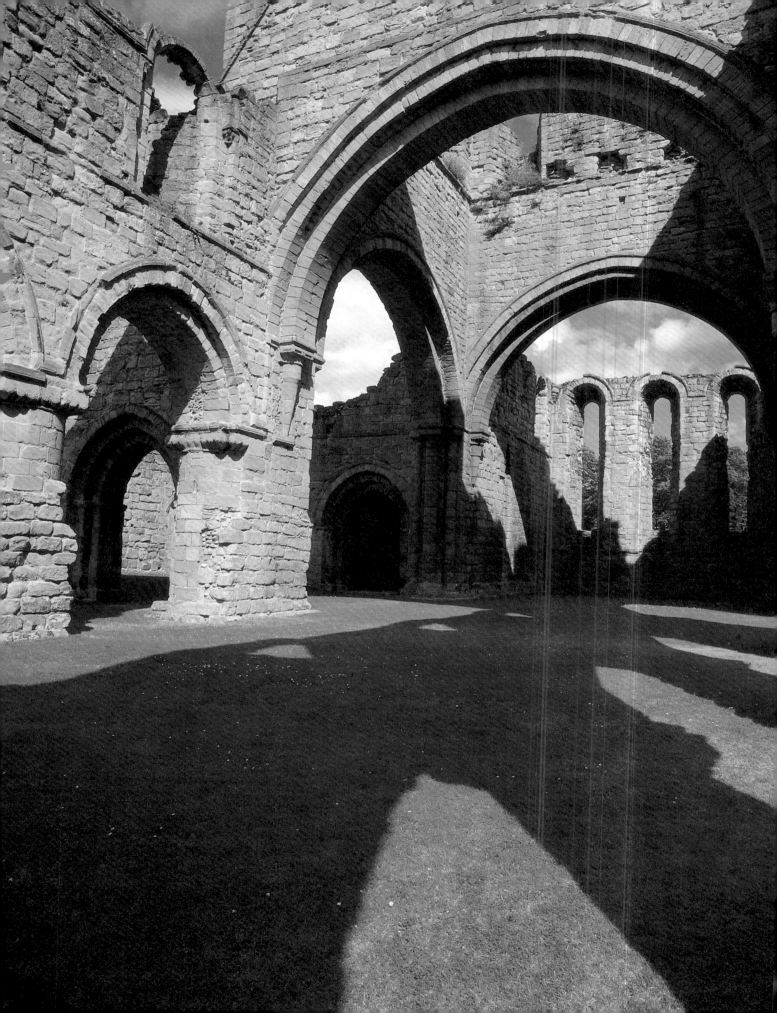

46 Buildwas Abbey, Shropshire, looking east
from the nave through the central crossing.
Mid-12th century
The monastery was founded as a dependency of
Savigny in 1135, and this order merged with
the Cistercians in 1147. The Cistercians
shunned excessive ornament in churches.

47 St Dunstan and the devil. Last quarter of 12th century.
Canterbury Cathedral, north choir aisle gallery
St Dunstan, archbishop of Canterbury 960–988 and monastic
reformer, was for a long time the 'chief of all the saints who
rest' at Canterbury. After 1173 he was overshadowed by St
Thomas, but his cult was kept alive, as this glass (from a series
on his life) shows.

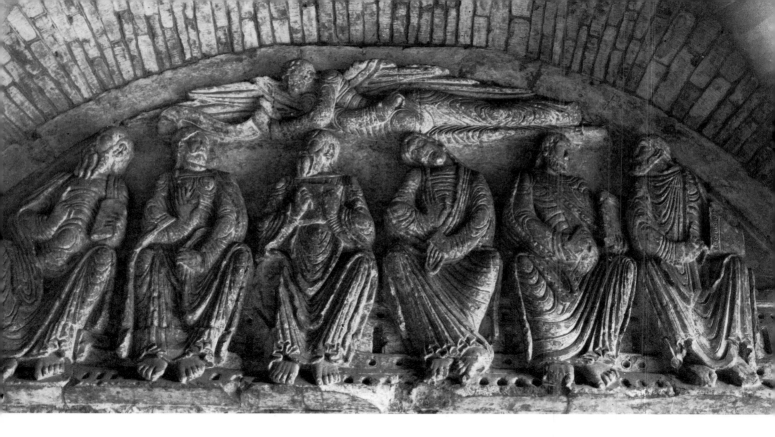

preted first as fickleness and then as treachery. Their first serious quarrel was at a meeting of the royal court held at Clarendon near Salisbury late in January 1164. Henry asked Becket and his fellow-bishops to allow him the same customs and privileges that Henry I had enjoyed over the English church. They were asked to set their seals on a written statement which listed these. The justiciar Richard de Lucy was later named by Becket and excommunicated, as one of 'the fabricators of those heretical iniquities'.

The Constitutions of Clarendon is the name usually given to what Henry II called his 'customs' and what Becket termed 'iniquities'. They represent the king's version of what was normal and proper, in his terms 'customary', in the relationship of church and state. This relationship was complicated by the feudal service owed by the higher clergy to the king, and by developments in the canon law, which the clergy were developing with increasing confidence (see above p. 23). Various particular areas of concern to the king lay behind his insistence that the 'customs' be written down. One of these was the lenient treatment of 'criminous clerks' (clerics found guilty of crimes which, had they been laymen, would have earned them the death penalty). One of Becket's biographers, William fitz Stephen, cites the particular case of a clerk of Worcester who had killed a man and then raped his daughter, Becket refused to allow the case to be tried in a lay court. The punishment of a church court would often simply be degradation, reducing the offender to the lay state. Henry thought, and demanded in clause 3 of the Constitutions, that after degradation the culprit should suffer the normal secular penalty for his crime. Becket countered with a tag from the canon law, 'God does not judge twice for the same offence'. The matter was far from clear, and Becket baulked at definition. He first promised to accept the customs, then changed his mind.

Less than a year later Becket was in exile. He would have claimed that he had no choice but to leave. In fact, he showed himself too impatient and perhaps too arrogant to play the game by Henry's rules. First he tried to leave England without the king's permission, thereby breaking one of the customs; his own tenants refused to transport him. Summoned to the royal court in September, to answer a claim that he had denied one of his tenants justice in his own court, he neither attended nor excused himself in the proper way. At the next meeting of the royal court, at Northampton, the king broadened the attack, and asked Becket to account for money received several years before, when he was chancellor. The archbishop was now isolated. He refused to accept the judgement of the court. The bishops who were present agreed to ask the pope to agree to Becket's deposition. The archbishop's knights renounced their homage and left his service. Feelings ran high, and the archbishop, fearing for his safety, left court suddenly and in disguise; on 2 November 1164 he crossed to France where he remained until 1 December 1170. At Saint-Omer soon after his flight he was sought out by the justiciar Richard de Lucy, who begged him to return and when he was refused, angrily renounced his homage. His

48 Six seated apostles.
Mid-12th century,
Malmesbury Abbey,
Wiltshire
A lunette from the south
porch shows six of the
apostles, with an angel
flying above them.

49 Door knocker. c.1180.
Bronze, diam. (of lion)
55 cm. Durham
Cathedral
The lion defends the
sanctuary of the church;
to grasp the handle was to
claim its protection.

anger is understandable, and an important ingredient in the final tragedy. As justiciar and archbishop he and Becket had for a decade been members of the small group that had run the Angevin empire, a charmed circle it must have appeared to its members and satellites. Becket was not just betraying the group but breaking the spell. He would not be forgiven.

The dispute between Henry II and Becket was a great media event. For the men who governed western Christendom, the leaders of the church and state, this was gripping drama. It had everything: a high level of intellectual debate, a strong cast of characters. At their head two powerful men of contrasting personality, each with a clear vision of his place in the world. And many attractive cameo roles – all played out on an international stage. 'You

may be astonished to hear', wrote John of Salisbury to Becket before the archbishop went into exile, 'that on the day that I was at Noyon the count of Soissons recounted to the dean every item of the conference (or perhaps better, difference) of Westminster [October 1163] in as much detail as if he had witnessed the whole affair.' In his mind's eye, he had. As with devotees of a modern soap-opera, men of this kind could not wait to hear the next episode.

The show was to run for a further six years. Becket stayed first at the Cistercian monastery of Pontigny. Then, after two years, he was forced out by Henry's threat to retaliate against the Cistercian houses in his own dominions. He went next to a monastery near the city of Sens, his expenses there paid by the French king. From these bases Becket tried to use his spiritual authority to force Henry

44

upales. & panthenon. Egypcij. u.
octeym. Itali. crocacim. Quidam ate
latiridem eam appellant. Vna
cura eſ. ad duritiem ſtomachi.
herbam latiridiſ granum cum
poptime purgatum fuit.
in aqua calida potatum dabis. ſta
tum alueum purgat. reum ſanat.
Nomen huiuſ herbe lactuca lepo
rina dr̄.

Bec autem eadem Item.oℴℴ
herba umbilico infantium tri
ta impoſita perfectiſſime medet̄
ipſa nat. Nomen iſtiuſ herbe lati
ridiſ nuncupatur.

A grecis ſiquidem dr̄ cocoſmidos.
Quidam u̅ camellam eam uocat̄.

Naſcitur in locis cultis ꝛſablofiſ.
Lep autem in eſtate cum animo de
ficit. hanc herbam comedit. ideoꝗ
lactuca leporina dicat̄. Prima cu
ra ipſiuſ. ad remediandum feb
herbam lactucam leptantem;

to climb down. He could not be ignored, but he was no longer his own master. He came to be important only when, and in so far as, he could serve the ambitions of others. This can be seen in an important meeting between the kings of France and England, held at the frontier town of Montmirail on Epiphany Day 1169. The balance of power between the two kings had by this time changed a little. In 1165, after nearly thirty years of marriage and by his third wife, the French king had had a son Philip, who might well be described as arriving 'by the grace of God'. Eleanor of Aquitaine had given Henry five sons, four of whom at this date survived. The main business of Montmirail was therefore to establish the succession to Henry's lands. His eldest son, another Henry, already married to the French king's daughter, was to receive his father's inheritance of England, Normandy and Anjou. Richard, the second son, was to receive Aquitaine, and was to be married to the French king's second daughter Alice. Each did homage for these lands to the French king. Geoffrey, the third son, was to have Brittany. There would be time later to worry about the fourth son John, who had recently celebrated his first birthday.

These arrangements did not involve the archbishop of Canterbury, but he was not brought to Montmirail solely for the ride. Henry wanted his archbishop to come home, partly on the general grounds that a disaffected primate was bad public relations, but also because there was a specific job for him to perform. Henry wanted to crown his eldest son in his own lifetime: the first time that a successor to the English throne had been so designated. King and archbishop met at Montmirail for the first time for over four years. As they talked on horseback, their supporters at a distance, all the old memories came flooding back. The king would not renounce the customs written down at Clarendon, which Becket's five predecessors – 'some of whom are saints and shine brightly with their miracles' – had all accepted. Becket in any reconciliation insisted on reserving 'the customs of his order'. They were soon back to where they had started and the next year Henry pressed on with the young king's coronation. This took place at Westminster, and most of the English bishops were present; the archbishop of York performed the ceremony. It was only after this that a peace was made at Fréteval, which allowed Becket to return home, the coronation, which was a clear affront to Becket's dignity, may have

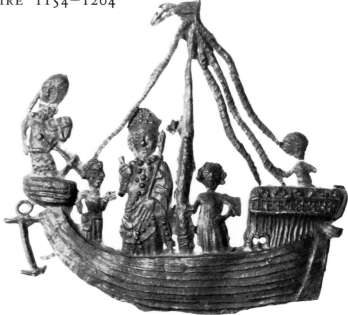

51 St Thomas returning from exile. Late 14th century. Tin lead, 7.5 cm × 7.9 cm. Museum of London
A fine example of a very popular type of souvenir, made in Canterbury for the tourist trade. This badge was found at Hull Wharf, London, in 1980.

been meant to encourage him to do so. He landed in Kent on 1 December 1170. Within a month he was dead – and his miracles were to shine more brightly than those of any of his predecessors.

There was never any prospect of a happy homecoming. An absence of six years had quite destroyed Becket's lordship. The great revenues of his diocese, over £1,500 a year, had during his absence gone to the crown. The royal agents who had collected this money, and had stood in the archbishop's place, were far from pleased at his return. They met him on landing, accused him of being a troublemaker, and demanded that he revoke the sentences of excommunication he had passed on those who had crowned the young king. When Becket went to meet the young Henry, his former protégé, he was refused an audience. Returning to Canterbury for the Christmas feast, he made difficulties over accepting the monks who had been professed in his long absence. It was an ill-tempered and insecure return. Some of the archbishop's men went over to Bayeux to complain to the old king. It may have been on Christmas Day that Henry, not for the first time, spoke angrily of the slights to his lordship offered by 'a low-born clerk'. An official delegation sailed to confront the archbishop. Four of its members, each with quarrels of their own against Becket, made the running – William de Tracy, Reginald fitz Urse, Hugh de Morville and Richard le Bret. On 29 December 1170 they confronted Becket first in his palace and then

50 Herbal. London, British Library, Sloane MS 1975, fo. 44r, c.1200, England
The herbs were valued for their medicinal properties, which the text explains.

in the north transept of the cathedral. Strong words were spoken, and Becket replied in kind (he was never a man to turn the other cheek). The discussion turned into an ill-tempered brawl. At the end of it the archbishop of Canterbury lay dead, his skull cracked open, before the high altar of his cathedral church.

Henry II was horrified when he heard the news of Becket's death: 'for three whole days', according to Arnulf of Lisieux, 'he remained shut up in his chamber, and would not take food or admit anyone to comfort him'. For a week after the pope heard the news he refused to speak to any Englishman. Envoys despatched to Rome to swear the king's innocence of any involvement with the crime waited almost until Easter before they were received. An accommodation was slowly worked out. The king swore to abolish any new customs, 'prejudicial to the church', introduced in his reign. This was a small concession, for he claimed to have introduced none at all. He promised to supply troops for the Holy Land, and himself go on crusade, unless excused by the pope. He promised his protection to the church of Canterbury, and to all whom he had penalised for supporting Becket. On these terms peace

was ratified at Avranches in May 1172. In the following year Becket was canonised. Over the ten years after his death he worked 703 miracles. In keeping track of them, and in ministering to the needs of the pilgrims at the tomb, the monks of Canterbury found a new vocation.

Henry on the Defensive

When any government starts to look vulnerable, its position is weakened by that perception alone. When a medieval king lay under the threat of Interdict, he had to be very sure of his secular power. During the early 1170s Henry's moral authority, in the aftermath of Becket's death, was weak. It is not surprising that these years saw the only serious rebellion of his long reign.

Jordan Fantosme, an English clerk who devoted a verse chronicle in French entirely to the events of the 1173—4 war, started with the position of the young king.

> *A king without a realm is at a loss for something to do;*
> *At such a loss was the noble and gracious young king.*

Behind that simple statement was a particular grievance,

52 The martyrdom of Thomas Becket. London, British Library, Cotton MS Claudius B.II, fo. 341r, c.1180
The illustration prefaces a letter of John of Salisbury in which he describes Becket's death. At the top the four knights are announced, bottom left they kill the archbishop, and to the right they do penance at his tomb.

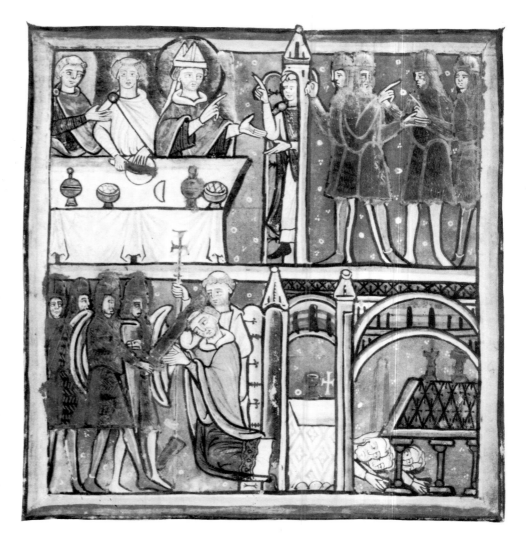

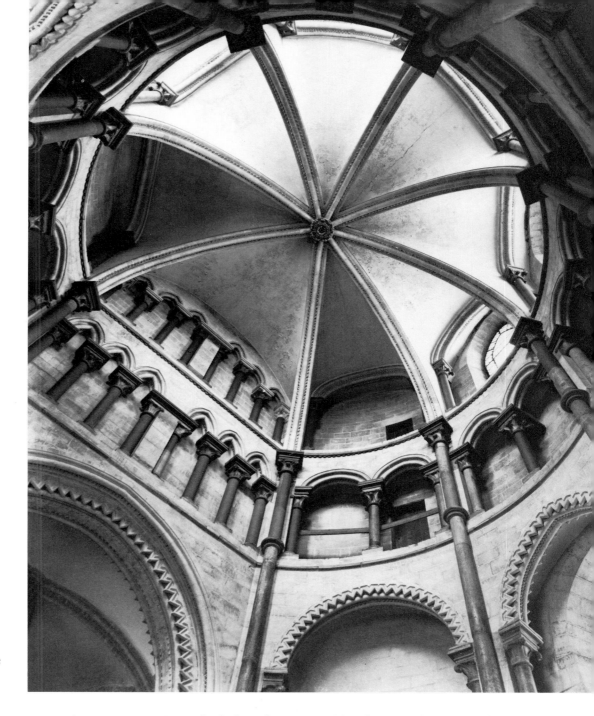

53 Canterbury Cathedral, Kent, the corona. Early 1180s The beginnings of the Gothic style in England. The corona lies at the east end of the cathedral, above the crypt that contained Becket's tomb; hence it was popularly known as 'Becket's crown'.

and, in all likelihood, a more general conspiracy. The grievance was that early in 1173 Henry had arranged the marriage of his youngest son John with the heiress of Maurienne in southern France. He had promised John the Loire castles of Chinon, Mirebeau and Loudun, but the young Henry, the heir apparent to Anjou, resisted the transfer of what he felt to be his right, and demanded some property of his own. He fled to Paris with his brothers Geoffrey and Richard, and was set up by Louis VII as a king in exile. Young Henry made great promises: Amboise and the Touraine to the count of Blois; Northumbria to the king of the Scots. Henry II had to defend

both those frontiers, and he also met substantial defections in the centre of the Anglo-Norman realm. Four earls declared against him: Hugh Bigod earl of Norfolk, Robert earl of Leicester (son of the justiciar), Hugh earl of Chester, and William de Ferrers earl of Derby. To these should be added the earldom of Huntingdon, which the Scottish King William transferred to his brother David at the outbreak of hostilities. For all Henry's achievements in taking castles in hand, the rebels could muster twenty-three castles between them, and were particularly powerful in the Midlands.

The chronicler Ralph of Diss saw the revolt as a reaction

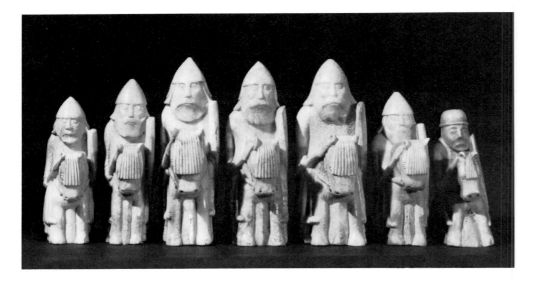

54 The Lewis Chessmen.
Mid-12th century. Walrus
ivory, height from 5 to 10 cm.
British Museum
The knights in full array, 7
pieces from the set of 93 chess
pieces, found in 1831 on the Isle
of Lewis, Scotland. They may
have been carved in Britain or
in Scandinavia.

to Henry's policies. This is in general convincing, but it does not explain why certain individuals rebelled. In part it was a conflict of generations, the young men against the old. When the young king first held his court in Normandy he gave a party for 110 knights, all called William. His father, who had been a landless knight for only a few months, advised by those a good deal older than himself, seems to have been quite out of sympathy with the culture of the young, at a time when that culture was particularly sharply defined. But not all the rebels were young, one of them was the earl of Norfolk, born in the previous century. The royal forces were led by the justiciar.

The lord Richard de Lucy – none better can be found –
Gives great help to his liege lord in the prosecution of his war.

He and William d'Aubigny, who had earlier been with the king in France, led the royal forces at Fornham in East Anglia, a battle (October 1173) in which Robert of Leicester was captured. Henry was able to spend all of the year in France. In mid-summer 1174 he returned to England for just a month. In that time he did public penance at Becket's tomb, and within days received news of the capture of the king of the Scots before Alnwick castle. Henry took David of Scotland's castles of Huntingdon and Northampton. With that the civil war in England was over, and soon thereafter the French king, who had co-ordinated the rebellion within Normandy, sued for peace.

Henry was praised for his magnanimity in victory. The Scottish royal house suffered forfeiture; their midland earldom was transferred (before the war was concluded) to the rival house of Senlis, but for the rest it was the ruin of their castles and financial penalties that were the symbols of defeat. Robert of Leicester was the most severely treated

of the English earls. His lands were not restored to him until January 1177, and his castles were not returned at all. Leicester and Groby castles were destroyed, and Mountsorrel castle was taken over by the king, for 'the men of the country swore that it was in the royal demesne'. The king emphasised his dominance by pressing his regalian rights, particularly those over the forest, very hard indeed. According to Jordan Fantosme the king boasted, before the rebellion:

However much they threaten him, by his hand he swears it,
He will not be deflected from hawking on river bank or hunting the stag.

This was more than just a metaphor of royal mastery. The forest justices rode out through the kingdom in 1175; the various circuits (or eyres) raised the truly enormous sum of £12,345 for the king. The list of those fined comes close to being a census of those living in the forest area. Criminals too found the king's justice bear more severely on them. In 1176 the Assise of Northampton reissued that of Clarendon ten years before. Penalties were made tougher: as one example, those of ill-repute were now given forty days to leave the kingdom, even if they had been successful in the ordeal.

A stickler for proper judgement, Henry II was a man of clear prejudices. He saw the clergy as a threat to his peace. A hundred murders, it was reported, had been committed by clerks in the early years of the reign, and much other crime besides. The king was furious. He came back to the point at Montmirail. His clergy, he claimed, were 'thoroughly immoral and wicked, for the most part sacrilegious men, adulterers, thieves, robbers, perpetrators of rape, arson and murder'. Only Rome could depose a bishop, the bishop of Chichester had claimed in 1159 in a conversation reported by the Battle chronicler. '"Very true", said

the king, "a bishop may not be deposed", and he made a gesture of pushing with his hands, "but see, with a good push he could be ejected."' The courtiers laughed dutifully. This was very much Henry's style. He was a great deflator of pretension. Those who wished to influence him would be wise to pay him in his own coin. One of the best, because one of the most characteristic stories of Henry II, is told by the biographer of Hugh bishop of Lincoln. In protest against 'the tyranny of the foresters' Hugh had excommunicated one of them, named Geoffrey. The king was not amused. He went into the forest, and summoned the bishop to appear. Hugh arrived and found the court totally silent. The king conducted an elaborate charade, whose point the biographer totally missed and we cannot now recapture, but which turned on the king repairing a leather bandage on his finger. The bishop claimed a place

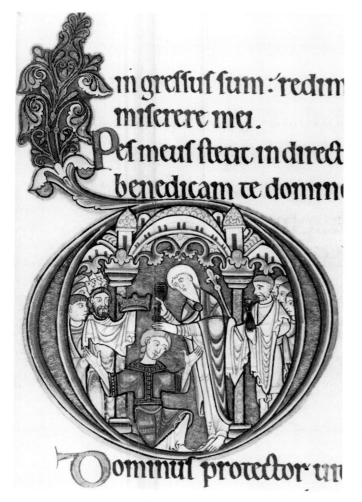

55 Saul anointing David. Glasgow University Library, Hunter MS 229, fo. 46r, c.1170, northern England. The miniature prefaces Psalm 26.

at the king's side, sat patiently awhile, and then quietly observed. 'How like your cousins of Falaise you look.' This was exactly on the right level. The king rolled on the ground with mirth. To some it had to be explained that William the Conqueror's mother was reputedly a leather-worker from Falaise. Then all were happy, except the forester, who was scourged.

Henry II's later years saw few such happy occasions, if the chroniclers are to be believed. In the final decade of his life he confronted a new king of France, Philip Augustus, crowned in November 1179. Earlier in the year, when the son's life was despaired of, Louis VII had crossed to England and prayed at the tomb of the most potent saint of the day Thomas Becket. The prayers were answered; the son was spared, and in a long reign he was to recapture much of the territory that the first Angevin king of England had ruled. The most influential chroniclers of the 1180s had at least part of that history before them as they wrote. And Walter Map and Gerald of Wales, the two men who have set the tone of the decade, had their individual disappointments as well. Well-educated, urbane, learned men, they felt that the world owed them a slightly better living than they had in fact achieved. Each was an archdeacon, Gerald of Brecon and Walter of Oxford, each wanted to be a bishop. Their ambitions frustrated, they were very harsh at the last on the king they had served. They wrote of him as a failure. Since failure in statesmen needed a moral explanation they viewed Henry's whole life in moral terms. Gerald of Wales based his disapproval on three things: (1) Henry's marriage had been illicit; (2) he had neglected the Holy Land; (3) the French monarchy was divinely approved. These three points may be taken in turn.

Eleanor of Aquitaine, said Walter Map, had 'cast her unchaste eyes on Henry, and contrived an unrighteous annulment' in order to marry him. This is a fine example of the rewriting of history, for it was 'the most pious king Louis' who procured the annulment, for reasons that have been examined (p. 63), and that owe nothing to her legendary love affair with Saladin, then a boy of thirteen. The last of Eleanor's seven children by Henry was John, born in 1166. Thereafter, and increasingly, the couple lived and grew apart. Eleanor returned to France and held her court at Poitiers, a centre of chivalric culture, which clearly much influenced her favourite son Richard; it was at her instigation that he was invested with the duchy in 1170, when he was thirteen. It must have been the political rather than the moral aspects of this estrangement which prompted the archbishop of Rouen to urge her in the spring of 1173 to 'return to your lord and husband before things get worse'. When they did get worse, later in the year,

Gerald of Wales

'OF ALL THE DIFFERENT parts of Wales, Dyved, with its seven cantrefs, is at once the most beautiful and the most productive. Of all Dyved, the province of Pembroke is the most attractive, and in all Pembroke the spot which I have just described is most assuredly without equal.' This is Gerald of Wales in his *Itinerarium Kambriae*, or Journey through Wales, speaking of his birthplace, Manorbier.

Gerald was born in Manorbier castle in 1146 into a family of Marcher lords, the de Barris, which was largely Anglo-Norman, although his mother's mother had been Welsh. All his life Gerald was to suffer from an identity crisis – a sense of being alien in both England and Wales – but at the same time he could, as a French speaker, feel at home anywhere in French-speaking western

2 Manorbier Castle (Pembrokeshire, now Dyfed) Gerald's birthplace. Some of the existing building dates from Gerald's lifetime, though most of the fabric is late thirteenth-century.

1 Salmon leaping. London, British Library, Royal MS 13.B.VIII, fo. 23 (Gerald, *Topographia Hibernica*), early 13th century
Gerald was fascinated by leaping salmon which he regarded as an exception but not a miracle.

Europe, including England. Like other ambitious English clerics Gerald found it natural to travel to Paris for his higher education. At Paris he studied logic and rhetoric c.1165−72, returning around 1176−9 to study civil and canon law and theology. Gerald was quick-witted and intelligent, but too interested in empirical observation and literary effect to make a

committed scholastic jurist or theologian.

In any case it was not necessary for him to follow such a career. In the early 1170s he probably obtained preferment in his native diocese of St David's. A complaint from him to the archbishop of Canterbury over non-payment of tithes led to his being made archbishop's legate to sort out the problem. In the course of this Gerald had the archdeacon of Brecon (diocese of St David's) deposed for living with his wife, and the bishop of St David's, David fitz Gerald, who happened to be Gerald's uncle, appointed him to the archdeaconry instead.

In 1184 Gerald entered royal service and hoped to win the favour of the Angevins' loyal family by dedicating some of his literary works to them. Henry II sent Gerald to accompany Prince John on the latter's disastrous trip to Ireland in 1185, and this allowed him to collect material for two books on Ireland. However, Gerald lacked the tact necessary to a courtier. When the Patriarch of Jerusalem visited Henry in 1185 to win

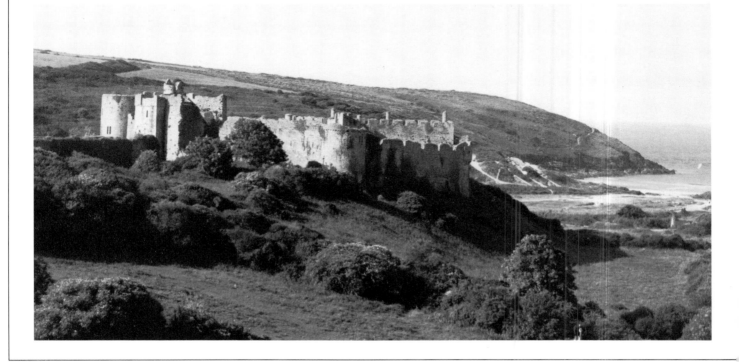

his support for a new crusade Gerald was openly shocked by Henry's cynicism. Gerald described the trip in his *Itinerarium Kambriae* and he later wrote a topographical work on Wales known as the *Description of Wales*. The 1188 journey began and ended at Hereford, then a centre of scientific studies, where Gerald attracted the attention of Bishop William de Vere, who gave him a prebend. In the 1190s Gerald made many visits to Hereford and Lincoln cathedrals where he could make friends in an intellectual milieu lacking at St David's.

In 1199 the then bishop of St David's, Peter de Leia, died. Gerald was elected to succeed him, but his election met with resistance from King John and Archbishop Hubert Walter of Canterbury, and Gerald himself did not want to be consecrated unless St David's could be awarded metropolitan status. Between 1199 and 1203 he made two trips to Rome to try to secure this, but his efforts were finally thwarted. Another candidate was appointed and Gerald agreed not to appeal on condition that he could resign his archdeaconry to his nephew. He hoped to continue to administer the archdeaconry for his nephew but the latter rebelled and took it over himself in 1208. Gerald's last years (he died in 1223) were spent writing bitter polemics against his

3 Hugh de Lacy. Dublin, National Library of Ireland MS 700, fo. 84v. (Gerald, *Expugnatio Hibernica*), early 13th century
Hugh, the head of a powerful Herefordshire family, acquired a large lordship in Ireland in the 1170s–80s.

nephew, the Angevins, and everyone who had opposed him in the St David's election.

Although Gerald's ecclesiastical career had been a failure his writings, notably his works on Ireland and Wales, which were widely copied, assured him of lasting fame. Gerald had keen powers of observation, especially in natural history. He was not interested merely in repeating threadbare traditions from medieval bestiaries, but included many details of behaviour which he had seen or heard described. He tried to give scientific explanations for natural phenomena, such as the leaping of salmon, although often he was content to describe events as 'marvels'. He rediscovered the genre of anthropology for the middle ages. He could see clearly that the pastoral life characteristic of Irish and Welsh societies went with a much larger freeborn and self-assertive warrior class than was the case in England and France whose predominantly arable farming was carried out by a large peasant class supporting a tiny military class: 'They (the Welsh) eat plenty of meat, but little bread. . . They are passionately devoted to their freedom and to the defence of their country.' While Gerald found some things to praise in Welsh society, his chief loyalty was reserved for Marcher lords such as Hugh de Lacy, whose activities in Ireland he enthusiastically supported.

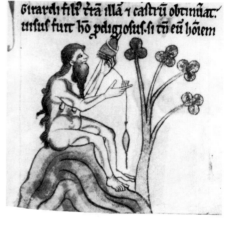

Moreover, Gerald was deeply prejudiced against Welsh and Irish sexual *mores*, and attacked the highly developed Welsh and Irish legal traditions on marriage as barbarism because they allowed divorce, marriage between near cousins and clerical marriage, contrary to the principles of canon law which were in the process of being defined and codified in the twelfth century. Here Gerald stood firmly on the Anglo-Norman edge of the divide.

JULIA BARROW

she was captured trying to escape to Paris, and was held responsible for her sons' rebellion. She was in captivity, or at least never again a free agent, for the remainder of Henry's reign. Eleanor was always good box-office: her supporters — sons, troubadours, clerks and laymen alike — ensured that she remained so. Her absence from Henry's side was a public reproach to him, for all that he felt it a political necessity.

In the two perhaps most important relationships with his contemporaries Henry failed. The first was with his wife, the second with his archbishop of Canterbury. The death of Becket tied him tightly to the defence of the Holy Land. Year by year he sent considerable sums of money to the Holy Land and by the mid-1180s these amounted to £20,000. This represented a very large fighting fund indeed and, in the microcosm of crusading politics, one capable of altering the balance of power. It was, though, Henry's private treasure, kept in trust by the Templars and Hospitallers, awaiting his arrival. He never came. The patriarch of Jerusalem, visiting the west to beg for assistance in 1185, heard Henry list his benefactions and summed up the problem very well. 'We want a prince who needs money, not money which needs a prince.' Henry's money could be released only by deception, its expenditure justified only by a major victory. The looked for victory turned into disaster, at Hattin in 1187, when Saladin was victorious, and 1000 knights out of 1200 in the Frankish army were either killed or taken prisoner. A few months later Jerusalem itself was captured, and the Frankish presence in the east was reduced to the coastal towns of Tyre, Antioch, Tripoli, and a few castles. When Richard heard the news, in November, he immediately took the cross. Henry was reported speechless for four days — one day longer than for the death of Becket: this was serious indeed. Henry's concern is understandable; his money had been wasted, and his advice ignored. Richard had embraced the crusading ideal with open arms. And Richard was now the heir to England.

Henry the young king had died on 11 June 1183. 'A prodigy of unfaith, a lovely palace of sin', was Walter Map's epitaph. Richard will certainly not have mourned him, for he died while fighting in alliance with various barons of Aquitaine against Richard's authority. Richard was now the heir to England, Normandy and Anjou. The old king, anxious to provide for all his sons, suggested that John, the youngest, should step into his brother's shoes in Aquitaine. Richard refused to relinquish a lordship he had worked very hard to secure. Henry had not the power to take it away from him, but he could and did deny Richard public support. His attitude may have reflected the disillusionment of old age, or may (as some contemporaries believed) have resulted from his partiality to John, and preference for him as successor. In either event the result was the same. With nothing to look for from the king of England, their father, the three young men gravitated to the court of the young king of France, Philip Augustus. He offered them the scope to realise their ambition; and he was pleased to do so, for this ambition was the break-up of the Angevin Empire, which he was to make the major thrust of Capetian policy. A further death simplified matters, and should have offered scope for compromise. Henry's third son Geoffrey was killed in a tournament in 1186, and buried in the cathedral of Notre-Dame in Paris.

The two more able of Henry's sons were now left to dispute his inheritance. At Bonmoulins in November 1188 the French king and Richard lined up against Henry II. They sought Richard's marriage to Alice as contracted for in 1169, though the marriage never did take place. They asked for public recognition of Richard as Henry's heir, but this Henry refused to give. He was a man who could move mountains but never mend bridges. Richard now felt that his suspicions of his father's intentions were amply justified. He would pursue him until his claims were recognised. Henry retreated to the haunts of his youth, the castles of the Loire valley, and Richard and Philip followed him there. At Chinon, on 6 July 1189, Henry II died, in the arms of his illegitimate son Geoffrey. Bishop Stubbs, the greatest of England's medieval historians, here took his cue from Henry's contemporary critics. 'The lawful sons, the offspring, the victims and the avengers of a heartless policy, the loveless children of a loveless mother, have left the last duties of an affection they did not feel to the hands of a bastard, the child of an early, obscure, misplaced, degrading but not a mercenary love.' This is a firm judgement, but it is almost totally unjust.

'Heartless policy' is wrong: both words take us in the wrong directions. Feudal politics was a game. It was played for high stakes, and it involved high risks. It was very exciting for those close to the centre of action, whether at the Exchequer board, 'where the king's glance was ever fresh', or following the itinerant court. John of Salisbury wrote to Becket in 1165 when both men were in exile, desperate for news: 'And so pray write and tell me about the courier whom the king of Scotland sent you, and the count of Flanders's embassy to the king; also what you have heard of the king and the Welsh, and if you have any news of the pope since he arrived at Montpellier.' Feudal politics had its own rituals, emissaries going back and forth continuously between the courts of western Europe. It was one of Henry's strengths that he sought to give his great magnates dignified employment. William

d'Aubigny in 1164 went as ambassador to the French king at Compiègne and to the pope at Sens; in 1168 he escorted the king's daughter Matilda to Gascony, where she was to be married to Henry the Lion. Such duties reflected a close relationship with the king which the earl clearly valued. Walter Map tells a story of this same earl striding into a meeting between the French and English kings and grasping the wine jug from the menial who waited at table. William was the king's hereditary butler; this was his job. 'And from that great court', says Walter Map in his *Courtiers Trifles*, 'he brought away the reputation of courtesy and not of presumption.' Whatever the faults of Walter Map, a man denied the glittering prizes, he conveys the excitement, the drama, of Henry's court very well. The worst that can be said of Henry is that in the last years some of the excitement, because some of the political initiative, was lost. In a long reign that is not remarkable; Henry's achievements were.

The Growth of the Market

England was a wealthy country in the second half of the twelfth century. Measurement of economic change is difficult, but a good case can be made for saying that the economy of England grew more rapidly then than at any other time in the medieval period. It grew because real resources grew, new land was taken in for the plough, more animals were grazed on the pasture. It grew because the scale of the market grew. In some important respects, though never totally, the ethos of the ruling class changed from one geared to consumption to one based on profit. The most important change may well have been that land itself became a commodity, to be traded on an open market. That was doubtless not the intention of those who drafted the Assise of Mort d'Ancestor in 1176, which gave the heir a right to inherit and access to his father's land even

56 New Buckenham, Norfolk. Motte and bailey castle mound of the 1150s, and new town of the late 12th century
The move from Old Buckenham to New fitted well with the work of reconstruction in the 1150s (p. 66), but it must also have reflected a desire to tap into the growth in trade along the Norwich – Bury St Edmunds road. The shape of a planned settlement is still clearly visible; the market area lies to the top right of the main road.

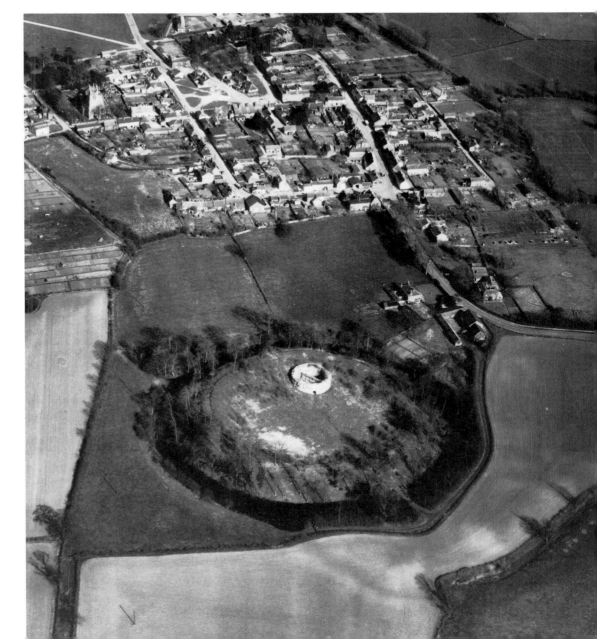

before he had done homage to his lord. But such was the result. Land was changing its character: from being the guarantee of a personal relationship in a feudal world it was becoming a piece of property which could be bought and sold. Men's attitudes did not of course change so suddenly, but the alienation of land became easier and, just as important, it became easier to use land as security for loans. This change helped fuel inflation, which was stimulated further by large imports of silver.

The silver flowed into England because of the expansion of the wool trade from the 1160s onwards to meet increasing demand from the cloth-producing region of Flanders. This trade in turn stimulated the growth of the towns, and in particular of the ports on the east coast. There are signs, even in Domesday Book, of a good deal of activity on the Lincolnshire coast. At Barton-on-Humber, for example, new tolls were taken 'in respect of bread, fish,

57 Charter of Richard 1 for the burgesses of Exeter.
Rouen, 24 March 1190. Exeter City Archives, charter iv
The charter granted the merchants of Exeter freedom from toll throughout the Angevin lands. Three identical charters survive, the duplicates presumably intended to be loaned to merchants for a particular voyage.

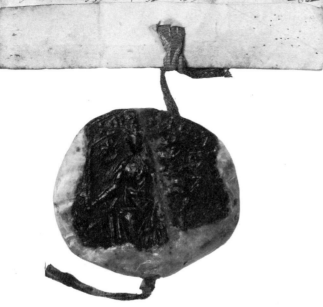

hides, and very many other things'. At Saltfleetby, where later Grimsby was built, 'Archil of Witham testifies that he saw Ansger receive the toll in respect of twenty-four ships from Hastings.' Grimsby is one of several new towns, not recorded in Domesday – a document focused on the old manorial centres – which mushroomed in the course of the twelfth century. Boston was another; it was worth £105 a year to the earldom of Richmond by 1183, and in 1206 it paid more in customs duty than did any other town in England after London. 'The revenues and expenditures of all good towns and boroughs in England are growing and increasing', said the monks of Bury in 1192, claiming that their town was the sole exception. They wanted a share of the action. The reeves of the town took 15d. 'from the carts of the citizens of London which had passed through the town carrying pickled herrings from Yarmouth'. The Londoners protested, claiming that they were exempt from all tolls throughout England. Both Yarmouth and Norwich were growing rich at this time on the profits of herring. Lords vied with one another to found new towns that could tap into the growing market. Stratford-upon-Avon, which turned out to be one of the more successful, was founded by the bishop of Worcester, on part of what had previously been a village. Burgage plots were laid out, each having a quarter-acre of land, privileges were promised, and with no more formality than this the new town was in business. The bishop looked for a profit. He also helped his agricultural tenants, by providing them with a market for their goods close to home.

It was the peasantry who were winning the new resources in land, which brought them greater wealth, which helped sustain the growing market for goods and services. In the movement of colonisation, the clearing and draining of new land, there were two frontiers – in the forest and in the fenland. When the forest justices were sent round in 1176, they levied fines on numerous villages situated within the royal forests, for the clearing of land without permission. The communities will have divided up the fines, for all were involved. Perhaps the best-known colonisers of the twelfth century are the monks and lay-brethren (conversi) of the Cistercian order. Their outlying granges, so prominent a feature still of areas such as north Derbyshire and north Yorkshire, might seem to show colonisation as something centrally controlled. In fact landlords of this kind were not colonisers but entrepreneurs. They had capital, and were able to buy up estates in some places from the free peasantry; but it was the peasantry who were the driving force. This was also true in the fenland where, during the late twelfth and early thirteenth centuries, great tracts of land, much of it highly fertile, were cleared. In the hinterland of the Wash the line of the med-

58 Detail from a calendar. Cambridge, St John's College, MS B 20, fo. 2v, c.1120–c.1140, (possibly) from Worcester Cathedral Priory The signs of the zodiac and the characteristic occupations of the months were two popular series of illustrations, often found together. The detail shows the pairs for the last three months of the year; for a different rendering of December see Pl. 139.

At the end of it Abbot Samson of Bury St Edmunds asked that all his monks who had personal seals should own up – 'and thirty-three seals were found'. Most of the monks had their own seals, and some of them lived like lords. Geoffrey Russ, a monk-warden in charge of four of the abbey manors, was found to have gold and silver to the value of two hundred marks in his chests. The monk may have had a private income, but most of that sum must have represented the profits of land.

It is small wonder that the pipe rolls were full of proffers for control of the wardship and marriage of those who had title to land at this time. John of Stamford, a clerk of the chapel royal, paid 40 marks to have the daughter of Walter Furmage. This was not a large sum, yet eight of his colleagues went surety for him. It is almost as though we are looking at a group of office workers, doing the medieval equivalent of the pools. William de Stuteville paid 1000 marks for the custody and marriage of Gilbert de Gant, 600 of that sum to be levied when the young man came of age. The considerations of profit that lie behind such proffers come out very clearly in Jocelin of Brakelond's life of Abbot Samson of Bury, perhaps the most famous of all the chronicles of the middle ages. A wardship worth £200 came on to the market, but the girl in question was under the control of the archbishop of Canterbury Hubert Walter. Abbot Samson had to sell his interest to the archbishop at a discount, and was mortified to see his clerical colleague cream off a profit for himself, when he in turn sold the wardship to Thomas de Burgh for £300. And still – this must have been Thomas's calculation – even after abbot and archbishop had taken their cut, there was a profit to be had.

The major landowners at this time sought to reclaim property that previously they had leased out. A knight offered Abbot Samson thirty marks for a carucate of land in Tilney, at the old rent of £4 a year: 'but the abbot refused him, and that year got £25 and the next year £20 from that land'. Abbot Samson, we are told, 'kept everything in his own hand', except the manor of Thorpe, which he gave to an Englishman, 'since he was a good farmer, and knew no French'. It was the English peasants, men who knew no French, who in the end paid for King Richard's ambitions in France, and for his crusade.

The Reign of Richard I

When, early in the fourteenth century, a royal clerk started to have serious doubts about the capacity of his young king, Edward II, he hoped that he might yet emulate the sterling qualities of his ancestors. Henry II had been 'industrious', Richard 'valiant', Henry III 'long-lived', and Edward I

ieval coast between Norfolk and the Lincolnshire uplands can be traced up to five miles from the present coastline by the location of the villages on the modern map. This shows the line of the silt fen. By 1300 up to ten square miles had been reclaimed from what was then the seaward side of the line, and a hundred square miles from the landward side. Colonisation produced new resources. As the village fields were extended, and the fens drained, the barriers between communities were broken down.

There seemed to be profits to be made everywhere in England in the late twelfth century. All that was needed was some security, preferably in land, and a personal seal, so that you could trade. 'Do you have a seal?', asked the justiciar Richard de Lucy of a knight of Battle Abbey. 'Yes', came the reply. 'The great man smiled. "It was not the custom in the past", he said, "for every petty knight to have a seal. They are appropriate for kings and great men only."' That was at the beginning of Henry II's reign.

Barfreston Church

CROWDED UPON THIS miniature church of nave and chancel (less than 50 × 25 feet overall) is a host of carved images of unique variety — pictures from the dream/world of peasant and ecclesiastic of that distant but approach/able England of Henry II. The Christian, the pagan subconscious and everyday scenes compete for attention. Nothing, seemingly, of the medieval cos/mos is left out. The Last Things consort with bizarre images of nightmare, as intermingled here as they were in the pop/ular mind; sculptures nearly as perfect as when they left the bench of the 'imagers' who carved them, and the hands of the stone/layers who set them (sometimes erratically) in place. Their exceptional delicacy of execution and artistry of design seem out of place on such a ver/nacular building.

The clearest message today is the preacher's to an illiterate flock; at all events, it is the least difficult to under/stand. Less easy is the folk religion, the vision of an ever/present spirit/world full of malign or mocking powers, which owes more to the pagan and Nordic underworld of superstition than to the preacher's orthodox theology. Grimacing demonic masks almost take over the pro/jecting corbels all around the eaves. Benign human faces and rational archi/tectural motifs are heavily outnumbered. Around the serene Christ above the main (and now only) doorway three rings, the innermost of stiff/leaf foliage; then humanised animals and (in the outer/most) scenes of manor life (plus a 'Sam/son rending the lion') emphasise the ordered confusion. Grotesque humans and anthropomorphic beasts coexist with calm ornament (chevron, billet, sunk star etc.) and with symbols of the Christian faith. It was already an outmoded style and was soon to vanish almost com/pletely. Here it remains as a wonderful (and often mysterious) final outpouring of Romanesque exuberance.

Best seen from the little valley, the church grandly presides over the tiny hamlet (about forty/five inhabitants all told) ten miles south/east of Canterbury. The normal pressures to rebuild and enlarge because of rising population and prosperity have, for some reason, passed it by. Consequently, the elaborately enriched cut/stone facing, applied to the upper parts of the walls (except on the west), of what had been a very elementary Norman flint building, by one of the De Port lords of the manor around the year 1175, has preserved its rustic but eloquent character. At this time the nearby cathedral was about to be transformed. Barfreston was miraculously left alone. Restless medieval modernisation, Puritan iconoclasm, eighteenth/century neglect and (often most destructive of all) Vic/torian 'restoration' have done amazingly little harm. The 1840 repairs were neces/sary but exemplary.

Parishioner, or pilgrim on the nearby route to and from Becket's shrine, would enter by the south door; overhead the 'Christ in Majesty', Byzantine and Carolingian in iconography within its pointed oval 'mandorla', the right hand raised in blessing, the Bible held open on the left thigh. Its location is significant. Terrestrial lordship placed emblems over gateways. These on the tympanum, between door/head and arch, relate to the second coming (Matthew XXIV) and to the end of the world. On either side, enclosed but looking through the Celtic/style foliage tracery, angels read from scrolls the names of the elect. Crowned heads, male and female, flank them (Henry II and Eleanor of Aquitaine?) and at the top float two cherubs. The stern, bearded and classically robed Christ is one who judges as well as redeems mankind. These people had a

1 The church from the south
Note the continuous shallow arched niches between the narrow and high set windows. They gave interest and proportion to the building, and economized on stone though not on labour.

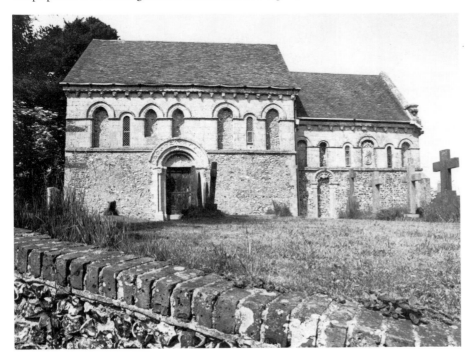

2 East wall, central blind niche with crowns of lancet windows.
The mason-layer could not resist adding the hunting-dog about to spring on a rabbit. The corbels to the projecting, leaf-tendril decorated course above are characteristic.

gable, on either side of the remarkable wheel window, wide-mouthed lions on moulded brackets gaze eastward and inward awaiting the second coming.

After these, the statuette of St Thomas tucked in over the Christ must have been reassuring. So too was the outer ring of figures in their 'medallions' — the mailed footsoldiers; lady with fashionable tight bodice and tippets; a cellarer filling a wineskin from a barrel on trestles. Plac-ing the lowly peasant (spade, bent back) near the summit shows a nice underdog humour, as do the fabulous animals and humans in rôle-reversal situations carved on the middle ring. A monkey riding a goat back from hunting, the rabbit over his shoulder, is charmingly whimsical. Such fantasies were not quite banished even from the severely elegant interior of this eloquent little church.

sombre awareness of the brevity of human life and a strong sense of evil. A sinister griffin, a siren and two sphinxes lurk above the cable-moulded lower frame, just overhead.

The same eschatology is found in the large plaque on the adjacent wall of the Chancel, ornately and distinctively niched. St Michael (barely visible), below a canopy of domed towers and windowed walls representing the Heavenly Jerusalem, defeats the satanic fish-tailed dragon (Revelation XII, XXI), while on the east wall, near the foot of the

C. L. H. COULSON

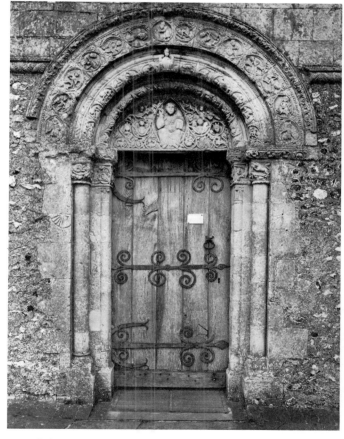

3 South door
A statuette of Thomas Becket helps date the church to shortly after the saint's canonisation in 1173, but the dominant image here is of Christ, surrounded by angels reading scrolls, set within a pattern of freehand interlace.

4 Detail of the voussoirs above the south door
On the middle ring of carving appear two hunting dogs and a horseman; on the inside ring is a fine, quirky carving of a monkey riding a goat, with a rabbit slung from a staff across its shoulder.

'wise'. (King John, who should have come between Richard and Henry III, was quietly forgotten.) Richard's valour was indeed legendary. He was king of larger than life-size. His reputation was gained in only a few months, the period of his participation in the Third Crusade, between 8 June 1191 and 9 October 1192, but in that time he secured the coast of much of the crusader kingdom in western hands. He had started by joining the siege of Acre, which Saladin had captured in 1187 after the battle of Hattin. The garrison of Acre surrendered on 12 July 1191. Richard then marched south to Jaffa, the key to the supplying of Jerusalem, resisting Saladin's attempt to cut the crusader supply lines and defeating him at Arsuf. Jaffa surrendered, but Richard failed to reach Jerusalem. The risks were too great and Richard, an impulsive man at times, was never an impulsive general. It was the confront-ation with Saladin which caught the popular imagination. The English paid dearly for the crusade, not least for the ransom which purchased Richard's release when he was captured on his way home, but they paid readily. They had enough saints, too few military heroes. Richard, like Becket, enjoyed a rapid promotion.

The Third Crusade was in theory a joint enterprise of the leaders of western Christendom. Yet in practice these leaders were deeply divided among themselves. A letter written home by an English cleric present at the siege of Acre complained of the morals of the Christian army and noted its divisions: 'the princes hate one another, and dis-pute about status'. This was before the kings of France and England appeared in person, and their rivalry proved an added embarrassment. Philip Augustus left the Holy Land within a few weeks of his arrival, swearing to protect Richard's interests in France but intending nothing of the kind. When Richard sailed home in October 1192 he found a wintry reception in western Europe. The count of Toulouse, encouraged by Philip Augustus, was reported to be waiting in ambush for him. Richard and his entourage therefore sailed up the Adriatic, and tried to make for home via Austria and the Rhineland. This proved to be no friendlier territory. The wealthy pilgrims, as they claimed to be, were recognised and captured by men of the duke of Austria, who had also been at Acre and had quarreled with Richard there. The German Emperor Henry VI, who had succeeded Frederick Bar-barossa, made an immediate bid for this valuable prize, for he had enemies both in Sicily and in Germany who were Richard's allies. Richard was held in captivity, first in Speyer and then at Mainz, throughout the year 1193, and was only released on 4 February 1194. A ransom of 150,000 marks was the price of his freedom, negotiated in June 1193 and paid promptly. While he was in prison

the king received frequent emissaries who brought him news of English affairs.

The news that came from England was not good. The country was unsettled by the king's captivity. 'All the barons were disturbed, castles were strengthened, towns were fortified and ditches dug.' Furthermore discontent had a focus in the person of Richard's brother John. John had been well treated by Richard in the early weeks of his reign. He was given a considerable estate in England, marriage to the heiress of the earldom of Gloucester, and lands in the south-west of England and the north Midlands. These lands offered John an independence, but no responsibility for the government of England and no strategic import-ance. With Richard away, John aimed to secure these. Responsibility for government seemed in prospect when William Longchamp, whom Richard had made justiciar, was deposed from office and forced out of England because of his unpopularity with the baronage. When Richard dis-appeared from view on his return journey, and in the eyes of many was 'missing presumed dead', John's treason appeared in the open. In January 1193 he made a treaty with the French king, who invaded Normandy and made an invasion fleet ready to come to England. It was left to Richard's agents to defend England and Normandy against the attacks of his brother. This they did with great success: Rouen was successfully defended, and John's castles in England were put under siege. News of Richard's whereabouts, even though he was in captivity, induced the French king to make peace; when Richard was released he returned to England, and John's revolt collapsed.

Richard remained in England for no longer than was necessary to put his younger brother in his place. He had landed at Sandwich on 13 March 1194. On 12 May he left for Barfleur and never returned to England again. The history of England without Richard is the story of mobilisa-tion, of money, and of troops for the king's wars in France. It is a remarkable story, and it has a clear hero. This was Hubert Walter. A pupil of the justiciar Ranulf Glanville, he had risen through the ranks of the civil service. He went on crusade with Richard, restored Christian discipline with the army, and proved an admirable quarter-master. Richard secured his appointment as archbishop of Canter-bury in 1193, by letters sent from his prison cell. Hubert Walter was a financial administrator very much in the mould of Roger of Salisbury. His career is studded with levies of money, spectacular both in conception and in scale. The Saladin Tithe (or tenth) was taken in 1188 to pay for the Third Crusade: it was new in that it was not a land tax, but based on an assessment of wealth. The ransom raised for Richard's release also bears the stamp of Hubert. This followed the previous pattern, and was

very severe. The laity pledged a quarter of their incomes; the clergy their chalices and silver plate, while the Cistercians (who had repudiated such ornament) paid the value of the year's wool clip. In 1197 Richard asked for 300 knights to be sent to him in Normandy to serve all the year round. This was a novelty (one that suggests that the royal army suffered from a lack of good officers), and resisted as such. Hubert Walter secured the men needed. About this time he is reported as claiming to have sent to Richard in the previous two years 1,100,000 marks to pay for his continental wars. This figure, even with some exaggeration allowed for, is quite remarkable. No comparable sum was levied, in so short a time, for the remainder of the middle ages.

Hubert Walter was a bureaucrat of remarkable quality and inventiveness. From this time dates the keeping of the first permanent record of royal correspondence: from now on, in the close and patent rolls (two distinct series, depending on how the royal letters were sealed), the work of English government can be followed from day to day. There were also changes in local government. In September 1194 Hubert Walter instituted a coroner in each county, who had to be notified of all sudden and suspicious deaths; the coroners' rolls are thereafter the indispensable source for the historian of English crime. At the same time he ordered that a record be kept of all debts and pledges to the Jews. Those who work on local history in England find an equally indispensable source in the feet of fines.

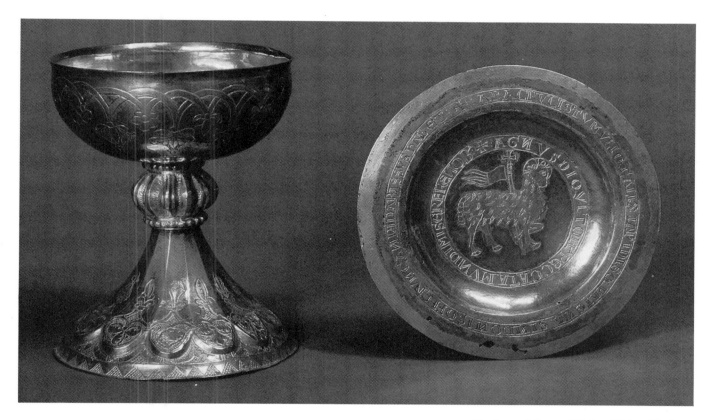

59 Chalice and Paten of Hubert Walter (died 1205). Mid-12th century. Silver-gilt and engraved, chalice height 142 mm., paten diam. 140 mm. Dean and Chapter of Canterbury
When the tomb of the archbishop was opened in 1890 his garments and various items of metalwork were found well preserved.

60 Patent roll. London, PRO C 66/2
Records of correspondence of the royal administration, here letters sent patent (i.e. with the seal open, as in Pl. 57). The series was started by Hubert Walter in the 1190s.

This was another of Hubert Walter's bright ideas. Previously two parties settling a dispute would have made their 'final concord' by making two copies of their agreement on a single sheet of parchment, each sealing the other's copy. Now a third copy was made, the 'foot' of the fine, and kept in a county file in the public records. A common standard of reference was provided in the Assise of Measures in 1196. This appointed common standards for cloth, beer, grain and wine; and £11 16s. 6d. was paid for 'measures and gallons and iron rods and beams and weights to send to all the counties of England'. No detail was too small for Hubert Walter. It was rumoured that the king might return to England in 1197. Hubert sent word that the kitchens at Winchester needed attention, and wine was taken at Southampton to stock the main hunting lodges of southern England.

Richard never did return. The prime objective of his policy was the defence of his continental possessions. There remained two frontiers of war, in the Vexin and in Berry, against both of which he sought to mobilise resources and purchase allies. The triumphs of diplomacy were in the south, the forming of an alliance with the count of Toulouse, who in 1196 married Richard's sister Joan, while in the north in 1197 a treaty was concluded with Baldwin count of Hainault and of Flanders. Economic as well as political pressure had been brought to bear here, heavy fines earlier being paid in the pipe rolls by those 'who sent corn to the king's enemies in Flanders' (the traders of King's Lynn and of Dunwich each paid fines of around 1000 marks). Alongside this went military endeavour, symbolised by the building of Château Gaillard at Les Andelys on the Seine, a reminder still of Richard's military genius and of his ambition (Pl. 62). There were also victories in the field, small in scale but most valuable for publicity. At Fréteval near Vendôme in 1194 Richard drove Philip Augustus from the field, capturing his treasure and the bulk of the French royal archives. At Gisors in 1198 a French force was engaged, and driven pell-mell to seek safety in the castle; a bridge collapsed under the weight of the heavily armoured men, and at least twenty knights were drowned.

In diplomacy and in warfare Richard proved himself

61 Tombs of the Plantagenets. Fontevrault Abbey
A line of Plantagenet kings and queens (from the right): Henry II (died 1187), Eleanor of Aquitaine (died 1204), Richard I (died 1199), and Isabella of Angoulême (died 1246).

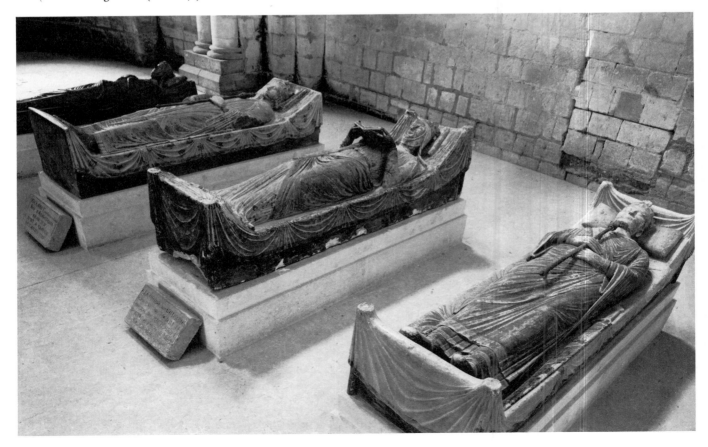

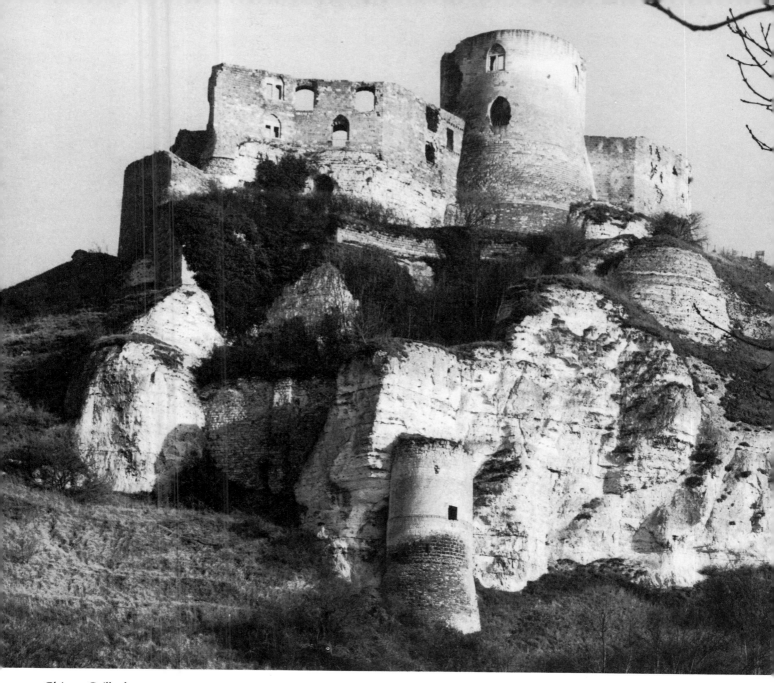

62 Château Gaillard. 1196–8.
One of the great castles of medieval Europe, what Richard I called his 'fair castle of the rock'. It overlooks the river Seine at Les Andelys on the frontier of Normandy, which it was designed to defend.

a master tactician, able to counter the French king and harass him on his own ground. He was able to recapture territory that he had lost while on crusade and in captivity. But for all this, he was on the defensive: Château Gaillard was a defensive earthwork, protecting the main line of attack into Normandy. It was the French king who was on the offensive. Philip gained important new landed resources in the 1190s, and developed an administration to mobilise them more effectively. He could afford to buy new allies, and force Richard to commit fresh resources

of money and manpower to counter them. In the spring of 1199 Richard undertook one of many such necessary expeditions, moving south against the vicomte of Limoges and the count of Angoulême. At the siege of Chalus-Chabrol the king was struck by a bolt from a cross-bow, the wound turned gangrenous, and he died on 6 April 1199. His body was taken to the nunnery of Fontevrault, and he was buried alongside his mother and father. Richard is the last of the kings of England to be buried in France.

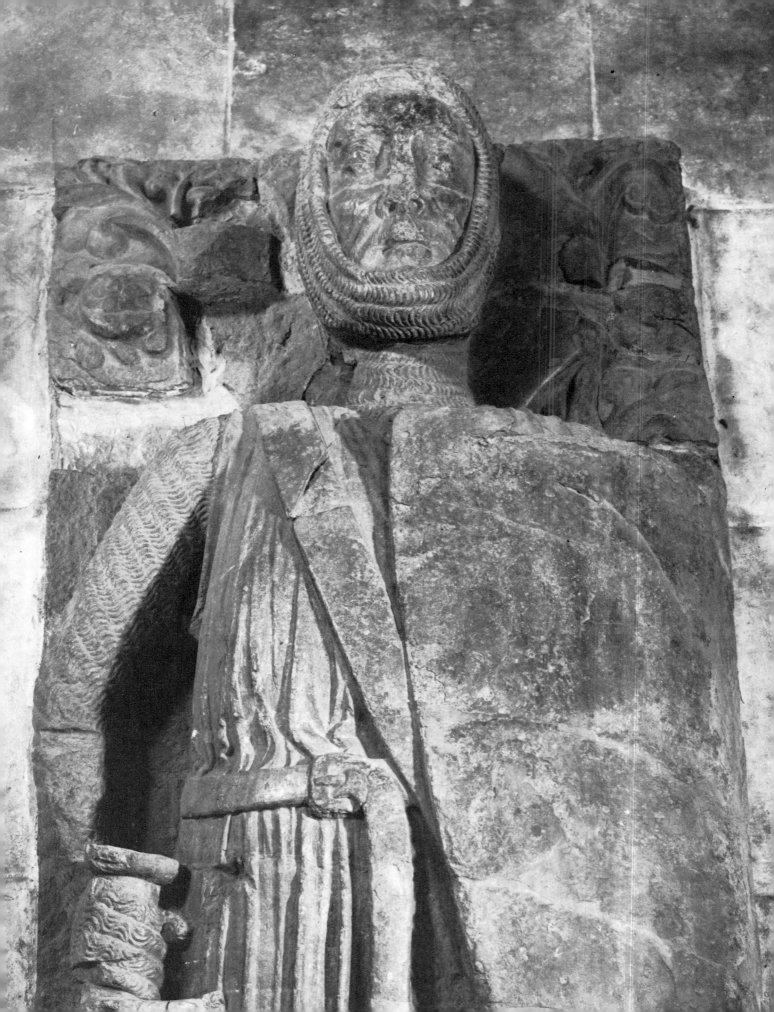

4

MAGNA CARTA AND BEYOND
1204—1258

IT TOOK ELEVEN DAYS for news of Richard's death to come from the south of France to England. This was a dangerous time: Richard had not been in England for five years, and the succession was not secure. 'Practically everyone, bishops as well as earls and barons, if they had castles strengthened them with men and provisions and arms.' John remained in France. He had a rival in Arthur of Brittany, the son of his brother Geoffrey, but the custom of the different parts of the Angevin dominions differed as to the succession. John's best title was to Normandy, and he did well to make first for Rouen, being invested there with the sword of the duchy by the archbishop on 25 April. The men of Anjou, Maine and the Touraine had meanwhile met together and accepted Arthur. John had the support of the English administration. Hubert Walter the archbishop, Geoffrey fitz Peter the justiciar and Earl William Marshall arrived in England hard on the heels of news of the king's death. They set to work immediately to garrison the chief royal castles: from Lancaster to Dover, from York to Exeter, all along the Welsh Marches, men were brought in 'to guard the castles and maintain peace'. £40 paid to ten knights and twenty serjeants for forty days, 'after the death of King Richard', was typical of dozens of such entries. John's advisers purchased time in this way, which they used to summon the chief men, stressing John's acceptance in Normandy when news came to hand. John was crowned king of England on Ascension Day, 27 May 1199. He girt with the swords of their earldoms those who had done most to further his cause, William Marshall as earl of Pembroke and Geoffrey fitz Peter as earl of Essex. He gained free lodging, and the assurance of prayers, from the keepers of the three great shrines of the day, St Alban, St Thomas at Canterbury and St Edmund at Bury. At the last of these, at least, the king made no great impression: the silk cloth he presented at the shrine had been borrowed from the sacrist and was never paid for, and he left only a meagre 13d. in the collection plate.

The Loss of Normandy

John left England less than a month after his coronation, for a rival was loose who did not lack powerful support. Philip Augustus professed himself angry that John had not submitted his claims to Richard's lands in France to the judgement of the French court. The point was made when the two kings met in person in August 1199 and again in January 1200. But negotiations were already under way to find a settlement that would recognise the claims of each party. It would involve the marriage of the French king's son Louis with John's niece Blanche, the daughter of Alfonso of Castile. At Le Goulet on 22 May 1200 agreement was reached. It came in the form of a notification by the French king of the terms on which peace had been made (*forma pacis*). It started with, and half a lengthy document was spent on, the castle and county of Evreux, to which the French king was to succeed 'as the rightful heir of King Richard'. John undertook to pay 20,000 marks as a relief and for the grant of Brittany, which Arthur was to hold of King John. John as the rightful heir of Richard was to hold all the lands which his father and brother had held, except those stated. Each side gave the other hostages. In this and other ways the document preserves the normal courtesies of a composition, an agreement between equals; but in becoming a vassal of the French king John had been forced to yield important ground.

The peace made at Le Goulet between the kings of France and England would not last for long. King John had had to cede territory because individuals in key areas had transferred their allegiance. He saw the next threat of a similar kind as coming in Poitou, where Hugh of Lusignan had become count of La Marche in 1199. Hugh was then betrothed to Isabella, the heiress to the county of Angoulême, and this further territory would give him

63 William Marshall, regent of England (died 1219). Purbeck marble. London, Temple church
'Behold all that remains of the best knight who ever lived,' said Archbishop Stephen Langton at the graveside. The tomb was damaged by bombing in 1943, and has been restored.

a predominant role in the duchy. John met this threat by marrying Isabella himself, on 30 August 1200. Such marriages were of the very essence of feudal politics, and few can have been surprised by this union, which proved a very happy one. But a betrothal was a contract, and breach of contract called for compensation. This John refused to give. Instead he attacked the Lusignans, and they responded by complaining to their (and John's) overlord, the king of France. John was summoned to Paris in April 1202, to answer the charges they made against him. The English king refused to attend, and in response the French court declared all his continental lands to be forfeit. Normandy was to be gathered into the Capetian demesne, while John's other continental lands were to be given to Arthur. That at least was the French plan. It would have to be fought for, and the first victory fell to John. At Mirabeau he captured Arthur, several leaders of the house of Lusignan, and 'all our Poitevien enemies'. Care was taken to transfer these unfortunates to a variety of secure castles in England and in Normandy. Arthur was kept first at Falaise and then at Rouen, after which he was not heard of again. What happened to him is not known, but undoubtedly he was killed, and undoubtedly John was held responsible for his murder. It was even said John had killed him with his own hands.

Arthur's death simplified matters, but did not strengthen John's cause. It led to a straightforward confrontation between the great powers, which those in the middle watched with particular care. On their side of the frontier the French prepared to strike. At the major fortresses, troops were mustered – at Gournay, at Lyons-la-Forêt, at Gisors, at Vernon and Evreux, and Nonancourt. These centres, many of them haunted by the ghosts of Norman and Angevin kings, were now under Capetian control. They were firmly garrisoned by 2500 troops, of whom perhaps a tenth were knights. The number is not large, but it was

mobile, well-provisioned, and permanent. The men were paid cash: 27,370 *livres parisis*, or perhaps £10,000. Money talked, undoubtedly but men also formed their own opinions of the combatants. In either case John was a clear loser. In 1203 Robert of Sées, count of Alençon received John in person. The king left after five days; he was served breakfast, and then rode off to Le Mans. By nightfall the count had sought out the French king, and transferred his homage. John was so shocked that he dated a charter by this treachery. His own frontier posts were weakened. Le Vaudreuil, defended by an imported garrison, was surrendered by Robert fitz Walter and Saher de Quency. John saw the writing on the walls, and returned to England in December 1203. Château Gaillard, under Roger de Lacy the constable of Chester, was left to fight on; it surrendered on 8 March 1204. When he heard of this John confiscated the constable's English lands, though it was not long before, better advised, he returned them and offered £1000 towards his ransom. By the summer the whole duchy had fallen to the French. John felt himself betrayed. There was, men felt, an element of retribution in his treatment of his subjects from then on.

John never abandoned the hope of recovering Normandy, but he had now to go back to the drawing board. Just as the Bayeux Tapestry shows the carpenters at work on the ships that were to take the invading force to England, so after the fall of Château Gaillard the English shipyards were set to work to supplement the resources of the English merchant fleet. A list of fifty-two ships, available in sixteen different ports, survives from 1205, word having gone out that no ships were to leave port without permission. And new ships were built on the Tyne (£24 8s. 0d. for the timber; £54 1s. 2d. in labour costs), at London (£360 10s. 3d.), and elsewhere. The fleet was gathered at Portsmouth, and arms and provisions were sent to it. All the workmen of the south-west

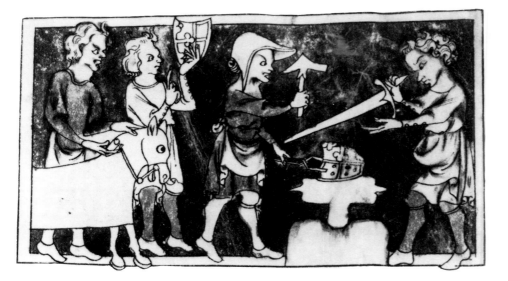

64 The knight's equipment comes in for repair. Paris, Bibliothèque Nationale, MS fr. 24364, fo. 67r, c.1300 – c.1310. (Thomas of Kent, *Roman de toute chevalerie*)

65 The Conyers falchion. c.1257 – 1272. Blade of steel, hilt of enamelled copper-gilt, grip (later) of wood. Dean and Chapter of Durham
In use until 1860 as a ceremonial sword of tenure by the Conyers family for its lands in Sockburn, Co. Durham. It was presented to each new bishop on his institution, and thereafter returned.

and the marches, said a writ of 16 April 1205, 'fit to be the king's workmen, making and leading his longships, and receiving his livery', were to report for duty. The administration was impeccable, the men appeared, but the preparations were all in vain. There was no army to transport. In June the same year Hubert Walter and William Marshall told John that the barons would not fight. The king was incensed, and the sailors too, cheated of action and their spoils. Within a month, the archbishop was dead.

The Interdict 1207–14

The election of a successor to Hubert Walter at Canterbury was protracted, and led to a serious quarrel with the papacy. John himself, the bishops of England, and the monks of the cathedral priory all claimed a say, and could not agree on their candidate. The papacy, which had developed no less rapidly than the other monarchies of western Europe, claimed the right to scrutinise the election down to the last detail. The key episodes took place in the papal *curia*. After two years of dispute, the archbishop elect, who was clearly the pope's candidate, was Stephen Langton, an Englishman by birth, and a professor at the Paris schools. The pope made him a cardinal, and consecrated him archbishop on 17 June 1207. The king totally refused to receive Langton, and vented his anger on the monks of Canterbury, since they had bowed to papal pressure rather than the king's own. All but a handful of the community, which cannot have been fewer than sixty strong, were sent into exile, the majority to Saint-Bertin in Ghent. The pope's response, to the king's refusing to accept a judgement in his court and the archbishop he had consecrated, was to place England under an Interdict. By the terms of the Interdict the clergy of England withdrew their priestly ministry; 'no ecclesiastical office is to be celebrated

except the baptism of infants and confession of the dying', matters within the province of what we would now call the priesthood of the laity. In effect, the whole of England was laicised. The king retaliated by ordering the confiscation of all church property. This brought in useful revenue, from lands taken in hand, and payments from those who retained their property. Some of the payments took unusual forms. The parish clergy were required to ransom their mistresses. In 1212 Hugh de Neville, the chief forester in addition to his main duties, owed 100 marks 'for the goods and the mistresses of the clergy' (*sacerdotissis* – strictly women priests, but the clerk was only joking). This was a dispute with a cutting edge. Chaste monks and sinful priests suffered alike. When he heard of the fate of the monks of Canterbury, Stephen Langton's father, a minor Lincolnshire landowner who might have reckoned to dine out on his son's distinction, abandoned his land and sought refuge with the bishop of St Andrews in Scotland.

The years of the Interdict were years in which protests against John's government grew in force. It is men's perceptions that are important, not administrative changes in themselves. 'A simple change in the exchequer machinery might seem to the barons to represent a fundamental change in their fiscal relationship with the crown'; J. C. Holt puts the matter very well. There was no typical baron of the age, and Earl David of Huntingdon was more untypical than most, but the history of his relationship with King John, recently well set out by Keith Stringer, is none the less instructive. In the early months of the reign, when a Scottish invasion was feared, David mediated with his brother the Scottish king. In return John was generous with his gifts, confirming on David estates in Huntingdonshire (Godmanchester being the most important of them) and elsewhere, and adding Alconbury and Brampton to them, in the years 1199–1202. But by the end of the decade all sign of royal favour had disap-

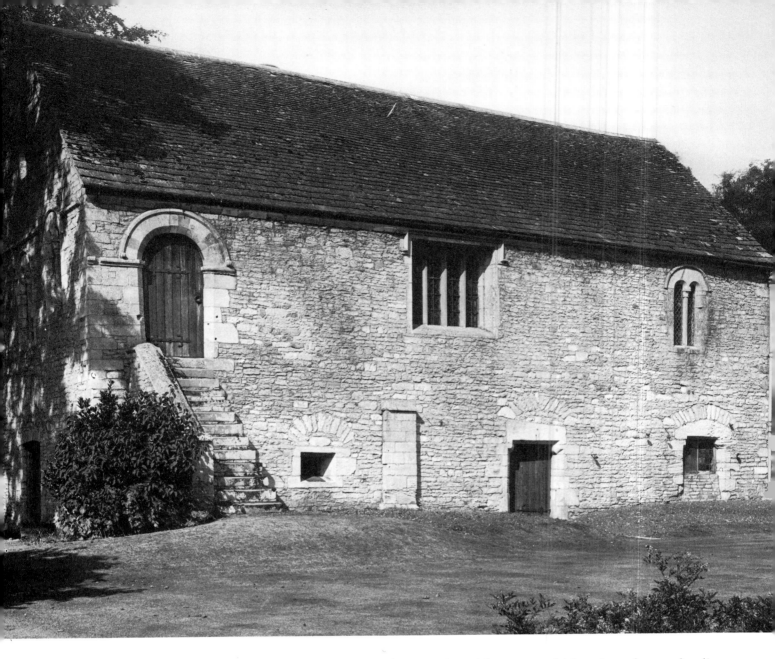

peared. Jewish debts of £300, though earlier pardoned, were now pursued; a forest fine of £200, though the liberties of the honour gave freedom, was levied; similarly traditional scutage exemptions were ignored. By 1211 the debts totalled £1100. The following year, when John was given news of a plot on his life, David was suspected of being involved; he was sent a reminder that his son was held as hostage, and an order to deliver Fotheringhay castle, his main English residence, to the king. The manor of Godmanchester was recalled. A measure of reconciliation followed. The earl was an old man. He played no part in the movement for Magna Carta, or in the civil war which followed. John had not treated him either particularly badly or particularly well. His experience may none the less help to explain why many did rebel. Years of loyalty and service could not be built into any permanent credit.

To financial pressure, which at times abrogated earlier concessions, was added the suspicion of disloyalty and a singularly direct vindictiveness.

The pipe rolls for John's reign are a beguiling source for historians. In them the king seems curiously approachable. The necessities of life follow him as he peregrinates his land. In December 1210 the king was at Craike castle in Yorkshire; a turbot was caught in the Thames, and sent to him there. All was being got ready for the Christmas feast at Windsor: as many as 1500 cups were brought, 1200 pitchers, and 4000 plates; 376 pigs were salted in the larder, and were to be joined by 900 haddock, 3000 lampreys, 1800 whiting and 10,000 herring. There were provisions, too, from further afield: pepper, cumin, galingale, cinnamon, cloves, nutmeg, almonds, dates and figs, some of the staples of the medieval spice trade, all

carefully listed, weighed and accounted for. And wine. Always wine. Wine with every meal, even on Good Friday. Wine from Auxerre, French wine, Gascon wine, and Angevin wine; white wine also (these others must have been reds). The king had his own wine merchant and his favourite suppliers; in 1204 Ralf the miller paid for wine from the monks of Corbières. Small wonder that when John was kept from his table by the sedate pace at which Bishop Hugh of Lincoln said mass, word went to the bishop to hurry up. For the king, very clearly, it

was the evening meal that made the day worthwhile. He sat surrounded by his household knights, who were expected to cut a fine figure in new robes that reflected the latest fashion, and barons of his intimate counsel. Their thoughts were never far from France. How could the knight-service of Normandy, lost in 1204, be replaced? Could not the king's burgesses make some contribution to the war effort? There were many problems of this kind. Later, as the wax-candles flickered in the hall and the wine began to talk, they might bet on the latest news from France or boast

66 Boothby Pagnell Hall, near Grantham, Lincolnshire. *c.*1200
The hall follows a typical 12th-century plan. The main living area comprised the hall, entered via the steps to the left, and an adjacent solar or private room. Underneath there was cellar accommodation. Compare, on a different scale, the buildings of the same period for the lay brothers at Fountains Abbey (Pl. 45).

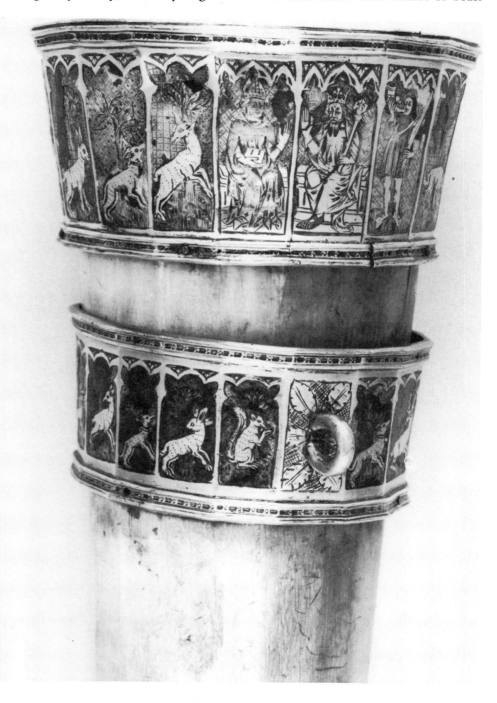

67 The Savernake Horn. Elephant ivory, *c.*1200; the silver and enamelled bands shown here are of *c.*1325– *c.*1350. London, British Museum
The hereditary horn of the Wardens of Savernake Forest, Wiltshire, showing charming scenes of hunting animals and beasts of the forest; at the top are a bishop, a bearded king, and a forester blowing a horn of just this type.

The University of Oxford

LIKE PARIS BUT UNLIKE most later medieval universities, Oxford was not founded at a particular date by a secular or ecclesiastical authority. Its origins remain obscure, but there seems to have been a recognizable university by 1187/8, when Gerald of Wales addressed the 'doctors of the various faculties' and their students. In 1214 the scholars were given a privileged relationship with the town and a chancellor was established as their head. The university's privileges, and the chancellor's powers, were steadily extended in the succeeding two hundred years, often in the wake of violent conflict between scholars and townsmen.

The masters assembled in congregation were the governing body of the university. The chancellor was its head and also its judge, with spiritual, civil and criminal jurisdiction. The university's main administrative officers were the two masters elected annually as proctors,

1 A lecture. Oxford, Bodleian Library, MS Laud misc. 165. fo. 149v, late 14th century, English Students probably came to Oxford in their late teens. They were not necessarily priests but were considered to be in at least minor clerical orders.

whose duties included keeping the peace. Of the university's faculties – arts, theology, civil law, canon law and medicine – arts had the most powerful voice in university affairs. Those entering the faculty of theology, other than the large contingent from the religious orders, were expected to be masters of arts. The two laws were closely connected, for canon law contained a large component of civil (Roman) law; the common law was not taught in the universities. The faculty of medicine was extremely small.

Students presumably came to Oxford with some competence in Latin, the language of instruction in the university. Teaching was based on the oral exposition of set texts. The student proceeded to his degree by attending the required courses of lectures, taking part in formal disputations and satisfying the masters as to his competence and suitability; he was then required to lecture himself. Lecturing by newly qualified bachelors and masters provided the core of university teaching. The statutes laid down a long

period of study for each degree, and although these requirements were sometimes relaxed, most students probably left the university without a degree.

The statutory curriculum in arts covered the seven liberal arts (the *trivium* of grammar, rhetoric and logic and the *quadrivium* of arithmetic, astronomy, geometry and music) and the three philosophies (moral, natural and metaphysical). Most attention was devoted to logic and natural philosophy (the physical sciences). These subjects were dominated by Aristotle, many of whose works, along with those of other Greek and Arabic writers, were introduced into western Europe in the twelfth century. In the early fourteenth century Oxford led Europe in the study of logic and the physical sciences. Oxford men, several of them fellows of Merton College, like Thomas Bradwardine and Richard Swyneshed, were prominent in the application of a mathematical approach to physics. William of Ockham and John Duns Scotus, both friars who characteristically spent only part of their academic lives in Oxford, were notable among those who made major contributions to both logic and theology. The faculties of law had no great reputation abroad, but provided a sound training.

The difficult questions of the social and geographical origins of students have not yet been adequately investigated. Few peasant or artisan families could have supported a son at university without the help of a patron, and few nobles attended the universities; most students are likely to have come from the upper peasantry and the gentry. Like Cambridge, Oxford attracted students from the midlands and the north, but while Cambridge naturally drew heavily on the eastern counties Oxford had strong ties with the west and south-west. There were some students from Wales, Scotland and Ireland, but very few continentals, most of them friars. Students from the same region tended to live together and regional loyalties were

2 A book-carrier. Detail of misericord in New College chapel, late 14th century
Books were valuable objects, often used as security for loans. A New College servant carried the fellows' books to lectures.

3 Congregation house, interior of upper storey
The congregation house was built alongside St Mary's church in the early fourteenth century. Its lower storey was the meeting place for congregation; chests containing the university's archives and valuables were arranged around the walls and provided seating for the masters. The upper storey was used as the university library.

4 (BELOW) A fight. Misericord in New College chapel, late 14th century
Students probably dressed much like other young men and, despite the statutes, carried arms. Petty quarrels easily escalated into lethal brawls and large-scale riots.

strong, sometimes leading to armed conflict.

Some scholars found private lodgings, but the typical student lived in an academic hall. Halls were run by principals licensed annually by the university; they provided not only board and lodging but a disciplined communal life and probably teaching too. The non-monastic colleges housed a small minority of med-ieval Oxford's scholars. Their founders, most often bishops, intended them to sup-port poor scholars and their regime was somewhat spartan, with diet and behav-iour strictly controlled by statute. Their permanent endowment of landed prop-erty assured their survival and distin-guished them both from the monastic colleges and the halls. The university itself had virtually no endowment and for most of the middle ages no building of its own apart from the congregation house. Most schools – that is lecture-rooms – were not owned by the university but like academic halls were rented by individual masters from private land-lords. In the fifteenth century the univer-sity managed to raise funds to rebuild its canon-law schools and to build the mag-nificent divinity (theology) schools.

It was rare even for a distinguished scholar to make his entire career in the medieval university. The surviving evi-dence tells us most about careers in the church. By 1500 graduates held a near-monopoly of the highest posts in the church, which they sometimes received as a reward for service in the royal admin-istration. But others achieved only hum-ble positions in the church, and the careers of the great majority of those who studied at Oxford remain unknown.

RALPH EVANS and
ROSAMOND FAITH

of the prowess of their horses. The earl of Chester, in 1210, offered the king 'the two best and most beautiful chargers' he could find. Some may have spoken in jest: did the man who promised 'a beautiful war-horse such as there should not be a better in Wales' think of offering an elderly nag? If he did, he would have been well advised to think better of it, for the king had a keen eye for a horse. Such talk might well have been the signal for the king to retire to his private chamber to read: when in March 1208 he ran out of books at Windsor he sent to the monks of Reading to replenish his stocks, and lent them 'our book which is called Pliny' in return. Thence to bed, and in the morning, at least after 1209, he could wear his new dressing-gown. The king never lost his style; but his mornings became increasingly hard to bear.

One morning in 1213, according to a French chronicler, Philip Augustus woke up and exclaimed, 'Mon dieu, what is keeping me from conquering England?' It must have been early in the year, and it was a good question. England lay under an Interdict, its king excommunicate. Many of the northern baronage were openly in revolt, and Peter of Pontefract, 'a simple Yorkshireman', had prophesied that before the regnal year ended on Ascension Day (23 May) the king would be dead. Prince Louis, the son of Philip Augustus, was set to invade, and had been given strict instructions that even if he became king of England the barons of England should owe liege homage not to him but to his father. This was the year, as remembered by a knight from Northamptonshire, looking back in the 1240s, in which John assembled

69 The Battle of Sandwich, 1217. Cambridge, Corpus Christi College MS 16, fo. 52r, c.1240s. Drawing by Matthew Paris accompanying his autograph text of the *Chronica Majora*
The bishops on the left stand ready to absolve 'those who shall die for the liberation of England', but it is the French who are being slaughtered, including (FAR RIGHT) their leader Eustace the monk.

the men of England on Barham Down in Kent to resist the French. In this situation word arrived of the terms on which the pope would lift the Interdict. They were sensational. The kingdoms of England and Ireland were to be resigned to God and the Roman church, to be held in fief of the pope. The king was to pay 1000 marks a year in recognition of this new relationship. John had no choice but to accept, for the alternative was excommunication, a suicidal risk for any king whose land lay under threat of invasion.

The Great Charter

This was on 15 May 1213. Within a week the barons wrote to the French king to tell him to stay away, and that advice was underlined when the French fleet was destroyed at Damme. Langton returned the following month, but it was a full year before the Interdict was lifted, on 2 July 1214. For the English, 1214 was the year of the relaxation of the Interdict. For the French, and long remembered, it was the year of the Battle of Bouvines. John and his allies, chief among them his nephew Otto, the German emperor, had sought to attack the French on two fronts. John led a force to Poitou. This took the attention of a part of the French army, but was otherwise unsuccessful. It was the northern campaign that was decisive. At Bouvines, on the borders between France and the Empire, John's allies, with his own contingent led by the earl of Salisbury, met the French under Philip Augustus. Two large armies, with at least 5000 and perhaps up to 7500 on each side, fought a set-piece battle, and the French

68 Men playing chess. London, British Library Add. MS 62925, fo. 78v, c.1260
From the Rutland Psalter, the earliest of the richly illuminated psalters of the late 13th and early 14th centuries, their secular drawings a foil to the sacred text.

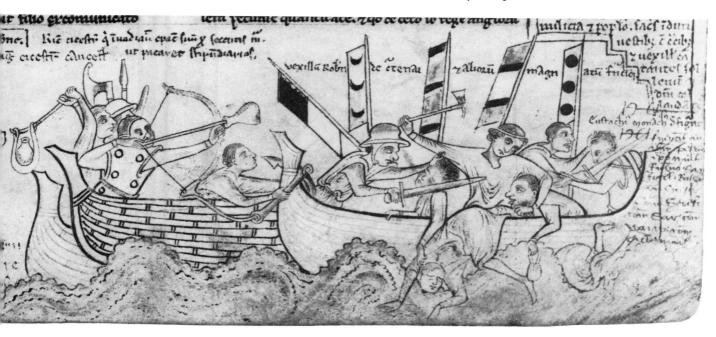

carried the day, 27 July 1214. From here it was to prove only a short road to the issue of Magna Carta at Runnymede.

In order to raise an army for his continental campaign, at a time when the settlement with the church was still being negotiated, the king had needed to promise general reform. The archbishop when he returned considered that the country was still convalescent, its peace threatened by a group among the baronage who were prepared to resort to arms. He had frequent discussions with the baronial leaders, urging them not to fight but to find a form of settlement. Kings at their coronation swore to follow good laws, and to protect the rights of every man. Such general promises were no longer sufficient; distrust of the king went too far, and extended too deep. The barons had particular grievances, and required specific remedies. There had been one past precedent for specific concessions to the baronage, and that was in the coronation charter of Henry I. This now became the starting-point of baronial demands, from at least as early as Christmas 1214. From not long thereafter must date 'the unknown charter'. The title is a typical conceit of J. H. Round, who 'found' the document in a series of transcripts from the French archives made for the Record Commissioners early in the nineteenth century. Though it lacks a precise date, it clearly marks an early stage in discussions, after it had become clear that a charter would be issued. The key to an understanding of the document lies in a phrase which comes half way through, after a text of Henry I's charter. 'This is the charter', it says, 'by which the barons sought their liberties, and that which follows King John concedes.' It then lists twelve concessions. This is an important list for it shows, more clearly than the final charter, which in trying to be comprehensive loses a little of its impact, the main issues on which the English baronage required satisfaction.

'King John concedes', according to this early draft, 'that no man shall be taken without judgement, and that he will not accept anything for justice, or deal unjustly.' In Magna Carta these sentiments would be expanded to provide for 'judgement by peers or by the law of the land', with the further promise, 'to no one will we sell, to no one will we deny or delay right or justice'. At the French court, at the papal court, and now reiterated by his own men, John could not escape reference to the rule of law. Much of English law, however, was customary law, and in some important areas of the crown's operations custom did not apply at all. It became important that custom be defined in certain areas of feudal obligation. The draft referred to 'the current relief', and Magna Carta was to specify this as £5 for a knight's fee and £100 for a barony or an earldom. When an heir was below age he could be placed in the custody of the men of the fee, and any debts owed to the Jews would be put in respite until he came of age, when he would resume his land without payment. Women recently widowed would control their husband's disposable income, with the help of other relations, who were always to be consulted in any marriages, so that the women should not be disparaged. In matters of military service the reformers also sought to define custom. The draft said that military service should not be owed outside Normandy and Brittany. This had long been a debating-point if not always a sticking-point for the

barons; there were considerable difficulties, and Magna Carta was to duck the issue by saying that no man should be forced to perform more than the service due. Finally, and most important, three clauses out of this short-list of twelve dealt with the forest. They sought to define the limits of proper custom. Lands put under forest law ('afforested') since 1154, and so in practice since 1135, were no longer to be subject to that law. And where it did remain its power was to be circumscribed, 'no man was to lose life or limb for the forest'. The forest proved too much for those who drafted Magna Carta: it merely provided that local knights should investigate customs, and it was not until 1217 that a separate charter was issued, the Charter of the Forest.

The forest was only one of the points discussed by the king and his agents and by the barons in the first half of the year 1215. In that time a much more lengthy document was put together. It became more lengthy for the same reason that it was necessary in the first place, because of men's distrust of the king. How could they be sure that the king, volatile, capricious, devious in their view to the point of dishonesty, would keep his word? They did their best to work out what they understood to be custom, and the much more difficult task of putting into words what they understood by 'good lordship'; but what they needed was a change of heart. They tried to legislate for this and, inevitably, they failed. At one stage in what must have seemed a long summer there appeared a document known as 'the articles of the barons'. This was much longer than 'the unknown charter', and was very close to the final document. It foresaw a charter issued by the king with, issued separately, two documents that would offer security that the king's promises would be kept, and sanctions if they were not. The clergy were to stand ready with bell, book and candle, while the barons offered a highly distinctive version of the constraints offered by feudal custom. In the event the clergy, not surprisingly fearful of the pope's reaction to such a move, declined to subscribe. The barons

70 King John (died 1216). c.1225-30. Purbeck marble. Worcester Cathedral
Alongside and supporting the king appear the figures of St Dunstan and St Oswald.

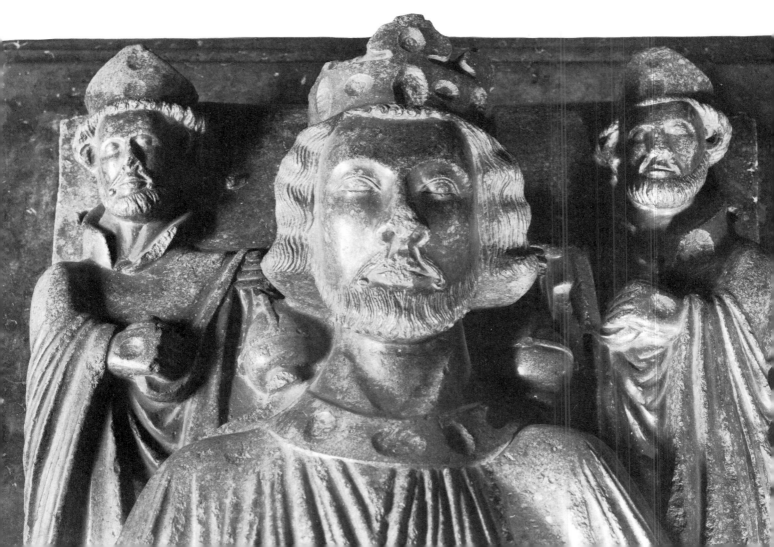

were left on their own, and they appended to the charter a long rambling disquisition, which is rather flattered by its traditional title, 'the security clause'. By this, twenty-five barons were to be chosen, 'who with all their might are to observe, maintain and cause to be observed the peace and liberties which we have granted'. It is tempting to call them a committee, but in the language of the day they are better described as a commune, a sworn association whose powers were recognised by the king. At the head of 'the Twenty-Five' stood Robert fitz Walter, one of the most recalcitrant of the king's enemies, who now took the title 'marshall of the army of God'.

The 'security clause' of Magna Carta makes it transparent that the document was only extracted from John by force. An influential group of the barons had come armed to London on Epiphany Day, 6 January 1215, demanding that the king make provision for reform. They were given a safe conduct to meet again at Northampton on 26 April. The interval was to allow for further discussions, and to allow each party to make its case in Rome. The barons got no encouragement there: they were urged to submit their case respectfully to the judgement of the king's court. This drove them a step closer to rebellion, and when the negotiations at Northampton failed, they did break with King John, renouncing their homage on 5 May. This was the beginning of civil war. The king was quite within his rights on 12 May in ordering the confiscation of the estates of the rebels. The rebels in turn were now legitimately in arms, and would use those arms to advance their cause. They almost immediately won a crucial and bloodless victory. The Londoners admitted them on 17 May, and thereafter the rebels had the capital city as their base. The king's own nearest secure base to London was his castle at Windsor. These bases give Magna Carta its geographical context. The barons were given a safe-conduct to meet the king at Staines. Outside the village, now swollen with the rebel barons and their retinues, on the bank of the Thames, 'in the meadow of Staines' or Runnymede, the final discussions took place and the text of Magna Carta was agreed. The place of issue of this famous document is a further reminder of the distrust which animated the whole dispute. Runnymede is an open area, almost an island: it offered both parties protection against an ambush. Tents were set up by the river: discussions began on 10 June and were concluded on 19 June. Magna Carta represents the written confirmation of an oral agreement, made on 19 June 1215.

When Pope Innocent III heard about Magna Carta he was horrified. The royal ambassadors, sent speedily to him, did not need to read the whole text; it was enough to underline the security clause, and the implications for the pope's jurisdiction as well as the king's if the agreement held force. The pope wrote both to the king and to the barons, for the latter omitting any blessing and saying that what he most objected to was the way that they had gone about things (*propter modum*). Magna Carta was annulled. Word of this arrived back in England in late September, but much had changed in three months, and the pope's judgement did nothing to further the peace which he looked for. The Twenty-Five had a title which allowed them to set up their own administration in the shires which they controlled. In ten counties they placed their own sheriffs; these included the whole of the eastern seaboard from Northumberland down to Essex, and several adjacent counties including Northampton, which had at times under John become almost a second capital. Added to this was their control of London, 'the head of the crown as well as of the kingdom' said the justiciar, complaining of the Londoners' perjury in not releasing the city three months after the issue of Magna Carta as had been agreed. In London the Twenty-Five had an army; a roll call of the troops at their disposal there came to nearly 1200 knights, a substantial force. They found themselves faced with King John, a man in the prime of life, who considered himself released from any obligation to respect Magna Carta, and who had the full support of the papacy. The barons sought to break the deadlock by offering the crown to Prince Louis of France. Louis brought a further 1200 knights with him when he sailed in May 1216, and made for London. The situation for the English monarchy was serious indeed. The Twenty-Five granted the northern counties to the king of Scotland. The bishops were as divided as the lay estate; and the London pulpits were dominated by those opposed to the king. The deadlock might have continued for years, and the damage done been incalculable, had not King John died. He died as he had lived, at least according to the chroniclers. He lost some of his jewels in the Wash, and a surfeit of lampreys carried him to his grave.

The Minority of Henry III

King John's elder son Henry was nine years old when his father died on the night of 18 October 1216. A minority was a time of crisis for any estate, and for a kingdom rent by civil war the crisis threatened to be severe. Magna Carta had given some thought to testamentary dispositions, and great prominence to the protection of the heir under age. The executors were to be left free to carry out the will of the deceased, once they had settled his debts. The guardian of the heir had to preserve 'the houses, parks, preserves, fishponds, mills and other things pertaining to the lands'.

Rochester Castle

LIKE LONDON AND CANTERBURY, Rochester in 1066 was a Saxon cathedral city within Roman walls, at a river-crossing. Using the ancient defences, the Normans promptly gave all three towns a new-style castle. About a thousand of these compact fortifications, mostly of earthwork and timber (e.g. 'motte and bailey') arose within the decade to enable the new ruling-class, thinly scattered throughout England, to live securely. Roman 'Watling Street' linked London speedily with Normandy via Dover, and so the crossing of the wide, tidal estuary of the Medway had to be guarded. A fortified bridge-head here, in addition, barred the upstream passage to hostile ships. During the early post-Conquest years surveillance of the Rochester townspeople mattered too, so the castle (as at London and Canterbury) was placed prudently on the edge of the town, with free communication both to the river and to the open country. Bishop Odo of Bayeux received this crucial trust along with the county. Although half-brother to the Conqueror his restless ambition gave trouble even before William's death.

The exact date, form and location of the first castle are all uncertain: it is highly probable that it was founded soon after the battle of Hastings and built of earthen ramparts with stockading and turrets of wood, but whether it was outside the Roman wall on Boley Hill or (as now) wholly within the old town, remains unclear. Very possibly it extended on both sides of the line. The cost of stone re-fortification often required enclosures to be reduced. Probably from the outset a rampart on the east side facing the cathedral cut off a roughly oval area running down to the bridge approach. Domination of the bridge was the castle's main purpose, so the two had to be close. Nevertheless, some effective defence (before the keep was built c.1127) against the rising ground of the riverside spur southwards might be expected – and may remain to be discovered.

1 The seal of the city of Rochester c. 1300. London, Society of Antiquaries
On waves, which stand for the river Medway, appears the castle, with the banner-flag of England over the entrance to the keep.

Thus sited, the castle compelled a force advancing on London, or up the Medway, inland to Maidstone and Tonbridge, first to blockade (besiege, properly speaking) or overwhelm it by risky but swift 'assault' – in the earthwork era using fire, grappling hooks and ladders, seconded later by rams, stone-throwing artillery ('engines') and deadly mine tunnels, dug below the foundations. Provided it was sufficiently manned and munitioned (a costly exercise reserved for rare emergencies) such a fortress might frustrate invasion by attrition and delay. The time won might be short. No castle was impregnable and rapid relief was usually needed to avert negotiated surrender or outright capture.

The importance of its position kept Rochester in the front-line of national crisis; major incidents include Odo's

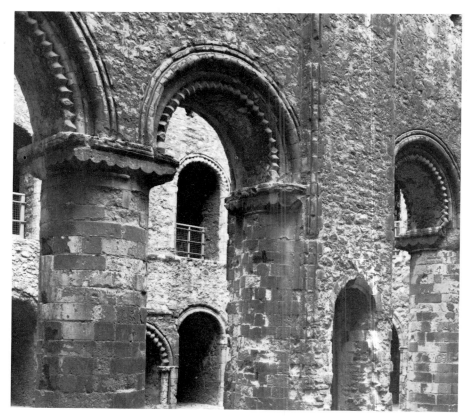

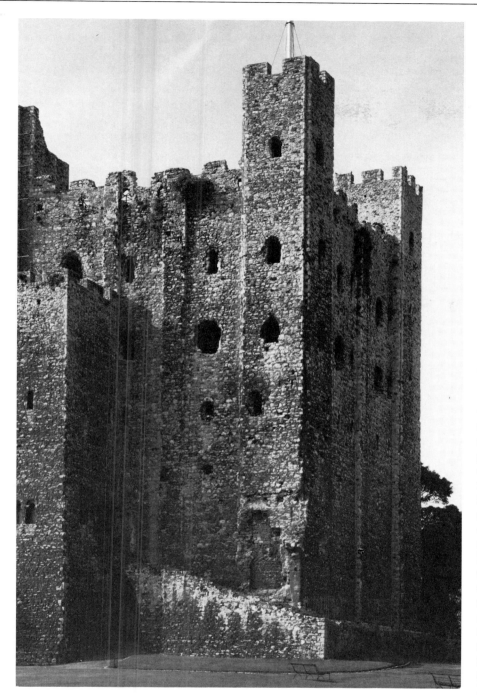

the bailey but had to withdraw before they could break into the keep. During its active life of four centuries the castle was reconstructed repeatedly: Bishop Gundulf cannily spent £60 (in discharge of a debt to the king of £100) on making good in durable masonry the ravages of 1088; in *c.*1127 the building of the keep transformed it; in 1226–7 Henry III repaired and modernized it again; and in 1367–83 the castle was re-equipped to meet the threat of a French attack.

But castles were also residences – Rochester's magnificent 'great tower' or 'donjon' was nothing less than a palace. A shrewd deal enabled the great building archbishop of Canterbury, William of Corbeil, 'to make for himself and his successors such a fortification or tower as they shall desire'. There were then very few, mostly squat 'hall-keeps'. Rochester is a 'tower keep', with its lord's Chamber over the Hall; probably the finest in Britain. Gervase of Canterbury rightly called it 'noble' or 'out of the ordinary'. Placed commandingly at the top end of the bailey its tapering bulk rises 113 feet to the main battlements, 125 feet over the turrets, forming a square of 70 feet at ground level, plus the annexe. Before artillery (mangonel and trebuchet) was much advanced in northern Europe, fortress and palace could be combined in a great fireproof tower, too lofty for ladders ('escalade') to attempt, with vulnerable roofs shielded and defence provided by an over-hanging timber platform at the summit ('hourding'). The first-floor entrance (inherited from timber prototypes) made for ceremony and precluded surprise. Within are store-chambers and rooms ranging from mere cupboards up to the elegant Great Hall, which occupies the whole third and fourth storeys. Two spacious spiral ('vice') stairs linked all levels, there are numerous fireplaces and fine windows (decorated with chevron carving), a large chapel and numerous latrines. Today's gaunt and floorless ruin still shows something of its departed glory.

C. L. H. COULSON

3 (ABOVE) The keep from the north-west
This view shows the long approach ramp, outer guard-turret, forebuilding entrance to the vestibule. In the base of the parapet can be seen joist holes for the hourding-platform to defend the wall-foot.

2 Chevron-decorated arcade in the cross-wall linking up the halves of the Great Hall
For the floor-joist holes, fireplace and remains of a stone-work partition in the furthest archway see the Frontispiece.

revolt in 1088, when William Rufus's army, composed of 'every honest man, whether English or French', took the city and castle, using two fortified camps ('siege-castles'); King John's capture of the rebel lords (1215) and destruction by a mine tunnel (the props were fired by the fat of forty pig carcasses) of the whole south-east angle of the keep; and an episode in 1264, when the rebel barons took

John's heir was protected by these assumptions. The king had named as his executors five churchmen headed by the papal legate and eight laymen headed by three earls (William earl Marshall, Ranulf earl of Chester and William Ferrers earl of Derby). The executors became the chief councillors of the minority. Their immediate task was Henry's coronation. This could not take place at Westminster, for the rebels held London and eastern England. It could not be performed by the archbishop of Canterbury, for he had been suspended by the pope for his support of Magna Carta, and had gone to Rome to appeal against this sentence. It was therefore at Gloucester, the seat in earlier days of one of the three annual crown-wearings, that Henry was crowned on 28 October 1216 by Peter des Roches, bishop of Winchester.

The coronation ceremony over, the men about the new king could make their dispositions. The government needed a head and the kingdom needed a leader. There was some discussion as to who this should be. 'I see only the Earl Marshall or the earl of Chester', said Alan Basset, surveying a crowded room. Both men had the weight, but it was the Earl Marshall who had the prestige: 'you are so fine a knight, so upright, so respected, so loved and so wise', said the earl of Chester and withdrew his claim. The source here is the *Life of the Marshall*, which is hardly likely to be critical, but there can be no doubt that these sentiments were widely shared. Nor is there reason to doubt its statement that the Earl Marshall thought long before accepting the regency. 'The boy has no money and I am an old man', he is reported as saying. This was no more than the truth. Accept he did, however, and was offered a plenary indulgence for his sins by the papal legate. William Earl Marshall was regent for only two and a half years, until his death on 14 May 1219, but in that time he settled the civil war and secured Henry's kingship.

The regent and his colleagues had the confidence to reissue Magna Carta on 12 November 1216, less than a month after the death of King John, whose government it had so criticised. This was a revised text. The council stripped away those clauses which attacked royal prerogatives, notably the security clause; these were weighty and difficult matters which needed further discussion, and with this phrase they brushed much of the politics of John's reign to one side. When they spoke of further discussions it must have been the rebels they had in mind. More concessions were possible: the file was not yet closed. The new text of Magna Carta bore the seals of the regent and the papal legate, and it became a weapon in their hands. It was aimed not just at the rebels but at Louis of France. It is no accident that the only copies of Magna Carta in the French national archives are of the 1216 reissue. These

were complimentary copies, and with the Earl Marshall's compliments came the assertion that the divisions in the kingdom of England, and the displeasure of the papacy, which offered the French prince his title to invade, were now in the past. It had some effect: for fear of excommunication the French king had to be wary in the support offered to his son. But it remained an assertion. The unity of the kingdom would have to be fought for.

King John appointed his executors in the midst of a civil war. A capacity to fight and a complete loyalty were qualities that he looked for. William Earl Marshall and the earl of Chester, whose military experience stretched back to Henry II's reign, had secure control of the west of England and the marches towards Wales. In the east of England the council also had strong bases. Hubert de Burgh the justiciar held the key fortress at Dover; this never fell into French hands. Fawkes de Breauté held the counties of Bedfordshire-Buckinghamshire, Huntingdonshire-Cambridgeshire, Northamptonshire and Oxfordshire, from the royal castles in each of these shires. At Nottingham on the Trent, the point at which the kingdom might divide, Philip Marc retained the castle, though he had been one of the Poitevins named in Magna Carta to be 'dismissed completely from their offices'. At Lincoln the castle which dominated the other main route north was also held for the young Henry III. It was in an attempt to take Lincoln that Louis's cause was lost. This was on 20 May 1217. The engagement was known as the 'fair' of Lincoln, for in the narrow streets of the city the knights of each side rode at each other as though in a tournament. The Earl Marshall was about seventy by then, but was in the thick of things, to the last the very model of chivalry: 'he looked the finest of them all and as light as a bird'. At Kingston on the Thames in September 1217 the two parties came to terms. Louis departed with honour, and was promised 10,000 marks as compensation for his trouble. The lands of the rebels in England were secured; there were no dispossessions. Magna Carta was reissued for a second time and was now joined by the Charter of the Forest on 6 November 1217.

The second reissue of Magna Carta marks the end of the civil war in England, and the beginning of the process of reconstruction. The exchequer clerks returned to their rolls, and started to salvage what they could from the year which followed Magna Carta, which to them was simply the seventeenth year of King John. The issue of the Charter of the Forest was only possible after local enquiries into forest bounds and customs. It was important to the new government that local government be supervised and the links with the centre maintained. For this reason a general eyre was sent out in November 1217. England was divided

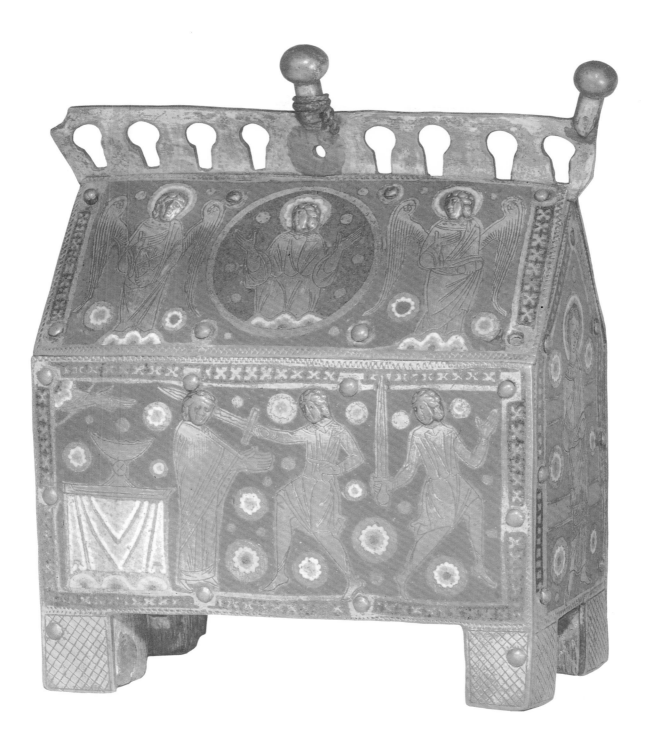

71 Casket for relics of St Thomas Becket. 13th century. Enamelled
copper work, with plaques pinned to a wooden core. Limoges. London,
British Museum
A surviving example of a very popular artefact from the Becket industry:
45 such caskets survive, the majority from the 13th century.

72 St Christopher carries the infant Christ. London, British Library, Royal MS 2.A.XXII, fo. 220v, the Westminster Psalter, mid-13th century drawing added to a text of c.1200

into eight circuits, and groups of royal justices visited each, most of them completing their work by the following summer. They visited some of the most distant counties in the depths of winter. Some counties will have been more popular than others. 'I beg you, my lord', wrote one clerk to his master in 1226, 'do not make me go on eyre in Cumberland. The climate there is bad, and it disagrees with my digestion.' The master here is Martin of Pattishall. It is his rolls that predominate in the survivals from the 1218-22 and 1226-9 eyres. They were passed on to his successors William Raleigh and Henry of Bracton. The great legal textbook, *On the Laws and Customs of England*, has always borne Bracton's name, but the cases quoted as exemplars in it mostly date from before 1236, the years when Pattishall and Raleigh headed the judiciary. The development of the common law strengthened the integrity of the kingdom of England.

The threats to the integrity of England would come chiefly, and paradoxically so it seemed to them, from the great men, who had won the civil war, and who must have seen themselves, as did the Earl Marshall, as carrying the young king on their shoulders like so many St Christophers, an image prominent in every English church. The case of Ranulf earl of Chester may serve as an example of the long-term problems which the power of these men threatened. In April 1216, during the civil war, Ranulf was given charge of the honour of Lancaster, and of the joint county of Shropshire-Staffordshire, where he was to be obeyed 'as earl, as sheriff and as royal official'. These were counties adjacent to Ranulf's own county of Cheshire. It was around the same time that he issued, osten-

sibly at the request of his followers, the Magna Carta of Cheshire. This stated the liberties of Cheshire as Magna Carta did those of England. It shows Cheshire still to be a society organised for war. The barons of Cheshire served the earl in person, and had to bring when summoned the full amount of their knight-service; similarly 'their knights and freemen shall have coats of mail and hauberks and shall defend their fees in person'. Local custom is here very strong, and the Magna Carta of Cheshire can easily be read as intended to strengthen that custom. This strengthening can only have been at the expense of royal authority. In the 1190s a monk of Chester abbey wrote: 'because of the indulgence of kings and the high dignity of its earls, the people are accustomed to look more to the sword of their prince than to the crown of the kingdom'. Twenty years later the civil war threatened to give substance to this literary conceit. And not just in Cheshire but in the counties adjacent to it. Earl Ranulf was extending both the range and the theory of his government.

Henry was re-crowned in Westminster Abbey in May 1220. The laymen there present promised on oath that they would surrender all the royal castles which they held, when it should please the king. Some surrenders were enforced straightaway, but the great men, including the earl of Chester, hung on. The show-down would come when the king came of age. This Henry declared himself to be in January 1223, and a papal confirmation of this opinion followed in May. Only then were the final and crucial resumptions of royal castles carried out. At Christmas of that year, the earl of Chester surrendered his royal castles. He was given a promise that no exceptions would be made, and no

exceptions were made. The final chapter in the story was the carefully orchestrated ruin of Fawkes de Breauté, the loyal but rapacious guardian of six midland shires. A special judicial commission sent to investigate his activities found sixteen cases of disseisin to be proved against him. Its work exhausted the patience of Fawkes's brother, who promptly laid hands on the offending justice, Henry of Braybrooke, and kept him captive in Bedford castle. Henry, like Martin of Pattishall, was one of the Northamptonshire mafia who ran the judicial system of the day, though Fawkes later sought to put him in his place by describing him as 'a certain knightly justice of a type called itinerant'. Fawkes's defeat was their victory also. Bedford castle was invested by a royal army. The garrison lasted out for eight weeks, and inflicted great damage on the attackers. When the castle surrendered the majority of the garrison were hanged. 'A monstrous crime against the law of arms', said Fawkes; but few wept for them. His own life was spared, but he was treated as a common criminal. His good and chattels were sold, and the profits paid in to the Exchequer. He was found to have 11,000 marks deposited in the London Temple, the medieval equivalent of a numbered Swiss bank account.

While Fawkes de Breauté had been amassing this great treasure, the king's government had been living from hand to mouth. The civil war was in part to blame, but far more significant was the permanent legacy of Magna Carta. This had cut down the opportunity to raise revenue by feudal means; the king, for example, could only charge the specified £100 as 'relief' on entrance to a barony. It had said, in clause 12, that scutages (fines for military

73 (LEFT) Henry III carries the relic of the Holy Blood from St Paul's Cathedral to Westminster Abbey, St Edward's day (13 October) 1247, Matthew Paris autograph. Cambridge, Corpus Christi College MS 16, fo. 215r.

74 The oppression of the poor. Matthew Paris autograph. Cambridge, Corpus Christi College, MS 16, fo. 44v
The text relates to the last months of the reign of King John, and the oppressor wears the livery of William Marshall (Pl. 63), but as an image of the power of lordship in the countryside it could serve for any period of the middle ages.

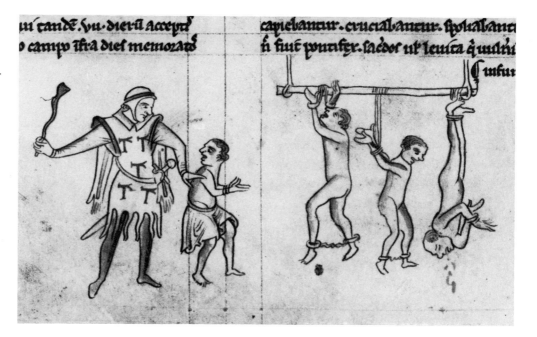

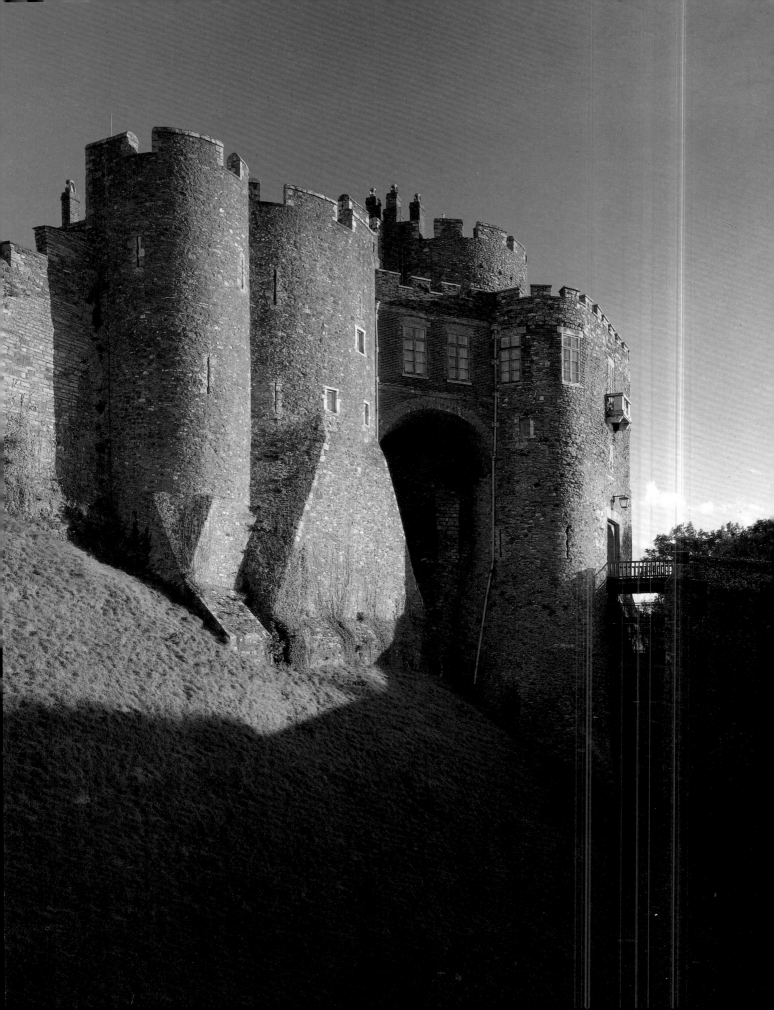

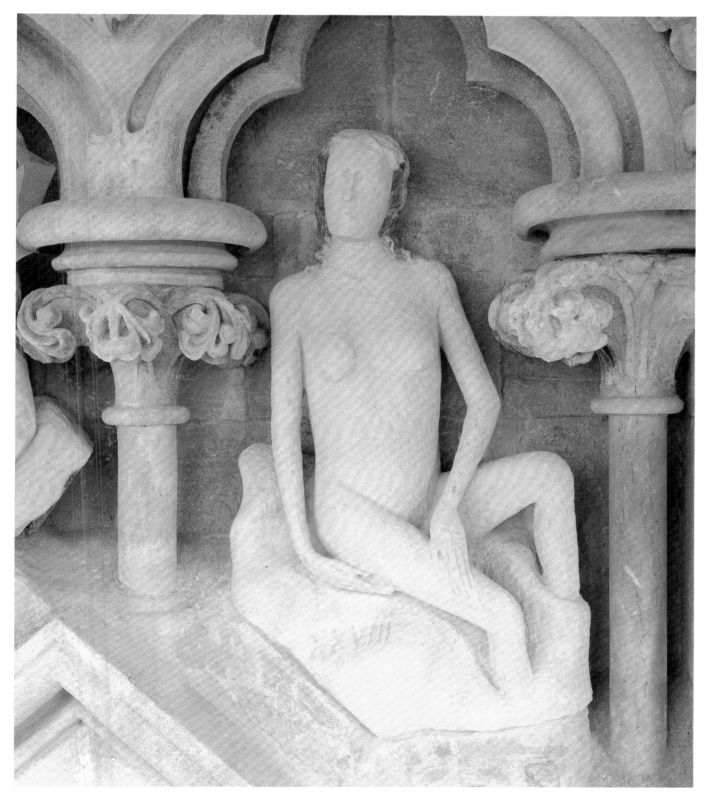

75 Dover Castle, Kent, the gatehouse. 1220s
Dover Castle, 'the key to England' (as Matthew Paris described it, see
Pl. 84), had almost fallen to the French in 1216. A new gatehouse, the
Constable's Gate, was built to replace the old. The five towers thrust
forward both as a challenge to any attacker, and to allow the defenders
the widest possible range of fire.

76 The Resurrection. c.1230–c.1250. Wells
Cathedral, Somerset
The west front of Wells has the most extensive
sculptural decoration of any English cathedral.
Here, benefiting from a holy life and from
recent restoration, is one of the Elect.

service) and aids (for the costs of warfare and the like) required 'common counsel', which the barons translated as their consent. This clause was dropped in all the reissues, but the idea lived on. In 1220 the council levied a feudal tax, a carucage or tax on ploughed land. Many of the magnates, including some of the royal council, refused to pay, saying that they had not been consulted. The earl of Chester's officials on his manors throughout England resisted the collectors, and where they served as collectors themselves, as in Shropshire and Staffordshire, no tax was levied at all. A reason had to be given for taxation, and consent sought. The 1220 tax was because of 'the most urgent pressure of our debts and for the safeguard of our land of Poitou'. In 1225 it was the protection of Gascony that was adduced, when a fifteenth of moveable wealth was granted. This grant is noteworthy because it was made specifically 'in return for the concession and grant of these liberties', namely a further reissue of Magna Carta. The 1225 reissue was the one that became definitive, and which would in due course, though at a time when its provisions were largely outdated, become statute law.

In the 1225 reissue of Magna Carta, Henry III described himself as 'king of the English, duke of Normandy, count of Anjou, and duke of Aquitaine'. To only the first and the last of these titles had he any secure claim, for Normandy and Anjou had been lost by his father, and the

barons of these provinces had transferred their allegiance to the Capetian kings of France. Henry suffered a further loss during his minority, when the count of La Marche, who had married John's widow, transferred his allegiance to the Capetians also. The count of La Marche was the chief of the barons of Poitou, the rich region centred on Poitiers, whose port of La Rochelle had boomed on the profits of the wine export trade to England. La Rochelle fell to the Capetians on 3 August 1224. Bordeaux was then attacked, and had it fallen Gascony would have gone with it. It held out, but there was no question that the protection of Aquitaine, given as the reason for the grant of the fifteenth, was very necessary. Henry entrusted the task to his younger brother, then only sixteen, investing him as earl of Cornwall and count of Poitou. Richard and his advisers were able to do no more than stabilise a situation in which all the initiative lay with the French. In 1227 Richard concluded a truce with Blanche of Castille, regent for her son Louis IX (king of France 1225—70; canonised 1297). The truce was to last for two years.

When the truce with France expired in 1229 Henry sent envoys to discuss the terms for a permanent peace settlement. The envoys were to make a series of demands, it being clearly recognised from the outset (for their briefing document survives) that most of them would be refused. The first demand was for the return of Normandy, Anjou

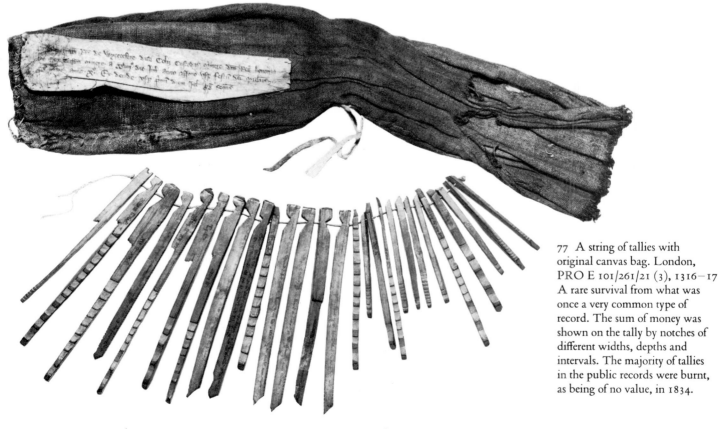

77 A string of tallies with original canvas bag. London, PRO E 101/261/21 (3), 1316—17 A rare survival from what was once a very common type of record. The sum of money was shown on the tally by notches of different widths, depths and intervals. The majority of tallies in the public records were burnt, as being of no value, in 1834.

78 Man and woman kissing. *c.*1255–80. Lincoln Cathedral, north choir aisle.
One of the roof bosses from the Angel Choir (Pl. 105). This seems a mature relationship, and quite unaffected by the figure below the couple, who may represent the Devil.

and Poitou; but this was just for the record. John's closest advisers, led by Hubert de Burgh, saw no realistic prospect of the return of Normandy. This they would let go in return for a secure hold on Poitou. Henry's enthusiasm for the recovery of Poitou is understandable, for three of his grand-parents had been Poitevin; but few of Henry's subjects shared this perspective. Men such as the earl of Chester had great hereditary claims in Normandy, and they accom-panied Henry when he went to war in France in 1230, hoping to have the chance to fight for them. Henry took his coronation regalia with him, and great events were in prospect. He landed in Brittany, where the count offered him support, but instead of going east into Normandy he went south to Poitou. Most of his followers had their hearts elsewhere; small wonder that, according to Matthew Paris, they behaved as though they were at a Christmas party. The one success of the expedition was the recapture of the islands off the coast of Poitou. These were not negligible prizes. The chief of them, the Isle of Oléron, was the Gibraltar of its day. It would shortly become a great terminus of European trade, as the salt deposits on the coast it protected attracted 'Bay fleets' from the Baltic. In taking Oléron Henry thus kept open the sea route to Gascony, and secured revenues of £200 a year. But this was the sole return on an expedition that cost at least £20,000.

In the years of Henry III's extended minority, his government had to beg or scrape for money, and in the great corporations with which it had regularly to deal a curious impression was formed. What it was may be seen by looking at the archives of one of those corporations, the diocese of Lincoln. Lincoln, like many dioceses around this time, made a cartulary, a book of its charters, in which the royal charters were given pride of place; these were the most important of its muniments, its fortifications against the outside world. The tone of royal pronounce-ments was to change over time, and become a good deal more conciliatory. In the Lincoln archive, which of course the clergy selected, the change is very sudden, and comes not in the minority but after the Interdict was relaxed in 1213. Then there were 'the Charters', valuable concessions indeed: Lincoln is unique in retaining to this day a com-plete set of 'first editions', Magna Carta 1215, the Charter of the Forest 1217, and those documents as revised and reissued in their final form in 1225. Dwarfed in scale by these pronouncements, but no different in their tone, were a series of letters in which the bishop was assured that grants of taxation would not be drawn into precedent, that the king's grants of fairs would not prejudice the bishop's own, and that when the bishop died royal agents would keep their hands off his lands until the end of the financial year. The grants relating to taxation are particularly important. They date from 1224, 1226 and 1231. They cover a land-tax, and a grant as a proportion of moveable wealth, and a scutage: the full range of taxation available to an English king, each grant made 'of grace, on this occasion only'. It is surely no coincidence that the two best-known critics of Henry III in the 1230s and 1240s inherited material of this kind – Bishop Grosseteste this very archive, and Matthew Paris one way inferior at St Albans. For Mat-thew Paris, as Richard Vaughan has noted in his bio-graphy, 'all forms of taxation are violently opposed, and invariably regarded as mere royal extortion'. There is more to this than simply a reluctance to pay tax. The whole moral basis of taxation was being undermined.

Henry III and Family Policy

A number of important marriages in the later 1230s mark out the policies of the next twenty years. Henry's ambition continued to focus on the continent, but now took a dif-ferent route, through the lands which lay to the east of the Capetian demesnes, their frontier towards the Empire. This was the road to Rome, well-known to churchmen and well-known to merchants, but now to become the main thoroughfare of Henry III's ambition. The most important marriage was the king's own, contracted on 20 January 1236, to Eleanor of Provence. The new queen was the second daughter of Raymond count of Provence

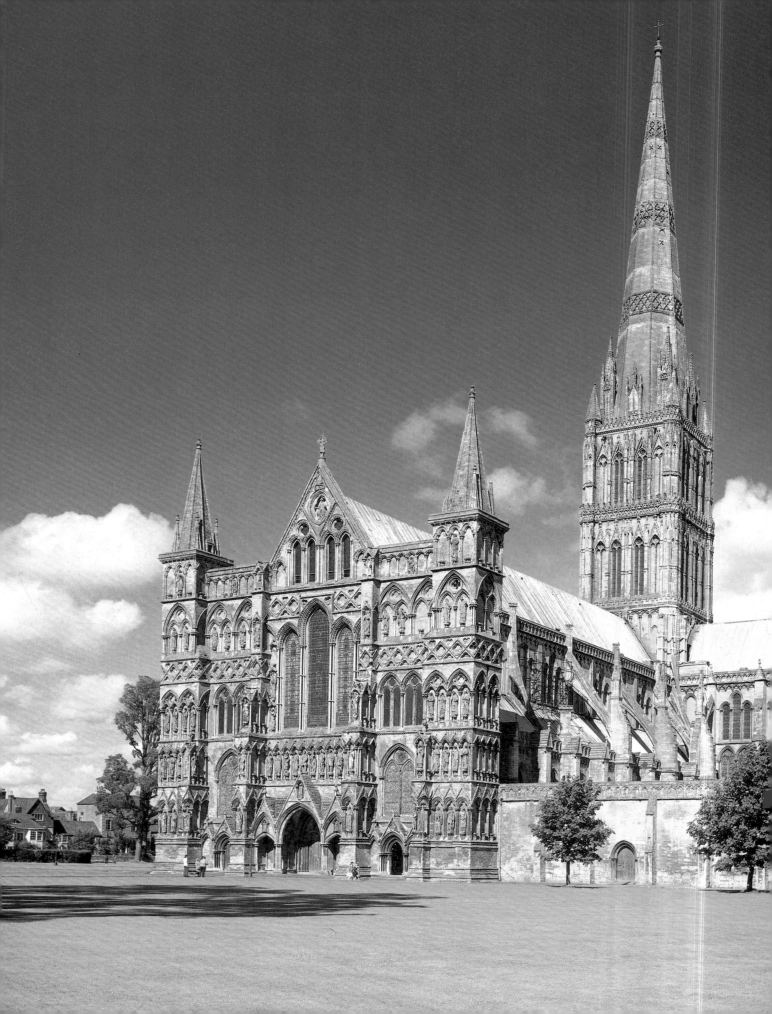

79 Salisbury Cathedral, from
the south-west. *c.*1220—*c.*1260;
the tower and spire, which rise
to 400 ft, are an addition of the
early 14th century
The exceptional unity of style
here is because this was a new
cathedral built on a virgin site,
after the move from Old Sarum
(see Pl. 20).

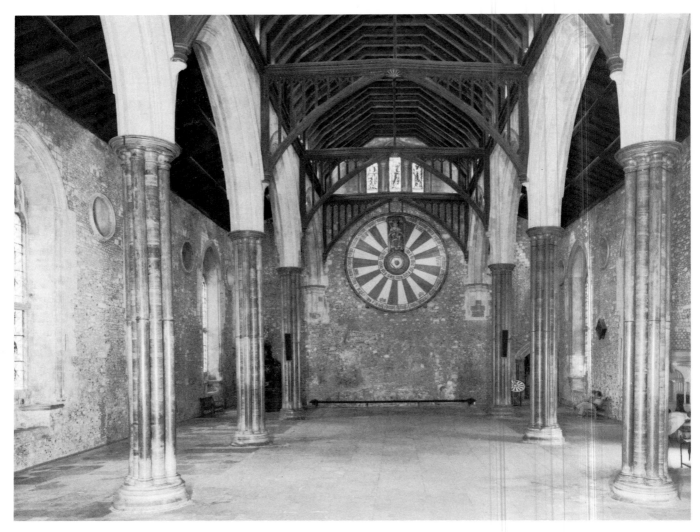

80 Winchester Castle, the great hall. 1222—35
This may represent the 13th century as Castle Hedingham (Pl. 36) does the 12th, and give an impression of the standards of secular buildings of the day. The round table on the far wall is from the late 13th century, and shows Edwards 1's interest in Arthurian romance.

and Beatrice of Savoy. Her elder sister had recently married the French king, Louis IX; so that now the kings of France and England became brothers-in-law. The marriage was a happy one, and after a delay which worried Matthew Paris and doubtless the couple themselves it proved fertile. Nine children are known of, and while death took away over half of them in childhood and infancy it left 'the heir and the spare'. The heir was Edward, named after his father's patron saint, born during the night of 17 June 1239; the 'spare' was Edmund, later earl of Lancaster, born 16 January 1245. The descendants of these two brothers were to dominate English politics for over two centuries.

Shortly before the king's own marriage, his sister Isabella had been married to the German Emperor, Frederick II. This was a splendid match, but it came at a high price: 30,000 marks was promised, to be raised within two years. This put great pressure on Henry's finances. He was given an aid to be taken at the rate of two marks per knight's fee, but there were no more than 6000 of these in England, so this grant is unlikely to have given him more than one-third of the sum promised. The balance had to be raised from sources not touched by the constraints of Magna Carta, from the king's own manors and from his rights over the towns and the Jewish communities that lived within them. Henry had capable civil servants in these years, and they moved his finances on to a more secure footing. Discussions at the parliament held in January 1237 reveal the magnates fears. The king, in resuming his own lands, was taking back some that had been granted out by charter. He had to back down here, and confirm the Charters once again in token of his good faith. The magnates, as reported by Matthew Paris, were reluctant to grant monies to a king who was 'easily led, and had never repelled or even frightened any one of the enemies of his kingdom'. The king was making slaves of his subjects, and the wealth of the kingdom was being

taken out by foreigners. A grant was made, however, of a thirtieth part of moveable wealth. It could have been the beginning of a war-chest for a further campaign in France. One successful campaign might have altered his subject's perceptions of the king and their prejudices about taxation.

By his marriage in 1236 Henry III acquired not only a wife but seven uncles, the brothers of Beatrice of Savoy. William of Savoy served as a go-between in the marriage negotiations, and in a quite remarkable development established himself in a similar position in England, becoming the senior of the royal councillors within a few months of his arrival in England. A second uncle, Peter of Savoy, was granted the honour of Richmond in 1240; a third, Boniface, became archbishop of Canterbury in 1241. It was over a hundred years since the last appointment of a foreign-born archbishop. A fourth uncle, Peter, had become count of Flanders in 1237. It was he who became the focus of Henry III's foreign policy over the next few years, and in 1239 he was given the traditional money-fief of 500 marks a year. If Henry could obtain the support of the German emperor also, there was in prospect an attack on Normandy which the English baronage would have been happy to finance. This prospect dissolved, as did so many of Henry's plans. He was forced to return to Gascony, and from there attempt the recovery of Poitou. The meeting of the magnates early in 1242 refused money for this purpose. Henry III did his best to work on possible waverers – 'on the morrow he summoned them one by one to his private chamber, like a priest summoning penitents to confession' – but to no avail. The Gascon expedition of 1242–3 cost the king around £80,000, which he raised from his own resources, but brought him no profit. More than once he could have been captured by the king of France, his brother-in-law, but that would only have complicated matters. The French king gained his main objective in securing the submission of the barons of Poitou, led by the count of La Marche. The Angevins had now lost Poitou. After a decent interval, and during the next domestic crisis, this would be publicly recognised.

Henry returned to England from Gascony in September 1243, and devoted himself to re-establishing his credit within England. One sign of this, at first sight a little surprising, was the setting-up of soup kitchens within the capital. In the year 1244 a total of 260,000 meals were

offered to the poor. With the beginnings of an organised system of poor relief came the continuance of lavish entertainment for those of higher rank. Much ceremonial was devoted to the marriage of Richard of Cornwall to Sanchia of Provence, further strengthening the ties with this house, for she was another daughter of the formidable and fecund Beatrice, who had come over for the marriage in November 1243 and evidently took charge of proceedings. The king gave Beatrice a gold eagle (the emblem of the house of Savoy) which cost over £100. All along the king was planning a more permanent focus for his kingship at Westminster Abbey, which in the twenty years after 1245 was almost completely rebuilt. This was to be a magnificent Gothic church in the latest style. It was to be built around a shrine to Edward the Confessor, the king's patron saint, whose remains were translated with great ceremony in 1269. Up to £5000 was spent on the shrine itself, and the king told Matthew Paris that it would cost over 100,000 marks. (If the king was thinking of the total building costs here, for both church and shrine, his estimate was not far wrong.) The new church was also to serve as a royal mausoleum; it was Henry's burial place, and that of most of his successors up to the eighteenth century. And before the king died it became the burial place of several of his young children. The best-known of these was Katherine, born on her saint's day in 1253, who died on 3 May 1257; 'she was deaf and dumb but the most beautiful child', and greatly mourned by her parents. After their death's, the remains of all these infants were placed in a single tomb in the new church.

In the nave of the new abbey church at Westminster there was one new feature, later to become common. This

81 Pilgrims at the shrine of Edward the Confessor. Cambridge University Library MS Ee.3.59, fo. 30r, c.1255–60, from Westminster
The volume contains a French life of the saint dedicated to Eleanor of Provence, wife of Henry III. In this illustration one of the pilgrims has almost disappeared from sight within a prayer niche.

82 The Crucifixion.
London, British Library,
Add. MS 44874, fo. 6r, mid-
13th century (The Evesham
Psalter)
A shaded line drawing. The
staring eyes of Mary and John
at the foot of the Cross help
focus attention on the suffering
of Christ.

83 Netley Abbey,
Hampshire. Mid-13th century
A daughter house of Beaulieu
Abbey, founded in the early
13th century. In this late
Cistercian foundation much
of the austerity of the 12th
century (as seen at Buildwas
Abbey, Pl. 46) has
disappeared.

was the carving on the wall arcades of a series of shields, bearing the arms of the king, the ruling families of Europe, and the great magnates of England. These shields represent the policy of the central years of Henry III's reign, for in the late 1240s and early 1250s it was to his extended family, and to a few favoured magnates, that the king's policy was directed. The shields were hardly in place, however, before the unity which they represented, and still represent, fell apart. This was in 1258, in circumstances for which a few individuals were singled out by the barons as respon-sible. These were the king's young half brothers, the Lusignans, Isabella's sons by the count of La Marche. They came to England in the late 1240s. Ten years later, those who had experienced their lordship were invited in the shire court to complain of their oppressions, and did so very readily. The jurors of Surrey reported as follows of Geoffrey de Lusignan and his bailiffs in 1258: they had leased a rabbit warren to the men of Byfleet for £5 a year, but for the next three years they had taken all the rabbits themselves; they had wasted the lands of a ward; they had

84 The road to Rome. Matthew Paris autograph. London, British Library, Royal MS 14.C.VII, fo. 2r, 1250s. From St Albans Abbey
Starting at London (BOTTOM LEFT) the road goes first to Rochester and Canterbury, thence to Dover, described as 'the entry and the key to the rich island of England'; then across the Channel, with its two boats, to (BOTTOM RIGHT) a choice of continental ports, Calais, Boulogne and Wissant; and thence into France. Each day's journey is marked out, as are the main buildings of interest to the discerning traveller.

85 (OPPOSITE) Censing Angel. c.1255. Westminster Abbey, south transept
The rebuilding of Westminster Abbey attracted the best craftsmen in England, and served as a reference point for craftsmen elsewhere (such as the Angel Choir at Lincoln, Pls. 78 and 105).

levied 40s. a year for common of pasture from the men of Effingham, which previously they had enjoyed for nothing; they had threatened to collect a tallage from the men of Walton until they paid a fine of thirteen marks to be left in peace. These offences look very like the routine manifestations of original sin in the English countryside.

It was a long way from the rabbit warrens of Byfleet in Surrey to Apulia on the southern tip of Italy. It is at the end of this road, an extension of the road to Rome, that the key to the crisis of 1258 may be found. Four ver-sions of a map of the road to Apulia via Rome survive, made by Matthew Paris in the early 1250s (Pl. 84). The heading on one of them will introduce the story. 'Earl Richard, brother of the king of England, was offered the crown of all this country [Apulia] in the time of Pope Innocent IV, in the year of grace 1253.' In fact the year was 1252. The popes viewed Sicily and southern Italy as a papal fief, theirs to give as they chose. They were anxious above all to avoid the traumas of the time of Frederick II (who died in 1250), who had succeeded in uniting Ger-many and Sicily in the same hands. A break was needed, and the brother of the king of England would do well

enough. Richard of Cornwall was not impressed. He told Matthew Paris, whom he knew well: 'You might as well say, "I will sell or give you the moon. Climb up and take it."' This sense of politics as the art of the possible was quite lacking in Henry III. The king of England had taken the cross in March 1250. The idea of the crusade still worked powerfully on the minds of the great men of Europe, but the popes were directing their enthusiasm in quite new directions. An attack on any of the pope's enemies could now be construed as a crusade. So could support for papal plans regarding 'the matter of Sicily'. When Richard of Cornwall declined, Henry III accepted the crown of Sicily on behalf of his second son, Edmund. The young man enjoyed dressing up in Apulian costume, and handed out the most splendid new titles to his friends.

The crusade would have offered Henry III a clear objec-tive, a chance of prestige, and at the very least some pleasant sight-seeing. When in May 1255 he transferred his attention to Sicily, he lost these opportunities. His role now was to stay in England, and to pay the bills for the imposition of his son's candidature. They were enormous: 135,542 marks had already been spent, and the king promised this sum by Michaelmas 1256. There was little chance of rais-ing so large an amount in so short a space of time, but a request was made of the clergy and the magnates at Easter 1257. The magnates refused any aid at all. The clergy pro-mised the considerable sum of £52,000, if the pope would rest content with that. An embassy sent to Rome to make this offer returned with a blank refusal. The king had to turn again to the magnates, in April 1258, and confess that he lay under the threat of excommunication, and his kingdom under threat of interdict, unless the full amount of the debt was discharged. The price of the barons' help came high, the beginning of a programme of reform, which will be considered in the next chapter. The one secure gain of these years was the making of peace with Louis IX of France. This peace was seen as necessary before 'the matter of Sicily' could proceed. Negotiations started in 1257, and were concluded by the Treaty of Paris of 4 December 1259. By this Henry III in person renounced his claims to lord-ship over Normandy, Maine, Anjou and Poitou. He did homage to the French king for Gascony, which he was to hold as a fief of the French crown. This was an important settlement, for it marks a genuine terminus. Claims there would be again to lands in France, many of them, and battles too, but they started from the agreement made in 1259, and did not try to go behind it. A large part of the Angevin memory was erased.

Ki est semblable a la beste
e ki purra turnbatre od lu.

Cil dragun estut sur la grauele de la mer.
E io ui une beste muntaunt de la mer
aiaunt set testes e dis corns. e sur les corns. dis dia
demes. e sur ses chefs. les nuns de blasfemie. E la bes
te ke io ui estert semblable a une beste ke lem apele
parde. e ses pes ausi cum pes deurs. e sa buche cum
bucche de leun. el dragun le dona sa force.

Car la guele de la mer. sunt entendus la multitu
dne des reproues. ki sunt aueir en tel tens. Cest
beste signefie aunteist. E pla mer ensemblem eit sut e
tendus. les reproues. La beste est ue muuter de la mer.
pur co ke aunteist leuera de la tumpainie as reproues
La gent ke aunteist fra suiet a sai sut signefie ples dis

5

CIVIL WAR AND RECOVERY
1258—1307

IN 1240 JOHN DE LACY, earl of Lincoln, died. He was given an excellent obituary by Matthew Paris, but is best remembered today for the advice given to his widow on how to manage her estate, the *Rules* of Bishop Robert Grosseteste. The countess may well not have needed this instruction. She may simply have written a polite thank-you letter after a party; but in return she got a treatise, for Grosseteste sought always to produce a thorough treat-ment based on first principles. The bishop was himself a great lord; he had been over this ground before, and he had found that good estate management could be redu-ced to certain basic principles. The starting-point was the regulations for the household: if this was well-run then on the outlying manors of the estate the corn would be safely gathered into the barns, there would be no waste but a continuing growth of stock and prosperity. At the

86 The Trinity Apocalypse. Cambridge, Trinity College MS R.16.2, fo. 14v, *c*.1255—60 The illustration is to the Book of Revelation, chapter 13, commencing 'Then I saw a beast emerge from the sea: it had seven heads and ten horns'; in the lower scene an aristocratic lady and a Franciscan friar are among those who contend with it.

87 Cain and his descendants. London, British Library, Add. MS 47682, fo. 6r, *c*.1320s (the Holkham Bible Picture Book) Cain is shown as the wicked farmer, his hat concealing the two horns that are the mark of Cain; his descendants below bear the same taint. It is difficult to see much that is evil in these medieval farmers and their wives.

centre, the animating force of this well-governed world, was the lord or lady, sitting in state at dinner-time, surrounded by guests, attended by squires in their livery, and waited on by servants. The lord, said the bishop, should never miss dinner unless absolutely necessary; there was no 'benefit and honour' in eating alone. All should sit down to their meal together, on long tables and not in small groups of three and four. The lord should be served first, his dish brought in state to high table, the marshall leading the procession. On high table it was only before the lord that the pitchers of wine and beer should stand visible; further along they were to be placed under the table. There was to be no loud noise. A dinner thus organised was a visible sign of the lord's authority.

In the countryside all was as carefully regulated. The principle of order here came from the nature of the land.

You ought to know that any ploughland which does not give you a hundred measures of corn is giving you a poor return. You should know the number of your ploughlands. With this knowledge you can calculate the gross yield of corn that you can expect. This will tell you how much you can use, how much you need to keep for seed, and how much you can distribute every day to the poor.

This corn was the basic maintenance of the household, and of the poor at the gate; when the land was assessed for taxation, this should properly be left alone. The stock

provided cash, and the bishop thought of it in cash terms: 'the wool of a thousand sheep in medium pasture ought to yield at least forty marks'.

The running expenses of the household could be met using income of this kind. 'With the moneys from the corn, from your rents, and from the profits from the pleas in the courts and from your stock take the expenditure for your kitchen and your wines, for your wardrobe and wages for your servants; and also increase your stock.' The profit economy has no place in the bishop's analysis. A well-run estate would be self-sufficient, able to meet the full range of its proper obligations, and allow its lord a surplus appropriate to his or her rank.

The state of the kingdom of England in the early months of 1258 fell a long way short of this idealised picture. Henry III owed the pope over £90,000. This was a lot of money. Though the king had great resources — his own manors and towns, an ability in certain circumstances to tax the surplus of his vassals, and his own customs — these would not extend anything like far enough. If the king wanted assistance he needed the consent of his own men. This was not likely to be forthcoming. In place of proper order, all was out of order, there was this 'ridiculous state of affairs' (*statum imbecilem*), the Sicilian Business (see above, p. 127). Several of Henry's most powerful vassals, including the earls of Leicester, Norfolk and Gloucester, formed a con-

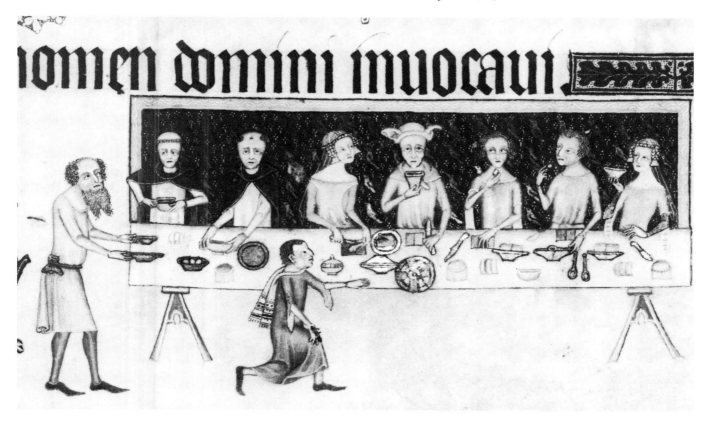

88 Dinner is served. London, British Library, Add. MS 42130, fos. 207v–208r, late 1320s (the Luttrell Psalter)
Sir Geoffrey Luttrell and his wife sit at dinner; on their right are two Dominican friars, probably their chaplain and their confessor; on their left other guests. In the kitchen scene a chef in cap and apron chops a sucking-pig in half, and with no more formality the food and drink are brought to table.

federation for mutual aid. It was only a short distance from here to armed rebellion, and they travelled further along the road on 25 April, arriving at Westminster 'armed in excellent fashion and girded with swords'. 'Am I your captive'? asked the king. 'No, no', said the barons; but the king was forced to undertake to be guided by their counsels. It was conventional to say that the king should be so guided. What was new here was the embodiment of the principle, in a group of twenty-four, twelve chosen by the king and twelve by those who then opposed him.

The council of twenty-four was set up and undertook to report to a parliament which was to meet at Oxford in mid June. At this meeting detailed provisions were made, with the assent of the king and Prince Edward, 'for the correction and reform of their own affairs and of the state of the realm'. The barons started by examining the king's household, and then moved on to the condition of the realm, very much in the manner of Grosseteste's *Rules*. The king's control of his household was much circumscribed. A new council was elected. New sheriffs

were appointed, and the major castles were given to new custodians, all of them in effect responsible to the council and not to the king. Royal lands could not be granted out without the council's permission. The king would later complain, with some justice, that these regulations (and there were many more in a similar vein) treated him as a child under age. And he was to have more to complain of than this, for the council was also concerned with the reform of the law and of local government. Under control of the new justiciar Hugh Bigod a searching inquiry was made into the conduct of the local officers of the crown. The principles of the inquiry differ little from those which had inspired the Inquest of Sheriffs in 1170 (described on p. 74), but the procedures now were much more bureaucratic. Four knights were to be elected in each shire, to attend sessions of the shire court and receive complaints of injuries and trespasses. These they had to write down, authenticate with their seals, and bring in person to Westminster. It was there, in January 1259, that the rabbits of Byfleet were let out of the bag (p. 126). The term Provisions

of Oxford, in the popular mind and so properly in later literature, covers the twin concerns of baronial policy in 1258, the reform of the household *and* of local government.

The Origins of Parliament

The barons at Oxford looked first for a motivating force, a coming together that would symbolise the proper order-ing of the royal household and of the kingdom it administered. This they found in parliament. Three parlia-ments were to be held each year. It was for parliament to 'review the state of the realm, and deal with the common business of the realm and of the king'. Since parliament has not so far been mentioned, it may seem strange to see it listed here as part of a conservative programme. In fact, parliament was not a new body, rather a new name given to an old gathering, as it evolved to meet the needs and reflect the ideas of the early thirteenth century. Under the Conqueror and his sons the great business of the realm had been discussed at the time of the crown-wearings, which took place at the great feasts of the Christian year, at Christmas, Easter and Whitsun. This routine left a long gap, and as the business of the king's court grew, a more balanced distribution of meetings was necessary. The assemblies specified in 1258 were to begin on 6 October, 3 February and 1 June, a routine which fitted with that of the legal terms (Michaelmas, Hilary, Trinity). The term parliament first appeared when the courts of law were reorganised at the end of Henry III's minority. In 1234, when Peter des Roches and Peter des Riveaux fell, the administration was reformed. There were to be three courts of law: (1) the king's bench, the court that could always be constituted wherever the king was (*coram rege*); (2) the court of common pleas, for disputes between private indi-viduals; and finally (3) the court of the Exchequer. These courts became more specialised, with their own staff, and their own records. Over them was set the great council of the kingdom, what Magna Carta had called the com-mon counsel of the realm. It was this which now came to be called parliament. The first mention of the word in an official document comes from late in 1236, when a case concerning the advowson of a church in Wiltshire was adjourned in the court of common pleas, and sent to be settled by the parliament meeting at Westminster in the New Year. Parliament appears here as a court of final appeal, a role that it has never lost.

Parliament was a new word. It took a little while to catch on, but from the beginning when it was used its meaning was clear. A parliament was a discussion – *parle-ment* in the language of the day. It might be a brief discus-sion settling a point of law, or a long discussion on a matter

of general principle. Some points of law, of course, were of considerable general importance; several such were raised at the meeting of the great council held at Merton in Surrey in January 1236 on the occasion of the king's marriage to Eleanor of Provence. One good example would be the law relating to bastardy. The common law of England provided that only children who had been born after their parents' marriage were legitimate. This ruling came under pressure from the evolving canon law, which on this matter legitimised bastards if their parents sub-sequently married; these were 'mantle children', a cloth was laid over them during the marriage service, just as over a child at baptism, and they were thereby legitimised. To a modern liberal, the clergy's view of the matter may seem the more attractive, but this was not a matter of liberal versus conservative. The laymen were not concerned with morality but with rules of inheritance. Bishop Grosseteste wrote another long treatise (a 'lengthy brief' said the chief justice), setting out the canon law. There was a long discus-sion, but the lawyers and the barons refused to give ground: 'we do not wish to change the laws of England'.

Though most bastards in England were not fathered by barons, it was the magnates and senior justices who deliberated on bastardy; their responsibility for them was not carnal but communal. The magnates and justices were the essence of the royal council, and so they were the core of the early parliaments. They were sent individual writs of notification and summons to each parliament. They spoke for the nation so far as matters of taxation were con-cerned. At some thirteenth-century parliaments, however, and at all but a few parliaments thereafter, a wider range of counsel was taken. The ideas here may be seen pre-figured in 1254, when the queen and Richard of Cornwall summoned two knights from each county to appear before the royal council at Westminster. They were to come with full powers to act 'on behalf of each and all' in the county community; they were to give clear answers to the council on the matter of granting an aid. These knights of the shire came as representatives and not as individuals. A clear routine had evolved by the early fourteenth century. From each county were summoned two knights of the shire. From each city and major town were summoned two citizens or burgesses. Their writs of summons were to com-munities and not to individuals, and while this may seem a technical point it is of some importance in considering the later history of parliament. Those summoned individu-ally are 'the Lords', from their separate place of meeting 'the house of Lords'. Those summoned as representatives are 'the Commons', from their separate place of meeting 'the house of Commons'. The commons here does not translate as 'of low rank' (for many knights of the shire

were lords in the medieval countryside) but rather as 'representatives of the people', of the communities of England.

The Provisions of Oxford inaugurated a decade of discussions between king and barons, with numerous proposals and counter-proposals. This was a paper war but, with no agreement reached about reform, it could only be settled by force of arms. It has become customary to call this the period of 'the reform movement'. It was born of financial crisis in the summer of 1258; it died with Simon de Montfort at Evesham on 4 August 1265. What was at issue through this period was, as has been seen, reform in the king's household and reform in local admin-

89 The marriage of Joachim and Anna. Late 14th century. English embroidery. London, Victoria and Albert Museum
This scene from one of the apocryphal gospels is embroidered on the orphrey of a chasuble.

istration. Just as in Grosseteste's *Rules*, with a proper regulation at the centre the principles of good order should manifest themselves in the countryside. The barons took it as axiomatic that the countryside was not properly ordered, and had set up local investigations to provide for reform. The justices had followed up the local inquiries, and had done their work vigorously. According to one chronicler: 'they yielded not to promises or entreaties, though they came from powerful persons, but sought earnestly for the truth and did their work of retribution with speed.'

The local inquiries and the judicial review culminated in the Provisions of Westminster, approved by the parliament which met in October 1259. They cover a wide range of matters, but have an essential coherence, for they never move far from the concerns of those who met in the county court, under the chairmanship of the sheriff. To take just one example, and follow some of its ramifications: 'let the tourn be held as it was customarily held in the times of the predecessors of the lord king'. This was the sheriff's tourn. Twice a year he went on tour through the local, hundred courts, and (the barons complained) he was justice for the day. He took the view of frankpledge, making sure all adult males were in a tithing; he took royal fines, such as the *murdrum* fine, levied on local communities in case of sudden death. There were lots of little things, and it was difficult for individuals to keep track of their precise obligations, easy for the sheriff to make demands. One of the lesser knights of the shire of Northampton, for example, William of Clapton, in 1255–6 called together his village elders, 'the old men with their venerable grey hairs', and inquired of these and other matters. How much was owing for sheriff's aid? How much at the view of frank-pledge? Why is the *murdrum* fine collected in two ways? In this inquiry William was looking over his shoulder, at the sheriff, for much of the time. It was the complaints of men like him, all over England, that were fed in to the Provisions of Westminster. And care was taken that these provisions became widely known. New sheriffs were to be appointed, and each was to come with four knights of his shire to Westminster on 19 November 1259, to hear a lecture from the justiciar on what the provisions involved. In just such a way a modern company will bring together key personnel for a week-end seminar.

Few save the king, discredited and ignored, saw themselves as losers as the reformers set to work. Among the magnates the two most important this time were Simon de Montfort (on whom see the picture essay on pp. 136–7) and the king's son, Edward. Edward made sure his own estates were not affected. Having done so he assured 'the community of the bachelry of England', meeting at the

time the Provisions of Westminster were issued, that they had his full support. Shortly thereafter he swore that he would maintain 'the new order' and not make war against the confederated barons. All this begged the question. On what principles was this 'new order' to be based? The group of 'bachelors' meeting at Westminster in 1259 had complained that a number of magnates had fallen away, becoming a good deal less keen on reform when it was their own local authority that was called in question. This was true, but it was a symptom of a deeper weakness. The magnate's view of good estate management has been examined in Grosseteste's *Rules*. The principle of unity is basic. A single chief administrator should take an oath of personal loyalty to the lord. He should be a full time salaried official, as should be all those who worked for him in the lord's service. The lord should be wary of giving even a few days' leave to his servants: 'if you will not serve me, I will find others who will'. In looking for a collegial or communal responsibility for the government of England, the barons were ignoring the first principle of their own estate management.

Towards Civil War

In April 1261 the pope absolved Henry from his oath to be bound by the Provisions of Oxford, and Henry thereafter used every avenue open to him to work against them. It was on the necessity for a single authority that he came to insist. In January 1264 both king and barons submitted their cases to the king of France. Henry hammered away at the principle of unity. He had lost control over his household officers, over his sheriffs, and over all those who did justice in his name. He had lost control over his castles, and from those castles his property had been plundered, and other 'infinite evils' had occurred.

The king's agents at the French court, if invited to specify the 'infinite evils' of which the king complained, might well have pointed to the wave of local rebellions that had broken out all over England in the winter of 1262–3. It had proved a very difficult matter to scrutinise the magnates' power in the localities, and yet leave it intact, seeming legitimate to those subject to it. Just how difficult may be seen by looking at what happened in London in the years of the reform movement. London was at the heart of the nation's political life. The Londoners were always first with the news. In January 1258 they were summoned to meet in the churchyard of St Paul's. This was the traditional place for the folk-moot or town meeting of the Londoners, the voice of the lesser citizens. They were told that there had recently been found in the king's Wardrobe a petition of some Londoners making complaints against

90 Mail shirt (habergeon). (Probably) 14th century. Iron or steel: made of alternate rows of riveted and one-piece rings. The Royal Armories, Tower of London

several of the aldermen. After several meetings and special juries had been arranged the complaints were found proved. Were the accused to be allowed to prove their innocence by an oath sworn by several of their friends? The question was put to the folk-moot. 'No, no', came the reply. It suited the king's government then to act against the city fathers, but it was soon to need their support. In the summer of 1263 the Londoners took to the streets; the Provisions provided their slogans, their title to challenge the merchant oligarchy. As was to happen in the Peasants' Revolt of 1381 (pp. 212–13) men heard in their own tongue, they translated in terms of their own experience, the slogans that went the rounds. 'Like so many justices itinerant', they travelled the city, taking down everything that stood in their way. Alan of Basing had put up a palace in Aldermanbury, building right across the main road; the mob reduced it to rubble. The Londoners also took

on the great abbey of Westminster, which stood outside their walls. The monks were forced to surrender their royal charter, and were told that none of their liberties would stand. Among many grievances here may be cited the establishment of a new fair at Westminster in 1258, during which the Londoners were forbidden to trade within their city. They had to bring their goods out to Westminster. This made them cross, and when it rained, as it did when the fair was inaugurated, they became crosser still. Whatever the local grievances, an attack on Westminster Abbey at this date came close to being an attack on the monarchy itself.

Pope Clement IV, hearing of the affront to Westminster Abbey, declared that all of England was 'in a boiling whirlpool of universal disruption'. The king had told the pope that he feared for the disinheritance of himself and his heirs. Edward had by now seen the force of his father's arguments, for he had seen at first hand the disorder on his estates in the marches and also in London where his mother had been insulted by the mob. Edward now stood firmly at his father's side, and guaranteed his survival. Since 1258 war, or the threat of war, had never been far from men's minds. In 1264 and 1265 it became a reality. The king on the one side and Simon de Montfort on the other appealed to a duty that lay beyond political expediency. The king appealed to his coronation oath, the earl to the king's oath to maintain the Provisions. The arguments on both sides were sent to the French king. His award, the Mise of Amiens in January 1264, took the form of a judgement in his court, and was entirely in favour of the king. Simon and his party prepared for war. His main area of support was the Midlands and East Anglia. This was the basis of his own earldom, and in the chief town of the East Midlands, at Northampton, Simon mustered his forces. So also did the king at Oxford: he sent a summons on 6 March 1264 to three earls, 112 tenants-in-chief and 56 churchmen. The list was annotated, 'those who are against the king have not been written to'; but the king really did not know who was for him and against, and at least a quarter of those the king summoned were his opponents in the war which followed. The town of Northampton proved not defensible, and on 6 April 1264 it was taken. All those found there, of equestrian rank, were presumed to have been in arms against the king. At least eighty knights were captured, their lands confiscated. The Montfortians having lost in their own heartland, the same misfortune would shortly befall the king. Simon defeated the royal army on 14 May 1264 at Lewes in Sussex, and sought to capitalise on his victory. An excellent propagandist to the last, and still sustained by popular support, he sent into the shires a document reiterating his position.

Many felt this worthy of record, for at least fifteen copies survive. For some of them it must have served as an obituary. The earl's castle of Kenilworth fell on 1 August 1265, and three days later he died on the battlefield at Evesham.

Simon de Montfort has been much criticised. His insistence on the Provisions, and nothing but the Provisions, runs against the perceived wisdom of late twentieth-century political analysis, in which 'a week is a long time in politics', and political leaders seem to change their stance from day to day. The leaders of the parties in the mid-thirteenth century were politicians as we understand them, no less avid for power. But perforce they played by different rules, at a tempo governed by the pace of medieval communications, and with reference to a limited stock of ideas. Simon de Montfort was tied to the Provisions not just in his own but also in the popular mind. In the first twenty-five years after his death, he worked nearly 200 miracles, the majority at his tomb at Evesham. His was a masculine cult, perhaps because of the way the saint behaved — a lame Winchcombe monk, for example, had his leg very painfully jerked into place — and it was clearly political, a national not a local shrine, drawing pilgrims from far afield, even from Becket's shrine at Canterbury. Some were poor, others rich: the abbot of Dale in Derbyshire came, the steward of the bishop of Hereford, and the knight Simon de Pattishall. All had had hopes of the reform movement; all now had memories. It had been hope and memory that had kept Magna Carta alive. Why, the earl might have asked, should the Provisions of Oxford not have achieved the same status as Magna Carta? It would not have been a silly question. The best answer we can give now is that Magna Carta as reissued drew on ideas of law and behaviour that were widely shared, while the Provisions ignored the basic principles of household government. The barons failed because they broke the *Rules*.

The Recovery of Royal Authority

The civil war of Henry III's reign proved a difficult one to settle. Earlier wars, each in their different ways, had seen two parties distinguished in terms of two different sources of lordship. When the lords came to terms their followers' positions were legitimised. A civil war which turned on attitudes to management was much more difficult to resolve. It seems at times rather like a game of musical chairs. Depending on when the music stopped, a different set of people would find themselves without a seat. The music cut off abruptly for those in the town of Northampton on 6 April 1264, so too for those taken in the battle at Evesham, and for the garrison at Kenilworth,

Simon de Montfort

BOTH ADVENTURER and idealist, Simon de Montfort pursued a course easier to chart than to judge. A younger son, born about 1208 into one of the great noble families of northern France, he inherited a claim to half the earldom of Leicester through the marriage of his grandfather to an English heiress. He came to England in 1231, secured his ancestral lands, and thereafter quickly became the confidant of his near contemporary, the young Henry III, winning in 1238 the greatest prize in Henry's gift: the king's sister Eleanor. Her disposal to a foreigner, by a marriage concluded virtually in secret, nearly produced a baronial revolt. The unpopularity of the match, together with other disputes over money, caused the first open rift between

2 (ABOVE) Montfort's arms. North aisle of the nave, Westminster Abbey
This shield is one of a series commemorating Henry III's earls, placed in the abbey by the king's orders.

Montfort and Henry. Although their friendship waxed and waned in the twenty years before 1258, and was punctuated by violent quarrels, Montfort remained more often than not a royalist, whose services the king needed. He helped to save the royal army at Saintes in Gascony in 1242, governed Gascony as Henry's lieutenant, and in the 1250s took a leading part in negotiating the Anglo-French treaty of Paris.

Like his spiritual mentor Robert Grosseteste, Montfort possessed considerable independence of mind and great ability. These and other qualities – his alien origins and the cosmopolitan range of his experience and family connections – set him apart from the other magnates. At a time when the English baronage was becoming increasingly insular in attitudes and interests, Montfort was as often in France as in England and remained part of a great cousinhood, spread across both France and the

1 (BELOW) Kenilworth Castle. Most of this dates from the late 14th century, but the keep was built in the late 12th century; the stretch of curtain wall at the foot of the picture was probably built in Montfort's time.

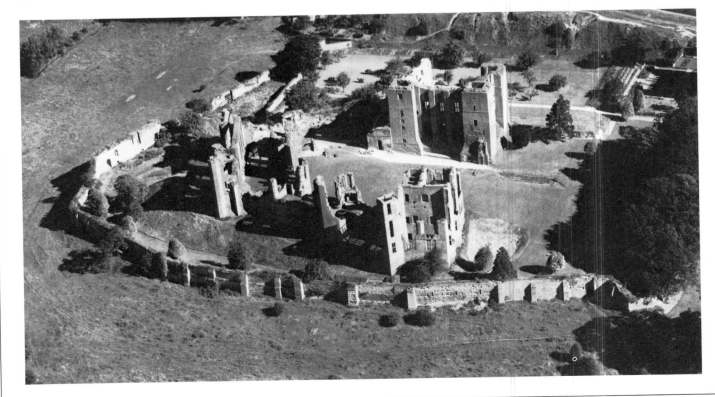

Holy Land. His abilities, reputation and connections explain both the attempt made to secure his appointment as governor of the kingdom of Jerusalem in 1241 and the French offer to him of the stewardship of France in 1252, when Louis IX was on crusade. He had a particular mastery of military affairs. Lauded as 'the most sagacious of warriors' by a chronicler, he refortified his castle at Kenilworth so effectively that in 1266 it withstood a six-month siege, the longest in medieval English history. *Dévot* as well as soldier, he filled both roles on crusade in 1240–42, while in England he moved in the circle of friars and reforming bishops whose work transformed the contemporary church. Zealous, intelligent, active, uncompromising and convinced of his own rectitude, he was a man uneasily qualified either for government or for the leadership of a faction.

It was one of the paradoxes of Montfort's career that in its last and best known phase, from 1258 to 1265, the alien who had risen through royal favour came to lead a movement largely directed against the king's alien favourites. Although Henry's incompetence and fickleness had often exasperated him, he had previously shown almost no interest in the reform of Henry's government. His new commitment to reform in 1258 may have initially owed more to personal grievances than to political convictions: he bitterly resented his recall from Gascony in 1252 and his subsequent trial, he had quarrelled with Henry's half-brothers, the Lusignans,

3 Montfort's Seal, 1258. London, British Library, Additional Charter 11296
By the deed attached to this seal Simon de Montfort and Peter of Savoy, Henry III's proctors, announce the prolongation of the truce with France.

who dominated the court, and he and his wife were owed much money by Henry. Once adopted, however, his commitment became absolute, and henceforth his oath to the Provisions, the reforming codes of 1258–9, governed all his actions. He thus aligned himself with the knights and freeholders of the shires who were the main beneficiaries of the Provisions: a somewhat adventitious alliance, since Montfort was abroad when most of the new legal and administrative reforms

were being drafted and did not serve, as did some other barons, on the judicial commissions which took the reforms to the localities. He failed because in the end his cause became identified with disorder, his own ambitions, and something close to republicanism. The civil war which began in 1264 resulted in the king's capture at Lewes and Montfort's supremacy, which he used partly to promote his family interests. As baronial support dwindled, he looked for it elsewhere. His most famous action, the summoning of the knights to parliament in June 1264 and January 1265, was the product not of any constitutional design, but of a prolonged political emergency. By then the baronial coalition of 1258 had become a Montfortian rump which, despite extensive but largely passive support in the shires, was virtually annihilated at Evesham on 4 August 1265. Its leader, 'martyred for the justice of the land and for truth', as a contemporary put it, became a popular saint, transcending in death the part of the flawed hero which he had played in his final years.

J. R. MADDICOTT

4 The Dismemberment of Simon de Montfort's Body after the Battle of Evesham. London, British Library MS. Cotton Nero D.II, f. 177
From an early 14th-century chronicle of Rochester Cathedral.

which fought on after their lord's death. For all these there would be no second chance – they were rebels against their king. They were at first threatened with the full penalties of disinheritance. Their lands were granted to the king's supporters and his family: the property of 316 rebels went to 133 individuals. A royal tournament this, with massive prizes for the victors. Wiser counsels prevailed, if only because men were forced to confront the logic of their own preconceptions. To punish the rebels themselves was one thing, but what of their womenfolk, what of their heirs? The royal council decided that women's property rights must be respected, and in so doing they dealt the principle of disinheritance a fatal blow. The terms offered to the garrison at Kenilworth, accepted on 14 December 1266, became those offered to the community at large. They provided for redemption; lands could be bought back, at one to seven years' purchase, depending on the level of guilt.

In his last years Henry III was able to recover a measure of financial stability, and his kingdom a measure of unity. The focus of that unity was Prince Edward's crusade. The royal finances had been badly hit by the civil war. The main burden of financial recovery fell on the noncombatants, and particularly on the clergy, who in 1267 contributed a twentieth of their revenues to the crown. In November of the same year, at Marlborough, the Provisions of Westminster of 1259 were reissued. It is clear from this that the Provisions continued to be important to local opinion in the shires. With this done, and with a peace being made with Llewellyn of Wales (on which more later), there was the basis for the recovery of the monarchy's rights to taxation. In October 1269, after the re-dedication of the new church at Westminster, a tax for the crusade was discussed, The matter hung fire there, and the Charters were once again publicly proclaimed, a sure sign of anxiety about security of tenure. A twentieth was granted in April 1270, and in August of the same year Prince Edward set sail for the East. In the same month the great king of France, Louis IX, died at Tunis, and Edward was left the clear leader of the crusade. He was in Acre throughout the summer of 1271, surviving an attempt on his life from a proper Assassin, an attack which went into legend with the story that his wife Eleanor saved his life by sucking out the venom from the wound. (A daughter, Joan 'of Acre', was born to the couple there.) F. M. Powicke suggested that for Edward the chief gain of the crusade was to see at first hand the disintegration of a feudal state where the power of the king had ebbed away. An interesting idea, but this is likely to have been a lesson that the heir to the English crown had already well learned.

Edward was in Sicily when his father died, on 16 November 1272, and did not need to hurry home. But if his title was assured, the monarchy which he inherited had been weakened, both in resources and in ambition. Edward, in Gascony for eighteen months, had kept in close touch with England: he knew what was required, and he knew his priorities. Within weeks of his arrival in England in August 1274 commissioners were riding round the shires, going from hundred court to hundred court with a long list of articles or questions to put to the local communities. They started with the royal lands, 'the ancient demesnes of the crown', went on to the king's rights, his 'customs', asking by what warrant they were held by individuals and asked for complaints about local officials. These were not new questions, but for Edward it was important that they be put at this time, and in this way. For the barons in 1258 had stolen the king's clothes. It was they who had asked about the misdeeds of royal officials, gaining popularity thereby, but taking no responsibility. Much evil followed. All complaints were now to come to the king. Parliamentary petitions, which were to have a long history, appear very suddenly at this time, probably as a result of positive royal encouragement. Edward's first parliament, held at Westminster in April 1275, issued a long statute which dealt with the abuses his commissioners had discovered.

Edward I, like all previous kings of England, was concerned to re-establish his lordship not just within England but beyond his frontiers, to have his overlordship recognised by neighbouring princes. Both in Wales and in Scotland the assertion of overlordship came to lead to the assertion of a more direct rule; more direct rule provoked a national reaction; and Edward's response led to the conquest of Wales and to a long struggle with Scotland. The initial difficulty, in each case, lay in interpreting the implications of oaths of homage. As society changed it was natural that these implications were reassessed. For the most part, over the generations, this reassessment was painless, for homage was a personal relationship and mortality compelled continual minor adjustments. But if a shift in power and a shift in mental attitudes occurred together there was scope for trouble. This is what happened in the late thirteenth century. The important shift in attitude was the attitude to law. Edward I came to insist that all within the British Isles acknowledge the superiority of his own jurisdiction. Llewellyn prince of Wales and John Balliol king of Scotland were each on this analysis victims of a movement general to the day, by which diplomacy was replaced by judgements in courts of law. This might seem a natural and a happy evolution. It was not. The art of diplomacy is compromise: the art of law is judgement.

When Edward I was crowned at Westminster on 19 August 1274 the most notable absentee was Llewellyn ap

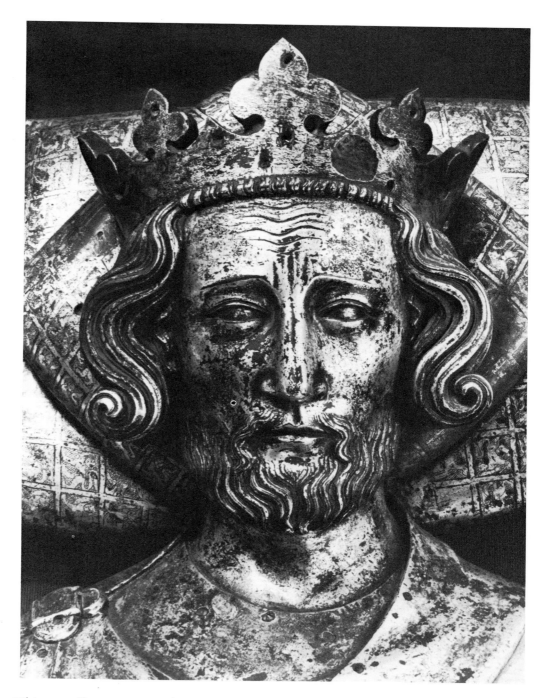

91 Henry III (died 1272).
1291. Bronze. Westminster
Abbey, chapel of Edward the
Confessor
The effigy is precisely dated, the
work of a London goldsmith,
William Torel (who also made
the effigy of Eleanor of Castile,
p. 143, no. 4).

Gruffydd, prince of Wales. This was discourteous, and
it seemed to threaten more than simple discourtesy. For
Llewellyn was a powerful man, more powerful, according
to Matthew Paris, than any Welsh prince since the coming
of the Normans. He had gained that power in the 1250s
and 1260s, establishing his authority over the local princes
in both north and south Wales. This authority had been
recognised by Simon de Montfort, in return for support
in the civil war, with the grant of the title 'prince of Wales'.
More remarkably, after Simon's death, Henry III's govern-
ment conceded the same title by a treaty made at Mont-
gomery in 1267. By the terms of this treaty Llewellyn was

to pay, in instalments, a fine of 20,000 marks, and was
required to do homage to any new king of England. Had
he come to Edward's coronation he could have done
homage at the same time, a mixture of ceremonial and
conviviality very much to Edward's taste. But Llewellyn
had his suspicions of the English king. His promised wife
Eleanor de Montfort was detained in England. His brother
Daffyd, an outlaw from Wales, was given sustenance and
support in England. Llewellyn wanted these and other
grievances put right before homage was performed. He
found the English king no less stubborn. In August 1275
Edward stretched a point in coming as far as Chester to

allow Llewellyn to perform homage, but the opportunity was declined, and beyond this Edward would not go. Thereafter Llewellyn was summoned to southern England, with no safe conduct, and his continued refusal to attend was taken as an occasion for war, declared on him in November 1276 as 'a rebel and a disturber of the king's peace'.

Edward mustered a substantial army at Chester in July 1277. It contained 800 cavalry and over 15,000 foot-soldiers, of whom 9000 were Welshmen. In addition there were specialist archers and crossbowmen (recruited from Genoa), also diggers and woodsmen. These last were indispensable, for this was an army recruited to hunt Llewellyn to his lair, the mountain fastness of Gwynedd (Snowdonia). Nearly two thousand axemen were employed in cutting a road through dense woodland between Rhuddlan and Flint. This new thoroughfare may be taken as a symbol of the end of Llewellyn's independence. The terms made at the Treaty of Aberconwy (Conway) left him the title of prince, but a principality confined only to north-west Wales. The native princes of Wales were now required to swear fealty to the English king, and

Edward at the same time extended his direct lordship into Wales, acquiring the Four Cantrefi (the region between the rivers Conwy and Dee) and much of Ceredigion. Llewellyn had to swear fealty to Edward at Rhuddlan before any peace could be made, and attended the Christmas court at Westminster where he did homage. After this acknowledgement Llewellyn was given his bride, whom he married at Worcester in 1278. Edward paid for the wedding feast, and for the couple's removal expenses. For a time relations between the two men were, at least on the surface, cordial.

This cordiality was not to last. Llewellyn had been a great man in his own land, but in Edward's eyes he was simply another of his more prominent subjects, who had for many years been an equally prominent trouble-maker. After the 1277 treaty the English king established a separate commission of royal justices to deal with cases in the Marches and in Wales itself; before them, in January 1278, Llewellyn was summoned to appear. The following month Llewellyn raised before them his claims to Arwystili, an upland area in central Wales which lay on the frontiers of Gwynedd. Llewellyn insisted that the mat-

92 Beaumaris Castle, Anglesey. (Mainly) 1295–1300
The building of the last of Edward 1's Welsh castles was begun in 1295 and pushed on apace; by 1300 a total of £11,400 had been spent here. A moat originally ran all around the site. The battlements were never completed.

93 (RIGHT) Conwy Castle, Gwynedd. (Mainly) 1282–7
Here in Aberconwy, one of the ancient centres of the kingship of the Welsh princes of Gwynedd, Edward 1 built one of the chief castles of his new settlement in Wales; the turrets are his assertion of royal power.

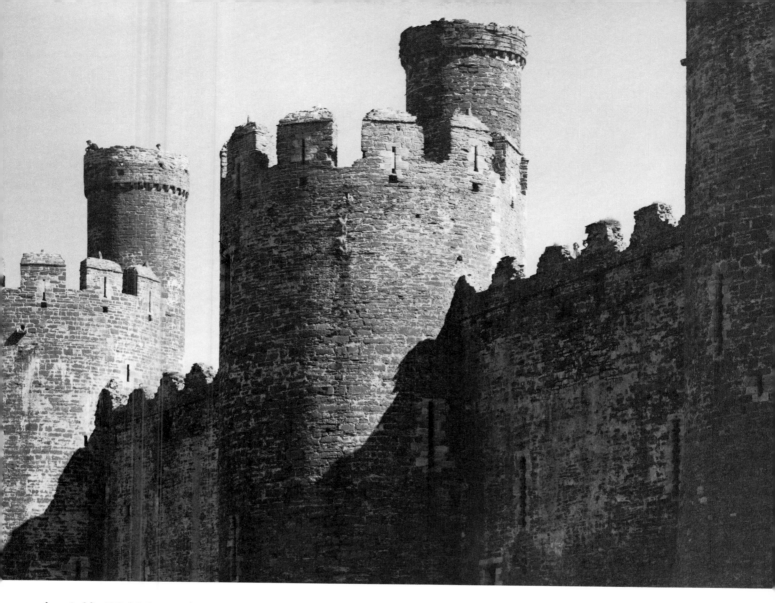

ter be tried by Welsh law. Edward did not deny this claim directly, but he sought to weaken the force of that law, and came to claim that it operated under the supervision of English justice. Arwystili, probably to Edward's surprise, for he was not an imaginative man, became a test case. As Rees Davies puts it, 'the defence of their laws and customs was a banner under which all Welshmen could unite'. A wave of revolt swept through Wales beginning in March 1282. Edward responded with strong words and the deeds to match them. He would, he said, 'put an end finally to the matter on which he was now begun of putting down the malice of the Welsh'. Another huge army was mustered, for a campaign that cost £150,000. Llewellyn was at least spared the humiliation of learning the terms which would be imposed following his inevitable defeat. He was killed near Builth in the Wye valley on 11 December 1282. 'And then', said a Welsh chronicler, 'all Wales was cast to the ground.'

Wales had become a problem. What was to be done about it was the main business specified in the writs summoning townsmen and knights of the shire to join the magnates at parliament at Shrewsbury in the late summer of 1283. The result was a military, and a landed, and an administrative settlement that was revolutionary. This was announced in the Statute of Wales, issued at Rhuddlan in March 1284. 'Divine majesty', said the king sententiously, had provided that the land of Wales had been 'united to the crown of our realm as part of the same body'. He and his magnates sat in judgement on the laws of Wales: 'some we have abolished, some we have allowed, and some we have corrected'. The Welsh were forced to accept the king's peace, secured by an administration on an English model. Wales was to be shired, though its sheriffs accounted at Caernarvon and not at Westminster. Lying behind and securing this was a resettlement, with the building of new castles and new towns.

For a decade and more the most important man in Wales was Master James, the master of the king's works.

Queen Eleanor of Castile

ELEANOR OF CASTILE was married to Edward, son of Henry III and heir to the kingdom of England, in October 1254 at the monastery of Las Huelgas near Burgos. A few days after the marriage the bride's brother, Alfonso X 'the Wise' of Castile, renounced in favour of the English king all the rights which he claimed in Gascony. The marriage, it is clear, was a business agreement, as were all marriages of this kind. Edward was fifteen at the time of his marriage, and Eleanor must have been several years younger, for their first child was not born until 1264.

Eleanor came to England with her husband in 1255. From the relative tranquillity of the Thames Valley, for Windsor was her first and always her favourite residence in England, she will have seen as she grew to womanhood her inheritance threatened by civil war. Little can be discovered of her life during the 1260s, save the birth of three children in 1264, 1266 and 1267, though the insecurity of these years must have threatened her no less than her husband. In 1270, however, she left with Edward on crusade. This may be taken as a first clue to her character, for it would have needed great spunk for a young woman to undertake such a voyage, and suggests a close relationship between the couple. All later records, which become much fuller after Eleanor retrurned to England as queen in 1274, confirm these impressions.

The records of Eleanor as queen are of several different kinds. Monastic chronicles, organised year by year, note the birth of children: four boys and seven girls, born between 1264 and 1284. They note also the great state occasions. In August 1277 the king and queen laid the foundation stones of their new foundation of Vale Royal abbey in Cheshire. The following year they were at Glastonbury, when the tomb of Arthur and Guinevere was opened. At Easter 1284 the king and queen sat together in high state at Caernarfon castle, their coronation robes

1 Queen Eleanor. London, Victoria and Albert Museum (loan from Hertfordshire C.C.), height 183 cm. A statue from the Waltham Cross Made in 1291 or 1292, in Caen stone, by the king's master mason, Alexander of Abingdon.

having been sent for from London. Just a few days afterwrds Edward their last child was born, and when Alfonso their only other surviving son died the following August the infant Edward became the heir to England. A vow made at this time was discharged by Edward and Eleanor at Bury St Edmunds in February 1285. The king and queen, touring the shrines of England, were mourning their lost children, and praying for those that remained.

Eleanor was the head also of a 'large household' – perhaps 150 strong at the time of her death – and it seems clear that she was a businesswoman of great ability. Just as a wealthy investor now will scan the share prices in the daily paper, so Eleanor and her staff kept a close watch on the inquisitions *post mortem*, surveys of the property of deceased tenants of the crown. One of her letters from the 1260s, after the civil war, lists several properties in the king's gift for this reason, and instructs her agent to procure the best one he can, 'though in such a manner that no one will think our behaviour covetous'. When she became queen she had the pick of the lands acquired in this way, and an income in good years of around £10,000 a year, accounted for at her own

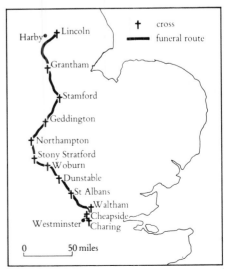

exchequer at Westminster. Many did indeed find her behaviour covetous. The archbishop of Canterbury wrote to the queen's treasurer in 1286, requiring him 'when you see an opportunity' to remonstrate with the queen for dealing with estates that were encumbered with debts to the Jews. It may be doubted whether the treasurer ever found an appropriate moment, for the queen's active involvement in these transactions is clear, as is her skill in making purchases. 'She acquired many manors, and those the best', said a chronicler simply.

All this presents the picture, clearly drawn from the life, of the very model of a medieval queen. She was Edward's much-loved wife, and his partner in the full range of public affairs. This picture is not materially altered, but it remains vivid to this day, by what happened after the queen's death on 28 November 1290 at Harby in Nottinghamshire. Her body was taken to Lincoln, and from there it started a slow and solemn journey towards London. The route, shown by the map, is known accurately because a memorial cross was afterwards erected at each overnight resting-place. The two finest crosses were set up in London: at Cheapside within the city, and at Charing Cross outside the walls, where the

4 Queen Eleanor; from her tomb at Westminster Abbey
This bronze was cast in 1291–3 by the goldsmith William Torel. 350 gold florins were bought from merchants of Lucca for the gilding.

2 Sketch of an Eleanor cross from the Luttrell Psalter. London, British Library, Add. MS 42130, fo. 159v
The date is late 1320s, and so this is the earliest known drawing of one of the crosses.

3 (BELOW) Eleanor Cross at Geddington, Northamptonshire
One of the last crosses built, made in the mid-1290s. The only surviving cross in a village setting, and also the best preserved, this now gives the best impression of the crosses as they must have appeared in the middle ages.

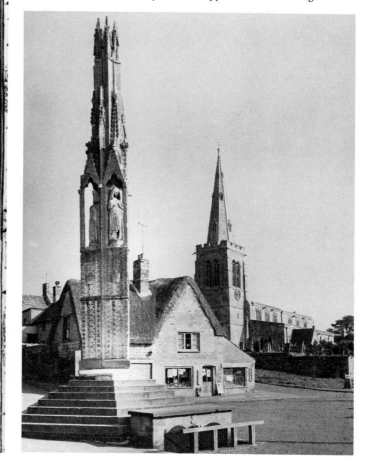

body rested for the final night before its burial in Westminster Abbey on 17 December 1290. The London crosses do not survive, but at Waltham, at Geddington and overlooking the town of Northampton, Queen Eleanor's crosses may still be seen. These are fine monuments in the Gothic style, monuments to royalty, but of a unique kind. They are the monuments of Edward's private grief. The king wrote to his subjects asking for their prayers, and to the abbot of Cluny also. 'We always loved her for as long as she lived. We will not cease to love her now that she is dead.'

EDMUND KING

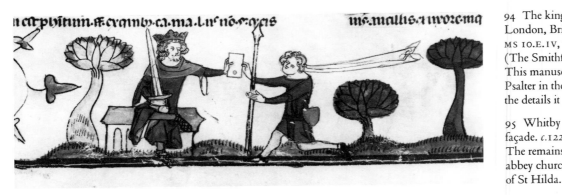

94 The king's messenger.
London, British Library, Royal
MS 10.E.IV, fo. 302v, c.1330–c.1340
(The Smithfield Decretals)
This manuscript rivals the Luttrell
Psalter in the range of its invention, and
the details it gives of English life.

95 Whitby Abbey, Yorkshire, east
façade. c.1220s.
The remains are those of the choir of the
abbey church, rebuilt around the shrine
of St Hilda.

It was he who supervised the building of the five massive castles that ringed Snowdonia – Beaumaris in Anglesey, Conway, Caernarfon, Criccieth and Harlech. At Beaumaris in 1296 he had 400 masons at work, their wages with materials accounting for £250 a week. At least £50,000 was spent in Edward's reign on these five castles alone. In their shadow there were founded new towns. English settlers came in, just as Normans, Flemings and English had colonised southern Wales after the Conquest. Now there was a crucial difference. The Welshmen were to be excluded. They were not allowed to trade outside these new boroughs, and they were not allowed to settle within them. They were 'Welshmen, foreign inhabitants' of their native land. In Welsh historiography it is Edward who is the 'Conqueror'.

The King's Revenue

It was the English who paid for Edward's wars. They were successful, for the most part, because the king was able to reassert his traditional claims to taxation and to develop new ones. One new tax was to be particularly important. Edward's first parliament, in 1275, granted him a tax on wool, to be taken at the rate of 7s. 6d. a sack. It was granted after discussion, 'by the common assent of the magnates and the will of the merchants'. From this dates the beginnings of the English customs service. All ships leaving port laden with English wool had to carry letters, authenticated by the official coquet seal, to show that duty had been paid. In the first four years of the tax, a period which included the first Welsh war, £43,802 was raised in customs duty. For the king, this form of taxation had several advantages. It was regular; and in times of emergency it could be increased though not without protest. In 1294, at the begining of a period of much more regular warfare, it was taken at the rate of 40s. on the sack; this was the *maltote*, or 'bad tax', no further description being necessary. It was very unpopular, and in 1297 it was remitted, but in the intervening time it raised the enor-

mous sum of £111,000. The wool custom was important also in that it allowed the king to borrow. Up to this time the kings of England, by comparison with their subjects and in terms of their resources, had not been great borrowers. This was to change, and the change was important. It gave them an independence. For those who lent to the kings of England there was always a risk. The good advice given to young merchants living abroad always contained one absolute prohibition: 'do not lend to princes'. But this did not bind their principals. The main lenders in the first half of Edward's reign were the Riccardi of Lucca, who in security for their loans to the king were granted the customs revenue of England from 1275 to 1294. The sole control over one of the staple commodities of western European trade was not bad security for a loan. And they had money to lend. Here is the final link which would bind the kings of England tightly to the great Italian banking houses. The Italians had money to spend on wool, and money to lend on the basis of the wool custom, because they were the pope's bankers. The main firms were Florentine, the Frescobaldi, the Cerchi and the Bardi prominent among them.

Not all the wool of England was of the same quality. The young Italian merchants needed some guidance as to where the best wool was to be found. Francesco Pegolotti of the Bardi company produced just such a guide. Calculating the value of wool on the Flemish market, he produced figures which ranged from 28 marks to 7 marks for a sack of wool weighing 364 lbs. The firms dealt with the monastic houses, who often acted as middlemen in marketing their neighbour's wool. The houses with the best wool were Tintern Abbey and Abbey Dore on the Welsh marches, and Stanfield in the Lindsey division of Lincolnshire. In terms of the number of sources of good quality wool, it was Lincolnshire and Yorkshire that were the most important counties. Around 10,000 sacks of wool a year were exported, representing the wool of about 3 million sheep, with a value of £60,000 to £100,000 a year. Boston was the busiest of the ports that handled this trade.

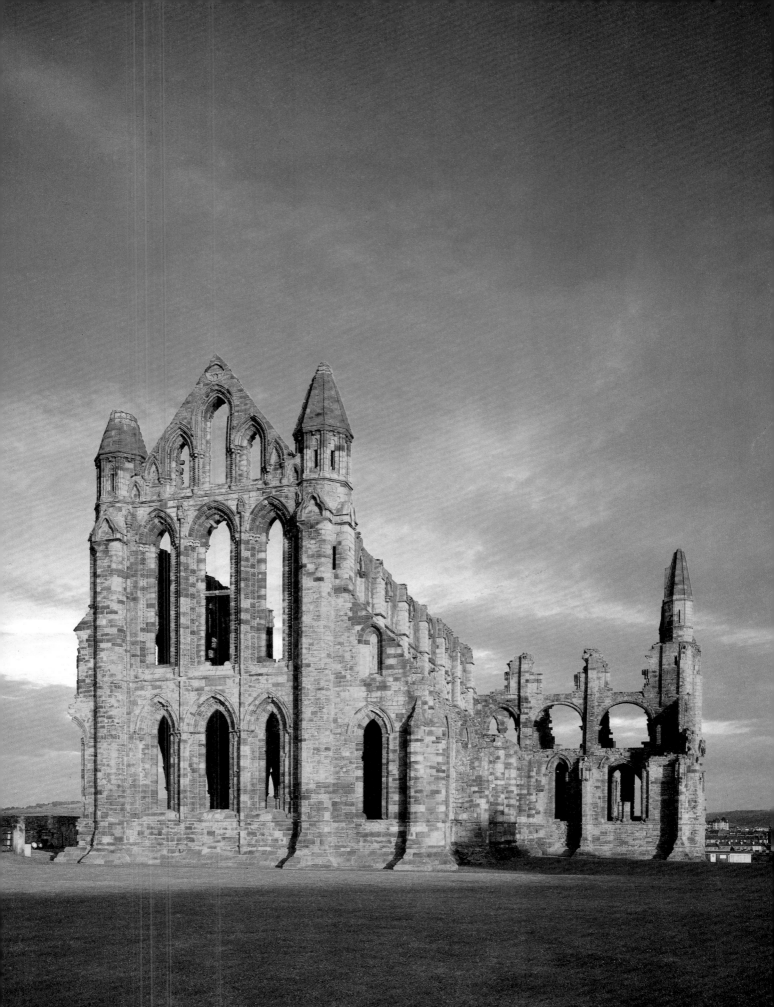

The map will help explain why this should have been so. It is a map that stresses the importance of water communications. The galleys of the Mediterranean (the direct sea route was opened up around 1270) and the cogs of northern Europe tied up alongside each other at the quays of Lynn and Boston, and plying to them were the small craft that supplied them with wool and cloth and carried the commodities that they brought in return to the furthest parts of midland England. Consider the position of Andrew Malherbe of Amiens when his goods were temporarily confiscate in 1294. He had a warehouse stuffed with woad at King's Lynn, and his trade stretched over a wide area, to small market towns such as Brackley in the south Midlands, 85 miles from his base. Woad was an important dye-stuff, a necessary import for the cloth-making towns of the Midlands, The map also identifies a commodity that travelled in a reverse direction, as it collects references over a period of time to the Derbyshire lead mines. It was lead from Derbyshire that roofed the abbey of Clairvaux in Burgundy. The aristocracy of Europe, clerical as well as lay, expected the best, and knew where it was to be found. They expected to drink wine, and in some quantity. When wine started to be taxed, in the early

fourteenth century, it too can be studied in detail. Boston probably imported around half a million gallons of wine in the late thirteenth century, representing perhaps a tenth of the value of the wool exports. There were Gascon vintners in Boston, and their records shown a similar pattern of river distribution wherever possible. The rivers are the forgotten thoroughfares of medieval England.

The records of the English customs are new in Edward's reign, and provide a source of great interest for historians. But in terms of their bulk it is the records of the great estates that provide the major part of the documents surviving from this reign, and for the remainder of the middle ages. It is a time when political attitudes start from estate management, and as more and more estates became professionally managed, so managerial attitudes became more pronounced.

Edward was a manager no less than his men. In looking at the large amount of work that can be surveyed under this heading, it is necessary to make a distinction. The great landowners, the king among them, had under their control two types of property, over which their rights were very different. The first was lands held by them in demesne, the second was lands held of them in fee. Bishop Gros-

96 Boston church, Lincolnshire. The church of Boston dates from the early 14th century, while the great tower, the famous 'Stump', was added in the 1420s
Boston was one of the great ports of England: via the river Witham, seen in the foreground, it gathered in for export the wool of Lincolnshire and (via the Foss Dyke) much of the midlands also.

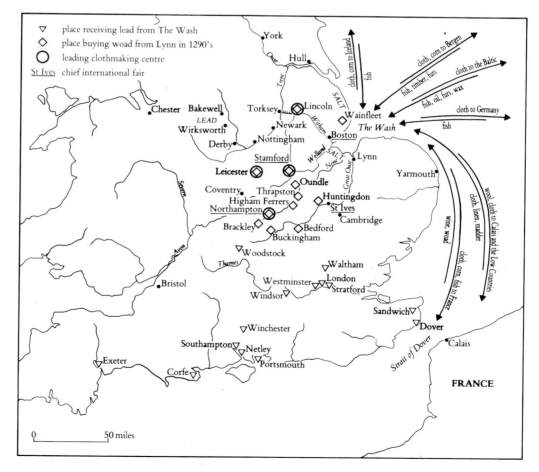

97 The medieval trade of the ports of the Wash
The importance of the network of river communications should be noted

98 Arms of Henry III. Late 13th century.
Salisbury Cathedral, west window
The use of heraldry as part of the scheme
of decoration of churches and secular
buildings became popular in the mid-13th
century (see also p. 136, no. 2).

99 Bury church, Sussex. The tower base is Norman
work, though the tower itself dates from c.1200; the
exterior is mainly 13th century, with late medieval
windows; the porch is Tudor. And yet all is in
proportion. No sudden accession of wealth has spoiled
the symmetry of this lovely parish church under
the Downs.

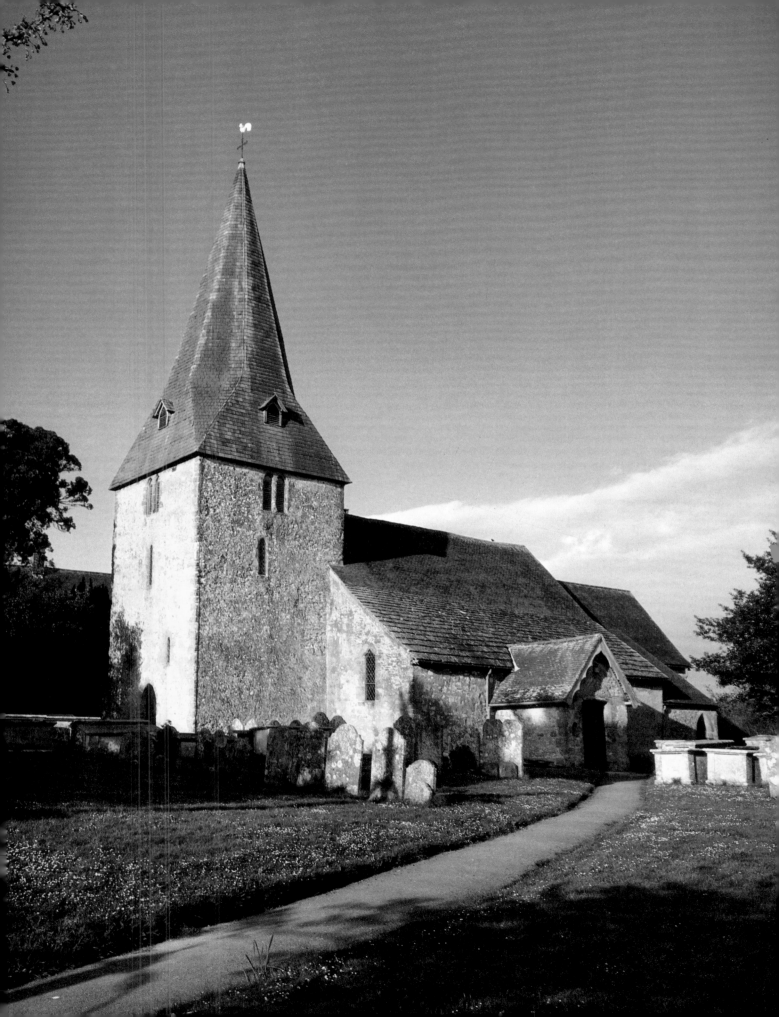

seteste's *Rules* started with this distinction, in advice given to a lord taking up an estate. Two sets of records should be made, one concerning the demesne manors, the other dealing with all other lands; 'and often study the first roll and this one also so that you can find out quickly what you ought to do'. The two types of property presented quite different managerial problems.

Lands held in demesne were subject to careful estate management, and were to be augmented by a policy of acquisition where circumstances allowed. The king himself in these matters was characteristically clear-headed and characteristically ambitious. He had started on his arrival in England with a survey of royal resources in which his own demesne lands had pride of place. He sought throughout his reign to extend his demesnes wherever possible, which he did for the same reason that all other of his subjects extended their lands. The king had a large family, and he was anxious to acquire lands for them. A typical transaction was the marriage settlement arranged on the marriage of his daughter Joan of Acre to Gilbert de Clare, earl of Gloucester. It provided for the bride, thirty years younger than the groom, a life tenancy of the whole of the Clare estate; if there were heirs of the marriage the children of the earl's first marriage would be disinherited in their favour, and if there were not Joan would retain property worth 2000 marks a year. This was a settlement very favourable to the bride.

Important changes were made in Edward's reign with regard to lands which were held in fee. In the later twelfth century lords had lost their effective control over lands held of them in fee, first their jurisdiction over their tenants, and then the right to prevent those tenants selling the land to whoever they wished. A long line of subordinate tenures might stretch from the chief lord (who in turn held of the king) and the person who sowed the grain and harvested the corn. The famous statute *Quia Emptores*, issued in 1290, starts with a complaint: 'since the purchasers of land' were no longer acting properly, the lords were losing out. Thus an estate held by feudal service of a magnate might be sold for ready cash by a tenant encumbered with debt. The new tenant would hold of the old, but the service element would become nominal, a rose at midsumer, a peppercorn, or even simply 'a greeting'. Now in some circumstances, most notably if the tenant left a child under age, the land would revert to the lord, and in a time of rising prices might be worth a great deal. But if the land had been sold for one of these token annual rents, it was to that token only that the lord succeeded, 'which seemed to the said lords (the statute went on) very hard and difficult, amounting almost to their disinheritance'. To stop this happening *Quia Emptores* said that no new grants could be made in

fee: a purchaser of land had to take over the obligations of the vendor, whose interest was eliminated. There were similar problems involved in the grants of land into the dead hand (*mortmain*) of the church. The Statute of Mortmain of 1279 gave a national authority to what was becoming a widespread provision of local charters. There was a total ban on all grants in fee to religious corporations. What in fact happened was that a licensing system evolved: a religious house could buy from the king licence to acquire lands up to a certain value. There was profit for the king here, but profit was not the chief motive of this legislation. Rather there was an attempt to make feudalism work, to get back to first principles, here to the idea of land as the security for a personal relationship between lord and man. It was Edward's wish to make the feudal bond the animating force of English society.

War on Two Fronts

In 1290 Edward was at the height of his power. His was an image of good kingship that the late thirteenth century could recognise. He provided a focus for the nation's political life. The Bury St Edmunds chronicler described the king as 'energetic, generous and triumphant, like another Solomon'. But the 1290s were to be a testing decade for the English monarchy. Two deaths mark the beginning of Edward's troubles. His queen, Eleanor of Castile (see picture essay), died on 25 November 1290. Much further north, a few weeks earlier, Margaret 'the maid of Norway' had died. If for Edward the loss of his queen was a private tragedy, for the Scots the loss of this child was a national disaster. Margaret was the grand-daughter and only descendent of Alexander III; with her death the royal line of Scotland failed. It had been arranged, in the treaty of Birgham made the previous year, that Margaret was to marry Edward, the king's fourth-born son and now his heir. Each in their lifetime would rule their own kingdoms; any son born to them would rule the two kingdoms jointly. Scotland would retain its own laws and liberties. It is interesting to speculate on what might have been – the reign of Edward II without Bannockburn and with a different queen, and with a son, who might have been Edward III, but who would have had no claim to the throne of France. A lot hung on one life.

When the young Margaret died in the Orkneys Edward lost any dynastic interest in the affairs of Scotland. It is not surprising, though it was resented, that he then changed his tune. When the English king and his council met the guardians (*custodes*) of Scotland at Norham in May 1291, he stated that he had come to do justice 'by virtue of the superior lordship which belongs to me'. It was recognised

100 Edward I's title in
Scotland. London, PRO
E 36/274, fo. 38v, 1290s
Material collected for Edward I
relating to his claims in
Scotland, kept in the royal
'coffers' or archives (*Titulus
Scocie in cofr'*).

that the Scottish succession would be decided in the English parliament, to which there would be added for this case eighty 'assessors' nominated by the chief contenders, John Balliol, Robert Bruce, and John Hastings. These were men whom Edward knew well. Each had substantial landholdings in England, which had been inherited in the time of Henry III. This meant, and the point is important for an understanding of the king's attitudes, that they were already Edward's subjects. The family of Hastings were the hereditary stewards of the abbey of Bury St Edmunds: the chronicle there noted the birth of John's eldest son on 4 October 1282, but took no special interest in his claim to Scotland. The family of Balliol, originally from Bailleul-en-Vimeu in Picardy, was of magnate rank in northern England, its main bases at Bywell-on-Tyne and Barnard Castle. Neither family had any standing in Scotland before the thirteenth-century marriages which were to make one of them, for a time, king of Scotland. The family of Bruce had been long established in Scotland, its position in Annandale already noted (p. 32), but it too had substantial estates in northern England. In terms of the loyalties of individuals, no easy division could be made between Scottish and English at this time.

Edward, starting from a consideration of these loyalties, was concerned that his rights in Scotland be clearly defined. He embarked on a programme of historical research. The monasteries were asked to search their chronicles, and to send note of 'anything touching the status of the realm of England, or the rulers of the same, at any time.' The returns of twenty houses survive, and

this was only a part of the historical effort, for monks from the great centres of historical writing, such as St Albans and Bury St Edmunds, went in person to Norham and Berwick, taking their books with them. It must have been a great occasion for these monks, the vindication of a lifetime devoted to scholarship. Inevitably, however, to lawyers looking for precedents, their findings seemed too diffuse and too academic: 'nothing to the purpose' was the verdict on the efforts of the monks of Bath; 'nothing new here', which may mean that the information was already to hand, the comment on the library at Reading. In fact, the faults lay in the authorities themselves, writing each in a different style – the careful but allusive William of Malmesbury being followed by the slapdash Henry of Huntingdon – but all of them writing at times when the relationship between the two kingdoms had not the sharpness that the lawyers sought. At the end of the day judgement was given in favour of John Balliol, the justice of his claim being accepted by a majority of the assessors nominated by his chief rival Robert Bruce. Edward brought peace to Scotland, and gave the Scots a new king. To explain why neither lasted for long, the story must shift once again to France.

Once upon a time the men of Bayonne in Gascony mounted a raid against a group of sailors from Normandy. The deeds of those who sailed to the Bay of Biscay had all the makings of an excellent bedtime story, for any child not of a sensitive disposition; but this marks the beginning not of a story but of a legal record, the French rolls of parliament. They take their name from it: they are the *Olim*

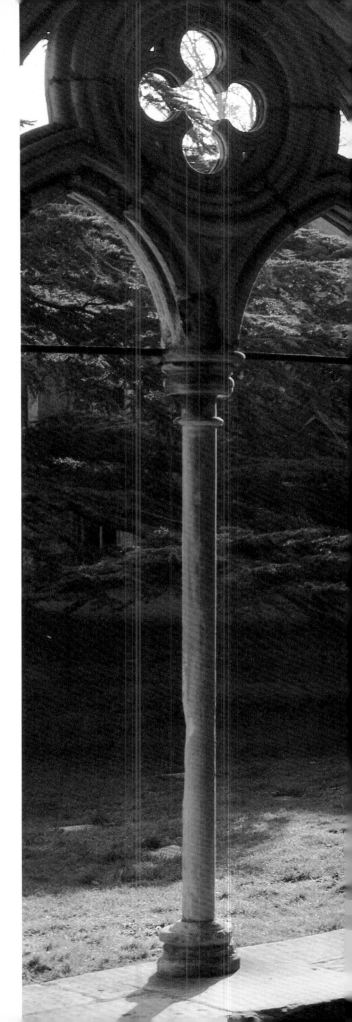

101 Earthenware glazed jug. *c.*1250–*c.*1300. Coventry, Herbert Art Gallery and Museum
The figure of a man is represented here, his body shaped as an hourglass. The jug was found on the site of Coventry Cathedral Priory, and very likely produced at kilns at Chivers Coton near Nuneaton. There were many local pottery centres of this kind in England, serving a local market.

102 Salisbury Cathedral, the cloisters. *c.*1270–*c.*1300
A late addition to the plan of the cathedral (Pl. 79). The cloister here may be counted as ornament, for there was no community of monks serving the cathedral.

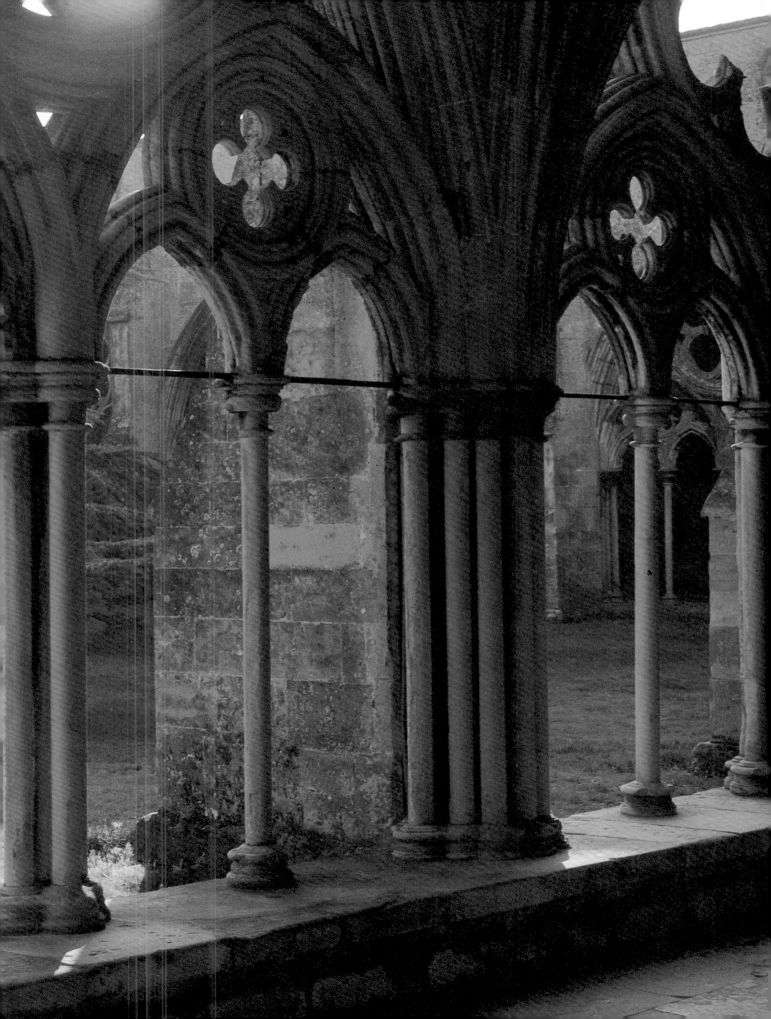

103 'Artery man', from a medical treatise. Oxford, Bodleian Library, MS Ashmole 399, fo. 19r, c.1292

The animating force in the human body is seen as being a black grain in the heart, from which the arteries radiate, and air bubbles appear to rise to the mouth. Other drawings in this 'five-figure series' (*Fünfbilderserie*) show veins, bones, nerves, and muscles.

or 'once upon a time' rolls. The story they tell is of a dispute between France and England, for the men of Bayonne and of Normandy were the subjects of two different lords. Under what law was the case to be tried? Philip the Fair, who had succeeded as king of France in 1285, insisted that as overlord of Gascony as well as of Normandy the case should come to his court. Edward, who had troubles enough in the British Isles, wished at all costs to avoid a war with France. He therefore negotiated a settlement which would acknowledge the French king's jurisdiction, but would not lead to any permanent loss of English control over Gascony. Bordeaux and other towns would be handed over; hostages would be given; after a suitable interval these would be restored, and the summons to the English king to appear personally in Paris to answer for his men's actions would be withdrawn. All was carefully worked out; the surrenders were made; but Philip refused to honour his part of the bargain. Gascony was not returned. To Edward's subjects, unaware of the diplomatic niceties, this all seemed very odd. What they did know

was that Edward was negotiating at the same time to marry Blanche, the French king's sister. This must be the answer, the king's reason was being clouded by passion, and he was giving away rights that should never have been conceded. The king was very anxious to marry again, for only one of his sons survived, but this was only a part of the answer. Faced with the imperatives of legal judgement, diplomacy had broken down. Edward, refused a safe conduct to the French court, had no alternative but to go to war. To add insult to injury, the marriage was then broken off: 'the woman, who was the cause of all the trouble, wrote to inform him that she did not wish ever to marry any man, especially such an old one'. That last remark became common gossip; for many of the king's subjects it helped briefly to cheer up what otherwise was the rather cheerless summer of 1294, for heavy rain ruined the harvest, and 'there was famine and great want throughout England'.

The Bury Chronicle, showing excellent historical sense, went straight from describing the king's disappointments to give details of the grand alliance which the king, on the advice of his council led by Anthony Bek bishop of Durham, put together. It involved bringing together, 'by bribes and treaties and promises of mutual friendship', among others the kings of Germany and Aragon, and a list of others in the Low Countries headed by his sons-in-law the duke of Brabant and the count of Bar. The cost of the promises made to these and others between 1294 and 1297 has been estimated at £250,000, of which sum more than three-fifths was actually paid. The king's own military expenditure was on top of that and at a much higher level. Spending within Gascony for the remainder of the 1290s was £360,000; and this did not cover the wages of troops in England, or their transportation. And the French war was not the king's only commitment in these years, though it was the most expensive; there were also major campaigns both in Scotland and in Wales. In the opinion of Michael Prestwich, from whom all these figures are derived, the king's military expenditure from summer 1294 to early 1298 amounted to around £750,000. No sum of this kind had been raised by a king of England for warfare for a century, since the great days of Hubert Walter. England had not grown poorer in the meanwhile, but it had grown unaccustomed to continuous taxation.

Edward of course did not lack a solid theoretical base for his claims, but essentially they were pragmatic. Could he have the use of the resources of his kingdom that lay to hand? It would be tedious to look at too much detail, but the king's behaviour in the summer of 1294 will show his approach. On 12 June he ordered the seizure of all wool and hides, wherever found; the merchants could

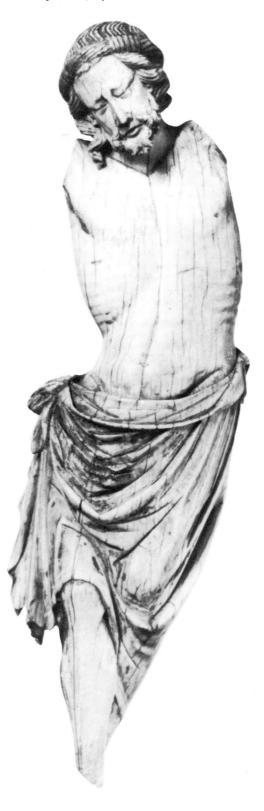

104 Crucifix figure. Late 13th century, elephant ivory, height 24.3 cm. London, Victoria and Albert Museum

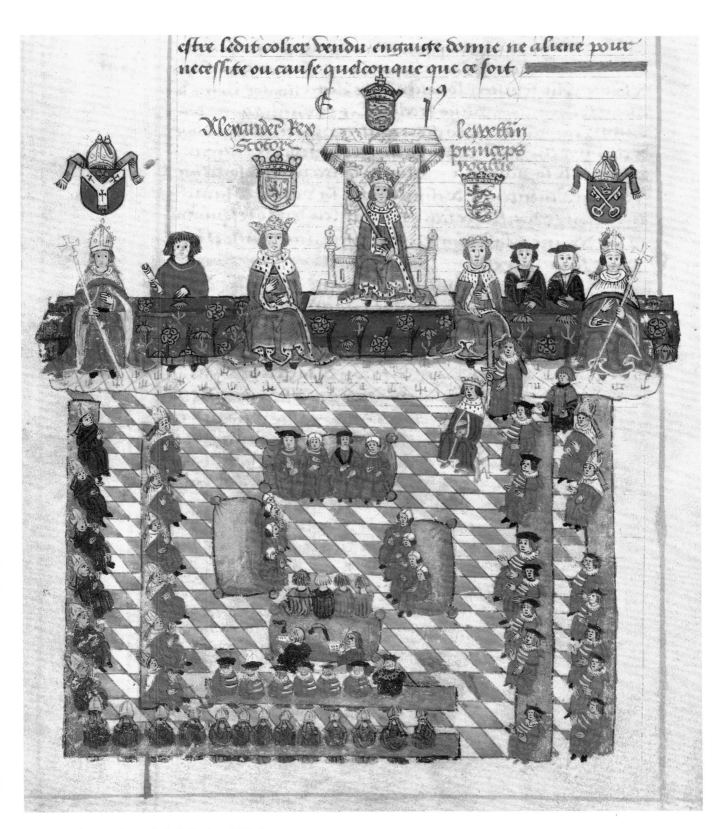

esire sedit colier vendu engaige donic ne aliene pour
necessite ou cause quelconque que ce soit

Alexander Rex
Scotore

lewellin
princeps
wallie

105 (LEFT) Lincoln Cathedral, the Angel Choir. *c*.1260–*c*.1280
The new choir at Lincoln, whose name comes from the angels who are so prominent a feature of its decoration, was probably completed
before the translation there of the bones of St Hugh in 1280.

106 Edward I's Parliament. Windsor, Royal Library, Heraldic MS 2, fo. 8v, early 16th century
This represents parliament as it was supposedly held in the late 1270s, with Alexander III of Scotland and Llewelyn prince of Wales sitting
in (to English eyes) their proper place, at the foot of the English king. The lay lords sit on benches to the right, the lords spiritual to the
left, and in the centre are the chancellor and judges, sitting on woolsacks.

reclaim their goods, but only on payment of an increased duty, the *maltote* (p. 144). On 14 June Edward required his feudal tenants to be at Portsmouth on 1 September, ready and properly equipped for service abroad. He was shortly to order the king of Scotland, as one of his tenants, and twenty-six magnates of Scotland to be there as well. On 16 June he ordered the examination of all money in churches and monasteries, bank deposits of a kind, to ensure – so at least it was claimed – that all was sound money of proper weight. On 18 June he ordered the clergy's prayers for the war effort, but offended them further by declaring confiscate money collected towards the crusade, which by arrangement should not have been released until the crusade was prepared. The scrutiny of the money, even though none was taken, was particularly resented, for it ignored the immunity of the clerical order, and was seen as an invasion of sanctuary. Some money was taken as forced loans; the majority was counted and sealed up, to be used only *ad opus regis*, for the king's use. Then in September the clergy were ordered to grant a tax of half their income, however derived. The sums involved were very different in each case, but the philosophy was the same: forced loans, forced service; the seizure of cash, and the seizure of wool which was almost as good as cash, All the resources of the kingdom were to be put *ad opus regis*, to the king's use. The king's directness drove this idea through. He was successful in changing his subject's presuppositions about taxation, and this is his great achievement. But he met with some spirited resistance, particularly from the clergy.

Laymen, said Pope Boniface VIII in February 1296, are notoriously hostile to clerks. He said this in a bull which takes its name from these opening words, *clericis laicos*, which was to ban all taxation of the clergy without papal licence. The pope had the kings of France and England particularly in mind, for these two kings, engaged in warfare with one another, were placing unprecedented demands on the wealth of their clergy. Early in November 1296, the papal bull, with its unequivocal instructions, was considered by the clergy at Bury St Edmunds where Edward had summoned a parliament. The clergy, as was their custom, met in a separate assembly whenever parliament was summoned. In this way they preserved their independence, but recognised that they had a common obligation to provide taxation at the same time as the lay estate. On this occasion the clergy could see no way to circumvent *clericis laicos*, and they asked for more time to consider the king's request for a subsidy. Edward, punctilious as ever but determined not to give ground, allowed them forty days (in fact a little longer because of Christmas) after which the clerical estate would be considered as

outlaws. Until then it was business as usual. Edward then 'solemnly kept the feast of St Edmund [20 November] with the chief men of the realm and entertained the convent'. By the time that the clergy met in January the political situation had changed: Edward was able to make an alliance with the count of Flanders, thereby opening another front against the French. In terms of value for money this alliance was to be highly cost effective; but this was not the perception of the king's subjects at the time. It seemed yet another, and this time insupportable burden; the clergy refused to pay and, as threatened, they were outlawed.

Edward was determined and single minded during the early months of 1297. He had a good chance of wearing down the clergy's opposition for, even under Archbishop Winchelsey's clear lead, they were a divided estate; the northern bishops, for whom the Scottish threat was more immediate, agreed to pay, and several of the southern bishops, influential royal servants, were also sympathetic to the king. What changed the position, and made 1297 an important year in English constitutional history with the last major reissue of Magna Carta, was the appearance of a lay opposition. It was led by the earls of Hereford and Norfolk, respectively constable and marshall of England, the two household officers who had particular responsibility for the royal army. In stressing these offices, long in their families but little emphasised hitherto, the earls were making their own appeal to history. In March they refused to serve in Gascony, as the king would not lead this army himself; later they refused to serve in Flanders, because there was no tradition of service there. In each case they had an argument, but the reason why those arguments were produced at this time was that the laity , like the clergy, felt that they were being pushed too hard. In the countryside there was particular resentment against prises, goods taken by prerogative right for the support of the royal household and armies.

Whatever principles they may have adduced, the earls' protest in 1297, drew its strength from political dissatisfaction that was widely spread through the country at large. That they judged the public mood aright was shown by Edward's response. He sent out, for promulgation in the shires, a letter which gave his own version, in some detail, of his quarrel with the earls, and which promised his subjects relief from the burdens of necessity placed upon them when he was free of his difficulties; 'in order to foster unity', he would confirm the Charters. Events in Scotland were to make this a promise that Edward had to keep.

John Balliol had been crowned king of Scotland in 1292. His effective rule lasted only three and a half years. In 1295 he was deposed by a Scottish parliament which

107 Edward I (LEFT) and Philip the Fair. London,
PRO E 368/9 m. 54
The sketch is found in the margin of a copy of the truce made
between the two kings at Tournai in January 1298.

met at Stirling, when control of the kingdom was vested in twelve 'Guardians'. This 'sober constitutional revolution', as Professor G. W. S. Barrow puts it, stemmed from events in the previous year, when Edward I went to war with France. Edward mobilised the resources of his kingdom, and made it clear that he felt that Scotland formed a part of those resources. He had already started hearing Scottish appeals in his own court; now he required the personal service in his army of the Scottish king and the leading magnates of Scotland. Instead they sent apologies, and formed an alliance with the French. This was rank insubordination. When next the English feudal host was summoned it was at Newcastle on 1 March 1296, ready to march against the Scots. Berwick was sacked; the Scottish army was defeated at Dunbar; and in a progress that extended as far north as Elgin Edward imposed his lordship on the Scottish rebels. But how was this lordship best expressed, and how best secured? Edward sought its expression, characteristically, in the swearing of oaths of fealty. Two thousand Scotsmen swore allegiance to the English king, and these assurances were sent to Berwick, which rose from the rubble as the command-post of English rule over Scotland. Edward established Englishmen to supervise the administration which these Scotsmen controlled. As had happened in Wales, this supervision

provoked its own reaction. First the English garrisons in the north of Scotland were driven out. Then, outside Stirling castle – where highland and lowland Scotland might be said to divide, an English army led by the earl of Warenne and the treasurer Hugh Cressingham was defeated by a Scottish force under the command of William Wallace. William was from Paisley near Glasgow, a tenant of James the Stewart (steward) of Scotland, one of the Scottish magnates who had always favoured the claim to the throne of Robert Bruce. The Battle of Stirling Bridge was fought on 11 September 1297. On 12 October Edward reissued the Charters.

It was as well for Edward that he was having some success in France. He had been able to take only a small army to Flanders in August 1297, but it was successful in opening up a new theatre of war. The king had found, said Professor J. R. Strayer, that 'he did not have the strength to do everything that he wanted to do and he certainly did not have the strength to conduct two major operations at the same time.' This describes Edward's position very well; but in fact the quotation refers to Philip the Fair. Both kings were overstretched. Because of this, the truce that Edward and Philip concluded in October 1297 (the month in which the Charters were reissued) marked the end of warfare between them. If Edward would not intervene to complicate Philip's position in Flanders, so it was tacitly agreed, then the French king would not intervene in Scotland. Circumstances changed in each of these theatres of war, but not enough to disturb this balance of interest. In England this made for a lowering of the political temperature, and if the king reduced his demands he could afford to do so, for the rights he claimed remained unaffected. In 1298 the clergy granted a tenth of their revenues, both spiritual and temporal. 'Certain people', said the Bury chronicler, raised their eyebrows at this, 'because this year they had contributed voluntarily what another year they had refused even under compulsion.' He supplied the answer: 'the war is lawful because it is fought for the safety of the kingdom and the common weal . . . the property of everyone is obviously (conspiciter) involved.' When this became obvious to the Bury chronicler, Edward had won his greatest battle. Every one of his visits to this monastery, and there were fifteen in all, may be accounted as skirmishes in a long campaign. It was a fight, in the last analysis, for his reputation. The excellent feasts he offered the monks on his visits were aimed to impress one monk above all, the one who continued in his own day the historical work that the king so valued. No modern politician ever cared more about his press notices than did Edward I.

qui non abyit in consilio
impiorum & in via pecca-
torum non stetit: & in cathe-
dra pestilentie non sedit.
Sed in lege domini vo-
luntas eius: & in lege eius
meditabitur die ac nocte.
Et erit tamquam lig-
num quod plantatum
est secus decursus aquarum:
quod fructum suum da-
bit in tempore suo.
Et folium eius non de-
fluet: & omnia quecum-
que faciet prosperabuntur.
Non sic impii non sic:
sed tamquam pulvis
quem proicit ventus
a facie terre.
Ideo non resurgunt

impii in iudicio: neque pec-
catores in consilio iustorum.
Quoniam novit dominus
viam iustorum: & iter im-
piorum peribit.
Quare fremuerunt
gentes: & populi
meditati sunt
inania?
Astiterunt reges terre.
& principes convenerunt
in unum: adversus dominum
& adversus christum eius.
Dirumpamus vincula
eorum: & proiciamus a no-
bis iugum ipsorum.
Qui habitat in celis ir-
ridebit eos: & dominus
subsannabit eos.
Tunc loquetur ad eos
in ira sua: & in furore
suo conturbabit eos.
Ego autem constitutus
sum rex ab eo super syon
montem sanctum eius:
predicans preceptum eius.
Dominus dixit ad me
filius meus es tu: ego
hodie genui te.
Postula a me et dabo tibi
gentes hereditatem tuam

6

THE END OF DIPLOMACY
1307—1349

O**N 10 FEBRUARY** 1306 John Comyn was murdered in the church of the Greyfriars at Dumfries. He had gone there to meet Robert Bruce, a grandson of the 'Competitor' for the kingdom in 1291–2 (see above p. 151). The decision then had been in favour of Comyn's uncle John Balliol, but Balliol had been removed by Edward I in 1296, and for a decade the Scots had had no king. The leader of the Scottish resistance to Edward I, William Wallace, had been captured and executed: his quarters still stood on the bridges of Newcastle, Berwick, Stirling and Perth. Those trying to revive the Scottish resistance to the English king were playing for high stakes; and to revive the Scottish kingship was to play for the highest stakes of all. Yet it is clear that Bruce suggested this to Comyn at their meeting. Well might they meet on hallowed ground, and in private. Before the high altar, on which a compact might have been sworn, Comyn urged caution, and was killed, the initial blow coming from Bruce's dagger.

The story spread fast, and for many what they heard must have represented a curious reversal of roles. The three Robert Bruces who had lordship during the previous decade had each taken Edward I's part. The youngest of them, whose dagger struck down John Comyn, had mustered troops against Comyn and Wallace in 1303 and 1304. His younger brothers were also tied to the English cause: Edward was in the household of his namesake the prince of Wales, while Alexander, after a brilliant career at Cambridge, had a benefice near Wigtown and hoped soon for better things. It had been Comyn, the older man, who had served as guardian of the Scottish interest, as had his father before him, and had been imprisoned from 1296 to 1298; as John Balliol's nephew Comyn would not sup-

port a Bruce claim to the throne. Edward might be failing, but there was life in him yet (his second queen was pregnant again). Bruce and Comyn, as they first talked and then quarrelled, must all the time have been looking over their shoulders at Edward I. In the years which followed, and which form the subject of this chapter, the positions were reversed. The English, and not just those who lived in the north of England, looked ever more anxiously towards Scotland.

This would have seemed a remote possibility in the early months of Robert Bruce's rule. It began on 25 or 27 March 1306, for two ceremonies were held, at Scone, the traditional place of inauguration of Scottish kings. The Stone of Destiny, on which the ceremony should have been performed, was at Westminster, in token of the Scots' subjection; but otherwise the ceremony followed the normal forms. It made Bruce king, but of what? The great castles of Lothian, from Stirling to Berwick, remained in Edward's hands. He retained the initiative. Bruce was driven from the highlands, and thence from the mainland to the southern Hebrides; his wife and the women of her party were captured. Two of the latter, one of his sisters and Isobel of Buchan, were kept at Roxburgh and Berwick, in chambers specially made for the purpose, which according to one report were then hung from the walls. Edward, who has been much criticised for this episode, may here be the victim of his own propaganda. The women remained within the fortifications, but they were meant to be seen. Scotland had become an obsession for Edward; and his treatment of the males whom he captured was savage in the extreme. Alexander Bruce was among those executed. Moving north from Carlisle, Edward I died on 7 July 1307 on the southern shores of the Solway Firth. He was sixty-eight years old. His son, unmarried and uncrowned, had little choice but to secure his own lordship within England. This gave Bruce his opportunity. The relaxation of English pressure enabled him slowly to gain the upper hand in the civil war against the Balliols, Comyns, and their supporters, who since 1306 had sided with the English in order to avenge John

108 The Peterborough Psalter. Brussels, Bibliothèque Royale MS 9961–2, fo. 14r, 1299–1318
The dates are those of abbot Godfrey of Crowland, who according to the chronicle of Peterborough Abbey in 1318 presented to Gaucelin de Euse, the pope's nephew, 'a certain psalter written in gold and blue and admirably illuminated'.

Comyn's murder. One by one Robert Bruce took the main castles – Aberdeen in 1308 was particularly important, for it gave him access to the North Sea trade routes – until in 1313 and 1314 came the attack on Lothian. Roxburgh and Edinburgh fell, and Stirling undertook to surrender unless relieved by the summer of 1314. When the castles were taken they were razed to the ground, lest, said the Lanercost chronicler, 'the English should ever again be able to lord it over the Scots by holding the castles'.

Edward II

The new king of England, Edward II, was married on 25 January 1308 to Isabella of France, the daughter of King Philip the Fair. The marriage had been contracted several years before, but Isabella had remained in France, and when the marriage did take place, it was on French soil, most surprisingly since the bridegroom was now king of England. According to some accounts Edward behaved boorishly at the wedding, ignoring the bride, talking solely to Piers Gaveston, and giving him the wedding presents. If the queen's uncles were displeased at this, relations with the French king were at first good. After the birth of an heir on 13 November 1312 Edward visited France with Isabella in 1313, and found Philip the Fair accommodating, ready to issue pardons in Aquitaine, provided the jurisdiction of his courts was acknowledged. The visit went very well, and it was well-reported, for it uncovered

109 Second Great Seal of Robert Bruce, king of Scotland, in use 1318–29. Edinburgh, Scottish Record Office
The king is shown here on the reverse of his seal, wearing a hauberk of mail and a short surcoat charged with the royal arms of Scotland.

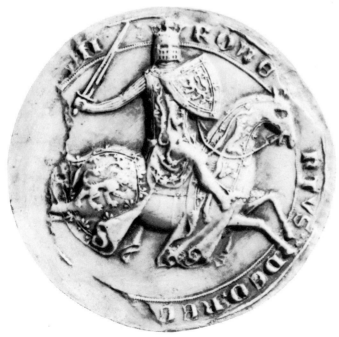

a sexual scandal at the French royal court. It was Isabella herself who was credited with the discovery that her sisters-in-law, the wives of her brothers Louis and Charles, were guilty of adultery. Their lovers were tortured until they confessed and were then flayed alive in the market-square at Pontoise. Isabella returned home, and before her husband's reign ended, her own adulterous relationship with Roger Mortimer was public knowledge. That relationship would help cost her husband his throne, and her lover his life. Isabella was not, and is not, a woman who can be taken for granted. In many ways she is the most significant figure in English politics in the first half of the fourteenth century. The story of her failed marriage becomes the story of Edward's deposition, and it was through her that there passed, to her elder son, a claim to the kingdom of France.

Edward returned from France to his coronation on 25 February 1308. The king and queen were crowned in a service which stressed majesty and royal duty in equal parts. The ceremonial had changed little since the Conquest, yet there were changes made in the undertakings which the new king gave to his people. Edward swore a new oath, 'to maintain and preserve the rightful laws and customs which the community of your realm will have chosen'. The oath did no more than anticipate future legislation, but upon it could be built a much more revolutionary doctrine, that the person of the king and the institution of the crown were two separate things. The crown was seen to be threatened by the king's irresponsibility in granting lands and offices to a small number of men. The first of them, 'the person who is talked about', as one text put it, was Piers Gaveston. Gaveston was a Gascon, a member of Edward's household when he was prince of Wales, whom he promoted to be earl of Cornwall after his accession. The eyes of all were on Gaveston at the coronation, 'so decked out that he more resembled the god Mars than an ordinary mortal'. For the rest of what was a short life, the spotlight never left him, and Edward, though frequently enjoined to do so, never willingly sent him away. Gaveston was named in the first parliament of the reign, accused of accroaching the powers of the crown. He was banished, but appeared again at the king's side at the Stamford parliament in July 1309. The Ordinances issued on August 1311 returned to the same criticisms that had been voiced in 1309; the king was warned that he risked civil war if Gaveston was not kept away. And so he was banished again, only to return within weeks, to be captured by a group of earls, and executed, on doubtful authority, on 19 June 1312. 'From that day', says the author of the indispensable *Life* of Edward II, 'a perpetual emnity grew up between the king and the earls'.

What was Gaveston's offence? He was a 'favourite', but one word is not an explanation. It translates *familiaris*, one of the king's intimate companions. All men needed their friends: kings, bearing the burden of public office, perhaps most of all. What was objected to was a relationship that drove out all other men, and all other considerations. 'Piers alone received a gracious welcome from the king', says the author of the *Life*, 'and the king would speak to no one save in his presence.' From such considerations would grow a conviction, widely held among the king's subjects, that he had no conception of his role as the holder of a public office; and this was to bring him down.

The ghost of Edward I, powerful, parsimonious, and ever watchful of his son's behaviour, broods over the Ordinances of 1311. These were a series of regulations, ordained by a committee of magnates for the well-being of the realm of England, and accepted by the king in parliament. They are important because they became the text for the decade, widely disseminated and much discussed. Discussion could only focus on the inadequacies of the king. 'The king must not', is the standard refrain. He must not grant any office, in central or local government, without the consent of the baronage in parliament. Nor was he to grant land, whether demesne or held of him in fee, without consent. He was not to leave the country, or to go to war. Parliament, in which the power of supervision was vested, was to meet once a year, twice if the pressure of business required. It goes without saying that the Ordainers, the archbishop of Canterbury standing at their head, were highly conservative in matters of taxation also. All monies should come to the Exchequer, and 'the men of the kingdom' should control the customs' revenue. This provision was aimed at the Italian banking-houses, whose loans gave the king the chance of independence from the constraints the barons sought to impose: the Frescobaldi were singled out. That 'the king should live of his own' was another recurrent phrase, to go with 'the consent of the baronage in parliament'. The Ordinances are a nagging document; the king must listen, and in his next parliament he was promised a full exposition of Magna Carta, the difficult bits resolved 'by the advice of the baronage, the justices, and other persons learned in the law'. All this, hard as it was to swallow, the king might have resigned himself to, had the person of Gaveston been left to him. This was not to be. Gaveston was exiled, 'as the open enemy of the king and of his people'. He had to be, for he summed up in his person the evils of which the barons complained. He had led the king to do evil, 'in divers and deceitful ways'. He was becoming rich. He was making sworn confederacies. And all this was against the common profit, as was well-known. To the question of

how it was known they had an answer to hand: 'ask anybody'. The whole kingdom knew, 'the prelates, earls, barons, knights and other good people of the realm'.

'And now', said the author of the Lanercost chronicle, after treating of the Ordinances rather less thoroughly than here, 'let us return to Robert Bruce and see what he has been up to in the meanwhile.' For him it was divisions at court, seen exclusively in personal terms, that gave the Scots their opportunity. 'When Robert de Bruce heard of this discord in the south, he assembled a great army and invaded England.' The reference here is to 1312, just after Gaveston's death, but it could serve for almost any year. The Scots terrorised the north of England: in 1312, as frequently thereafter, they levied protection money. 'The men of Durham, fearing more mischief and despairing of help from the king', gave them £2000 for a temporary truce; the men of Northumberland paid the same; those of Cumberland and Westmorland a smaller sum, surrendering hostages for the balance outstanding. These northern counties paid Bruce at least £20,000 in the decade which followed. The money was only part of the objectives of the raids: they undermined Edward's lordship, and they left fatally exposed those fortresses north of the Tyne which he still controlled. When in 1314 Edward went to the relief of Stirling his army was stopped short and defeated at Bannockburn (see picture essay).

The victory at Bannockburn conveyed legitimacy to Bruce's kingship, while Edward's reputation among his own people never recovered from this defeat. He saw the importance of Berwick, but could not defend it; starved of men and supplies, it fell in April 1318. The following month a raiding-party swept deep into Yorkshire, burning Northallerton and Boroughbridge. At Ripon the townsmen offered 1000 marks for peace; as security for payment, six of them were taken as hostages. Two years later, the men still in captivity and three-quarters of the debt still unpaid, their wives petitioned the king to force the archbishop of York, the lord of the town, to pay up. The archbishop might reasonably have replied that he had more important things on his mind. The previous year he had committed all the resources of his church and the cathedral city to meeting the Scots in the field. At Myton-in-Swaledale in September 1319 a second Battle of the Standard was fought, the Yorkshire militia trusting in the relics of the saints confronting trained Scottish troops. The result was a massacre, as damaging to local pride as was Bannockburn; it became known as 'the chapter of Myton', from the number of clergy slain. Edward abandoned his attempt to recapture Berwick, and retreated south; the Scots crossed the Pennines, laid up until after the harvest, and then burnt the corn and seized the animals of West-

The Battle of Bannockburn

IN ANGLO-SCOTTISH WARFARE the English generally won the main battles while the Scots won the wars. At Bannockburn on 23–24 June 1314, however, the Scots for once won a major victory. It was the culmination of the remarkable campaign in which Robert I, a defeated fugitive in 1306, wrested control of Scotland both from the English and from his Scottish enemies, the Balliol-Comyn faction. By late 1313 Stirling castle was the only major fortress held against Robert, and it was due to surrender if not relieved before midsummer 1314. When Robert made that agreement, he possibly calculated that domestic political problems would continue to prevent Edward II from making a major effort in Scotland. In the event, Edward led some 2–3000 cavalry and around 20,000 infantry north in June 1314.

Robert I could have avoided pitched battle, as usual, but that would have gravely undermined his position within Scotland. Yet battle was an awesome prospect. For centuries European battlefields had been dominated by mounted knights and men-at-arms, whose charges generally won battles by simply terrifying opponents into flight. Thus at Dunbar in 1296 Edward I's knights drove the much weaker Scottish cavalry from the field and then massacred the infantry, while at Falkirk in 1298 the Scottish cavalry fled at the first English charge. But at Falkirk William Wallace did manage to stop his infantry from running away. He formed massed circular formations of pikemen, around which were fixed stakes tied together by ropes, fencing them in. These *schiltroms* repelled the English knights, but were destroyed by Edward I's archers.

Robert I therefore had to do even better. Parts at least of his army were now experienced in warfare, and these he

arranged into four *schiltroms*, each apparently containing 1–2000 pike- and axemen, while his less reliable recruits were kept out of the way behind Coxet Hill. Instead of fencing the *schiltroms* in, he stationed them on a narrow front across the road to Stirling, with the trees of the 'New Park' on one flank and the low, boggy Carse of Stirling on the other, and had pits dug and spikes scattered in front of the position – all to disrupt

cavalry charges. Behind the *schiltroms* he positioned his own small cavalry force, about 500 lightly armoured horsemen, safe from the English knights but ready to counter archery attacks.

The battle started on the afternoon of 23 June, when King Robert (who was reviewing his lines) was charged by a lone English knight Sir Henry de Bohun, whom he killed. Part of the English vanguard then attacked the first Scottish

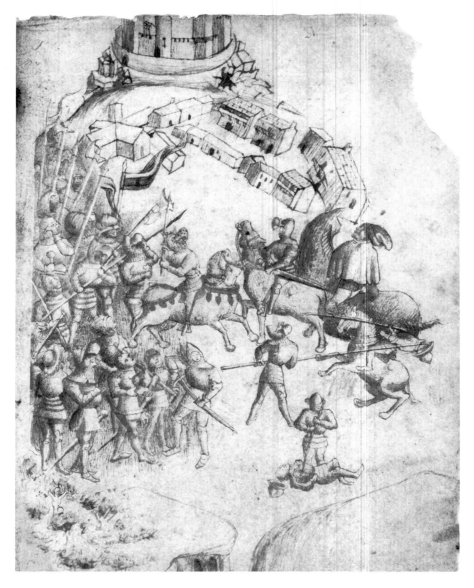

1 King Robert about to kill Sir Henry de Bohun. Cambridge, Corpus Christi College, MS 171, fo. 265, c.1445 (Walter Bower's *Scotichronicon*) Bower's impression of the Scottish weapons and formation is probably reliable.

schiltrom, only to be repulsed. Meanwhile other English knights tried to reach Stirling *via* the Carse, and Robert's nephew Thomas Randolph was sent to stop them. Randolph led over 1000 pikemen through the New Park quickly enough to intercept the English knights, and, fighting on open ground, drove them back.

By then night was falling, and the English commanders swung their army north-east across the Bannock Burn, to bivouac in the Carse. Robert had probably not expected that, and (since further fighting would not be on his prepared ground) he contemplated retreat. But reports of English quarrels and his realisation of where the English army had gone made him decide to fight. The English

2 The *Brecbennach* of St Columba (or 'Monymusk Reliquary'). 8th century, Edinburgh, Royal Museum of Scotland
This casket contained a relic of St Columba, and was used to inspire the troops at Bannockburn.

position had streams on three sides, and only a narrow front – making it safe against a night attack, but hopeless for a day-time cavalry battle. Therefore when day broke Robert moved his *schiltroms* forward, and confronted the English cavalry – who did not expect a daylight challenge – moving up out of the Carse. The earl of Gloucester charged with the vanguard to his death on the Scottish pikes. The battle then became a confused mêlée, in which the English cavalry had no room to manoeuvre. After a time an effort was made to deploy the English archers, as at Falkirk; but they were routed by the Scottish cavalry. Gradually the Scottish *schiltroms* pushed their enemies back into the boggy Carse and down the steep banks of the Bannock Burn. Victory finally came when the inexperienced levies left in the Scottish rear suddenly rushed into the battle. This broke the English nerve. The Bannock Burn and River Forth hampered flight; larger numbers of Englishmen were cut down, trampled to death, or drowned. Six magnates died, and many more were captured. Edward 11 was hotly pursued back to the Borders; Stirling castle surrendered.

With Courtrai (Flanders, 1302) and Morgarten (Switzerland, 1315), Bannockburn was one of three infantry victories which ended the mounted knight's centuries-long dominance. It taught the English a lasting lesson. When pro-Balliol English adventurers invaded Scotland in 1332 they had worked out how to deal with *schiltroms*. At Dupplin they (like Robert 1 at the start of Bannockburn) took up a narrow, defensive position, with *dismounted* knights and men-at-arms in line across the centre and with archers on the flanks; the archers, able to engage at the beginning of the battle, provoked and disrupted a Scottish charge, which the knights and men-at-arms then defeated. These tactics were successfully followed by Edward 111 himself at Halidon in 1333, and were applied even more devastatingly in 1346 against the French mounted knights at Crécy. Paradoxically, the disaster at Bannockburn paved the way for the English triumphs in France.

ALEXANDER GRANT

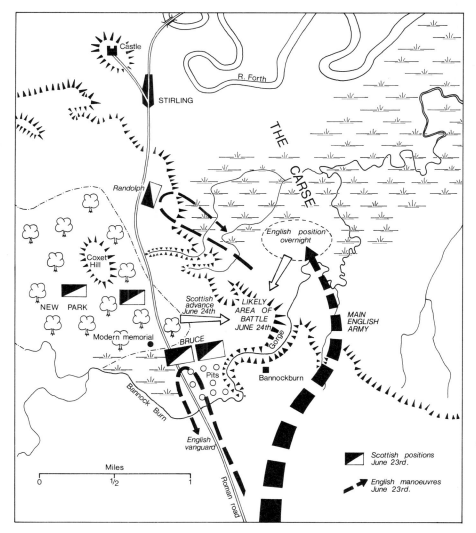

3 The Site of the Battle
Drawn by John Haywood, after G. W. S. Barrow, *Robert Bruce*, pp. 301–21. The whole area is on two tiers; the bank between the lower and the upper is steep, and over 50 feet high.

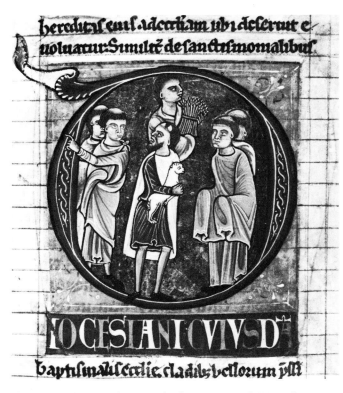

110 A dispute over tithes. Cambridge, Corpus Christi College,
MS 10, fo. 181r
A tithe (a tenth part) of grain and of animals was owed to the church.
The peasants, surrounded by a text which makes this plain (as is
pointed out by the cleric to the left), are still reluctant to perform
their obligation.

morland. Once only, in 1322, Edward attempted a
retaliatory raid into southern Scotland. He found the
country into which he marched stripped of all sustenance.
In the whole area, said a chronicler, they found only one
lame cow, on seeing which the earl of Surrey supposedly
remarked: 'this is the dearest beef I ever saw, it must surely
have cost more than a thousand pounds'.

The disruption of Bannockburn was not simply to the
peace and stability of the north England, it extended also
to the other marcher region, that of Wales as a result of
the death in battle of Gilbert de Clare, earl of Gloucester.
The Clares had been a force in the southern Welsh
marches for two centuries, since the time of Henry I. Now
the power was split, for Gilbert's heirs were declared to
be his three sisters. Eleanor was already married to the
younger Hugh Despenser. Her two younger sisters were
married in 1317: Margaret (who was Gaveston's widow)
to Hugh Audley, and Elizabeth to Roger Amory, who
had fought bravely at Bannockburn. Audley and Amory
were courtiers, raised to magnate status by their marriages.
The three brothers-in-law, along with the elder Hugh
Despenser and William Montague, made up a powerful

court party in the central years of the reign. Together they
shared an interest in destroying the Ordinances, for these
marriages, and many other grants made to them, should
by the terms of that document only have been made with
the consent of the baronage in parliament.

Thomas of Lancaster

For the Ordinances there stood the powerful figure of
Thomas of Lancaster. Thomas was the son of Edmund,
the younger brother of Edward I. He benefited from
Edward's acquisitiveness for his own family, inheriting five
distinct earldoms, and estate worth over £11,000 a year.
His birth and wealth made him the natural leader of the
English baronage. It was he who took the lead after
Bannockburn, and between 1314 and 1316 he supervised
the royal household and sought to provide fresh impetus
to the Scottish war. These were years of economic difficulty
(see p. 173), and he had no permanent success. In the per-
sonalities and actions of Edward and his courtiers he came
to see a return to the politics of the early years of the reign.

It took some time for Lancaster's perception of corrup-
tion at court, and support for the Ordinances as the univer-
sal remedy, to become a leading force in English politics.
The reaction when it came was against two of Edward's
courtiers, the younger and the elder Hugh Despenser. They
controlled access to the king, and took bribes for their
favours. The recently appointed bishop of Rochester was
required to pay the younger Despenser, in his capacity as
royal chamberlain, £10 for the restoration of his temporali-
ties; for both men it was a tiny sum, almost a gratuitous
insult, and no doubt intended as such. The Despensers
also denied the protection of the law to those who stood
in the way of their acquisitiveness. It was in the Welsh
marches that their ambition was most clearly revealed,
and provoked the first general reaction. The younger
Despenser's third share of the Gloucester inheritance was
strategically placed in the southern marches: first
Glamorgan was added, then the Gower peninsula. The
Welsh lordships were large and compact; the power given
by them correspondingly great. In the early months of 1321,
at meetings convened by Lancaster at Pontefract and the
nearby manor of Sherburn-in-Elmet, assemblies of
magnates, both northerners and marchers, agreed to seek
the Despensers' removal. They were exiled at a parliament
that met at Westminster in July 1321, each described as
'a destroyer of the people, a disinheritor of the crown, and
an enemy of the king and kingdom'.

Exile had not solved the problems of Piers Gaveston.
It would not solve the problem of the Despensers either.
The elder went to Flanders; the younger, like the classic

entrepreneur, anxious wherever he found himself to make a profit, turned to piracy in the Channel. The archbishop of Canterbury declared their exile invalid, and Edward proceeded to move against his enemies. He summoned troops to meet at Cirencester on 13 December 1321, and early in the New Year he moved towards the Welsh marches. 'For it was there', as the author of the *Life* observed, 'that the barons had their safest refuge, and it was difficult for the king to penetrate it without a strong force.' The most prominent of the barons at this point, after Lancaster, were Humphrey de Bohun earl of Hereford, and 'the lords Mortimer', Roger Mortimer of Wigmore and his uncle Roger Mortimer of Chirk. The earl of Hereford had married one of Edward I's daughters, and had initially supported Edward's son, but after the Ordinances he consistently took Lancaster's part. The Mortimer family had been established in the marches since the 1070s, their main castle being at Wigmore. The three magnates at first had some success, but a swift campaign brought the king to Shrewsbury. From there he stood poised to destroy the Mortimer power in central Wales. It was not simply English troops that he could call upon. For this king of England was Edward 'of Carnarfon', of Welsh birth and with his own lordship in Wales. 'It is not wise to set yourself in opposition against the king', said the author of the *Life*; 'the outcome is apt to be unfortunate.' The Mortimers, reflecting on the truth of that

observation, submitted and were sent to the Tower of London. Hereford survived to fight another day.

Edward II then moved north. Lancaster was the enemy. A crude English patriotism was the weapon; and on this matter Lancaster's reputation was at best ambiguous. The author of *Life*, no severe critic, more than once testifies to popular suspicions of the earl's motives. Why had Lancaster's lands been spared by the Scots? Why had they been able to pass through his lines? It was difficult to judge: 'whether the earl is a breaker of faith in this, or is guilty of treason, may be left to the verdict of more important persons.' There were no doubts in the king's mind, and there was Gaveston's death to revenge. Lancaster's support fell away, and even his retainers were reluctant to fight for him. At Boroughbridge on 16 March 1322 his forces were intercepted by troops led by Andrew Harclay. The earl of Hereford fell that day. Forced to dismount from his horse, he was struck from below; 'it is not the custom of knights to protect their private parts', observed Sir Thomas Gray, the author of the *Scalachronica*, and the wound proved fatal. Even so, Hereford was lucky. Lancaster was captured the following day, and kept in custody in his own castle at Pontefract. He was given no chance to answer the charges laid against him; they were held to be public knowledge, and on 22 March, in front of a jeering crowd, many of whom must have been his own men, he was executed. His was only one of the many public

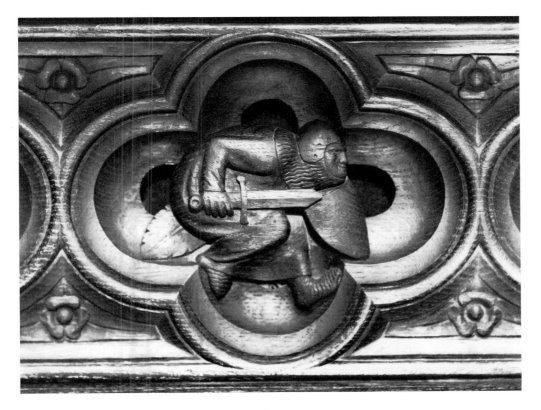

111 Armed warrior. *c*.1370. Lincoln Cathedral, desk front on the choir stalls, north side.

executions. After Boroughbridge, a parliament was immediately convened, to meet at York from 2 May 1322. This was Edward's formal revenge for the humiliations that he felt had been heaped on him for a decade. The Ordinances were revoked. The lands of those who had opposed the king were declared confiscate.

Lancaster lived at a time when feudal loyalties, for Edward's father the very basis of politics, were hopelessly compromised. More straightforward men than Lancaster would suffer in consequence. The fate of his captor, Andrew Harclay, for his services made earl of Carlisle, is eloquent witness to this. As sheriff of Cumberland, in the front line of resistance to the Scots, Harclay had one of the most demanding military commands in England. In the summer of 1322 one of many truces made with the Scots expired. At the time the Scots were raiding deep into England, and Edward himself narrowly escaped capture near Rievaulx Abbey. Harclay was not alone in seeing this summer as a turning-point in the war, evidence that it could not be won. But while many said this the earl, with the directness of a military man, took action; he disbanded the local militia, and sought out Bruce to discuss terms of peace. The peace would have to recognise Bruce as king of an independent Scotland. To anyone in the north, this seemed to be commonsense; but to the king and his council it seemed treasonable. The earl was captured at Carlisle, taken to London, and tried under the laws of arms; his spurs were cut from his boots, the sword of his earldom was broken over his head, and the outer garments which bore his arms were stripped from him. Did the royal justices, as they first degraded and then killed one of the best of the king's officials, understand anything of the problems he had had to face? The friars of Carlisle, to whom the earl told the full story of his life, gave him absolution.

What had gone wrong? Why had things come to this pass? The questions were asked, ever more insistently, in great halls, in cloisters, and in taverns throughout the land. One of the friars of Carlisle wrote what is known as the Lanercost chronicle. His summary of the king's behaviour is but one of many in a similar vein.

From his youth he devoted himself in private to the art of rowing and driving carts, of digging ditches and thatching houses, as was commonly said, and also with his companions at night to various works of ingenuity and skill, and other pointless and trivial occupations unsuitable for the son of a king.

The extract takes us back to the king's youth, and to the place where much of that youth was spent. The Edward of these stories was best known to his subjects as the squire of King's Langley in Buckinghamshire.

112 Pilgrim badge: Thomas of Lancaster. London, British Museum, 2nd quarter of 14th century, 165 mm. × 127 mm. The life and death of Thomas of Lancaster: (FROM TOP, LEFT TO RIGHT) the king grants the Ordinances, 1311; the battle of Boroughbridge, 1322; the earl taken in a boat to York; he is tried; put on a horse with no bridle; and executed.

King's Langley was the Chequers of the fourteenth century, the retreat in the Chiltern Hills where the country's leader rested from the cares of state. The manor, one of the many acquisitions of Eleanor of Castile, was given to Edward in 1302. A good deal of money had already been spent on it. In addition to the public rooms of any large house – the hall decorated with paintings of '54 shields and four knights seeking a tournament' – there were extensive suites of private rooms for both lord and lady. There were gardens and vineyards, a park with its own lodge, which Edward as king converted to accommodate the Dominican friars whom he established there. A new lodge was built to replace it, with its own hall and chambers and outbuildings, one of them thatched. And there was a small working farm, with meadowland down by the river, and two water-mills, one for grinding corn, and the other for fulling cloth. Edward, as prince and then as king, was active about his estate. It was here that Gaveston's body was received for burial.

Isabella and Mortimer

It had been the king's misfortune, and was now to be his tragedy, that his relationship with his wife failed. The story of the king's deposition is the story of a failed marriage; but to say that is not to say enough. Isabella was an important political figure, in some respects the most important political figure, throughout her husband's reign. In part this was a matter of wealth. She was given a generous establishment, and allowed to overspend: with £10,000 a year, she was fully the equal of any of the earls. In part it was a matter of temperament. Her household books from early in the reign show her maintaining an active correspondence, with the French court, with several of the earls, and with her own friends. The queen felt excluded, as did the rest of the political community, by the favours shown first to Gaveston (a relationship which many at the time believed to be homosexual), and then to the Despensers. The St Paul's chronicle says that in 1321 she spoke for the people in asking that the Despensers be banished. The whole basis of her activity was threatened by the confiscation of her land in September 1324, the alleged reason being the threat from France. There were precedents, but Isabella was outraged by this treatment, for which the Despensers were held to be responsible. Before her lands were returned the queen had gone abroad, in March 1325, on a peace mission to France. 'It would be right, father,' wrote the prior of Canterbury to his archbishop 'that the lady queen, before she crosses over, should have restored to her her accustomed and dignified state.' This was well observed. The threat to her own household, and the break from the court, did what no earlier insults had achieved, turned Isabella directly against her husband.

Isabella was not exiled. She went as ambassador to the court of Charles IV (1322–8), the youngest of three of her brothers who had succeeded their father Philip the Fair who had died in 1314. These short reigns had exacerbated the problems of homage, due from the English king in his capacity as duke of Gascony. War had broken out in 1323 when bungled diplomacy had made it appear that Edward II was reluctant to perform his obligations. Isabella's legation resolved the immediate problems. A truce was followed by the arrival of her son Edward, then aged twelve, who did homage for Gascony and promised a relief of £60,000. Their mission completed, the queen and her son stayed on. They joined a group of exiles from England, of whom the most significant was Roger Mortimer, who in 1323 had joined the select band of those known to have escaped from the Tower of London. Edward came, much too late, to see the danger offered to him by his wife's connections, to which were now added rumours of an affair with Mortimer. A watch was kept for the queen's messengers, wherever bound. Papal legates, announcing terms for peace, were turned back at Dover by the king in person. Rumour spread fast. The government's press officers, from their post in St Paul's churchyard, denied the more damaging of them, but could not halt the tide. The whole reign had been a public relations disaster, and now it was approaching its end. The queen and Roger Mortimer landed at Orwell on 24 September 1326. The English version of the very popular *Brut* chronicle describes the king and the Despensers sitting at table in the Tower of London when word of this was brought to them. The first messenger brought news that a great army had landed with the queen. This provoked no alarm, but then a second messenger appeared, who said the queen had brought only 700 men. Then the elder Despenser cried aloud: 'Allas, Allas! We beth alle bitraiede; for certes with so litil power she had never comen to lande, but folc of this lande were to her consentede.' The scene is doubtless imagined, but it expresses an important truth. The queen's enterprise was risky; it would have been foolhardy had she not counted on popular support, and the help of key individuals contracted for in advance.

There were two views about Queen Isabella, then as now: 'some declared that she was the betrayer of the king and the kingdom, others that she was acting for peace and the common welfare of the kingdom, and for the removal of evil counsellors from the king.' When they had to decide, they came down in her favour. The queen, as soon as she landed, sent messengers to the Londoners and to the other towns of England, and their support proved crucial. The king could not hold his capital. He retreated westwards, to the Despensers' power-base in the marches, to the last identifying his cause with theirs. The queen followed at a distance, 'doing no harm to the countryside, but only devastating the manors of the Despensers, father and son'. The elder Despenser was captured at Bristol, the younger with the king at Neath Abbey. They suffered trial by their peers, were degraded, and then destroyed. Precedents were accumulating, and public executions took place of pageantry. The execution of Thomas of Lancaster was still in men's minds, and the king was taken, for practical reasons which still look symbolic, to Kenilworth Castle, where the ghosts were even more critical than the living of the abuses of royal power (see p. 135). The king's seal was taken away from him, and his son ruled as regent; but this offered no hope of stability, and the capital was reduced almost to anarchy in the last weeks of 1326.

Parliament was the natural expression of national unity. Summoned in the king's name, it set itself the revolutionary

task of deposing the king. It was easy to formulate charges. The king was incorrigible and incompetent. He had destroyed the church and many noble men of the land. Scotland had been lost. He had not listened to wise counsel; he had not done justice to all, as at his coronation he had promised. Much of this case had been rehearsed at the Despensers' trials. As a view of history it was at best partial, but there was no single view of the history of the reign, for the king, who should have stood at its centre, had abdicated this essential role. He was now 'invited' to abdicate formally, and, we may presume, promised his life if he did so. How did a nation renounce the king's lordship? Men seem to have looked on England as a single nation, held together by a great number of individual acts of homage. It was the representatives of the

different estates, not of parliament as a whole, that waited on the king at Kenilworth. The English *Brut* chronicle dramatises the scene, 'how King Edward was put adoune'. A single representative of each of the estates stepped forward on behalf of all their peers to renounce homage: and so, 'from this tyme afterwards ye shal be holde a singular man of the people'. Edward III was crowned on 1 February 1327. His father lived, as a private man and in close confinement, until September of that year, when he was murdered at Berkeley Castle.

It was only a short step from this episode to the beginings of Edward III's personal rule. Roger Mortimer was captured at Nottingham Castle in October 1330, the result of a plot laid by the young king and his household, led by William Montague. As Mortimer was taken prisoner,

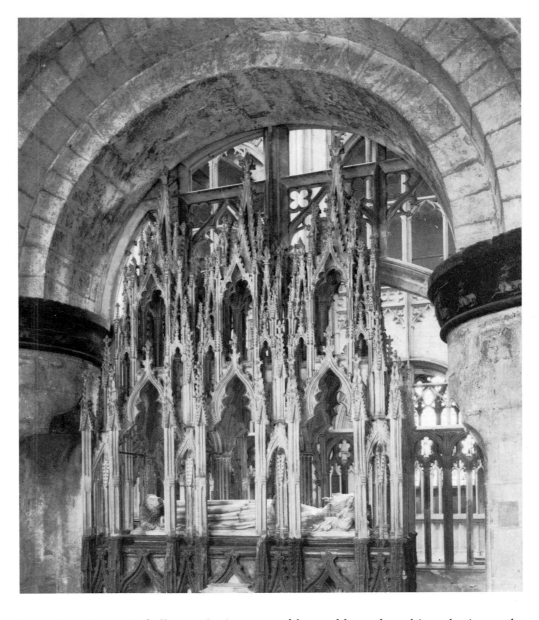

113 (LEFT) Gloucester
Cathedral, the choir vault.
1330s
An early masterpiece of the
perpendicular style, which may
be associated with the burial
here of Edward II.

114 Tomb of Edward II.
1330s. Gloucester Cathedral,
the choir
Beneath a solid Norman arch in
the choir of Gloucester lies the
tomb of Edward II, the canopy
of which seems to come from a
romantic fantasy. Edward was
buried here on 20 December
1327, but this fine work in his
honour was probably not
commenced until his son came
to power in 1330.

a scene well-realised by the chroniclers, Queen Isabella
asked for mercy for 'a worthy knight, our well-beloved
friend and our dear cousin'. No mercy was shown.
Mortimer was executed the following month, charged with
complicity in Edward's death, a charge very likely though
impossible to prove. Well-beloved Mortimer was indeed;
it was a matter of public knowledge that he and Isabella
had been lovers for several years. Mortimer had no formal
place in the council of regency that governed in the name
of the young king, but he was paid allowances as though
he was a member of the royal family, and it was to him
and to Isabella that the main windfalls of the minority
came. These were considerable, for £62,000 was found
in the treasury of the late king, and the lands and great
wealth of the Despensers had also been confiscated.

Mortimer was able to add greatly to his authority on the
Welsh marches. In the parliament of October 1328 he was
granted the title earl of March. 'Such a title', a chronicler
remarked, 'had never before been heard of in England.'
This was true, but it accurately reflected the power
Mortimer had achieved, as the map from Rees Davies's
fine study of Wales in this period, shows. In the same year
at Hereford a great tournament was held, to celebrate the
marriages of Mortimer's daughters. Edward and his mother
were present, and such chivalric display was very much
to their taste. But with no clear source of authority the chief
councillors fell to quarrelling among themselves. The earl
of Lancaster fell under suspicion; the earl of Kent (one
of Edward I's sons by his second marriage) was executed
in 1330. For Edward III the taking over of power from

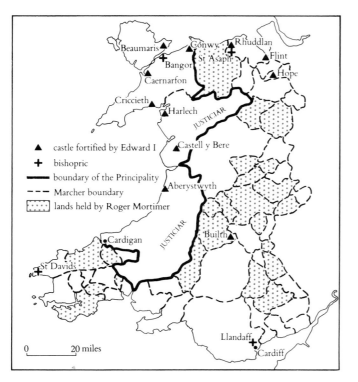

115 Wales in the early 14th century, showing the authority exercised by Edward Mortimer, earl of March, in the period 1328–30

Map legend:
▲ castle fortified by Edward I
✚ bishopric
━━━ boundary of the Principality
- - - Marcher boundary
⣿ lands held by Roger Mortimer

Map labels: Beaumaris, Conwy, Rhuddlan, St Asaph, Flint, Bangor, Hope, Caernarfon, Criccieth, Harlech, JUSTICIAR, Castell y Bere, Aberystwyth, JUSTICIAR, Cardigan, Builth, St Davids, Llandaff, Cardiff
0 — 20 miles

elder brothers who had reigned before him, had no surviving male children. It was a moot point whether Edward III had a title through his mother to succeed to the French crown. The matter was considered, but in the end the crown adjudged to Philip, the son of Philip the Fair's brother, Charles of Valois, who became Philip VI. His succession marked the end of the Capetian dynasty, which had lasted since 987 in the direct male line. In February 1329 Edward III crossed to France, and did homage to his cousin at Amiens for his French possessions. In the peace settlements made with France and Scotland, the positive features of the minority, the hand of Isabella is clearly to be seen. She presided over the marriage of her son to Philippa of Hainault, celebrated in York Minster on 30 January 1328, before the parliament opened. The marriage of David Bruce and Isabella's daughter Joan followed at Berwick. In June 1330 Queen Philippa, the 'junior queen' to a chronicler with a clear view of the realities of power, gave birth to a son Edward, the future Black Prince. With the king under age, the political atmosphere could hardly be changed overnight; it was necessary that Mortimer be taken down. But Isabella, purposeful and in her own way punctilious, remained the dominant figure in English politics throughout the 1320s. She deserved well, better than some modern commentators have allowed, of her adopted land.

England in the Early Fourteenth Century

England at this time had reached the peak of its medieval population levels. It is easier to assert that than to produce a figure, for the last nationwide survey of households had been taken in 1086, the next was not taken until 1377, the year of the first of the highly unpopular poll-taxes, and in between the two lay the great shadow of the plague. A figure of five million inhabitants may be suggested for England in the 1330s, with 10 per cent living in towns. The percentage of urban dwellers had not changed since 1086, but the total figure had increased two and a half times. These are high numbers historically, for while the population of England has increased ten-fold in the modern period, that increase has been in urban not rural areas. The figures for village populations in southern Lincolnshire, preserved in local surveys made c.1300, correspond closely to those of the first national census taken in 1851. Were these numbers then too high for the land to support? This is often suggested, with the plague cast in the role of nemesis for a society that would not control its numbers in any other way. This is not so. This was a prosperous society, and the peasantry shared in the general prosperity.

an unpopular and divided regime was only a matter of time.

The regime of Isabella and Mortimer had none the less the virtues of its vices. As it spent money – Edward II's treasure was exhausted in two years – it needed to reduce its commitments. It made a peace with the Scots. Robert Bruce obtained all that he looked for: he was recognised as having a hereditary right to Scotland, a kingdom which was to be independent, rendering no homage to the English king of any kind. Some concessions were made on the Scottish side, an agreement to pay £20,000 in damages, and an arrangement for the marriage of Edward III's sister Joan with David the son of Robert Bruce. In addition to these substantial matters, the eye is caught by the small things which were reckoned symbolic. The Scots were to be given back the archives which supported the English (Pl. 100) claims to overlordship; they were also promised the Stone of Scone, but this the Londoners would not part with. This was not a popular treaty, for the first king of an independent Scotland was in English eyes a war criminal; but Bruce had his peace, ratified by a parliament at York in February 1328, and a few months later he was dead.

In the month that the Scottish peace was agreed, Queen Isabella's brother Charles IV of France died. He, and the

Society had grown more prosperous through the growth of exchanges, the expansion of the market economy. The market-towns of England, in which the majority of exchanges were transacted, were last examined in a period of particular growth, the years around 1200 (pp. 89–91). Throughout the thirteenth and into the early fourteenth centuries, the number of markets continued to increase. Some fine studies by Richard Britnell have shown the dynamic of this development. The new markets were to serve the needs not of international trade, which largely by-passed them, but of local exchanges. The increase in population since the time of Domesday Book was in large measure an increase in the numbers of those who did not support themselves, did not provide their subsistence, from the produce of their own holdings: wage labourers, crafts-men, those engaged in extractive and manufacturing indus-try. These men and women were not necessarily poor, but they were dependent on the market, which made them vulnerable to fluctuations in the price of grain. This was shown in 1315 and 1316, when two harvests in succession were ruined by heavy rainfall. The yield of grain was between 55 per cent and 85 per cent below normal in dif-ferent places, depending on the type of crop, but this dis-equilibrium was sufficient to drive up the price of grain four-fold in some places. The monks of Bolton Priory in Yorkshire put themselves on reduced rations. The poor starved. In the areas where demand was strongest, the price of wheat went up from an average of 6s. to 20s. or even 24s. a quarter. In Taunton the death-rate among the poor in those years may have been as high as 10 per cent. This was just the type of small town that might be expected to be particularly vulnerable in these circumstances; but in the countryside also the death-rates rose. A study by Zvi Razi of Halesowen in Worcestershire shows at this time the classic demographic response to famine, with marriage-rates remaining low even with the easier availablity of land.

Seen from a European perspective England, even with its well-developed network of market towns, was still a comparatively underdeveloped land. A merchant of Bruges in the 1250s, surveying the main sources of his trade, noted that 'from England come wool, hides, lead, tin, coal and cheese'. England was a country rich in minerals, which supplied the raw materials for the manufacturing industry of western Europe. The chief of these manu-factures was cloth. In understanding its development in England in the later middle ages it is important to realise that the cloth industry was not one industry but many. All were based on a household system of production, and all could be carried out as well in the countryside as in the town. The different industries corresponded to the dif-

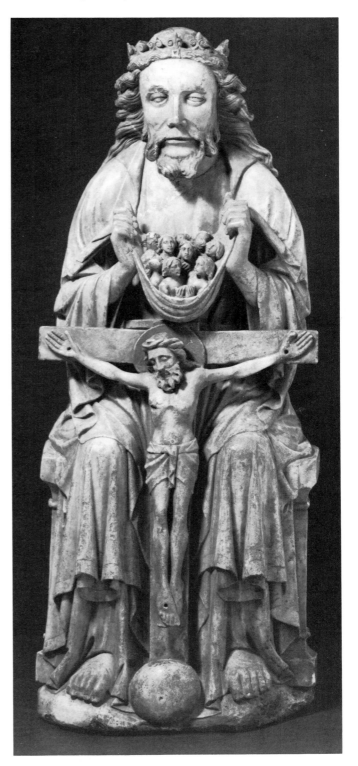

116 The Trinity, 14th century, alabaster, height 88.9 cm. Glasgow, the Burrell Collection
God the Father sits enthroned, the figure of Christ crucified between his knees; The Son's sacrifice releases souls to the Father, seen here as gathered together in a napkin.

The Order of the Garter

THE ORDER OF THE GARTER has enjoyed a continuous and illustrious history from its inception in 1348 down to the present day. Like other secular orders of knighthood founded in later medieval Europe, the Garter upheld the cultural and religious values of a militaristic society. Its founder Edward III was an enthusiastic patron of chivalry, who indulged his courtiers' tastes for the Arthurian legends and extolled their valour in war. The Order of the Garter was one of several knightly confraternities formed in 1347–8 at tournaments held to celebrate the victories of Crécy and Calais. But it outlived its original context and became a permanent institution because it proved politically useful to Edward III and his successors.

Much of the symbolism attached to the Order is obscure, and no conclusive explanation has yet been found for the use of a garter as its emblem. But it is significant that the members wore the French royal colour of blue rather than the Plantagenet red; and their enigmatic motto *honi soit qui mal y pense* (shame on him who thinks ill of it) probably refers to the title of King of France assumed by Edward III in 1340. The knights of the Garter were therefore intended to promote the foreign ambitions and military adventures of a warlike king. In addition, the Garter provided a new and practical means of rewarding faithful followers. By the end of Edward's reign, membership of the Order was the highest honour which could be bestowed on a subject of the English Crown. Long after the motto had lost its original significance the Order continued an essential element in the system of patronage operated by the late medieval kings.

The Garter was by its very nature an elitist institution. It comprised a maximum of twenty-six knights, and was inevitably dominated by the royal family and the high aristocracy. The king and his eldest son were automatically members even if they were minors: Henry VI presided over a meeting of the Garter knights at the tender age of seven. The great baronial families, such as the Beauchamps of Warwick and the de la Poles of Suffolk, were also regularly represented. But the founder had been eager to reward the good services of relatively obscure knights such as Sir Nigel Loring and Sir Walter Paveley, and in the fifteenth century honour and valour continued to be the only formal criteria for election to the Garter. There was also an international element. Sanchet d'Abrichecourt and Enguerrand de Coucy were among several men who changed sides, served Edward III in the French wars, and were promoted to the Order of the Garter. From Henry IV's time it became the practice to elect con-

1 (LEFT) Sir Nigel Loring in his Garter robes. London, British Library, MS Cotton Nero D VII, fo. 105v (*Liber Vite* of St Albans Abbey), late 14th century
Loring was one of the founder members of the Order, and this is the earliest visual impression of its regalia.

2 Funerary badge of the Black Prince. London, British Museum, c1376
The Black Prince's membership of the Order is commemorated in this tin lead badge worn at his funeral.

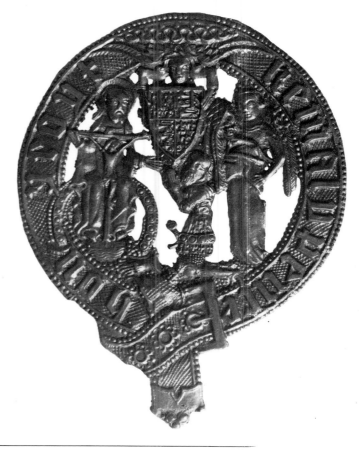

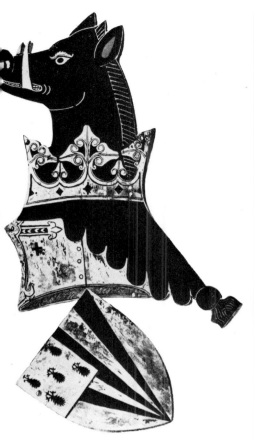

3 (ABOVE) St George's Chapel, Windsor Castle. Stall plate, late 14th century
The stall plates commemorate former knights of the Garter. The oldest surviving plate is that of Ralph, Lord Basset, who fought with the Black Prince at Poitiers.

4 St George's Chapel, Windsor Castle. The choir, looking west 1477–83
The choir was completed in time to receive the body of Edward IV in 1483.

tinental rulers. The Emperor Sigismund was instituted a Knight of the Garter in 1416, and Duke Charles of Burgundy followed in 1470. Small and exclusive though it was, the Order maintained a surprising diversity throughout the later middle ages.

In 1348 Edward III established a college of priests and poor knights in the royal chapel at Windsor Castle, which he re-dedicated to St Mary the Virgin and St George and rebuilt on a grand scale. The intention was to provide the headquarters of the Order of the Garter. From 1349 the members of the Order assembled every year at Windsor for the feast of St George (23 April), to re-affirm their vows and to have concourse with their king. The religious ceremonies were elaborate and sumptuous. By the fifteenth century the chapel possessed the heart and fingers of St George, in addition to other valuable relics, and under the patronage of the Garter knights became a shrine to the patron saint of English chivalry.

The rituals, and the values of loyalty, equity and compassion to which the knights of the Garter subscribed, may seem ludicrously irrelevant when set alongside the unscrupulous warfare and political chicanery of the later middle ages. By the 1450s, indeed, the whole credibility of the institution was threatened as a result of the repeated refusal of the duke of York and his followers to attend meetings of the Order. But in the hands of a capable king, the archaic concepts embodied in the Garter statutes could still be put to sound practical use. In the 1470s Edward IV gave the Order a new political importance by filling vacancies and creating a still more lavish environment for the Garter ceremonies in the new chapel of St George at Windsor. The chapel remains today much as Edward left it, a celebration of the English Perpendicular style, a royal mausoleum, and a curious monument to the universal but elusive ideal of chivalry.

MARK ORMROD

ferent stages of production, of which only the most import-
ant will be noted here. As a first stage, the prepared wool
was spun into yarn, by means of a distaff or spindle. This
was women's work (Pl. 87), but thereafter most of the
operations were performed by men. The yarn was woven
into cloth; large flat looms allowed for the production of
the distinctive English broadcloths, 24 yards long and 2½
yards wide. When it had been woven, the cloth was
washed and then fulled – placed in troughs filled with
water and fuller's earth or alum – to thicken and felt the
cloth. It was this process which the fulling-mill, introduced
into England from the late twelfth century, allowed to be
mechanised. The fulled cloth was rinsed and dried, and
then finished: teasels were used to raise the nap of the cloth,
and it was then shorn to produce a good finish. The final
stage of production was dyeing, in which large vats were
used, each with a different colour dye. Whole areas of
towns in the thirteenth century had been given over to these
various trades. Small wonder that they figure so promi-
nently in the great psalters and service books of the day.

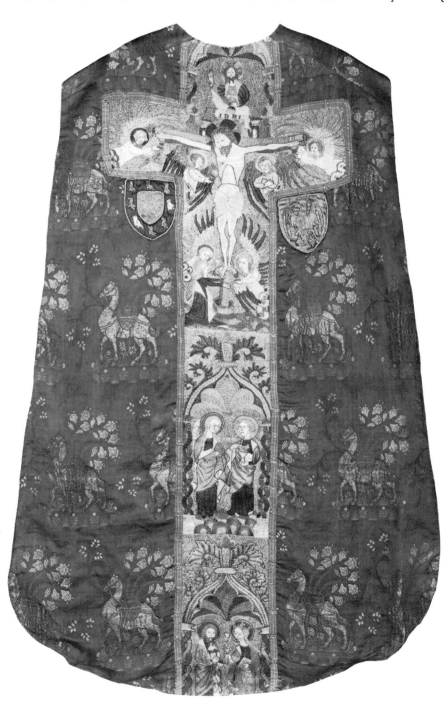

117 The Erpingham Chasuble. London,
Victoria and Albert Museum
The silk cloth was woven in Italy; the
embroidery is English work of the early 15th
century. Identified by the arms as made for Sir
Thomas Erpingham (died 1428), a
prominent Lancastrian; he is the 'good old
knight' of Shakespeare's *Henry V*.

118 Coronation Order of Edward III.
Cambridge, Corpus Christi College MS 20,
fo. 68r, *c*.1330
The coronation order is in French, as is the
Apocalypse with which it occurs; this
suggests the volume was made for a lay
patron. The reference to 'Prince Edward' in
the text suggests the king is Edward III,
crowned after his father's deposition in 1327.

super infernu̱ ⁊ contulbat c̄ valde ⁊
laxate sunt o̅s a̅ie ꝗ erant i̅ inferno ⁊
clamalāt voce magna dicētes bu̅
dicimus te xp̄e fili dei inin ꝗ dignat̄

es nob̄ refugeru̅i dare ḣ diei ⁊ ḣ noc
tis quam totum temꝑ ꝗ uiuimus
uitia̅. bi ergo ꝗ tuĉo duit die ꝺc̄ā
ꝗn ꝛpi ḣebit ꝑt̄ ai scis i̅ sc̄a sc̄oꝛ.

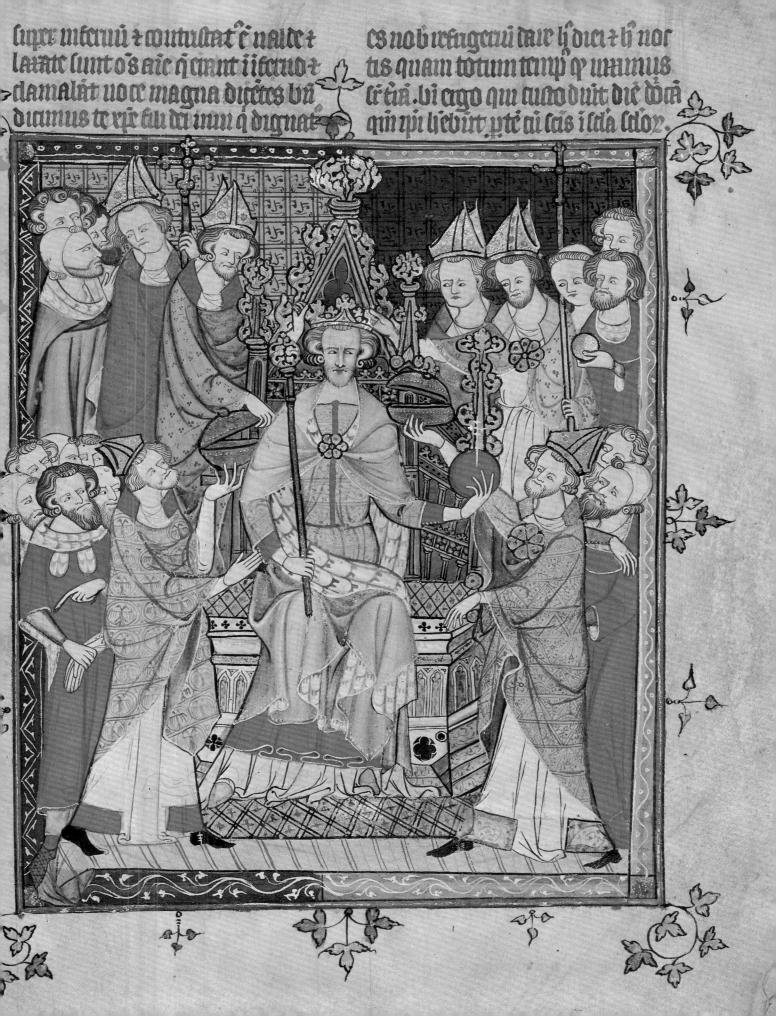

119 Christ and the dyers. London, British Library, Add. MS 47682, fo. 16r, c.1320s (the Holkham Bible Picture Book)
One of the (apocryphal) infancy miracles of Christ. (AT LEFT) Christ is told by a dyer to dye each cloth a separate colour; he ignores
the advice, stuffing all into one vat; but when the cloths are removed all is well.

In the delightful Holkham Bible Picture Book the Christ-child walks unharmed and unsullied through the busy, dirty and dangerous streets of a typical medieval English town (Pl. 119).

In the course of the thirteenth century the English producers had been driven out of the international market for high quality cloth, and the urban industry which supplied this market had suffered severely in consequence. It was claimed in the 1270s that cloth-workers had entirely deserted the city of Winchester, and had moved to the suburbs and surrounding countryside. In 1334 it was stated that of 300 weavers previously employed in Northampton none at all were left. Recovery came, both in town and in countryside, as a result of changes in the fiscal policy of the English government. The high taxes, or *maltotes*, on the export of wool, first applied in the 1290s, were reapplied in the late 1330s, in the early stages of the Hundred Years War. They then became regular, and offered a considerable (though accidental) protection to the English industry. A tax that amounted to 33 per cent on their raw material was a substantial addition to the costs of foreign producers, and for diplomatic reasons the supply of wool to Flanders was at times stopped entirely. The English cloth producers reaped the benefits. First the imports of foreign-made cloth were driven out, going down from around 12,000 cloths a year in the late 1300s to only 2000 cloths a year in the late 1330s. Then English cloths moved to take over markets that earlier had been supplied by Flemish manufacturers. This was a long-term development, but highly significant: by the late 1360s exports were 16,000 cloths per annum, and in several years in the 1390s they exceeded 40,000 cloths per annum. Initially the main exports were to south-west France, as a return cargo for Gascon wine. In the fifteenth century the cloths went further afield, to the Baltic and the Mediterranean. In the region of Toulouse the marriage-contracts of the peasantry often specified the source of the cloth that was to be provided for the bride. In the early fourteenth century this came from Flanders and Brabant, but in the 1450s it was English cloth that was often specified.

The increase in the volume of English cloth production saw also its expansion in new areas. The old cloth-making towns lost their monopoly of all stages of the production of cloth, and with this had to change their attitudes to the surrounding countryside. In three regions especially there was new growth in the cloth industry, in East Anglia, in the west country and in the West Riding of Yorkshire. The beginnings of expansion in the West Riding, which remains to this day an important centre of cloth manufacture, can be seen in the poll tax returns in the 1370s.

Pontefract, where the final scene in the tragedy of Thomas of Lancaster was played out, was still the largest town of the West Riding, but Bradford, Wakefield, Halifax and Leeds all had inhabitants engaged in the cloth trade. Many of them were cottars, that is to say smallholders, which lessened their dependence both on the market and on merchant capital. There was a similar expansion in the other two areas mentioned. It is sometimes said that what was involved here was a movement from 'town' to 'countryside'. But some of the country villages grew to being towns in all but name: thus Lavenham in Suffolk had no urban privileges, but it paid more in tax in the early sixteenth century than either Winchester or Leicester. And the old towns were not superseded: they continued to produce cloth, and they remained essential centres for its distribution. For these reasons it is better to speak of the undoubted changes in the English cloth industry in the later middle ages as a shift not from 'town' to 'countryside' but from 'town' to 'region'. The change may be noted in the changed descriptions of the product. In the thirteenth century the demand was for 'Lincoln scarlets' or 'Stamfords'; in the later period it was for 'Cotswolds' or 'Westerns'. The movement away from the top-quality market meant that the place of origin was less important.

Tin, lead and coal all featured in the Bruges short-list of English commodities. The English miner had international fame but his local reputation was very often unsavoury. It was most unwise, it was claimed in 1256, to approach Newcastle after dark, because of the danger of falling into abandoned pit-workings. Newcastle coal, universally known as 'sea-coal' from its necessary mode of distribution, had markets far afield. In London, it was complained, it 'infected and corrupted the air', but still it continued to be used, for lime-burning, for smelting iron, and increasingly (in particular in the north of England) as a domestic fuel. The findings of archaeology show this pattern: coal was found underneath the guest-house of Halesowen Abbey in Worcestershire and at a house at Pevensey in Sussex, the latter from the early thirteenth century, as well as near lime, iron and pottery kilns. The records of royal government show coal put to military use, as fuel for smelting the iron used for siege engines in 1333, to cast anchors for the royal barges, the *Christopher* and the *Cog Edward* in 1337.

As coal was to the economy of Newcastle, so — and to a greater extent — was tin to the economy of Devon and Cornwall. As many as one person in ten of the adult population of Cornwall was involved in or connected with mining work. The county was a royal duchy — hence the protests when it was given to Piers Gaveston — and the crown's mineral rights were carefully preserved. Figures for taxation of the tin produced (the 'coinage') show that the level of production in the 1330s was at its medieval peak, in several years over 1,400,000 lb. of tin being produced. In the production of tin, unusually in the medieval economy, there was scope for a factory system of production. In 1357 Abraham the Tinner stated that he employed 300 men in seven tin works. There were individual 'free' miners also, who characteristically had smallholdings, and worked at mining only part-time. For mines of any kind

120 Pottery of the late 13th and early 14th century. Museum of London
A variety of containers in everday use are shown: a spice bowl, storage and drinking jars, a serving flagon. The centre piece is from south-west France; the remainder from southern England (see further Pl. 101).

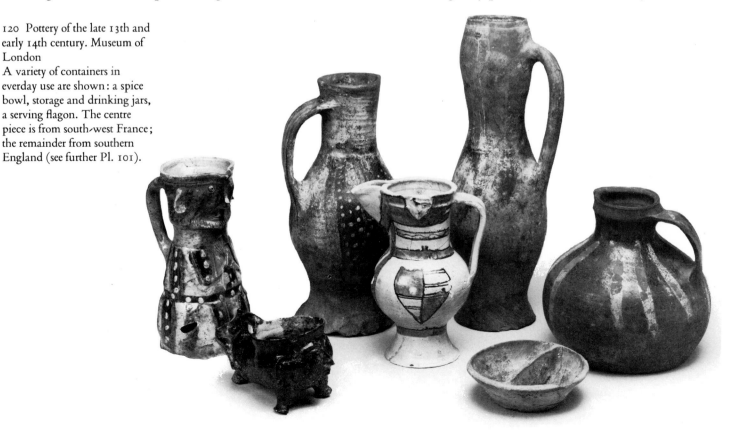

121 Wall-paintings in Longthorpe Tower, near Peterborough, Northamptonshire. c.1330s
A remarkable series of images surrounded the owners of this midland manor house in their great chamber. Shown here is the west wall:
a philosopher and his pupil provide the main scene; above them are St Anthony and two angels and a variety of wildlife; and on the arch
the first of the labours of the months.

122 (BELOW) Harrowing. London, British Library, Add. MS 42130, fo. 171r, late 1320s (the Luttrell Psalter)
The harrow is drawn by a horse, led by the man on the right. The man on the left, armed with sling and stones, attempts to drive away
two crows, but his shot misses.

123 (RIGHT) Prior's Hall Barn, Widdington, Essex. An eight-bay aisled barn, c.1400
This priory belonged to the monks of St Valéry in Normandy. Their English properties, were confiscated during the Hundred Years War
as being 'alien priories'. This estate came to William of Wykeham (Pl. 153) and was granted by him to New College, Oxford.

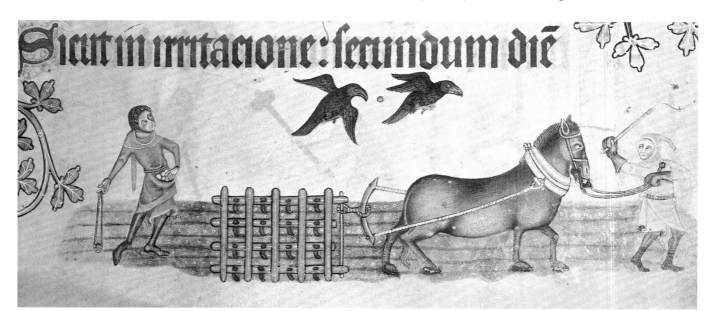

were unpleasant places to be in the winter months. It was in the summer months that the greater part of the lead, tin and coal was mined. Tin mixed with lead formed pewter, the pewter vessels were widespread in late medieval England. Here too archaeology helps to give an idea of the spread. The chalice and paten found in a twelfth-century priest's burial from Barton-on-Humber are typical of many such. In the thirteenth century the main chalice in each church, almost without exception, would be made of silver, but churches had a wide variety of pewter vessels, cruets, candlesticks and basins for water. In the fourteenth and fifteenth centuries pewter spread to households of all levels. The miners were privileged people and it was a part of their privilege that they escaped normal taxation. This means that their wealth is under-recorded in official records, which cannot be used to show that either the north or the west of England were economic backwaters.

For much of the early fourteenth century, indeed, it must have appeared that York was the capital of England. Edward I had set the precedent, moving the government north in 1298, where it remained until 1304: this meant the removal not just of the chancery, but of the Exchequer, and the courts of king's bench and common pleas. They were moved lock, stock and barrel. It was the first of several such migrations in answer to the threat of Scotland. At Torksey on Easter Monday 1322 the sheriff of Lincoln was instructed to have ready 'four good and strong small ships each able to bear the weights of eight wine casks'. The wine casks were not for wine, of which there would have been ample supplies in York already. They were to be cleaned and mended, lined with waxed canvas, and packed with necessary records – the unwieldy but indispensable tallies of the exchequer (Pl. 77), official rolls, books (perhaps even Domesday Book itself) and the royal treasure. Thirteen days the trip took, up the Great North Road, and then from Torksey by water. York was the scene of Edward II's greatest triumph; it was here in 1322, after the migration just considered, that the royalists repealed the Ordinances of 1311, and condemned many of their opponents to death or exile. These were exciting and anxious times for the citizens and townsmen of York – the mayor had died at the Chapter of Myton in 1319 (p. 163) – and the influx of men to this temporary capital city brought tension in its wake.

125 Travellers approaching an inn. Oxford, Bodleian Library, MS 264, fo. 245v, c.1400 (Marco Polo, *Li Livres du Graunt Caam*) The story of Marco Polo's travels in Asia was both a popular romance and a practical challenge to Europeans to discover alternative routes to the east. This volume was bought in 1466 by the bibliophile Richard Woodville, earl Rivers (see also Pl. 175).

124 Tripod jug. 14th century, bronze. London, British Museum

126 A stonemason. *c*.1330s. York, Yorkshire
Museum
These fragments from the tomb of St William of York
show their maker at work with mallet and chisel.

The Beginning of the Hundred Years War

In May 1333 the wagons set off from Westminster once
again. The peace with Scotland, however sane its
provisions, was the work of a discredited regency
(p. 172). When Isabella and Mortimer fell a powerful
group of exiles returned, many of them nourishing claims
to lands in Scotland. They found a figurehead in Edward
Balliol, the son of the ruler appointed in 1292 and thereafter
deposed: with the support of the disinherited he was
crowned at Scone on 24 September 1332. The institutions
of Scottish kingship remained in the hands of those ruling
in the name of Robert Bruce's son David, a boy of only
five when his father died. Edward at first kept his distance
from the disinherited and Balliol's cause, but then became
drawn in; those wagons were evidence of a new commit-
ment of the Scottish war, fought over old ground. Berwick
was invested by the English, and on 19 July 1333 a Scottish
force sent to its relief was defeated at Halidon Hill, a few
miles to the north. After this battle, which took a heavy
toll of the Scottish nobility, Balliol gave Edward III much
of lowland Scotland, and Bruce fled to France. In 1335,
according to one chronicler, only small children would
admit to supporting 'King Dawy'. But Balliol's, and with
him the English, cause was still difficult to sustain. In the
absence of a network of strong castles, a standing army
was needed, and this was expensive; on a three-month
campaign in 1335 Edward III spent £25,000. And it
suited the French king, Philip VI, to take seriously his
obligations under the Treaty of Corbeil, 1326, by which
the kings of France and Scotland had promised each other
mutual aid at times of war with England. This aid exten-
ded further than sustaining Bruce in Paris, and supplying
arms and food to Scotland. There was also the threat of
direct military intervention by the French.

In May 1337 Philip VI of France declared Gascony
forfeit. It was not to be until the 1450s that one of his
successors was able to carry this judgement out. The inter-
vening period is commonly referred to as the Hundred
Years War. From one point of view the title gives a false
impression of unity to an antagonism with the French
which continued much as it had done before, with bursts
of military activity punctuating long periods of truce. Yet
from another point of view there is unity to be found, for
now a claim was made to the French crown, first in
October 1337, with the support of the political nation.
Edward claimed that it was he who was the rightful king
of France, his title descending via his mother Isabella. This
even though he had recognised Philip VI's title by doing
homage to him in 1329. It was a considerable feat to involve

Ordinances of the local variety, made by the king's
council and the civic officers in 1301, were intended to
supply a remedy. The prices of foodstuffs, take-away meals
and accommodation were to be fixed. Doctors were to be
properly qualified, and prostitutes, whether qualified or
not, were to be kept off the streets. So too were pigs and
all manner of excrement; in each of the four quarters of
the city a public lavatory was to be built. In this sanitized
world many of the citizens grew wealthy. The taverners
and brewers seemed particularly prosperous at this time,
their wealth allowing them to branch out into other aspects
of the provisioning trade. A permanent record of this tran-
sitory prosperity survives in the nave of York Minster,
which in its sculpture and stained glass shows the influence
of the royal court. Along the clerestory went a line of
heraldic decoration, in each window the royal arms of
England, were flanked by the arms of the northern
magnates, like Percy and Vavasour, who had close con-
nections with the Minster church. The arms of Sir Edward
de Mauley, who died at Bannockburn, appear, and among
the donors appears his brother Stephen de Mauley, arch-
deacon of Cleveland. They mingle in the glass with the
wealthy citizens of York. York is very clearly here the great
metropolis of northern England.

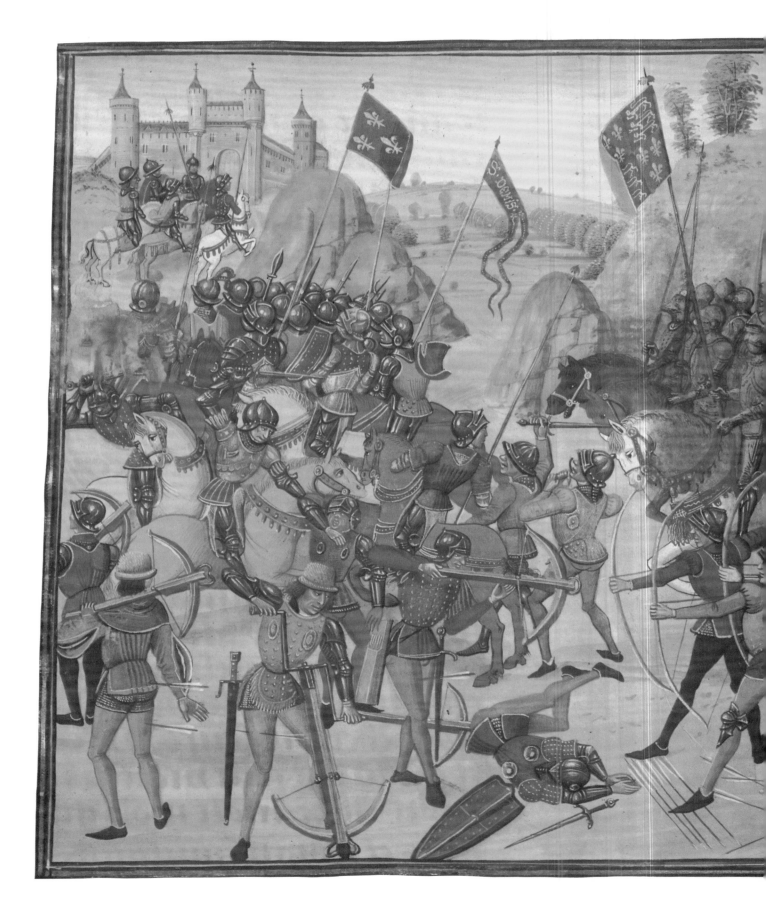

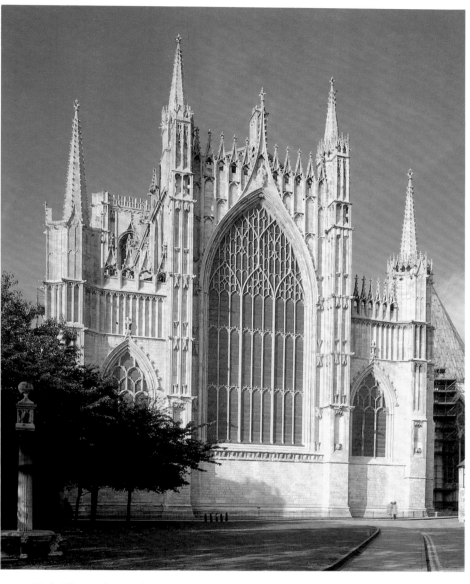

128 York Minster, the east front.
The building work was completed in 1361–72, and the window was installed and glazed later, in 1405–8.

127 (LEFT) The Battle of Crécy, 1346. Paris Bibliothèque Nationale MS fr. 2643, 15th century (*Chroniques* of Jean Froissart)
Froissart's work covers the history of western Europe from 1327 to 1400. His patrons were the great princes of western Europe, and he gave them the sort of history they liked, full of battle scenes and deeds of valour.

the English people in the war effort in France. For it was an individual not a national claim that Edward was pursuing. It was *his* right that he sought to vindicate. His subjects featured as soldiers and as tax payers; why should they fight, and pay for another man's quarrel? The first battle that Edward won was the crucial battle of publicity.

The machinery for publicising the king's views lay readily to hand, in the shire and hundred courts, and in the network of market towns that has never been far away in this chapter. The king's success can be seen in the change that comes over the Lanercost chronicle, written in Cumberland, where the 'old enemy' was not the French but the Scots. In spite of this, and quite suddenly in the late 1330s, a northern local chronicle starts to carry all the most important documents relating to the French war. It contains the manifesto issued in 1337 which gave Edward's version of his recent dealings with the king of France, the many efforts he had made, by offers of marriage and other means, to avoid war. All these, so he claimed, the French king had rejected. To Edward the statesman there stood opposed a wily opportunist, who 'busied himself in aid and maintenance of the Scots, the enemies of the king of England'. This view, which in essence saw the French war as growing out of the Scottish conflict, was doubtless sincerely held by the English, but it was also highly politic. For it allowed Edward to represent his aggressive pursuit of his claim to France as a necessary defensive action, necessary for the preservation of his rights. The same chronicle copied also an exchange of letters with the pope, then resident at Avignon in southern France, and seeking to mediate peace. And they copied the letter that Edward issued at Ghent in February 1340, announcing that he had assumed the title of king of France, and informing his new subjects of the nature of his claim and of his desire to offer them good government. There would be no unjust exactions, for 'we have sufficient of our own resources, thanks be to God'. What Edward's subjects thought of this blatant untruth we cannot now tell, but they wrote it down, and in writing it down, they became associated with it.

One group of his subjects Edward was particularly concerned to please, for without their support the French war would have been impossible. This was the knightly class, much changed and reduced in numbers since the time of the Conquest, but still distinctive in its ethos, its training in the profession of arms. That ethos is best known under the name chivalry, the culture of the knightly class, the *chevaliers* or horsemen. Chivalry was cosmopolitan; its heroes needed an international stage. As the English withdrew from France, and the west generally was forced from the Holy Land, opportunities for the exercise of arms were reduced. A substitute was found in tournaments, 'peaceful

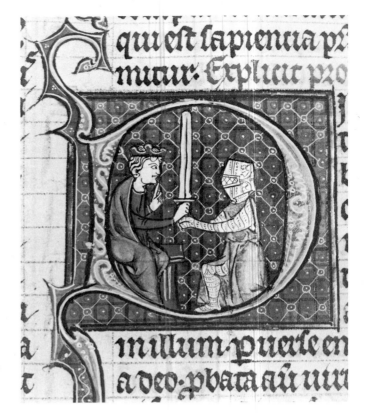

129 The royal commission. Durham, Dean and Chapter Library MS A.II.3, fo. 225v, an initial from a 13th-century Bible.

130 (RIGHT) Carved oak chest, from the Chapter House, York Minster. Early 15th century
The chest shows a courtly scene from the legend of St George.

warfare' to the chivalric chroniclers Sir Thomas Gray. He describes Edward III in his youth very much caught up in this culture, leading a pleasant life 'in jousts and in tourneys and entertaining ladies'. Several fine tournaments were held in and around London in the early years of the reign. To one, held in Cheapside in September 1331, came 'all the knightly class of England'. They processed in their finest clothes, their tunics of red velvet and their caps of white fur, and all were masked in manner of the Tartar hordes. Each knight as he rode had on his right a fair lady, whom he led by a silver chain. After the procession, on the three following days, battle was joined. This was left to the professionals – sixteen knights took on all comers, and did great deeds. The only accident reported here was to the queen and her ladies, when an upper room from which they were watching the fun collapsed from weight of numbers.

The ladies of course, watching on the sidelines, were central to the whole concept of chivalry. The tournament was courtship display just as much as it was training for

war. The stories of the deeds of valour performed by young men to impress their ladies make this very clear. At times they were directly challenged. Soon after the disaster at Bannockburn, Sir William Marmion was sent by his lady a gilded war helmet, with the command that he should take it to the most dangerous place in Britain and there win renown. It seemed natural to go to the Scottish border, and so soon afterwards, wearing his fine helmet, he presented himself at Norham castle. The knights of the garrison entered into the spirit of the thing, and so did the Scots; they attacked, Sir William led the first charge, and he was nearly killed. The ladies were watching all this as well. They were marking their men. And this almost in a literal sense. Just as in a modern tennis tournament the leading professionals are gaining points towards the all-important computer rankings, so too with the medieval knight and his tournaments. It could be said of an English knight, Sir Giles d'Argentine, that he was the third-best knight in Christendom. The young King Edward III wanted to make his mark also; he was 'eager for arms and glory'. The prize for the highest rankings in his day would be membership of the Order of the Garter (see picture essay). He would turn to his own ends the chivalric ambitions of his followers.

Financing the War

The parliament that met in 1337 at the beginning of the Hundred Years War made a generous grant of taxation. It gave three fifteenths and tenths, a tax in effect on the harvests of the years 1337, 1338 and 1339. It was based on the 1334 assessment of wealth, and each year's grant was intended to raise £38,000. This was customary taxation, but there were particular reasons why it was resented in these years. The assessment was left to the localities: it pressed more heavily on the poor, so that, for example, while in Kent around 11,000 people paid the tax in 1334, in 1338 the figure was around 17,000. On top of this came the prerogative right of purveyance, the taking of goods for the war effort. The markets in these years were depressed, the harvests being too good for the king's needs. 'There was such plenty of goods and scarcity of money', said Ralph Higden in his *Polychronicon*, 'that a quarter of wheat in London fetched only two shillings'. A contemporary poem echoes the same complaint: 'at market the buyers are so few that in fact a man can do no business, though he may have cloth or corn, pigs or sheep to sell'. These texts list the symptoms of a severe deflation. Parliament in 1339, though it recognised the king's need for money, was reduced to taking a tithe on goods because of the shortage of coin. The king was asking for more than the market could bear. And it was not just in the local markets of England that this was so.

Edward was in the Low Countries from July 1338 to February 1340. He sought to raise there the money which he needed to pay his allies. The market for English wool would be directly managed to produce the funds required. It was not just a question of raising loans on the security of wool exports, which merchants had to export via certain specified or 'staple' ports but could then deal with as they

131 The Syon Cope, detail showing St Michael. *c.*1300–*c.*1320, embroidery. London, Victoria and Albert Museum

England was a great centre of embroidery in the late 13th and early 14th centuries; the name *opus anglicanum* (or 'English work') served then almost as a trade mark guaranteeing excellence, and some of the finest work is found abroad. This cope came into the possession of the nuns of Syon Abbey, Middlesex.

132 Gloucester Cathedral, the monks' lavatorium, off the north cloister. Early 15th century
The abbey church of Gloucester became a cathedral at the Reformation, which helps account for the
fine preservation of the monks' washing area ('lavatory' properly so-called), with its fine miniature fan-
vaulting. On the ledge set against the walls would have beeen lead water-tanks, which discharged into
a lead-lined trough, the water draining away through holes that are clearly visible.

chose, as the normal pattern had been. There was now to be a royal monopoly of the wool trade. Wool exports from England to Flanders were suspended by the crown in August 1336. In 1337 the wool merchants of England, led by William de la Pole of Hull and Reginald Conduit of London, formed themselves into a consortium. They calculatd that they could collect 30,000 sacks of wool, which because of the shortage of wool could be sold at a premium price; and on this basis they promised the king a loan of £20,000. On paper there should have been a profit for everyone, but in practice the scheme was a disaster. Less than 12,000 of the 30,000 sacks promised left for Dordrecht in Zeeland in November 1337; and when the merchants not unnaturally could not raise the full sum promised, their wool was confiscated by the crown. The 147 merchants named in the consortium were given bonds in promise of future payment, which would need to be heavily discounted before they could be redeemed. Money was needed urgently to pay pensions to the king's allies. 'The great lords are in great need', the king's agent Paul de Monte Florum reported, 'they cannot wait for the wool's sale.' What was intended as a lucrative monopoly now became a simple glut, with the inevitable result. The price fell. The Bardi and Peruzzi, to whom some of the wool confiscated in 1338 had been assigned, even with their network of trading contacts, could in the following two years only sell at £6 a sack, at which price they made no profit. These Florentine merchant bankers, the king's main creditors when war broke out, now sought to reduce their commitments to him. The place of the Florentines was taken by the Germans, but they would lend only on terms that became prohibitive. In February 1339, in pursuit of Edward III's claim to the crown of France, the great crown of England was pawned to the archbishop of Trier, one of the electors to the crown of Germany.

The title of king of France was formally adopted by Edward on 26 January 1340 in the market place of Ghent. The Flemings, led by Jacques van Artevelde of Ghent, accepted Edward's title. The wool staple was moved to Bruges. The Flemings were promised £140,000 by the English king, and ships and arms should the French attack. Edward then returned to parliament in England, leaving his wife and family, and several of his military commanders, behind at Louvain, virtually as hostages for his debts . He obtained from parliament the money that he asked for, and shortly thereafter won the victory which was essential for his continued credit. In the summer of 1340, as the Flemings had feared, the French mustered a considerable navy at Sluys. It is a good atlas indeed that shows Sluys now, but it was a familiar landmark to the sailors of Europe in the fourteenth century. For it stood at the head of the river Zwin, and upriver was Bruges. Bruges was the great entrepot of northern Europe, the terminus on the one hand of the northern merchants and on the other of the Italian galleys which sailed in regular convoy each year bringing the goods of the Mediterranean. So Sluys stood then to Bruges in shipping as Clapham Junction does now to the railway network leading south from London. News of victory in such a place would be spread as far as that network stretched; and this is what Edward achieved. On 24 June 1340 the king wrote in triumph to his son, God had granted him the victory: only 24 out of 190 ships on the French side had escaped, only 5,000 out of 35,000 men, 'the rest lie dead in many places on the coast of Flanders'. The slaughter at Sluys was well remembered; if fish could speak, said the chronicler of Meaux Abbey in Yorkshire fifty years later, they would have spoken French, so many corpses filled the Zwin estuary. Shortly after this, when Edward commissioned the first English gold currency, it was the image of his naval victory at Sluys that he sought to spread abroad.

Victory at Sluys brought no immediate benefit to the English cause. It may even have made things worse, for it led the king to believe that there were no faults in his policy, that other and greater victories would have been his had his subjects only delivered what they had promised him. The chancellor, John Stratford, forseeing the storm, resigned his post shortly before the battle of Sluys was fought. He had mediated as best he could between Edward and the tax-payers of England, but judged in the great traditions of the English civil service, alongside men such as Roger of Salisbury and Hubert Walter, Stratford cuts no great figure. The king remained in debt, and was forced to make a truce with the French at Espléchin in September 1340. Edward returned again to England, intent on bringing to book those publicly identified with the policies of the previous four years. On 30 November 1340 he arrived unannounced at the Tower of London. The constable of the Tower was not at his post, and so found himself imprisoned there. Several of the judges, charged with maladministration, and a number of merchants, including William de la Pole and his brother John, suffered the same fate. William was singled out as one of the leaders of the wool consortium of 1337, to whose failure Edward attributed all his subsequent difficulties. It was not easy to find irregularities. Wool had been smuggled outside the scheme, at least 2500 sacks according to a jury verdict. Customs duties had been beneficially assessed: the royal official at Boston had been releasing between $1\frac{1}{4}$ and $1\frac{3}{4}$ sacks of actual wool for every sack on which duty was paid. For the venial crimes of others William de la Pole remained imprisoned until May 1342.

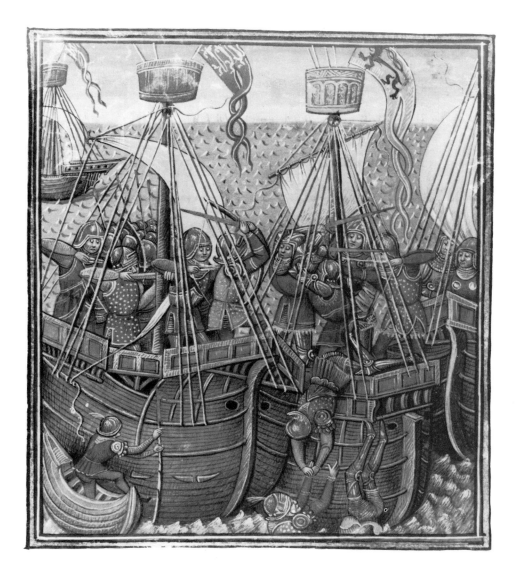

133 Battle at sea. London, British Library, Royal MS 14.E.IV, fo. 276r. A late 15th-century manuscript copy of a part of Jean de Wavrin's *Chronique d'Angleterre*, made at Bruges for the library of Edward IV

134 Gold noble of Edward III. London, British Museum
The first English gold coins were issued in 1344. This coin is the noble, struck in London in 1351. Edward III stands in a ship, a presumed reference to his victory at Sluys in 1340. His shield quarters the arms of England and France, and the inscription proclaims him ruler of both kingdoms.

Edward would doubtless also have liked to have imprisoned John Stratford, but Stratford was archbishop of Canterbury. It was Stratford whom nobles like the earls of Derby and Northampton, themselves in effect imprisoned in the Low Countries during the previous summer, held responsible for their plight. And so, after the king's return, his first action was to send a simple knight, asking the archbishop to come to London, prepared to go abroad himself to serve as hostage for debts owed to the merchants of Louvain. 'See how you would like it', was clearly the message, which was to be reiterated. This was the justice of the school playground, but Stratford was far too canny to stand right there. The pulpit of his own cathedral was a much better base; on St Thomas's feast day (29 December) he spoke in the vernacular, and to the point, to answer the charges that were made against him. The point which he chose for his sermon, in which the murder of his predecessor and the death of Edward II ('what happened to him you will remember very well') both figured large, was the need for proper counsel. There

were several similarities with the early stages of the Becket quarrel, the archbishop resisting attempts to call him to account like any minor official; but Stratford was much more diplomatic. He would answer, he said, but he insisted on trial by his peers; the lay lords, fearful of the summary trials that had despatched great men such as Thomas of Lancaster and Andrew Harclay, could be relied upon to support him in this. For 'proper counsel' in his speech, read the political community in parliament. The parliament of April—May 1341 offered the lords trial by their peers, offered the commons a proper accounting of all monies spent since the beginning of the war, and offered both estates the accountability of officers of the crown to parliament.

The early stages of the new French war had pointed some clear lessons. The English could defeat the French at sea, as the battle of Sluys had shown. But if they wanted to attack the French on land, then Flanders on its own did not offer a secure enough base. Another theatre of war almost immediately became available when in April 1341 John III, duke of Brittany and earl of Richmond, died. The succession was disputed, and it was in Edward's interest to ensure that it remained so. He recognised the claims of the late duke's brother John de Montfort; in return, John recognised Edward as the rightful king of France. The French king then recognised and invested as duke a rival claimant, Charles of Blois, who was married to a daughter of the late duke. The English king was here following his characteristic policy, of seeking to destabilise the lordship of his neighbours. English garrisons occupied several towns in Brittany in the Montfortian cause, and some notable feats of arms were performed there. But in strategic terms the importance of Brittany was that it allowed Edward to attack Normandy at its weakest spot, in the west, without immediate danger of opposition. The scene was set for the first important military engagement on land.

The Battle of Crécy

A great army was mustered at Portsmouth in July 1346. It sailed to St Vaast la Hogue, close to the modern port of Cherbourg. From there Edward struck south and east into the centre of Normandy, claiming lodging from the leading monasteries (some of which still retained their English lands), sacking towns that were undefended, and leaving alone those well fortified. Some French were sur-

prised. At Caen, according to Froissart, the constable of France and the count of Tancarville finished up cowering in the gate-tower, in fear of their lives from capture by archers, 'who would not know who they were'. Help was at hand, in the person of Sir Robert Holland whom they recognised 'because they had campaigned together in Grenada and Prussia and on other expeditions'. They called down and asked to be taken prisoner. The gallant knight was happy to oblige; 'their capture meant an excellent day's work and a fine haul of valuable prisoners'. The English at Caen sent home 'boats and barges laden with their gains', and marched on. They came at last to Crécy in Ponthieu, where the first and one of only a few land battles of the war was to be fought.

The battle of Crécy was a mêlée on which the chroniclers tried to impose some principle of order, and sought to give men of rank the recognition that was their due. The victory went to Edward, at least according to Froissart, less because of the advantages of the longbow than because the English took up a defensive position and held their ground. They had formed up in three divisions. Edward the Black Prince, with the earls of Warwick and Oxford, commanded one division, with numerous men of rank, 800 mounted troops, 2000 archers and 1000 infantry. In the other two divisions, the second under the earls of Northampton and Arundel and the third under the king, he listed a further 1200 men at arms and 3200 archers. They took up their position in regular order, 'each knight under his banner or pennon, surrounded by his men'. The French attack was led by Genoese crossbowmen – according to the Florentine chronicler Villani there were 6000 of them – and they were driven back by the English archers, whose arrows fell on them 'as thick as snow'. The roads for miles around were choked with common people, many of whom did not know whether they were coming or going. 'A very cruel and murderous affair', in short, 'and many feats of arms went unrecorded.' The heralds' time came only the next day, as they rode the battle-field, identifying the fallen from their arms, men whose lives might have been spared had their attackers only known 'who they were'. The loss of ransoms was Edward's chief regret according to Froissart, a conventional enough remark, but on the other side he has an unforgettable picture of the French king staying on the field of battle all day long, numb with shock but still standing his ground, until at last he was led quietly away.

135 The Pepysian Model Book. Cambridge, Magdalene College MS Pepys 1916, fo. 12r.
The volume contains painted drawings of figures, animals and birds; it may have served as an artist's model book. Shown here and named are (AT TOP) two pairs of falcons (*Hawkes*), on gloves and on perches, and (AT BOTTOM) a bullfinch (*a bwoll fynch*); between them are a moorhen, a drake, and a mallard being attacked by a hawk.

7

AFTER THE PLAGUE

1349 — 1399

IN THE AUTUMN OF 1822 William Cobbett set off on his *Rural Rides*. As he travelled through England he rode more than one hobby horse. One of them was prompted by the landmarks on his journey, the spires and steeples and towers of the parish churches of rural England. He saw large churches, packed tight together, in fertile valleys that seemed largely depopulated. In the vale that stretched between Salisbury and Warminster in Wiltshire he counted twenty-one churches, any one of which could easily contain the existing population of the entire valley, And yet he was told, by 'Scottish feelosophers' such as Adam Smith, that England was then much more populous than it had been in the fourteenth century. Cobbett challenged them to explain, 'why these twenty-one churches were built; what they were built for; why the large churches of the two Codfords were struck up within a few hundred yards of each other'. There were areas on the downs of each village, all bearing the marks of the plough, but in Cobbett's day not cultivated. On every side of the villages there were numerous small enclosures, 'which had, to a certainty, each its house in former times'. All this was well observed, and the questions put were good ones, though Cobbett knew the answers before he set out. For him, depopulation was the result of a conspiracy between landlords and the parish clergy (the worst criminals of all) to drive out the ordinary people of England.

A modern explanation of these changes must start with the most dramatic and most significant event in fourteenth-century European history, the arrival of the Black Death. The plague originated in the steppes of central Asia. It spread by sea, from the Mediterranean, and thence along the shipping lines which linked it with northern Europe. Edward III's daughter Joan died of the plague at Bordeaux in September 1348. Thence it arrived in England at Melcombe Regis in Dorset, for 'one of the sailors brought with him from Gascony the seeds of the terrible pestilence'. Or it may have been Bristol, or Southampton, where the plague first appeared; both ports were among the earliest places affected. It is difficult to say, for by the time the disease was diagnosed it had spread over much of southern England. By the end of 1348, and probably by water, it had arrived in London. Parliament, which had been summoned to meet there in February 1349, was postponed, because of 'the plague of deadly pestilence which had suddenly broken out'. For most of England 1349 was the plague year. 'The fearful mortality rolled on', said Henry Knighton, canon of Leicester, 'following the course of the sun into every part of the kingdom.' Knighton looked to the heavens; but what men had to fear lay underfoot. It was *rattus rattus*, the domestic rat, in the eaves of their houses, hidden among the grain stacked in their barns, that was the agent by which the disease was spread. It struck suddenly; its symptoms were horrible, and for many death came after a few days. The symptoms were the boils or buboes that appeared under the armpits or in the groin; they swelled up, grew putrid, and finally burst. From this, said the physician to the papal court in a matter of fact way, you died in three to five days. This was the classic bubonic plague; but there was worse. There was pneumonic plague also. This got to the lungs, showed natural symptoms in the spitting of blood, and killed you even more quickly: 'from this you died in two days'.

People did die, and in great numbers. It is impossible to provide exact figures, for neither the church nor the state kept any register of deaths. The nearest to a nationwide record is that of the number of parish clergy taking up new benefices. In the 535 parishes of the diocese of York, 233 benefices were vacated by death, a figure of 43 per cent. In the Lincoln diocese there was a turnover of 40 per cent in the numbers of the parish clergy, though plague deaths are impossible to isolate. Figures for individual villages are taken from the transfer of land, not from deaths directly, but because of the smallness of the communities the samples are easier to control. Figures of between 30

136 Ely Cathedral, the Octagon and Lantern. 1322–53
The carpenter of the Lantern was William Hurley, the king's master craftsman; the commission was granted by the sacrist of Ely, Alan of Walsingham, a goldsmith. This coincidence allowed them the confidence to build one of the masterpieces in the Decorated style.

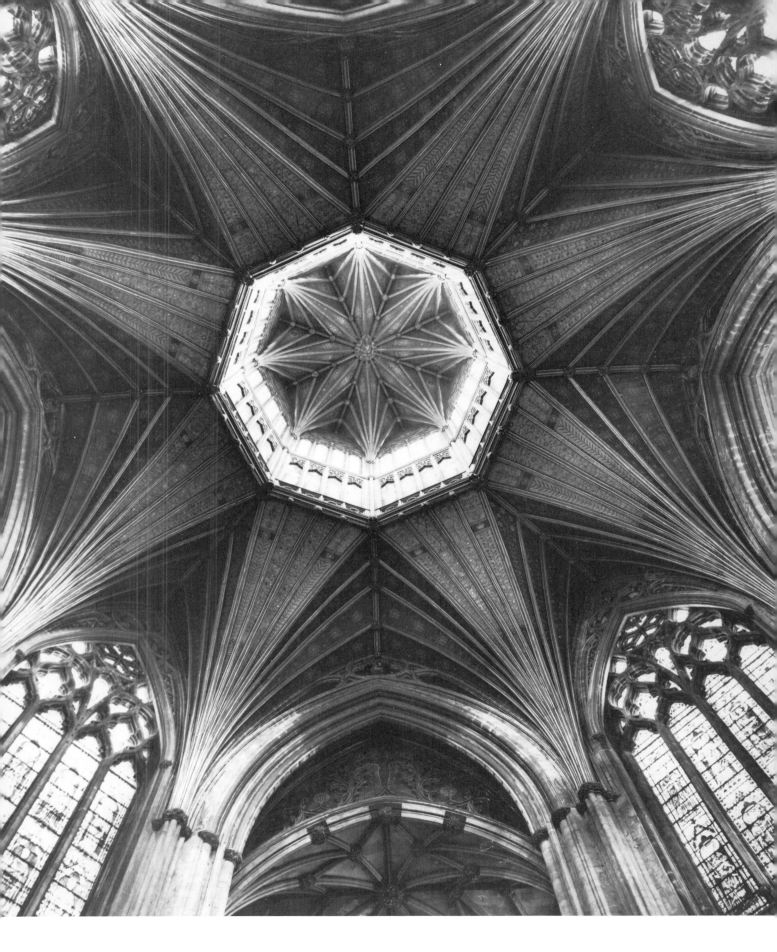

alone there were three further plagues in 1361, 1369 and 1375. The plague of 1361 is worth particular attention. For the nobility it struck severely, with a death rate of 24 per cent, much higher than that recorded in the first plague. Henry Knighton at Leicester observed that 'the greater and the less died', but particularly young men (a group earlier largely immune) and children. If the sex ratios within the population were distorted, the process of regeneration would inevitably have been held up. Alongside the plague there was also a whole range of infectious diseases – cholera, influenza, typhoid and tuberculosis – against which there was no inoculation. The fifteenth century, in Sylvia

137 The Last Days of the World. Early 15th century. York, All Saints Church, North Street, north aisle 'All that lives shall then die': the sign on the 14th day of the 15 in which the world would be destroyed. An English allegorical poem, *The Prick of Conscience*, here translated into stained glass.

and 45 per cent seem common in these records. In richer communities also, those with access to the best medical care, figures were similar. At Westminster Abbey the abbot and twenty-six of his monks died. Most Londoners, however, sought to flee the contagion of the city. The king stayed in the country, at King's Langley (where his relics were sent to him in July 1349) and at Woodstock. We shall return to him (p. 202).

The plague did not strike all alike, The old and the young were particularly vulnerable, while those in their twenties and thirties had the greatest immunity, as figures for Halesowen produced by Zvi Razi show. This should have allowed population figures to return to their previous level within a generation, but they did not. Having fallen rapidly during the plague years, they continued to fall throughout the fourteenth century, so that by its end the population of England stood at half the level it had been before the plague. The figure of two million for the population of England in the reign of Richard 11, though Cobbett found it impossible to credit, remains a good estimate.

The decline in population in the late fourteenth century cannot be ascribed solely to the plague of 1348–9. Other factors must be looked for. One, and the most obvious, is that the plague returned again; in Edward 111's lifetime

138 Padbury, Buckinghamshire: fields north-east of the village, looking south-west Two landscapes can be seen here, the medieval (which continued until enclosure) and the modern. The post-enclosure hedges cut right across the ridge and furrow of the old fields.

Thrupp's phrase, was 'the golden age of bacteria'. The monks of Canterbury kept a record of what their brethren died of, where this could be diagnosed: more died in this period of tuberculosis and of 'sweating sickness' than of plague. So, if population levels stayed down, it was continuing high mortality that was the chief cause; but a lower level of fertility seems likely as well. Families in the fifteenth century were smaller, and the number of unmarried people larger, than before the plague.

The fall in population had important repercussions in the English village. These in turn were determined by the way in which the village was organised. The villages were communities. They operated, many of them, a communal system of agriculture. The most visible feature of this system, which has given its name to the whole, is the open field. There were, most commonly, two or three large fields in which the holdings of the peasantry, of the priest (known as the glebe) and sometimes those of the landlord (known as the demesne) lay intermingled. The best map that survives is that of the village of Boarstall in Buckinghamshire (see Pl. 160). This names as fields three areas immediately surrounding the village, Frithfield, Cowhousefield and Arnegrovefield. The village is shown in the centre, with the church, the market cross and the gatehouse into the

139 Misericord: December. Late 14th century. Worcester Cathedral, choir stalls on the south side
An old man and his dog warm themselves by the fire; two flitches of bacon hang on the right. The chimney indicates that the man is quite well off.

140 Child's shoe. Museum of London, Late 14th century, leather, found near Blackfriars

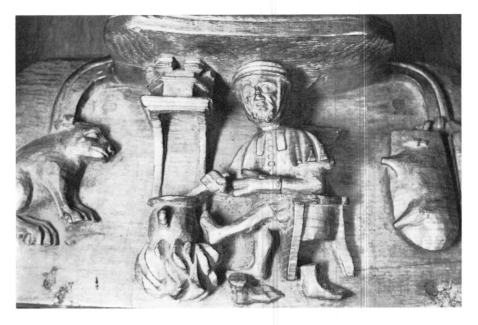

manorial complex, the symbols of social organisation, all appearing prominently. At the foot of the map appears Deerhide, about 200 acres of land, divided into small closes. To this land there was a story attached, and the story is told in an adjacent illustration, which shows Nigel the huntsman, having cleared the area of wild boar, present, ing a boar's head to the king. The king has a hunting, horn in his right hand, dangling alongside the family arms; with his left hand he points to Deerhide, the reward for loyal service. Holdings of this kind, for specific service, were known as serjeanties. Around the landscape of open fields and small closes there was woodland, fine strong trees, and among them the beasts of the forest rest secure. The wood, land was an important resource for the villagers, providing pannage for their pigs and timber for their buildings. In this 'model' village all that is missing, or rather is not specifically identified, is the pasture and meadow land, the grazing for the great beasts which drove the plough teams. This was an indispensable and scarce resource: an area of pasture would commonly be valued at three times that of the same area of arable.

To keep a balance between the needs of animals and of men was the chief problem that a village like Boarstall

had to face. The animals needed open spaces for grazing. The men, farmers in pursuit of their own profit, wanted individual ownership of arable land. The needs of both were met, imperfectly but adequately, when the open fields were organised to allow communal grazing at certain times, and were supplemented by the other manorial resources just listed. When the author of the Boarstall map identified three fields, he had in his mind a rotation in which in each year the land use of each field would be different. One field, roughly a third of the arable area, would be left fallow. This served two purposes: it allowed the land to recover its fertility, and it provided necessary grazing for the animals. The other two fields would be sown with a variety of crops. They might be called, as at Wymeswold in Leicestershire c.1425, 'the whete corn field' and the 'pese corn field', from their distinctive but not their sole crops. Wheat and rye were the main winter, sown crops; peas was one of the main spring crops, along with barley, oats, and other mixed grains and legumes. As between the three fields, there would be a rotation. Because of the rotation there was need for the scattering of land allocated to each peasant farmer, to ensure a mix of lands of different quality, and that no villager had more than a proportionate share of the fallow land. The three main fields were areas under a particular routine, and would seldom be sown with only one crop. The unit of cropping was the furlong, normally several to a field, as is shown by the aerial view of Padbury, Buckinghamshire. Here there are two landscapes super, imposed, the lines of the hedges that form the boundary of the parliamentary enclosures of the eighteenth century cutting right across the lines of the medieval furlongs. The villagers sowed their own crops, but there was much that needed

communal regulation, to keep men and animals apart, and to protect their proper interest. 'All the meadow and pasture within the three fields shall be enclosed when these fields are being sown', it was stated at Harlestone in North-amptonshire in 1410; they were to lie as common, 'when the needs of those fields and of the village shall render cus-tomary'. The precise dates would need to be regulated from year to year. This was one of the duties of the manorial court, a necessary part of the communal organisation of the village, as well as serving the interests of the lord.

In the spring of 1349, men sowed crops that they would not reap. At Warboys in Huntingdonshire eight main holdings and ten cottages were left vacant by the plague, and the landlord was able to sell the corn growing on them for £7 1s. 8d. Life went on. The greater number of hold-ings were occupied again within a matter of months. There was still a pool of heirs, blood relations if not sons and daughters, available in well-populated villages to take up land. But it was soon drained. And as it was drained, the nature of the village came to change. Men would no longer take up land on the old terms. In particular, they declined to take up land that was burdened with labour services. They would pay only the *versus valor*, the true value of the land; and as prices fell, from the 1370s, that value declined. The landlords, as they gazed out over what they felt to be their villages, became increasingly worried. Two developments in particular concerned them. The first, very clearly visible on the ground, was the decay of build-ings. The landlords were prepared to reduce rents, but they insisted that newcomers make repairs, and often provided the main timbers for their timber-framed buildings. Par-ticular house-sites had come to be linked with particular units of land in the fields. The links were weakening, and the landlords were concerned. It was only a short step to the peasants moving away, and their manpower and service being lost to the lords and to the village community entirely. Hence the concern in the court-rolls of this period with those who had moved away, men and women who were stated to have villeinage in their blood. In 1387, for example, the villagers of Maidwell in Northamptonshire were asked the whereabouts of their former neighbours, 'villeins of the lord by blood'. Members of four families were mentioned, and their whereabouts were given. One of these was Sarah the daughter of Geoffrey Hochun, who (they said) used to live at Rushton, a nearby market town. Attempts to track down the missing families failed. The villagers slowly forgot what little they knew. Only the memory of Sarah's good looks survived, for in later entries she is *fayr Sara* (English: what the villagers said) or *pulchra Sarra* (Latin: the clerk's translation). Many surveys of this kind were made around the same time.

Why were the landlords so concerned? It seems to us obvious that a population half the size it had been earlier in the century would not need the housing stock inherited from a more populous age. The abandonment of some settlements, for the same reasons, does not seem surprising either. But we know that the process was to end, and that most villages, though they might be shrunken in size, would survive. The landlords of the 1370s and '80s could not foresee this. This was the time of the Peasants' Revolt, in which the peasantry's confidence and the landlords' fears each had their parts to play (pp. 212–17). Around 3000 sites, deserted or seriously shrunken, have been identified in England by fieldwork, excavation and the use of aerial photographs. For many of them the late fourteenth century was a key time. To take another example from North-amptonshire, Kingsthorpe in Polebrook parish was a small estate belonging to Thorney abbey, which held a court there in 1386. Ten jurors were listed, of whom four did not attend. Those who remained declared that thirteen vil-leins of the lord were living outside the estate. The next records are from 1488, when there were only two tenants

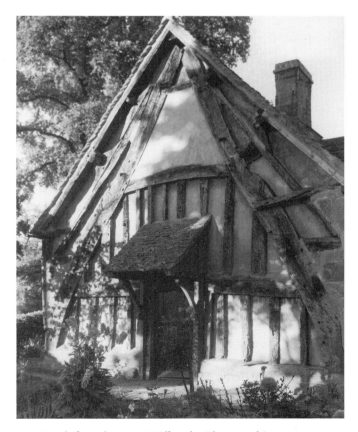

141 Cruck-framed cottage. Didbrook, Gloucestershire, (probably) 15th century
Compare the illustration on p. 201 no. 5, where the style of building is explained.

A Deserted Village—Upton, Gloucestershire

UPTON LAY IN a small valley on the northern edge of the Cotswolds, about 750 ft (230 m) above sea level. Two sources of information tell us about the village and its inhabitants – the archives of the bishops of Worcester (who were lords of Blockley, the manor to which Upton belonged), and archaeology, because Upton's desertion in the fourteenth century has made it available for excavation.

In about 1250, its heyday, twenty families lived at Upton, mostly holding a yardland of forty acres of arable together with grazing rights on the common pasture. They cultivated land in strips with ox-drawn ploughs, and grew a variety of cereal crops, especially barley. Here was the basis of their diet of bread, pottage and ale, while their sheep and cattle gave them a regular supply of milk products, manure to maintain the fertility of the arable, and above all an income in cash from wool sales. The Upton peasants combined self-sufficient farming with a modest production for the market. Horses were used to carry produce to the local towns, such as Chipping Campden. The village women spun woollen yarn and brewed ale for sale in the village. Cash was needed to pay the landlord's rent of about seven shillings annually for each yardland, to buy pottery, metal goods and cloth from outside the village, and to employ poorer neighbours, both as full-time shepherds and as temporary hired labourers.

The peasants' buildings ranged in length from thirty to seventy ft (9–21 m) with a standard width of about fifteen ft (4.5 m). There were buildings for animals, and barns to store crops. The houses themselves, though small in size, suggest that the villagers had some surplus wealth, because the stone foundation walls were skilfully constructed, and supported a substantial superstructure of timber. Internal fittings included partition

1 Plan of peasant long-house
The 'lower end' may have served as a byre for cattle, or a dairy, or a workshop. It was equipped with efficient drains. Above the cross-passage was a living room with a hearth and oven, from which a stair gave access to an upper room for sleeping. A latrine stood conveniently outside the east door.

2 (BELOW) A peasant long-house of the thirteenth century after excavation
The walls are of local limestone, well-constructed and packed with clay. Timbers for walls and roof would have rested on top of the stonework.

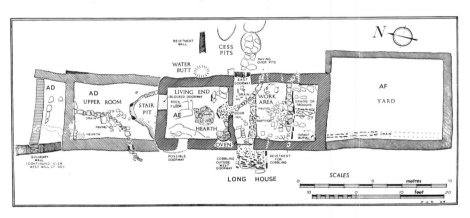

3 (RIGHT) A plan of the surviving remains of the village of Upton
The walls of the houses, and the boundary walls around the 'tofts' (garden enclosures) survive as low mounds in a modern pasture field. The plan of the western end of the settlement is regular, with a continuous boundary wall that separates the village from its arable fields. The large building to the south-east was a sheepcote, probably built after the desertion of the village.

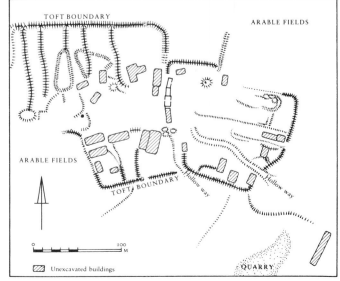

walls, hearths, drains and, in one house, an oven. There is evidence of an improvement in living conditions in *c.* 1300, when a 'long-house' that accommodated both people and animals under the same roof was replaced by a separate dwelling-house. The villagers' possessions included useful equipment for farming or cooking, but they were sometimes able to afford such small luxuries as bronze buckles and ornaments.

The privacy of households is suggested by the village plan with its walled quarter-acre 'tofts', yet there is good evidence in the form of the continuous boundary wall for the existence of a community. The peasants also needed agreement among themselves to manage the common fields and to collect dues for payment both to their landlords and to the state.

Upton began to decline by 1299, when three tenants had taken over neighbours' holdings that had formerly been held as separate units. Peasants throughout the Cotswolds had problems in the fourteenth century in maintaining grain yields with limited amounts of manure, and even Upton's relatively low rent and tax obligations became more difficult to meet. The famine of 1315–17 and the plagues of 1349 and 1361–2 made vacant holdings available in other villages, and people were glad to move to larger places with more facilities. They shook off their servile status, which in theory tied them to their lord, and gained their freedom by migration. The last inhabitant of one Upton house apparently killed and buried his dog as a final act before his departure. Desertion was complete by 1383. The village and its fields became a sheep-pasture, served by a sheepcote nearby. From the late fifteenth century 'Upton Wold' was leased to graziers who kept enough sheep to pay a rent of £9 6s 8d from their profits. All over England, 3,000 villages were being deserted in the period 1320–1520, reflecting not just the fall in population, but also the vulnerability of corn-growing peasant communities; the future lay with the large-scale farmers who took over the empty lands.

Although an inhabited place called Upton existed as early as the ninth century, the village itself may not have

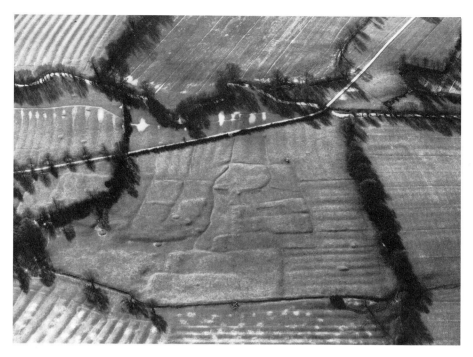

4 Aerial photograph of the deserted village of Upper Ditchford, three miles from Upton, and once of similar size
Rectangular tofts, streets, and the ridge and furrow of arable fields are clearly marked, as are the hedges of the enclosures made when the site was converted to sheep pasture in 1475.

5 Cross-section of a peasant house. London, British Library MS Royal 6.E.VI, fo. 148v, mid-14th century
This shows the use of crucks (curved upright timbers) as the basis of a timber frame. The spaces between the timbers were filled with wattle and daub

been formed as a single nucleus of settlement until the eleventh or twelfth century, judging from the traces of timber building and fences found under the stone walls of the later middle ages. This is typical of other villages, which were not primeval settlements, but creations of the period 900—1200, when under pressure in a crowded landscape groups of peasants found that co-operation gave them the best means of managing extensive arable fields. The deliberate act of village foundation is reflected in regular village plans, like that of the western part of Upton. Villages were artificial products of the peculiar circumstances of the early middle ages, and were becoming obsolete by the fourteenth century.

CHRISTOPHER DYER

in Kingsthorpe, one of whom had the demesne and the other the tenant land. The village was enclosed in the early sixteenth century. It goes down as a desertion of that period; but it should not. In 1386 the village was, as it were, 'brain-dead'. The community had disappeared. The absence of fifteenth-century pottery from the site confirms this impression.

The settlements that died, that were totally deserted, were the exceptions. More common was a process of adjustment, which frequently involved changes in land use. The early fifteenth century, when population levels had stabilised, was the time of adjustment over much of the Midlands. Several examples have already been taken from this period, a time when customs were being written down, for otherwise they would be lost. Once open-field agriculture was abandoned there would be no going back, for the system needed manpower and it needed money, and in the fifteenth century both were in short supply. Over much of the Midlands, an area suitable both for arable farming and for the raising of stock, land once under the plough was put down to grass. The old ridge and furrow still stands witness to this change. There were some dated evictions. In 1491 the nuns of Catesby priory destroyed fourteen houses, evicted sixty people, and enclosed the land for pasture. These 'depopulating' enclosures were highlighted by Tudor pamphleteers, and the landlords were much criticised. The important time of depopulation was earlier: it was the disease-spreading rats not the landlords that were to blame. The most tenacious institution, in the midst of change, was the parish church. A solitary church, standing in the midst of fields, is not an uncommon sight. The story will in each case be different, but for many of them the key period was the years after the Black Death.

The Continuation of the French War

All landowners were affected by the plague. They lost key personnel, their routines were disrupted, and their impetus and self-confidence were threatened. Those with whom they dealt had all suffered similarly, and would probe for any signs of weakness. At Elton in Huntingdonshire, the reeve of the Ramsey abbey manor claimed a deduction of the amount of tallage normally paid by the villeins; the auditors were alert enough to note that, because of the plague, he had not been charged with this sum. The effective exercise of lordship was dependent on vigilance of this kind. Royal lordship and royal government were particularly vulnerable, because of their distance from the taxpayers and the labourers of England. There were many links in the chain of authority, and all had to hold firm. They did so. During the weeks of crisis the king was on

his country manors, but at Westminster the clerks worked on. The tax on moveables, granted in 1348 for three years, continued to be collected. In 1352 it was renewed for a further three years; and it was renewed on the same assessment, even though the number of taxpayers had fallen by at least a quarter. The landowning class came to be more cohesive. Parliament legislated to control the labour market in 1349 and 1351, seeking to keep wages stable and to restrict the mobility of labour (p. 205).

That the English government came through the years of crisis so well, with its authority unimpaired and with the political consensus so little affected, was a remarkable achievement. It was able to do so because that authority and that consensus had been initially so strong. The crisis of 1341 had been administrative. The king had had servants whom he did not trust, and had made demands on resources that he could not sustain (see pp. 187–91). There were to be reforms in both areas, and after 1341 the king himself became more actively involved in his own administration, which in the 1330s he had neglected for 'pleasant pursuits and the company of young ladies'. The most important official of the 1340s and 1350s was William Edington, a royal clerk who was treasurer between 1344 and 1356, a quite exceptional length of service, and who then moved to the chancery from 1356 to 1363. Edington restored the financial stability of the crown. That taxes continued to be raised throughout the plague years has just been noted. In all, between 1344 and 1357, parliament granted eleven direct subsidies, all of them based on the 1334 valuation. When clerical subsidies are added, over half a million pounds was raised in these years. This sum, substantial as it was, was overshadowed by the taxation of the wool trade. In the aftermath of the plague there was a boom in wool exports, and the government made sure that it maximised its income from this source. To the 'old custom' (6s. 8d.) and the 'new custom' (3s. 4d.) was added a *maltote* of 40s. paid by aliens, who alone (because they paid the higher duty) were allowed to trade. The market was able to bear a tax of 50s. on a sack of wool, and between 1353 and 1362 over £700,000 was raised. These sums were raised with the consent of the political community, as represented in parliament. The chronicler John of Reading described Edington as a friend of the *communitas*, who saved the people from royal extortion, and worked for the common profit of king and realm.

The king took a particular interest in administration just before, and during, his major campaigns. This is not to be wondered at. The money was being raised for the war effort. The battle of Crécy in August 1346 had made Edward III's reputation as a military commander, and from parliament there came rare praise, that all the money

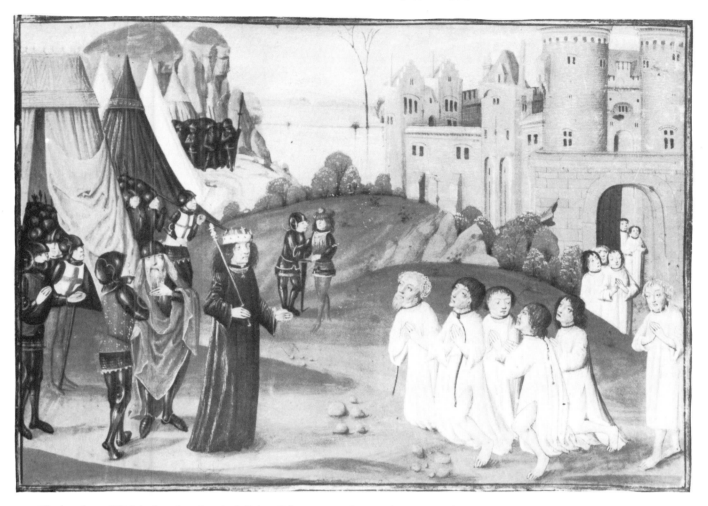

142 The burghers of Calais. London, Lambeth Palace Library MS 6, fo. 218r, last quarter of 15th century
The illustration is in a French or Flemish style, but the text is an English language version of the popular *Brut* chronicle.

it had raised in the king's support had been well spent. From Crécy the king moved immediately to the siege of Calais, the chief port on the short sea route to the continent. The garrison of Calais was to be starved out. To supply his own army on French soil Edward built a new town, laid out as though for a major trade fair, supplied both from England and Flanders. 'There were haberdashers' and butchers' shops', said Froissart, 'stalls selling cloth and bread and all other necessities, so that almost anything could be bought there.'

The French king was not able to lift the siege, nor could he tempt the English into battle. When he withdrew the burghers of Calais surrendered. It is Froissart who has the story of the six leading citizens, on behalf of the garrison, presenting themselves stripped, bound and with nooses round their necks, ready for execution; but saved finally through the intercession of Edward's councillors and his pregnant queen. This story, perhaps more than any other

from the Hundred Years War, has entered the western consciousness, kept there most recently by Rodin's famous sculpture. Edward entered Calais on 4 August 1347. It was politic as well as chivalrous to save the town the devastation which elsewhere a conquering army would have expected as of right. Edward needed Calais. It needed to be defensible, and labour was needed not just on the town's defences but on the ring of fortresses which surrounded it. Carpenters, masons, and those skilled in 'water-work' were brought over from England: there was a maintenance staff of over 200 men later in Edward's reign. The town represented a heavy drain on resources, and when the wool staple was moved there in 1363 it was with the intention of making it self-supporting. Calais offered the hope and the model of a permanent English settlement in France, and it remained in English hands long after that hope had disappeared, not being lost until 1558, in the reign of Mary Tudor.

The king's claims in France, the victories he had won by land and sea, and the ports he controlled, all brought uncertainty to France. The French government machine was much more severely disrupted than was the English by the Black Death. In 1350 John II, a new king, took over a dispirited country, whose effective authority was in danger of being reduced to the area it had controlled two centuries before. English armies were sent out to cover great distances and destroy all that stood in their way. This was the *chévauchée*, a recognised tactic in manuals of warfare, and much used by the English in the middle years of Edward III's reign. Edward's son, the Black Prince, was twenty-five years old when he was sent to Gascony in 1355. He was already a thorough professional, and his short life provides a textbook study of fourteenth-century warfare. Almost immediately on landing he embarked on a classic *chévauchée*, in the two months of October and November covering 900 km, an average of 15 km a day, and reaching as far as the ancient city of Narbonne, close to the Mediterranean, before returning. The following spring he struck more directly into French territory, moving towards Berry and the Loire valley, and following the same procedure. 'The country was well stocked, but they left it broken and devastated behind them.' They took Bourges, the great cathedral city of central France, and one of the historic centres of French kingship.

The loss of Bourges was more than John II could bear, and when the Black Prince turned westwards towards Poitou the French army, which had been mustered near Chartres, went in pursuit. The armies met a few miles south of Poitiers on 19 September 1356. Peace negotiations gave the Black Prince the opportunity to choose his ground, and for scouts from each side to inspect the other's position. Almost certainly outnumbered, the Black Prince had to avoid open ground; and he took 'a strong position, among hedges, vines and bushes'. Only a few of the best of the cavalry would be needed at first. The rest had their armour and equipment adapted to the new terrain. Their lances were cut down, and their spurs removed. This must have seemed degradation to many, but it paid dividends. The French, well-informed on these tactics, and perhaps over-impressed by them, dismounted many troops in turn, but lacked the forces of archers to offer support and were driven back. This was a battle for the connoisseur, Froissart stated, in a way that Crécy had not been, the two sides well-prepared and able to show off their skills. At its end the Black Prince won the day, and the French king was captured. The English took more prisoners than they could handle. Many of the captured knights and squires were able to ransom themselves on the spot, or were released on parole. It was only the most valuable, the king 'and

143 The English victorious. London, British Library, Egerton MS 3277, fo. 68v, *c.*1361–73, Psalter and Hours of the Virgin, probably made for Humphrey 7th earl Bohun.
In the left margin of this initial a pleasing scene shows Edward III (mounted on a lion) receiving a sword in token of the surrender of John II of France after the Battle of Poitiers, 1356; King Charles 'the Bad' of Navarre skulks beneath.

most of the captured counts and barons' who were retained. The prince entertained them to supper on the evening of the battle, and took them back to Bordeaux, whence they were shipped to England as a vintage of rare quality.

The prisoners of Poitiers thus waited, in some comfort, the resolution of a problem which their capture made ever more difficult. On what terms could the quarrel between the two kings be settled? It is easier to settle a war if you know what you are fighting for. The English king did not know. He had taken the title 'king of France' in 1340, three years after the outbreak of war. The title was a consequence not a cause of the dispute. It came to provide him, however, with much the most powerful of his bargaining counters. He grew accustomed to the form of address, from French as well as English, and when the war was going well the prospect of becoming king of France may not have seemed totally ridiculous. Even at such times, however, he was prepared to renounce the title of king in return for concessions by the French which would include sovereignty over an (often much enlarged) Aquitaine. This

was where Edward told the Black Prince to start discussions with the French king, his prisoner, at Bordeaux in 1357. The prince was instructed to initiate peace talks, 'always remaining adamant on the question of having perpetual liberty with all the lands one can obtain'. A modern reader will translate 'liberty' as 'sovereignty', which is acceptable only if it is remembered that the modern concept of sovereignty encapsulates a different set of ideas, and presumes a state far more powerful than the medieval. The medieval idea of liberty was composed of historic rights: in Aquitaine the English king was seeking effective jurisdiction over territory clearly defined.

At Brétigny near Chartres, on 8 May 1360, the two sides sealed the draft of an agreement. The English king was to be given in Aquitaine the perpetual liberty which he sought. He was to retain Calais and several maritime lordships to the north; he was to receive, as ransom for the French king, the enormous sum of three million gold crowns (£500,000 sterling), 600,000 crowns to be paid at Calais within four months, the remainder in annual instalments of 400,000 crowns. In return for the concessions the English king made only one of substance, the renunciation of his rights to the French crown. This was the nearest the two sides were to come to agreeing a settlement. They failed. There was a lot of small print to discuss, and until it was worked through the vital renunciations, of sovereignty on the one hand and of claims to the French throne on the other, were deferred; they were never carried out. Edward III must take most of the blame for this failure, for it was he who had the initiative in these years. He lacked the stimulus, and possibly also the vision, to make peace. His longevity prolonged the war.

The Last Years of Edward III

Edward III was under very little pressure in the 1360s. It was a decade of peace, in which he was able to retain much of the taxation that had initially been justified by the necessity of war. The Black Death had created a community of interest among the landowners, both magnates and gentry, who were represented in parliament. Some of the most important of the legislation of the next two decades needs to be seen in this context. An immediate response was the Statute of Labourers of 1351, which fixed wage-rates and tried to restrict the mobility of agricultural workers. The local gentry tried cases under this statute, which they saw as essential for their effective lordship, and had the extra incentive that they were allowed to keep and set against their tax burden the fines which they levied. In criminal cases, however, the gentry's powers were limited, and they had long sought to increase them. They

served as 'keepers' of the peace, with the power to present criminals for trial, not to punish them. Punishment was reserved to royal justices, lawyers and magnates, at their most severe in special commissions of trailbaston, sent to hunt out criminals, and in regular visitations of the justices in eyre. These last were to atrophy in the fourteenth century. In acts of parliament, first in 1361 and then in 1368 the gentry were given for the first time powers to try or 'determine' some categories of crime. Local knights now served as justices of the peace, or JPs, an office which survives to this day both in England and America. A county commission of the peace might typically contain two magnates, two knights and two lawyers. From this time also dates a new concept in committee government, for a *quorum* of lawyers was necessary before felons could be tried.

Edward III was rich in his later years. After Brétigny the war effort ran down. The king was able to apply an ample capital to his own comfort and ease. Most individuals show their own tastes clearly in such circumstances, and Edward was no exception. He introduced into England the first striking clocks, the earliest of which was installed in the keep at Windsor castle between 1361 and 1364. The clocks were made in England, but the technology was imported, for among the expenses were the wages of three Italians. In the late 1360s three further clocks followed, at Westminster, at King's Langley, and at Edward's new castle, at Queenborough on the Isle of Sheppey. This last was the only wholly new royal castle of the later middle ages. It was started in 1361, and the cost over the next decade was around £20,000. It is, however, in his established residences, in and around London, that the king's tastes are most clearly revealed. The king's bath-houses, at Westminster and at King's Langley, must have been among the wonders of their day. There was a water supply at Westminster palace between the king's and queen's apartments. In the year 1351–2, as the king's subjects struggled to rebuild their lives after the plague, the king paid 56s. 8d. for 'two large bronze taps for the king's bath', one for hot and one for cold water. There in his bath the king clearly lingered, for in 1370–1 at King's Langley a new kitchen was built to serve the royal bath-house (*les steus*).

It is, however, with his castle at Windsor that Edward is most closely associated. Here was to be seen both a domestic king and a hero of chivalry, the leader of a country whose people's wishes echoed the king's as faithfully as the great bell *Edward* echoed over the Great Court. Here in 1348 there was established a new college to serve as a centre for the order of the Garter (see picture essay, pp. 174–5). Here a force of carpenters and masons built anew, the king monopolising the labour market for miles around, and

Robin Hood

FEW SUBJECTS IN MEDIEVAL history are more tantalisingly mysterious than the origins of the Robin Hood legends. We can be reasonably certain that their hero once existed, but his identity eludes us. Our chief difficulty lies in the lengthy gap between the time of his appearance and of our having any knowledge of his sup-posed activities. The legends were circulating as early as the mid thirteenth century, but they did so orally rather than in writing, and we know nothing of their content until the first written ballad appears about 1450. All we have to fol-low during this long period, when the legends themselves were probably being augmented and transformed, is a trail of allusions. The first, recently discovered by David Crook, comes in an exchequer record of 1262 which refers to a certain 'William Robehod', fugitive and outlaw. Although his real name was William, son of Robert le Fevre, his criminal career had led the clerk writing the record to coin an appropriate nickname for him. Clearly the parallel could only have come to mind if stories about Robin Hood were already well known. Other examples of the Robin Hood surname occur in the late thirteenth and early fourteenth centuries, and in 1377 comes the first literary reference, when the priest Sloth in Langland's *Piers Plowman* says:

I do not know my Paternoster perfectly as the priest sings it. But I know rhymes of Robin Hood and Randolph, earl of Chester.

From then on the allusions proliferate both in government records and in liter-ary sources. Some thirteen precede the first surviving written ballad, *Robin Hood and the Monk*, of about 1450. This in turn precedes the two printed texts of about 1500 which preserve similar versions of the longest and best known of the tales, the *Gest of Robin Hood*.

We have no means of knowing how long before 1262 the legends arose. A plausible case has been made for their origins in the activities of one Robert Hood, otherwise known as 'Hobbehod', a Yorkshire outlaw who appears in finan-cial records of the 1220s; but this is no more than a possibility. The earlier their origins, the more difficult it is to know what to make of the existing ballads, for the longer the process of change and development which will have modified them. Such a process has left its mark on the *Gest*, which represents a fusion of at least two different ballad cycles, one (probably the earlier) set in Barnsdale in South Yorkshire, and a second set in the traditional location of Sherwood Forest and featuring the sheriff of Nottingham. The *Gest* seems to have reached its final

1 The first literary mention of Robin Hood, *c*.1377. Bodleian Library, Oxford, MS Laud Misc. 581, fo. 22v
The extract shown is taken from one of the earliest manuscripts of Langland's *Piers Plowman*.

2 Archery practice at the butts, *c*.1330. British Library Add. MS 22130 (the Luttrell Psalter)
Robin Hood's skill at archery provides themes and variations in several of the early ballads.

3 Roof boss from Norwich Cathedral, early 14th century
This carving shows Esau's return from the chase. It is a vivid depiction of life in the forests at a time when the Robin Hood ballads were in wide circulation.

same time remaining a devout Christian and a man loyal to his king.

In the real world of later medieval England, grievances against corrupt officials were commonplace, and anticlericalism, often in combination with lay piety, widespread: hence the legends could appeal to sentiments and attitudes which transcended social boundaries. Yet by the time of the first surviving ballads they had probably lost any subversive or ideological thrust that they may once have had and become what they have been ever since, pure entertainment. They may originally have been spread by the itinerant households of the aristocracy and by the minstrels who worked within them, as J. C. Holt has argued, but by the fifteenth century they were more universally popular. If they appealed to the boorish people, the *stolidum vulgus*, as the Scottish chronicler Walter Bower noted in the 1440s, they also attracted others who would have thought themselves far from boorish. Robin Hood plays, for example, were patronised both by the mayor of Exeter in 1427 and by Sir John Paston in 1473. As part of a common popular culture, and not of any narrower culture of protest, they had a long future before them.

J. R. MADDICOTT

form in about 1400 and, in its allusions to liveries, fees and retaining, to reflect the social world of the fourteenth century. It may be that little more than the name of the hero has been carried forward from the primordial and now irrecoverable legend.

The earliest ballads that we know of contain few of the themes with which their hero has subsequently become associated. They are not concerned with robbing the rich to give to the poor, English resistance to oppressive Normans, or peasant resistance to oppressive landlords. If they have a motif, it is that of opposition to the corrupt use of authority, whether by the sheriff of Nottingham, by a royal justice or by avaricious churchmen. It is Robin Hood who represents true justice and who uses violence to set a perverted world to rights, while at the

4 The present-day remains of Sherwood Forest, west of Ollerton in Nottinghamshire. This is the setting for what seems to have been a later ballad-cycle than that set in Barnsdale.

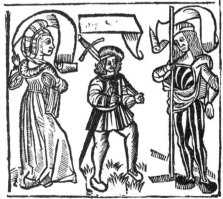

5 Frontispiece to Wynkyn de Worde's edition of the *Gest*, 1492–1534
This woodcut illustration from one of the earliest printed texts of the ballads gives some idea of popular conceptions of Robin Hood in the early Tudor period.

painters refined the visual imagery of Edward's kingship. Each year on St George's day all combined to put on one of those shows for which the English monarchy has become famous. That in 1358, to celebrate the completion of the new college, was particularly splendid; the staging cost over £200. The French king, some of whose ransom money went straight into the building fund, was among those entertained. The queen mother, Isabella, made one of her last appearances.

At what was to become a legendary occasion, the French king is supposed to have remarked that he was astonished that such a magnificent show could be paid for by tallies, without payment of gold or silver. Behind the banter there may well have lain a shrewd observation,

144 New College Oxford. Oxford, New College MS 288, second frontispiece, early 1460s. The model of the collegiate foundations of the late middle ages. In the foreground the master, the fellows and the scholars of the college; in the background the main quadrangle, which remains unchanged today.

that Edward's administration seemed to be run on tick. Edward relied for his income, as has been shown, on regular subsidies, and on loans raised on the security of the wool trade. For the subsidies he needed the approval of parliament, while behind the loans lay a complicated network of financial dealings which obviously depended on the continuing vitality of the wool trade itself. In the last decade of Edward's reign, between 1367 and 1377, the trade ran down and Edward's reputation with it. This happened at a bad time, for in 1369 the war with France was renewed. The 1370s saw regular and heavy taxation. Between 1371 and 1381 around £400,000 was levied, building up steadily to the heaviest taxation level of the late middle ages. In only one year was there no grant of direct taxation, in 1376, and this only because the Good Parliament of that year refused to pay. This parliament shows that Edward III had lost the confidence of the political community. This was both an administrative and a political failure.

The administrator singled out for criticism was William of Wykeham. Wykeham is one of the best-known civil servants of medieval England. The successor to Edington as bishop of Winchester, he founded there a school that remains part of the fabric of the city and of English education. He founded at Oxford, with lands which he purchased, the college that is now New College. He was a great builder, and it was at Windsor, where he was clerk of the works between 1356 and 1361, that he made his reputation. One chronicler spoke of him in these terms:

This William was of very low birth ... yet he was very shrewd and a man of great energy. Considering how he could best please the king and secure his goodwill, he counselled him to build the castle of Windsor in the form in which it appears today.

In 1363 he could be described as 'the king's secretary who stays by his side in constant attendance on his service'. He became chancellor in 1367. Thus closely identified with the king, he was a natural target when things went wrong. In the parliament of 1371 his removal from the chancery was part of the price which the lords exacted for the grant of taxation. In 1376 he was accused of a variety of misdeeds committed while he was chancellor, and was tried for them after the Good Parliament of that year had disbanded.

The Good Parliament of 1376 is one of the most famous parliaments of the middle ages. It started conventionally enough, with the commons meeting apart to discuss the normal requests for grants of taxation. They deliberated a long time, and the king grew restless. When they reappeared their spokesman was Sir Peter de la Mare, who performed this office throughout the parliament, and who is thus accounted the first Speaker of the House of Commons. They refused to grant the king money, an unprecedented act of defiance, saying that the only reason that Edward was short of cash was because 'he has with him certain counsellors and servants who are not loyal or profitable to him or the kingdom'. The commons' speaker was challenged to name names and specify charges. He did. He named William Lord Latimer the king's chamberlain, John Lord Neville, Richard Lyons and several other London merchants, and also Alice Perrers the king's mistress. Some of the chroniclers took a high moral line, making the king's adultery the main point at issue. The speaker did not. He said, and it took courage to say even this, that 'that lady' was costing the country £2000 to £3000 a year, money which could more profitably be spent on the French war. The main charges were against Latimer and Lyons for removing the wool staple from Calais, and making a profit from licences to evade the staple. They were also making too great a profit on their financial dealings with the king, examples being cited, which were clearly well known. Finally Latimer was held responsible for the loss of the French ports of Bécherel and Saint-Sauveur near Cherbourg, surrendered the previous year. These charges encapsulate the clear themes of Edward III's later years. High taxation was being levied to finance an unsuccessful war. The high living and low tone of the royal court only added to the offence.

The commons were successful at this parliament because they were united: 'what one of us says all say and assent to', as the speaker put it when he first appeared before the lords. Their unity continued when it came to pressing charges. When Latimer asked for an accuser the speaker, clearly ready for the question, said that he and the commons would maintain their charges in common (*en. commune*). This marks an important stage in the evolution of conciousness of the commons as a body. It marks an important innovation in procedure also, for the common charge is of the essence of impeachment. The commons acted as prosecutors at a trial held before the lords in parliament. The Good Parliament set up a 'continual' council to supervise the king's government. Its authority lasted only three months before there was the inevitable reaction. The Good Parliament was followed by the 'Bad', summoned to meet in January 1377. It issued pardons for those impeached, ordered the imprisonment for a time of the speaker de la Mare, and granted supply in the form of the first of the famous poll taxes. Thus ended a year of remarkable public awareness and debate on political issues. It had provoked a minor renaissance in historical writing, in which the major characters start to come alive. This was not to happen again until 1381, at the time of the Peasants' Revolt.

The Minority of Richard II and the Peasants' Revolt

Edward III died on 21 June 1377. The Black Prince had died the previous year, while the Good Parliament was in session. A military hero at a time when the war was stagnating, and held to sympathise with the critics of his father's court, he was universally mourned. The succession fell to his son Richard of Bordeaux, then aged ten. He was crowned as Richard II on 16 July 1377. At his side, as he walked in procession at Westminster from the palace to the abbey, was his uncle John of Gaunt. John, born in Ghent in March 1340, was now the eldest surviving son of Edward III. He had become duke of Lancaster in 1362, after the death of Henry duke of Lancaster, whose daughter and heir Blanche he had married. Blanche died of the 'third' plague in 1369, and John then married secondly the eldest daughter of Pedro 'the Cruel' of Castile, which gave him a claim to this Spanish kingdom which he would actively pursue. For nearly thirty years thereafter, for the Black Prince had fallen seriously ill in 1370, John of Gaunt, duke of Lancaster, was the leading subject of the kings of England, his birth and his wealth setting him apart from the other lords. He led the reaction of the court to the work of the Good Parliament of 1376, and he made many enemies at this time, the Londoners and the leading clergy prominent among them. Some of his enemies put it about that he aimed at the crown, though there is no evidence that he did. In some ways it is a pity that John of Gaunt was not the heir. The succession of an adult, who had some of his father's good qualities, would have provided new impetus; that of a child ensured that English politics remained in a rut.

The unpopularity of John of Gaunt at the time of Richard II's accession meant that he could not be given power as regent, such as William Marshall had been given over the young Henry III in 1216. Power was vested instead in the royal council. The council of the late fourteenth century was well adapted to fill this role. It had by this time a regular place of meeting, and precise duties and membership. Its meeting-place was a room newly constructed next to the Exchequer at Westminster, known then and thereafter from its decoration as the 'Star Chamber'. Its president was the chancellor; its members royal officials, justices, senior clerks, and other advisers of the king. The council had taken on much of the judicial work of parliament, including the hearing of petitions and dealing with complaints about the behaviour of royal agents such as purveyors. These councillors worked office hours, often from seven in the morning five days a week (or at

least four and a half, for the scale of their Friday 'breakfasts' suggests that only routine business should have been properly conducted that afternoon). In Richard II's minority this core of the council was added to with representatives of the various estates, including the leading magnates, and it came inevitably to take on political as well as a judicial and administrative role.

The king's council took over the unfinished business of the previous reign. There was continued concern with the conduct of the French war and how taxes might best be raised in its support. Since the reopening of the war in 1369 the English had been on the defensive. The French, under the command of their great constable Bertrand du Guesclin made substantial gains, most notably in the recapture of Poitou and much of eastern Aquitaine. The gains made in the early part of the war, and confirmed at Brétigny in 1360, had, by the end of Edward III's reign, for the most part been lost. The English then controlled Calais and its neighbourhood, Brest and a number of other Breton fortresses (though du Guesclin had driven them back here also) and the historic centre of Gascony around Bordeaux. In 1378 the first of Richard II's councils determined on what has been termed a 'barbican policy', in which an extended ring of continental bases was to be acquired, as a first line of defence as well as bases for attack. Brest was confirmed and Cherbourg was acquired by treaty, but an attempt by John of Gaunt to take Saint-Malo in the summer of that year failed, and the earl of Arundel was driven back from Harfleur. In 1380 the English undertook a chévauchée through north-west France under the command of Thomas of Woodstock, the youngest of Edward III's sons, recently created earl of Buckingham. The march concluded before Nantes, but this also refused to fall.

How was the money to be raised for such expeditions? The decline in the wool custom, and the shifts in policy designed to compensate for this, led men to question the continued usefulness of lay and clerical subsidies. They were old and inequitable. This could be agreed on, but how they were to be replaced was not so easy. The commons in 1377 spent a long time discussing this, 'for some wanted to grant tenths and fifteenths, some a mark on the wool customs, some a hearth tax, some fourpence a head'. A major problem was that they had only a vague idea what sums the alternative methods of taxation might raise. This had been seen in a remarkable way in 1371. At that date the subsidies had not been taken for ten years. It was

145 The Black Prince. Late 1370s, effigy of gold-latten copper. Canterbury Cathedral.
'The flower of chivalry of all the world' was Froissart's epitaph on the Black Prince.

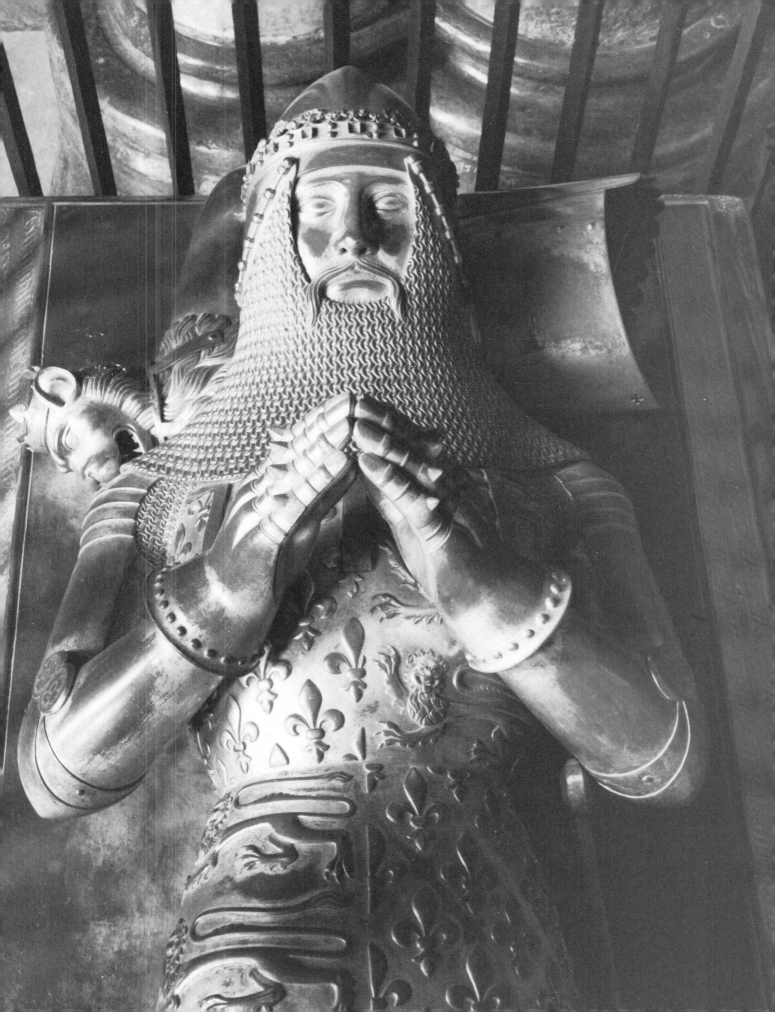

decided that there should be a parish levy, and that the commissioners should work from a notional assessment of 22s. 3d. a parish, with the wealthy parishes paying more and the poorer paying less. But how many parishes were there in England? On the figures discussed it seems to have been assumed that there were 45,000 parishes. That was widely exaggerated, and it took an inquiry by the sheriffs to arrive at the more accurate figure of 8600. No greater research lay behind the next expedient tried, the poll tax of 'fourpence a head' on which opinion finally settled in 1377. There was a second, graded poll tax taken in 1379, and a third, taken at the rate of 1s. a head, was granted in 1380 to be collected in the early months of 1381. The tax was intended to raise £100,000. It brought in a good deal less, and it led to the Peasants' Revolt.

Parliament in 1380 not only questioned the need for a new poll tax, but (most unusually) stated that a tax at this level was 'insupportable', more than the people could bear. There was massive evasion. When the initial assessment was completed there were nearly half a million fewer names on the lists than there had been in 1377. A further set of commissioners was sent out, but was no more successful. John Bampton, for example, arriving to collect the tax at Fobbing in Essex on 30 May 1381, was told that the people 'would have nothing to do with him nor give him a penny.' There were many reasons for the sustained opposition to the new poll tax. There was a continuing feeling that the war was being badly managed because of corruption in high places. People were forced to pay the poll taxes who previously had been exempt. Teenagers were one such group, for in 1381 those fifteen years old and over paid; so too did smallholders and craftsmen. Craftsmen suffered also from the labour laws, and many were to be implicated in the revolt. The reeves and the chief men of the village had no authority with the poll tax to apportion the tax burden amongst the villagers, as they had had with the old subsidies. This was one of several ways in which their position became more difficult in the years after the Black Death. The lords were concerned to keep up their court income, to compensate for a decline in rents; it was the chief men of the village who had to collect the fines. And it would have been clear to them that there was a measure of policy in what has been termed the 'seigneurial reaction'. The lords detected, to a much greater extent than was in fact the case, a shift of prosperity from them to their labourers, to their villeins. Froissart's comment on the reasons for the revolt reflects their feelings very exactly; it was, he said, 'because of the ease and comfort the common people were of'.

Because of these shared perceptions, of corruption at court and of class antagonism, the grievances of individuals and communities quickly grew into a major revolt. Within a month of John Bampton's leaving Fobbing penniless and much shaken, England had seen its one popular revolt of the middle ages. The events were so dramatic, the views of the leaders so shocking to those in authority, that they were reported in detail. And they were well reported, because by a (for us) happy accident, the rebels brought a direct challenge to the great centres of historical writing in England, the abbeys of Bury St Edmunds and St Albans, and the city of London. It was for London that the rebels made. There were two groups, one from Essex and one from Kent, maintaining close contact across the Thames estuary. It was Kent that provided the leaders of the revolt. Their prophet was John Ball, whom they released from the archbishop's prison when they got to Canterbury; their general was Wat Tyler, who joined the Kentish mob at Maidstone and turned it into a force with some sense of discipline. On 12 June the men of Kent arrived at Blackheath, and it was here, as reported, that Ball preached his famous sermon on the text

When Adam delved, and Eve span
Who was then the gentle man?

Among his congregation were many of the Essex rebels, who had arrived at Mile End the same day and crossed the Thames to hear him. The sermon spoke of the end of lordship in England. Most of the rebels had more restricted ambitions, as events of the next few days were to prove. They needed a king, and it was the king (then aged fourteen) whom they had come to see. That same day Richard came to Greenwich by water, but his councillors, fearful for their own lives, would not allow him to land; they returned, via the water-gate, to the Tower.

The key events of the Peasants' Revolt took place in the city and the eastern suburbs. On 13 June the rebels were allowed to cross London Bridge, whence they moved west, attacking the priory of St John at Clerkenwell, and burning John of Gaunt's palace at the Savoy. They were joined by the Londoners. Roger Gaillard of Holborn was reported as stealing from Clerkenwell a missal, a side of bacon and some papal bulls; all of which he later returned. There was method in what the Westminster chronicler thought was madness. The priory at Clerkenwell was the headquarters of the knights hospitallers, and the prior of this order, Sir Robert Hales, was the treasurer of England. He was one of the two chief officers of the crown in 1381, the other being Simon Sudbury, archbishop of Canterbury and royal chancellor. These two were in the Tower when the rebels entered London, and it was probably in a vain effort to allow them to escape that the rebels were told that next day the king would come to meet them at Mile End

146 The Peasant's Revolt. London, British Library, Royal
MS 18.E.I, fo. 165v, c.1460–c.1480 (*Chroniques* of Jean Froissart)
The peasants bear the arms of St George and of England; their
leaders John Ball (on horseback) and Wat Tyler are named. The
manuscript bears the arms of William Hastings, executed in 1483.

(a mile from the city walls). This meeting, on 14 June,
is the key to the whole revolt, because of what was said
there, and what was reported. The rebels put their main
demands, of which three were crucial. They asked that
they should be able to do justice upon 'the traitors'. They
suggested a form of words by which villeinage should be
abolished. They required that labour services be performed
only on the basis of free contract, though they wanted the
right to rent land at the fixed price of 4d. an acre. They
asked also for a general amnesty for all irregularities com-
mited up to that time. The demands were clear, and the
arguments well-rehearsed. It is less clear what was con-
ceded. But the king did issue charters of pardon, which
clerks transcribed on the spot. And he did state, though
in very general terms, that any traitors would be brought
to justice. In the towns and villages of England great things
were to be made of these necessary temporisings. Two
slogans in particular went the rounds, as summarising what
had been achieved, that 'the traitors should be arrested'
and that 'all men should be free'.

As these two slogans travelled through England, they
were translated but did not lose their essential character.
'Freedom' meant different things to different people; 'the
traitors' had a variety of different faces. In London Sudbury
and Hales paid the penalty, being summarily executed on
Tower Hill, and their heads placed on London Bridge.
This was still on 14 June. The same day the revolt started
at Bury St Edmunds. The heads of authority here were
Sir John Cavendish, chief justice of the king's bench, and

John of Cambridge, the prior of Bury, who was head of
the house because the abbot had recently died. Both men
fled for their lives. Cavendish was caught and executed
at Lakenheath, the boat in which he hoped to escape being
pushed away by one Catherine Gamen, and a certain Mat-
thew Miller serving as executioner. The prior was found
at Newmarket and killed at Mildenhall. Their two heads
were impaled on spikes in Bury market place, and used
as puppets, first kissing and then whispering advice to one
another. The purpose of this 'grisly charade' was to identify
Cavendish as corrupt, and it must also be significant that
he had served as a justice of labourers. It was to the labour
legislation provoked by the Black Death and embodied
in the Statute of Labourers 1351 that the commons referred
in one of their demands at Mile End, for labour services
to be performed on the basis of free contract.

The idea of freedom also needed to be translated in the
terms of the local environment. St Albans was an old-
established Benedictine monastery. Around it lay a large
town ranking eleventh in England in a league table cal-
culated using the figures of the 1377 poll tax, with up to
5000 inhabitants. Some of these, learning of what had hap-
pened at Mile End, behaved in what may seem to be rather
petty ways. They drained the abbot's fishponds; they killed
his game; later they took from his private chamber mill-
stones that had been placed there 'as a witness and a
memorial' of an earlier dispute about rights of access to
mills; and they demanded that the abbot hand over to them
a 'charter of liberties' dating from the time of King Offa.
Behind these various actions there lay two main areas of
concern, the townspeople's demand for borough status,
and the desire of all tenants of the abbey to be free of the
monopoly of milling which the abbot claimed. Many
towns of similar size were at this time being granted the
privileges of incorporation, in which they were recognised
as corporate bodies with their own officers, able to sue in
the courts and to issue their own by-laws. No such privile-
ges and independence had ever been granted to the men
of St Albans. Thomas Walsingham, the abbey chronicler,
who gives a detailed and vivid description of the revolt
at St Albans, is at pains to describe all the abbey's tenants
alike as serfs. Similar considerations had lain behind the
revolt at Bury St Edmunds, another town of some size
whose Benedictine monastery had kept urban privilege on
a tight rein.

By the end of the middle ages there would indeed be
no more villeins in England, or at least only a few, just
as John Ball had predicted. This was not a result of the
Peasants' Revolt. After the heady scenes at Mile End on
14 June, the following day the rebels moved to Smithfield,
where Wat Tyler met his death. At this they dispersed,

Peasant Seals

IN MANY RESPECTS the seal was to the English of the high middle ages what the signature is to their twentieth-century successors. An impression of a seal attached to any document indicated who had authorised or ratified it. The making of wills, settlement of disputes, conveyance of property, borrowing and lending of money, and ordinary correspondence would be authenticated by a seal.

The personal seals of the bourgeosie and peasantry have received relatively little attention from historians, partly because there are so many of them. But this quantity allows shifts in fashion to be seen even more clearly, as well as giving insight into the tastes of classes of individuals whose material possessions have otherwise hardly survived.

During the second half of the twelfth century, the earliest period from which personal seals survive in any numbers, there were essentially three options available to a layman who was not of the

1 Wax impression of the seal of Diota de Luceby on a charter of 1322. 19 × 15 mm. Durham, Dean and Chapter, 2–11 Spec. 38.

2 Agreement between the Earl of Chester and the men of Freiston and Butterwick, c.1225. London, Public Record Office, DL27/270.

knightly class. The commonest motifs were animals and birds, stylised flowers or an elaborated cross. An additional, small but significant category showed the owner of the seal in a professional capacity. Thus a butler could be seen carrying a covered cup, and a taxgatherer his moneybag and coins. Personalized seals of this type must obviously have been specially made for their owners. But seals with animal, foliate and cruciform motifs on them could have been engraved without a particular client in mind, and then been kept in stock until a customer appeared. Only then would a legend giving the owner's name be added to the chosen matrix. There are fifty or so seals of this kind on an agreement between the men of Freiston and Butterwick in Lincolnshire and Ranulph, earl of Chester (fig. 2), and foliate seals are in the majority. When a bird or beast occurs it is usually a lion or an eagle of a stylised and quasi-heraldic type. But occasionally

3 Wax impression of the seal of Ralph Hairun, *c*.1200. Diam. 48 mm. Durham, Dean and Chapter, 2–12 Spec. 10.

gentry and aristocracy, but in the early fourteenth century this was not the case. Traders, craftsmen and servants (at least those attached to lordly households) might use seals bearing a shield charged with heraldic motifs. Devices outside the normal vocabulary of heraldry were sometimes employed. William de Grendon's shield included his initials and a flowering heart (fig. 4)! He borrowed the latter from another category of seal, referred to nowadays as 'love and loyalty' seals. These must normally have

an altogether more naturalistic image appears, such as the heron in figure 3. This seal belonged to Ralph Hairun, and obviously the motif was chosen as a canting reference to his name.

During the course of the thirteenth century a number of changes took place, so that by 1300 the size and form of the seal matrix was quite different from that of fifty years earlier. Instead of flat discs or ovals of metal, dies were now engraved on the base of a solid cone with concave sides. Although the overall mass of metal used in these matrices was greater than in their predecessors, the diameter of the die itself was smaller, seldom more than one inch across. Despite the decrease in size, the central motif became more complicated. Lions are often incorporated into scenes. We frequently see them curled up asleep at the base of a tree with a playful motto such as WAKE ME NO MAN. The connotations of woodland seem to have been such that a 'proverb' in English was often used as the legend. Sometimes other creatures are present too: on Diota de Luceby's seal of the early fourteenth century there is a squirrel (a popular 'character' on seals of this period) who, from the safety of the branches, pelts the lion with nuts. The legend reads I NOTIS CRAK ON LYOUN BAK (fig. 1). As well as lions and squirrels, other animals such as dogs, hares, monkeys, asses, foxes, goats and many different birds make regular appearances. There are also a few hybrid monsters, sometimes with the legend SIGILLUM NULLUM TALE (Nonesuch Seal) which indicates a degree of irreverent wit on the part of the owner.

In a more serious vein, the late thirteenth and early fourteenth centuries saw an efflorescence of religious motifs on seals. On these the legend is nearly always written in Latin. Many of the owners are clerks, but some are merchants or women. John Bunting, London goldsmith, used a seal showing the head of Christ surrounded by the four beasts which symbolised the evangelists (fig. 5). Quite probably he engraved the intricate die for his own use: it would serve to advertise his talents as well as to authenticate documents.

The most popular small seals of the period were heraldic. We have come to regard heraldry as the prerogative of the

4 (ABOVE) Wax impression of the seal of William de Grendon, on a charter of 1359. Diam. 19 mm. London, Public Record Office, E329/452.

been for sealing private correspondence rather than legal documents and had anonymous legends, usually in French, such as *JE SUIS SEL D'AMOUR LEL* (I am the seal of loyal love). The way in which William constructed his hybrid device is typical of the inventiveness found on small personal seals of the first half of the fourteenth century. The range and combinations of subjects and the language and message of the legends have been extended so far beyond the limited repertoire of the twelfth century that they now offer a serious possibility for the expression of status, piety, taste and even humour among the 'ordinary' people of medieval England.

T. A. HESLOP

5 Wax impression of the seal of John Bunting, on a charter of 1359. Diam. 23 mm. London, Public Record Office, E329/452.

and thereafter were pursued by judicial commissions which brought the more conspicuous offenders to trial. Parliament met in October 1381 in anxious mood. The landlords there represented expressed horror that the king seemed to have promised (at Mile End) to free the villeins. 'They would have never agreed to this,' they said, 'even had it been their dying day.' This though they must have known that villeinage had lost much of its point.

The historical point of serfdom was that the peasants should work for the lords on their home farms or demesnes. Much of the farm work was already done by hired labour or full-time servants. The high price of labour (from the 1350s) and the low price of grain (from the 1370s) were

to make the cultivation of those demesnes uneconomic. Over the course of the next half century the great landlords leased out their demesnes to local men, piecemeal or en bloc. When this happened the labour services which were of the esssence of villeinage lost whatever meaning was left to them. Logic demanded that villeinage be abolished; but for the lords this was not a matter of logic. Something of their way of thought may be seen in what was required of a tenant manumitted (or freed) by the Abbot of Ramsey in April 1439. He had to promise that he would not show himself ungrateful or cause trouble to the abbot; another villein, licensed to take holy orders about the same time, was told, almost in so many words, that he would still

147 Ightham Mote, Kent.
A moated manor house, built in the mid-14th century, and in outward appearance little altered since that date.

be expected to 'know his place'. This concern of the great men with what the poor said about them is most revealing. It shows a worry that their whole place in the world would be threatened by peasant freedom.

The end of villeinage came not from general confrontation on the matter of general principle, as was attempted in 1381, but from local agreements on matters of detail. On the Merton College manor of Kibworth Harcourt in Leicestershire one important change was the recognition, in the year of the revolt, that families might die out or move away, that there might not always be a relative available to take up vacant land (see p. 199). The village could no longer be seen as a group of families held fast to the land and to their lord by ties of blood. There were fewer and fewer families thus tied, villeins by blood (*nativi de sanguine*) as they were described. In 1427 the next stage was reached and tenure 'in bondage' (*in bondagio*) was abolished. In these Latin phrases was encapsulated a long history of lordship over the English peasantry. They were abandoned with reluctance. By the second quarter of the fifteenth century it had become a little easier for the lords to do this. By this time population levels had stabilised, the villages of England though shrunken had for the most part survived, and the other part of John Ball's vision had not materialised. There were lords in England still.

Richard II and his Critics

The king was cast almost in the role of hero by many of the common people in 1381. It proved more difficult to mark out a role for him in the years which followed. He was in his late teens, neither directly under tutelage nor in full control of the government. Because of the king's inexperience the concerns of the political nation continued to be what they had been in the 1370s, with close attention being paid to the behaviour of those close to the king and how he should be advised. The Westminster chronicle, written by a monk of the house, is a particularly valuable source for the 1380s and will often be cited in the discussion which follows. It is valuable for its detail, particularly on diplomatic negotiations and on the political crisis of 1387-8, and valuable also for its tone. There is an intemperance in the nation's political life, as seen from the far from sheltered cloister of Westminster Abbey, which seems to colour the whole reign.

On the diplomatic front the main theatre of war with France was once again, and for a short time, in Flanders. The English had suffered a major reverse in 1369 when Margaret, the heiress to the county of Flanders, whose hand had been sought by Edward III for his son Edmund earl of Cambridge, was married to Philip 'the Bold' duke of Burgundy. The union of Flanders and Burgundy, to which were added in the course of the fifteenth century many of the territories which lay in between, created a unit of great political strength and cultural vitality, which had many of the features of an independent territorial state. Flanders, however, was unstable. The largest of its cities, Ghent, suffered most from the centralisation of authority in the hands of the count, and in 1379 it again rose in revolt. When peace negotiations failed in 1382 the townsmen accepted the title of Richard II as king of France. This was a throwback of two generations – for the leader of the men of Ghent was Philip van Artevelde, the grandson of Jacques, and the title recognised was that of Edward III's grandson, Richard II (see p. 190) – but it proved no more successful in the long term. The English parliament was reluctant to grant funds for a major campaign, and without English support van Artevelde was defeated by Philip the Bold at Roosebeke in November 1382. This important engagement helped to persuade Michael de la Pole, appointed chancellor in March 1383, that the English should make peace. This was a sane policy, and it had the king's support; he was later reported as saying that the war was 'intolerable'. It needed a strong leadership, however, to carry the support of a people who had recently been heavily taxed for war; and this Richard II could not provide.

The policy of looking for a peace settlement with France fell victim to the unpopularity of members of the king's household, and to dissension among the leading men at court. Richard was felt to be increasingly influenced by a small clique, in one source called a *cuvyn*, a word that conjures up some of the claustrophobic atmosphere of Edward II's disastrous rule. Michael de la Pole had made his way in the service of Richard's father the Black Prince, and had the grant of the earldom of Suffolk in 1385. Robert de Vere, the son of another member of the Black Prince's household, was even more closely associated with the king. He was the hereditary chamberlain, an office in the household which his personal standing rendered important. The under-chamberlain, Simon Burley, had served as Richard II's tutor. To men of this kind the king was remarkably generous: 'in his early years the king was so open-handed', said Westminster, 'that to make any legitimate request of him was to have it immediately granted.' Only a narrow line separated generosity to individuals from grants detrimental to the royal estate, and many felt that Richard II crossed it too often. Prudent government demanded caution. In the April parliament of 1384 the earl of Arundel described the country as almost in a state of decay. The king reacted angrily – 'you lie in your teeth; you can go to the devil!' A year later the archbishop of Canterbury

opined that the king was receiving bad counsel. He went on and on; the king lost his temper, and 'drew his sword, and would have run the archbishop through on the spot' had he not been restrained. Richard then turned on the peacemakers, who were so frightened they jumped from his barge into that of the archbishop, in search of sanctuary. Behind these 'astonishing squabbles' lay the alienation of the older nobility, men such as Arundel and Thomas earl of Buckingham (from 1385 duke of Gloucester), the youngest of Edward III's sons.

A peacemaker in the 1384 parliament, standing between the two factions, and with his own retinue which served as a powerful 'third force' in English politics, was John of Gaunt. It was a role which brought him few friends among Richard II's intimates, several of whom (including de Vere) seemingly hatched a plot to kill him at a tournament held in mid-February 1385. The Westminster chronicler describes John of Gaunt shortly thereafter going to visit the king at Sheen, and speaking to him 'with some harshness and severity' on the familiar subject of bad counsel. It is the detail, which must have come from the duke himself, which conveys the atmosphere of the visit. He left most of his guards north of the Thames at Brentford; others crossed the river with him and stayed in his boat; others went to guard the palace gate, to make sure that their master was not taken unawares; and even thus secure he wore a breastplate in his nephew's presence. The following year, in July 1386, John of Gaunt sailed south to pursue his claim to the throne of Castile. He was away for three years, returning in November 1389. During that time his son, Henry Bolingbroke earl of Derby (born in 1366, and the future King Henry IV), was the representative of the Lancastrian interest. In that time Richard II came near to losing his crown.

The first parliament after John of Gaunt left England was held in October 1386. A French navy was mustered at Sluys, where the major battle in 1340 had been fought, and stood poised to invade England. There was panic in southern England, and in parliament those responsible for the conduct of the war were called to account, The king at first simply refused to attend, and in what has become a famous phrase said that he would not thus dismiss so much as a scullion from his kitchen. Faced with threats which extended as far as his own deposition, Richard was unable to defend the treasurer, John Fordham bishop of Durham, and the chancellor de la Pole earl of Suffolk. Suffolk was impeached, following the procedure set up in the Good Parliament of 1376, charged with failure to send help to the men of Ghent and with not setting up a committee of inquiry into royal finances which had been demanded by parliament in the previous year. Suffolk

was found guilty and imprisoned. His position as chancellor was filled by the bishop of Ely, who was the earl of Arundel's brother, and like him a consistent critic of the king. A much more searching commission was set up by this 'Wonderful' parliament of 1386, and given wide powers over the royal household. In the year which followed, the year of the commission's authority, the king kept away from Westminster. He sought in a direct way to recover the authority which he had lost. First to Shrewsbury and then to Nottingham in August 1387 he summoned his justices, then on vacation, and put to them a series of questions. He obtained the answers which he sought, that the commission had been set up against 'the regality and prerogative' of the king, and that all those involved in setting it up and in impeaching the king's officers were alike liable to the penalties of treason. The judges' answers threatened many individuals, and concentrated many minds.

The immediate result of the 'questions to the judges' was that some of the more prominent of the individuals who felt threatened formed themselves into a coalition for mutual support. The Westminster chronicler called these 'the lords of whom I have spoken', but they have subsequently become known as 'the Appellants', because they 'appealed' (i.e. accused) of treason Suffolk, de Vere and several others. The Appellants came together in the winter of 1387–8. Gloucester and Arundel were joined by the earl of Warwick, and the three magnates mustered their retinues in Haringey Park north of London, where 'huge numbers of gentry came flocking from all directions to join them'. They were also joined by two younger earls, Gaunt's son Bolingbroke earl of Derby (who was a brother-in-law of Gloucester) and Thomas Mowbray earl of Nottingham (who was a brother-in-law of Arundel). The quarrel of these two earls ten years later precipitated the deposition and death of Richard II, and it was to turn on the events of the next few months. In 1387 Richard met the threat from the five Appellant earls by despatching de Vere, whom he had recently created duke of Ireland, north to Chester to raise troops. On his returning towards London his forces were intercepted by the Appellants at Radcot Bridge, where the road between Burford and Faringdon crossed the Thames. Over ten years later Richard deposited 4000 marks at Chester Abbey to be used for the support of the victims of that engagement. The king's loyalty to his troops does him credit; but this was poor policy. It made a minor skirmish into a major battle for the king's prerogative power.

Worse was to follow. Immediately after Christmas 1387 the Appellants sought out the king in the Tower of London, and after making obeisance in public withdrew

to the chapel, 'where they spoke to the king with some severity about his conduct'. They then threatened Richard with deposition. According to one chronicle indeed the king *was* deposed for two or three days, and only reinstated because the lords could not agree on a successor. When parliament convened on 3 February 1388 the lords 'arm in arm and dressed in cloth of gold' presented their appeal. They defended their earlier rebellion by claiming that they had at court 'arch-enemies, men who never left the king's side'. The courtiers were named. Of twenty-three chamber knights, retained in the royal household, no fewer than twelve were named as undesirables, of whom four were executed. The two most prominent of these were Simon Burley, held particularly responsible for the king's actions the previous year, and John Beauchamp of Holt. Executed also were Sir Robert Tresilian, chief justice of the king's bench, for the answers given to the king's questions the previous year (the other justices were condemned but their lives were spared), and Nicholas Brembre the former lord mayor of London. De Vere and Suffolk only escaped a

148 The Resurrection. *c.*1400, alabaster, height 43.3 cm. London, Victoria and Albert Museum
A powerful image of the risen Christ, and a fine rendering also of the dress of the infantryman of the late 14th century.

149 The Wilton Diptych. 1390s, each
panel 36 cm. × 26 cm. London, the
National Gallery
The iconography of English kingship in
the later middle ages: Richard II kneels
before his patron saints, St John the
Baptist, St Edward and St Edmund; the
king wears his badge of the White Hart,
as do the angels who surround the
Virgin and Child, one of whom bears
his banner of St George.

similar fate by fleeing abroad; they were condemned in
their absence. It was indeed a 'merciless' parliament. The
Appellant lords had the full support of the parliamentary
commons, and were voted by them £20,000 for their
expenses in bringing 'the traitors' to justice.

The two houses of parliament were seldom as united
as they were in the Merciless Parliament. One of the main
issues which divided them surfaced in the second or

'Cambridge' parliament of 1388. There, according to the
Westminster chronicler, 'the commons complained bitterly
about the badges issued to the lords'. Just as cap-badges
in the modern army serve to identify the regiment, so the
liveried retainers of a great medieval lord bore his device.
Henry of Bolingbroke's was the swan; his father John of
Gaunt used as his badge the letters S.S. (the two devices
are found together on John Gower's tomb in Southwark

150 Mould for making hart badges. *c.*1390s, 4.6 cm. × 6.6 cm. Norwich, St Peter Hungate Museum (loan from the Anglican Shrine, Walsingham) The mould is broken, but clearly at least three badges could have been cast, in pewter or in lead, at one time. The mould was found in a well at Walsingham in 1971.

Cathedral). The most famous badge of all was to be Richard's own livery of the White Hart (Pl. 150), which he first distributed generally at a Southwark tournament in 1390. The king's response at the Cambridge Parliament was that he would issue no badges himself if the lords followed his example. This they declined to do. The issue here raised, one of some importance to an understanding of late medieval English society, is that of livery and main-

tenance. The 'badges' were one distinctive part of the lord's livery, which could also take the form of an issue of hoods and of suits of clothing. These were to the commons symbols of an attachment to lordship which threatened proper order in the English countryside. This threat they called maintenance, 'the maintaining of another man's quarrel to which he is not a party by reason of either blood or marriage'. They would have cited cases similar to one

Geoffrey Chaucer and his Family

GEOFFREY CHAUCER, poet and customs official, was the son of a citizen and vintner of London; his more distant ancestors were taverners from Ipswich. Geoffrey's son Thomas was five times Speaker of the Commons and, between 1424 and 1427, a member of Henry VI's regency Council. His grand-daughter was the wife successively of the fourth earl of Salisbury and the first duke of Suffolk. One of his great-grandsons was recognised as heir-apparent to the English throne. The Chaucer family thus presents one of the most strikingly successful instances of *arrivisme* in later medieval England, and Geoffrey Chaucer's own

life seems to lie at the point of balance, between obscurity and splendour, in the fortunes of his family. What was his contribution to their rise?

Principally, it consisted of his move from London to Westminster, from the largely mercantile *milieu* of his father to the world of the aristocratic household and the royal court. Beginning as a page to Elizabeth, countess of Ulster, Chaucer subsequently moved to the service of Lionel, duke of Clarence, Edward III and Richard II. His employment as an esquire of the royal household brought him a moderate livelihood, in the form of a pension of 40 marks a year, and access

to other offices in the Crown's gift. Between 1374 and 1386 Chaucer was controller of the royal customs in the port of London, while between 1389 and 1391 he was clerk of the King's works at Westminster, London and Windsor. But though these appointments brought with them a useful salary and occasional windfalls, they were 'modest offices for a modest man'. Chaucer's brief appearance as a justice of the peace in Kent (1385–9) and his single return to Parliament as an MP (1386) adequately reflected the limited social consequence that accrued from such occupations.

The real, and unforseen, advantage for

1 (LEFT) Poet or preacher? Corpus Christi College, Cambridge, MS 61, frontispiece (*c*.1420) Once regarded as a depiction of Chaucer and his courtly audience, this frontispiece to a copy of *Troilus and Criseyde* now seems more likely to represent a standard, and anonymous, 'preaching' scene.

2 Geoffrey Chaucer. London, British Library MS Royal 17.D.VI, fo. 43v, early 15th century In his *Regement of Princes* Thomas Hoccleve expressed his admiration for his friend by including a marginal portrait, from which this depiction is probably copied.

his family of Chaucer's long presence at court stemmed, instead, from his marriage to Philippa, daughter of Sir Paon Roet, Guyenne King of arms. Philippa had been a lady-in-waiting to Edward III's wife, and on the death of her mistress, she transferred her services to Constance, duchess of Lancaster.

It was probably at her petition that her husband was granted a pension of £10 a year by John of Gaunt duke of Lancaster in 1374. Far more important, though, was the fact that Philippa's sister, Katherine Swinford, was by that time John of Gaunt's mistress and became, in due course, his wife, for this created a connection between the great house of Lancaster and the modest Chaucer family that was to transform the latter's social expectations. When Henry IV doubled Geoffrey Chaucer's royal pension in 1399 he was acknowledging the claims of kinship that existed between them. Thomas Chaucer's career was made by his faithful service of the new Lancastrian dynasty and, in particular, the considerable favour shown towards him by his cousin Henry Beaufort, bishop of Winchester and 'Cardinal of England'.

To combine so prosaic a career with an interest in poetry was not unusual. Thomas Usk, the under-sheriff of Middlesex, wrote a vivid and personal *Testament of Love*; Thomas Hoccleve, an otherwise obscure clerk in the Privy Seal office, gave copious poetic advice to his

social superiors. Did the fact that Geoffrey Chaucer was a poet as well as a customs official play any part in the rise of his family? Not really. Although *The Book of the Duchess* is, among other things, a consolatory elegy on the death of Blanche of Lancaster, John of Gaunt's first wife, there is no evidence that the poem was ever presented to the duke. Although *Troilus and Criseyde* and *The Legend of Good Women* address themselves to the ladies of the court, this is an elaborate literary artifice for the amusement of the cognoscenti, not a crude bid for attention. Although *The Complaint of Mars* was once thought to refer to the contemporary scandals of high society it is rather an elegant astronomical conceit for the learned. Chaucer's poems were not, in fact, intended for an audience as particular as the king or the duke of Lancaster, nor as general as 'the court'. His decision to write in English may, indeed, have been deliberately intended to distance his work from the tastes of the aristocracy, who still favoured French romances of an antiquated kind. Rather, his audience was a small 'Arnoldian clerisy' of cultivated intellects, drawn from a background very similar to his own, which consisted both of Londoners – such as Thomas Usk and Ralph Strode, common serjeant of the City – and courtier – knights such as Sir Philip la Vache, Sir Lewis Clifford and Sir Peter Buckton. From them and their common concerns, Chaucer acquired his

3 The rewards of office. Gatehouse of Donnington Castle (Berks.), built in 1386
Bought from the knightly Abberbury family in 1415, Donnington gave the Chaucer family social consequence and influence in the Thames valley.

characteristic 'tone' – tolerant, ironic and consciously unheroic, concerned mainly with the dilemmas of daily life, advocating an ideal of balance and practical wisdom.

Writing for such readers in such terms, it seems unlikely that Chaucer's poetic talent had much bearing on his public career and its rewards. His poems brought him prestige – not many esquires of the royal household were, as he was, favourably compared to Socrates – and they may have helped to keep his son Thomas, in the public eye. Henry Scogan, tutor to Henry IV's children, was soon recommending Chaucer's ballade *Gentilesse* to their attention, for instance, and Henry, prince of Wales, probably owned a copy of *Troilus*. But it was to the more practical talents of his son and the considerable charms of his granddaughter that Geoffrey Chaucer's descendants owned their brief but startling prominence.

SIMON WALKER

4 Tavern life. Elmwood chest, *c.*1410 (Museum of London, 75.2)
A scene from the *Pardoner's Tale*, illustrating the dangers of over-indulgence in 'the white wyn of Lepe/ That is to selle in Fysshstrete or in Chepe'.

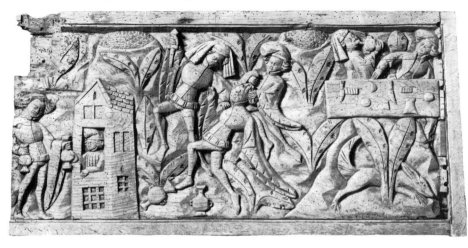

that would occur in 1392. The earl of Devon was accused of intimidating JPs and local jurors, before whom one of his retainers, Robert Yeo, had been indicted on a charge of murder. The earl admitted the offence, but was pardoned instantly. There was nothing new in cases such as this, and not much could be achieved. Some small concessions were made to popular opinion; for example, the lords' power to nominate to commissions of the peace, and their power to sue for pardons for felonies committed by their men, were reduced at this time.

The Cambridge Parliament concluded with a grant of taxation which was to be spent on 'the defence of the realm, the safekeeping of the sea, and the protection of the northern border'. The settlement of the dispute with France, on terms that would honour his father's and his grandfather's memory and would be acceptable to his subjects, was an important objective of Richard II. Discussion came to focus on the issue of the status of Aquitaine and on the person of John of Gaunt, whom Richard appointed duke of Aquitaine in March 1390. One suggestion was that Aquitaine should be held by John of Gaunt and his heirs as vassals of the French king, the link with the English crown being broken. This, and other such suggestions, foundered on the opposition of the English commons and of the men of Gascony themselves. A further peace, this time for twenty-eight years, was concluded in March 1396. The French king, Charles VI, afraid that the English might form an alliance with Castile, offered his daughter Isabella as a bride for Richard. He held out great hopes for the marriage, which would allow the two kings together to emulate the great figures of romance literature, able to unite, like Roland and Oliver, against the enemies of Christendom. And there were more tangible benefits also. Richard, whose ambassadors kept reminding the French that John II's ransom had never been paid in full, was offered with Isabella the substantial dowry of £200,000. The couple were married by proxy in March 1396. Isabella was seven years old. The succession to the English crown would remain uncertain for a decade and more.

The Cambridge Parliament had asked for the protection of the northern border. It did not ask for peace with the Scots: most would have thought this impossible, and some would have thought it undesirable – Sir Thomas Gray in his *Scalachronica* said that the advantages of peace were by no means clear-cut. He and his like continued throughout the fourteenth century to be mustered regularly against the Scots, the soldiers for the French war being drawn from central and southern England. Garrisons were needed for the frontier castles of Carlisle, Newcastle, Berwick and Roxburgh, and money from the English exchequer was sent north to sustain them. The leaders of the northern nobility lived very much in a world of their own, their status recognised by the grant of authority as 'wardens of the marches' towards Scotland. Two families in particular are important here, those of Percy and Neville. Their heads in the late 1390s were Henry Percy (created earl of Northumberland in 1377) and Ralph Neville of Raby (created earl of Westmorland in 1397). Between 1390 and 1396 Northumberland and his son Henry 'Hotspur' controlled the two wardenships of the marches. Thereafter, and seemingly of policy, their authority was transferred to a number of the king's friends, who had no landed bases in the region. Clear signs of that authority can be seen in the great castles of the north-east, testimony still to the confidence of their lords and to the competition between them. The great keep of Warkworth dates from the late fourteenth century, and it is interesting that Northumberland sought to create within this bastion of marcher authority a collegiate church after the fashion of Windsor. The Nevilles fortified Raby. John of Gaunt, created lieutenant of the Marches twice in the reign, perhaps as a title of honour but still an offence to local sensibilities, had his own fortress at Dunstanburgh (Pl. 152), now very sadly decayed. All three families made common cause against Richard II in 1399.

The 'Tyranny' of Richard II

The insecurity in the north mirrored the situation in southern England. After 1397, according to Thomas Walsingham a monk of St Albans, Richard began to 'act the tyrant and oppress the people'. In July of that year he arrested the duke of Gloucester and the earls of Arundel and Warwick. These had been the three senior Appellants in 1387–8, and of Arundel's loyalty in particular the king had never been confident. In the parliament of September 1397 the three men were in turn appealed by a group of lords, charged with treason for their behaviour in the years 1386–8. Involvement with the commission of 1386, with 'riding against the king' at Radcot Bridge in 1387, and with the attainders of the Merciless Parliament of 1388, were alike held to be treasonable. Gloucester had been arrested, taken to Calais and there murdered, before the parliament opened. The two others had at least a version of due process. Arundel pleaded earlier pardons, but these availed him nothing. Richard held him responsible for Burley's death, and he was condemned to death in his turn, sentence being pronounced by John of Gaunt. Warwick broke down and confessed his guilt, and suffered no worse fate than exile to the Isle of Man. While these cases were being tried, the king sat on a high throne in Westminster

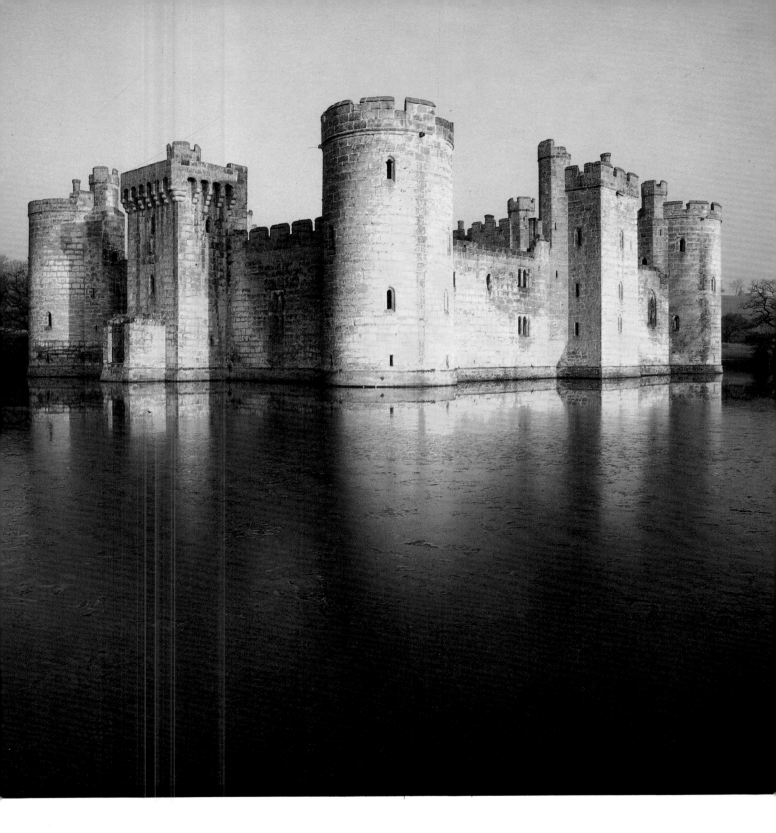

151 Bodiam Castle, Sussex. Late 14th century
In October 1385 Sir Edward Dalyngrigge was granted
licence 'to make a castle . . . in defence of the adjacent
country against the king's enemies', the French. But the
castles of this period are best viewed as fortified manor houses,
designed for domestic comfort rather than for defence.

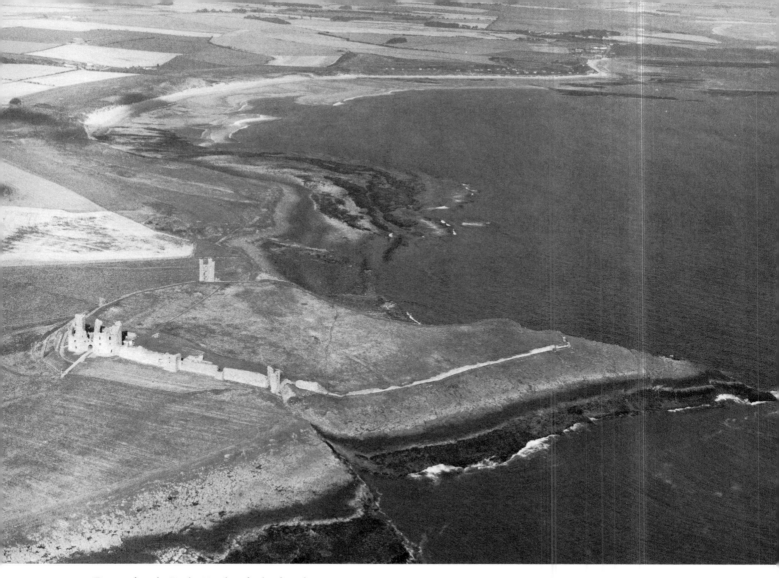

152 Dunstanburgh Castle, Northumberland. 14th century
Much has been lost, but one can still sense here the 14th-century power of the house of
Lancaster, which would propel one of its members to the English kingship in 1399.

palace yard, 'more splendidly and in greater state than any
previous king'.

Had Richard simply taken revenge on these three men
for his humiliation ten years before few, other than the
direct heirs (for their disinheritance was the most terrible
of the penalties of treason), would have been likely to com-
plain. But large parts of the political community shared
in some way in the offences with which they were charged.
Recognising this, the king issued a general pardon at the
parliament, but then undid the good work by exempting
fifty men whom he declined to name. The speaker of the
commons protested at this refusal, but the king was
unmoved. Many more than fifty will have slept uneasily
in their beds after they heard this news. They were invited
to sue for pardon, and over 600 men did so. Richard kept
the lists. And it was not just individuals who paid. Rep-
resentatives of Kent and sixteen counties in the south and

east of England were forced to admit a communal guilt
and sue for pardon; 'because', they acknowledged, 'before
this time we greviously offended your majesty, we now
give up ourselves and all our goods to your will'. These
are the famous blank charters. These too the king preserved.
It has been plausibly argued that the king wanted these
lists because he was afraid; without a doubt, for financial
rewards which were not great, his behaviour provoked fear
in his subjects.

Alarm at the king's actions, and fear for the future, was
not confined to those of middling rank. Of the Appellants
of 1387–8 two were now left, Henry of Bolingbroke, now
duke of Hereford, and Thomas Mowbray, made duke of
Norfolk at the same creation in 1397, immediately after
proceedings in which their erstwhile colleagues had been
destroyed. In January 1398 Bolingbroke told the king that
Mowbray had spoken to him of the dangers to the two

of them because of 'what was done at Radcot Bridge', and each made his version of the story into an accusation of treason against the other. The matter was sent to be decided by judicial combat, at Coventry on 16 September 1398. Richard there halted the proceedings, and sentenced both men to banishment, Bolingbroke for ten years (soon reduced to six) and Mowbray for life. With this scene we are at the beginning of *Richard II*, one of the greatest of Shakespeare's plays. It was indeed for Richard the beginning of the end. There is no record of what John of Gaunt felt about the severe sentence passed upon his son. He had been in poor health for some time. The focus of his recent policy had been to build up a network of retainers who would loyally serve his son. On 3 February 1399 he died. In a detailed will he made provision for his soul, with legacies of plate, money and fine garments to religious houses in the areas where he had lordship. He could express quite simply the hope that his great inheritance of land would descend to 'the right heirs of Lancaster'. He doubtless hoped, and most would have expected, that Bolingbroke would shortly be called back from exile, and given control of his father's estates. Instead he was punished more severely, being exiled for life. His lands were given in custody to various of the king's friends, including William Scrope, earl of Wiltshire.

Bolingbroke now had a grievance, which he could pursue only by force. He returned early in July 1399, and on being driven from the south made for Ravenspur on the Humber, thence making for his ancestral castle at Pontefract. There 'all the people of the north country' came to join him, including the earls of Northumberland and Westmorland. The king was in Ireland, and his lieutenants proved inadequate to meet the challenge. Richard returned to Milford Haven, and thence struck north for what he felt should be the security of Chester. Chester had become very important to the king. In the 1397 parliament he had given Cheshire the status of a principality. He had fortified the Cheshire castles of Chester, Flint and Rhuddlan, and with the forfeitures of the earl of Arundel in 1397 there were added the castles of Chirk, Oswestry and Holt. At Holt in particular the king lay up great stores of treasure, 100,000 marks according to Adam of Usk, who described the Cheshire archers as the particular agents of the king's personal rule. So much emphasis had been placed on the development of royal power in this region that Bolingbroke's capture of Chester on 9 August proved crucial. The king arrived at Conway two days later, and halted there when he heard the news. In this short space of time, Richard II lost his kingdom.

With Bolingbroke ensconced at the centre of his loyal principality, Richard had no choice but to come to terms. Just what terms were offered is a matter of considerable debate, for there is both a 'Lancastrian' and a 'Riccardian' version of the events that followed. It may be that at this point what was asked for was the surrender of five councillors to trial and the reference to parliament of Richard's claim to be hereditary king; in return the king's dignity would be left intact. Accepting his opponents' undertakings, secured by oath, Richard met Bolingbroke at Flint, and thereafter was treated as a captive. Writs were issued, in the king's name, for parliament to meet at the end of September. By the time it met deposition had been decided upon. There was a precedent in the deposition of Edward II in 1327, but the transfer of power had then been made easier by the king's son being put in his place. Richard had no child. Bolingbroke himself was the next heir in the direct male line; few when parliament met in Westminster Hall, where the throne stood vacant, will have been in any doubt that he intended to succeed. They had the more difficult task of convincing history of the propriety of what would now be done. In the version of the deposition preserved in the rolls of parliament, Richard sealed an instrument of abdication and indicated that he wished to see Bolingbroke rule in his place. A long list of Richard's crimes was then inserted in the rolls, the 'deposition articles', which detailed his offences over the previous two years in particular, the general theme being that the king had ruled by will and not according to the custom of the realm. Richard was again left with little choice: the most that he could hope for now was that his life would be spared. Richard was taken to Pontefract, the most secure bastion of Lancastrian power, and by mid-February he had been murdered. Henry of Bolingbroke, who had been crowned king as Henry IV, had his predecessor buried at King's Langley, perhaps as another appeal to history, for this had been the private retreat of Edward II. A fine tomb stood ready for Richard in Westminster Abbey, built by him for himself and Anne of Bohemia, but his body was not transferred there until 1413.

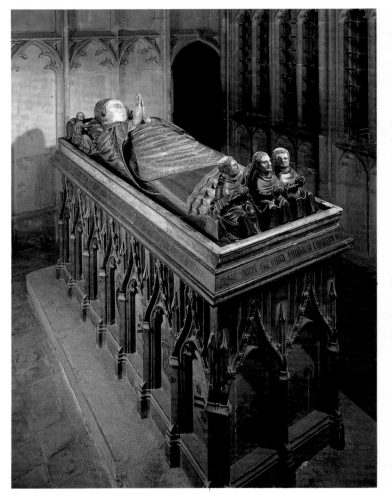

153 William of Wykeham's tomb. Winchester Cathedral
In his will of 1403 William of Wykeham referred to 'a certain chapel
lately built by me', in which he wished to be buried, and in which his
fine alabaster tomb was clearly already prepared. The three clerks,
distracted while at their devotions at the foot of the tomb, are vigorously
rendered.

154 Scenes from the Apocalypse. 1372–1404. Westminster
Abbey, the Chapter House
The painting is in what has been termed the 'international'
style (it may have been the work of German or Flemish
craftsmen), and was the commission of John of
Northampton, a monk of Westminster. The texts explaining
each scene were written on parchment and pasted to the wall.

8

LANCASTER AND YORK
1399—1485

IN 1406 PARLIAMENT MET for twenty-three weeks. This was the longest parliament held in medieval England. Its length reflected both the growing importance of parliament, and dissatisfaction with the policy of Henry's early years. The two main tasks of the commons in parliament were to present petitions and to consent to taxation. They asked for an account of the spending of land tax which they had voted in 1404. 'Kings were not wont to render account' came the haughty reply; but this one was forced to, and six of the commons were named to the commission which audited the 1404 tax. The 1406 parliament did then grant taxation, but the king promised to take no further grant for three years, and each MP was given a written undertaking to this effect which he could show to his constituents. The main work of the parliament was to secure the appointment of a very aristocratic council, and to put much of the royal power in its hands. 'In all matters the king should govern with the advice of his councillors and trust them.'

In Henry IV's early years the commons were in assertive and critical mood. They saw themselves not just as judging the misgovernment of the previous few years. In the 1404 parliament they had asked that all royal grants made since 1366 should be presented for scrutiny. The commons here were in effect 'writing off' nearly forty years of English history, looking back to Edward III at the height of his pomp as the last model of kingship of which they could approve. Edward III in his decline, Richard II for his whole reign, and their own king up to that point all failed the test. They were characterised as having alienated royal lands, and as not responsive to the needs of the wider political community. The commons in 1406 asked for 'good and abundant governance', a peg on which many thoughts and clichés could be hung, but which certainly included an awareness of common interests and common needs.

If Henry IV was not at first a model king, this is not to be wondered at. He had not expected to become king; more important, others had not expected him to become king. The last great magnate who had become king as it were by default was Stephen in 1135. The auguries had been better then. Stephen had succeeded by consent, Henry IV (in effect) by conquest. Stephen at his first court was surrounded by a baronage who hoped for the best, Henry by a peerage — smaller in size — who feared for the worst. These last were men associated with Richard II's personal rule, many of them men of substance. The new king did his best to reassure them. A handful of men, notably the earl of Wiltshire, John Bussy and Henry Green, the 'caterpillars of the commonwealth' of Shakespeare's play, who had been executed in 1399, were declared 'culpable of all the evil that had come on the kingdom'. The remainder of those who had appeared for the king in the state trials of 1397 now had their lordship and authority curtailed; they were not to be allowed to give liveries, or to retain men other than their own officials.

This was a measured response, in part to reassure the commons, whose worries about livery and maintenance continued (see p. 220). The real problem was finance. The richest of the magnates, such as the earls of Lancaster, probably had more surplus wealth, in proportion to their obligations, than had the king. Their spending was certainly less carefully scrutinised. Henry IV was to learn this lesson the hard way. He wanted to make a splash, to cut a great figure among the western monarchs whose equal he had now suddenly become. When Richard's young widow Isabella returned to France in July 1401 she was accompanied by a retinue of 500 people, and the cost was over £8000. A similar retinue had earlier escorted Henry IV's daughter Blanche to Germany to marry Lewis of Bavaria and had taken over £5000 in cash, as a first instalment

155 The Lancastrian succession: York Minster, the choir screen (probably) 1450s
Richard II and Henry IV are seen here side by side, with no hint of animosity. The original design for the screen, before 1422, left space for 14 kings, from the Conquest to Henry V.

156 (OVERLEAF) Alice de la Pole, duchess of Suffolk (died 1475). Late 1470s. Alabaster. Ewelme church, Oxfordshire
A fine example, almost certainly carved in London, of a cadaver tomb. Above the duchess lies serene and in state; here, in the lower part of the tomb, she is in the grip of *rigor mortis*.

towards a dowry of over £13,000. The beginning of a reckoning came in the same year, when the treasurer of England demonstrated to the council that £130,000 a year was needed to meet the costs of administration and defence. The sum was probably a little inflated, but even so more than Henry IV could ever raise, with his revenues amounting to between £75,000 and £100,000 a year. To make the difference the king had to borrow, to transfer money from the revenues of the duchy of Lancaster, and cut back on his household expenditure. Several officers from the duchy, promoted to senior posts in the royal financial administration, proved to be inadequate for the task and

157 Richard Whittington's spoons. c.1410. Silver, the knops gilt, length 18.4 cm. London, the Mercers Company
Each spoon bears on the back the arms of Richard (Dick) Whittington, three times Mayor of London (died 1423).

were removed. It was the king's financial weakness and the inexperience of his personnel which offered the commons their opportunity in 1406. The royal household, said Speaker Tiptoft, was 'full of raskals'.

It had invariably been a symptom of weak government in the centre that authority slackened on the frontiers of England. This proved true both in Wales and on the northern marches of England. The trouble in the north was the less predictable, for the earls of Northumberland and Westmorland, the heads of the two main families of the region, had been Henry's supporters in 1399. Between then and 1403 the Percys' relationship with the new king had deteriorated, and in the last of these years they rebelled. They cited unpaid debts, owed them for their duties as wardens of the Marches, and they resented not being allowed to ransom the prisoners they had taken in the defeat of the Scots at Homildon Hill in September 1402. This was an important engagement, and among the prisoners were the Stewart of Fife, four earls and a dozen barons. As the Percys became alienated they appealed to the memory of Richard II; they claimed, quite unjustifiably, that they had not consented to the coup of 1399; they asserted, quite wrongly, that a better title to the throne lay in the person of Edmund Mortimer, to whom they were related. The first Percy rising was defeated at Shrewsbury in July 1403, when Henry Hotpsur was killed and his uncle Thomas Percy earl of Worcester was executed. Northumberland was tried by his peers, and exonerated from any treason; he lived to fight another day. A second rising, again focused on the claims of the Mortimer heirs, took place in 1405. Thomas Mowbray the earl Marshall and Richard Scrope archbishop of York were among the leaders of this rising, and executed when it failed. Many of the citizens and townsmen of York had been involved, incited to revolt by a series of handbills, written in English, which were posted in streets, market-places and on the doors of churches. They complained of 'an excess of government', almost a modern phase, and of the financial pressure put on the gentry (generosi), the merchants and the common people. The clergy seem to have been much involved, and the archbishop suffered as much for the abuse of the pulpit as for any treachery.

Around the time of the second northern revolt, Northumberland, the earl of March and Owain Glyn Dŵr (Glendower in Shakespeare's play) concluded what has become known as the 'Tripartite Indenture', by the terms of which rule in England and Wales would be divided between the three of them. Glyn Dŵr's revolt in Wales ran parallel to those in England already described, and their conjunction threatened Henry IV's position. More than the English the Welsh could complain of 'excessive

government'. They had remained throughout the fourteenth century 'foreigners' in their own land (see p. 144). Their disadvantages did not diminish over time. After the Black Death English landlords had, albeit reluctantly, made concessions to their tenants. Not so in Wales, where many of the same landlords maintained seigneurial monopolies, control over hunting, over trade, and the use of mills. They took large sums out of this conquered land: £60,000 a year according to Adam of Usk. It all seemed very easy. But then in the late 1390s, through death and forfeiture (in particular the execution of the earl of Arundel in 1397 and the death of the earl of March in 1398), there occurred what Rees Davies describes as 'an earthquake in the map of lordship' in Wales and the Marches. Effective lordship was a matter both of administrative routine and personal loyalties. There was a hiatus in both when Henry IV came to the throne.

The Welsh in their poetry looked for a messianic deliverer for their people. 'Is there a champion in the line of Llewellyn who will stand forth?' one asked, and was answered. In September 1400 Glyn Dŵr had himself proclaimed prince of Wales. He was a man of high rank in the race of Welsh princes, yet he was closely tied to the English lordship over Wales, and had fought in English armies against the French. Men of this rank had been knighted by English kings during the fourteenth century, but no longer. Further signs of English inflexibility – the English parliament in 1401 asked for sanctions against the Welsh as a race – gave Glyn Dŵr and his compatriots their opportunity. The castles and boroughs of the Edwardian conquest were laid under seige. The castles of Conwy, Harlech and Aberystwyth were each for a time taken, and the outlying centres of English lordship were harassed by guerilla warfare. By 1404 Glyn Dŵr had been able to give some substance to his title as prince, holding his own parliament, and making a formal agreement with the French, by which they offered arms and troops. These came the following year, which was that of the Tripartite Indenture. Yet here was the difficulty. Glyn Dŵr needed outside help to offer sustained resistance to the superior resources of the English kings, mustered regularly each summer from 1401 to 1408 under the command of Henry prince of Wales. One by one Glyn Dŵr's allies fell away. First the French; then the northern English, when Northumberland and Lord Bardolf were killed at the battle of Bramham Moor in February 1408. Harlech and Aberystwyth were retaken by the English that same year. Glyn Dŵr remained at liberty, the English powerless to pursue him in Gwynedd, and was last heard of in 1415. 'Very many', said one Welsh chronicler, 'say that he died; the seers maintain that he did not.'

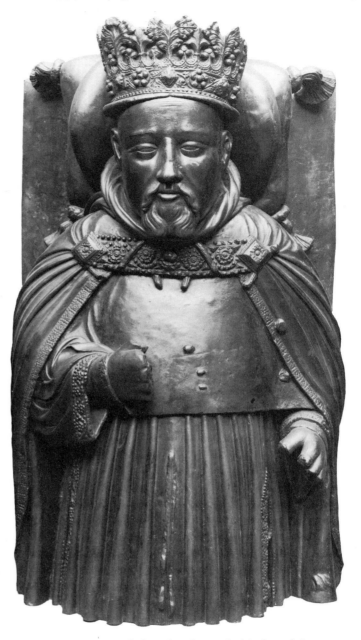

158 Henry IV. Cast made from the effigy on the king's tomb in Canterbury Cathedral
When the tomb was opened in 1832 the head and beard of the king were reported to have been found well preserved, and this heavy-jowled face on the tomb was declared to be quite a good likeness.

In domestic politics the later years of Henry IV's reign lie in the shadow of his son's achievements. Some chroniclers, such as Adam of Usk, simply left a gap between 1409 and 1413 when the king died. Later chroniclers set out to fill the gap. The evident tensions between father and son, and the equally clear popularity of the prince, gave rise to a series of stories, improved in each generation and set firm in Shakespeare's *King Henry*

159 Angel. 2nd quarter of the 15th century. Ewelme church, Oxfordshire,
The angel is from the spandrels on the north side of the nave, and bears a shield with the sacred initials I.H.S. See further Pl. 156.

160 Map of Boarstall, Buckinghamshire. Aylesbury, Buckinghamshire Record Office, Boarstall Cartulary, Boarstall section, fo. 1r, 1444–6
A full description of the map will be found on pp. 197–8.

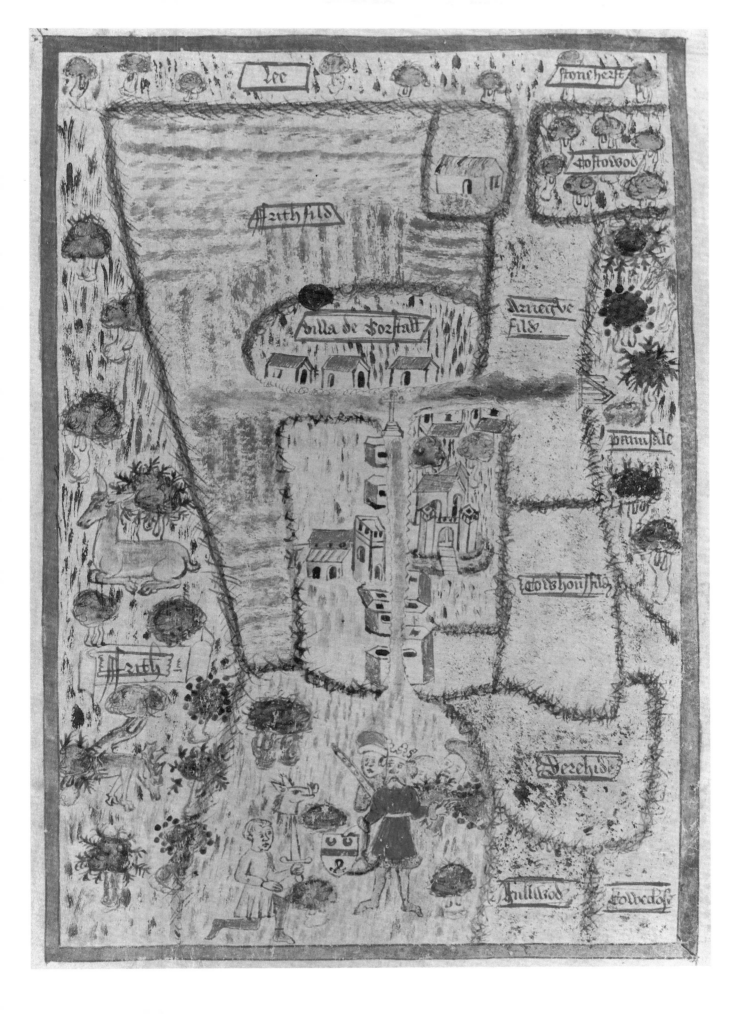

iv Part 2. The king was a sick man – he may have been one of the first westerners to suffer from syphilis – and showed signs of remorse at the way in which he had acquired the kingdom. The prince was restless to take over his father's authority, and had a taste of this in 1410 and 1411 when the council was dominated by his supporters. An expedition was sent to France under the earl of Arundel in September 1411, and a full-scale invasion was planned under the prince himself. The moment seemed propitious, for France was engaged in civil war. The nominal ruler continued to be king Charles VI (1380–1422), but he suffered from insanity, and the royal dukes competed for power. Very much in control in 1411 was John the Fearless duke of Burgundy, who had succeeded Philip the Bold in 1404, and who in 1407 had had assassinated his chief rival, the duke of Orleans. The excluded faction was led by the dukes of Bourbon and Berry, the new duke of Orleans, and by his father-in-law the count of Armagnac (from whom they took their title and became known as the 'Armagnacs'). The Armagnacs saw one route back to power in an alliance with England, and in May 1412 by the treaty of Bourges made great concessions. They said that they supported the 'just quarrels' of Henry IV, including his claim to the duchy of Aquitaine, 'which they regard as rightfully his', and offered him military support and marriage alliances as appropriate to assist him to regain it. Little came of this, but the extravagent claims made by the Armagnacs were not forgotten. Prince Henry preferred the Burgundian alliance, and it was this difference of policy with his father which led to the last episodes of Shakespeare's play, an emotional scene in which the prince offers his father a dagger to use if he has any doubts of his son's loyalty. There is little sign that in life the younger Henry was an emotional man. It was clear by September 1412, when the scene occurred, that the king would soon die, and this he did on 20 March 1413.

Henry V

The prince of Wales, who now became king as Henry V, was twenty-five years old. It is as a military leader, as the victor of Agincourt, that he is best-known; but this was only one facet of his main work, which was to make the monarchy once again a force for unity in English life. The disjunction of the previous forty years had been religious as well as political and economic. The views of the Lollards (see picture essay pp. 242–3) were seen by the English establishment not just as seditious but as threatening its survival. Their worst fears must have seemed to be confirmed early in Henry V's reign, when the last of the revolts against the Lancastrian régime was led by Sir John Oldcastle. It was the more remarkable because Oldcastle was a Lancastrian retainer, who had served as an MP, had fought against the Welsh, and had taken part in diplomatic missions abroad. He was a public figure, and his Lollard views were notorious. In September 1413 he was arrested, and tried for heresy before the archbishop of Canterbury Thomas Arundel (brother of the Earl Arundel executed in 1397). Oldcastle was found guilty, but because of his friendship with the king he was given time to recant before execution, which time he used to escape. He then set about planning what has become known as Oldcastle's revolt. In January 1414 groups of Lollard sympathisers met in London with the intention of capturing the king. Their plans became known; the rebels were intercepted before they could band together; and Oldcastle, seeing all this, did not appear. The necessary inquests on what had happened found that over half the counties of England had some representation in the rising. Oldcastle himself was offered a pardon, but this was declined. Captured at last, he was executed on 14 December 1417.

Henry himself took a much more active interest in Christian observance within England than had most of his predecessors, His father, to atone for the execution of Archbishop Scrope in 1405, had promised a new monastic foundation. Henry V discharged this obligation by building two houses, a new charterhouse at Sheen, and across the river a new house for Brigittine nuns at Syon. These were the last new monasteries to be founded in medieval England, and they were to be renowned for the strictness of their observance. Sheen was one of the royal palaces, on the Thames half way between London and Windsor. It was to become the most prominent centre of Henry V's kingship, a genuine holy place, defended by the orthodoxy of the king and the piety of those who served there. The king was also concerned to preserve the quality of the religious life in the old monasteries. Towards the end of his reign, in April 1421, he summoned to Westminster a general chapter of the Benedictine order at which he claimed to be the 'founder' and 'patron' of English monasticism, standing in the place of all those who supported the monasteries, and shared in their spiritual benefits. The king spoke to his monks of the benefits of fidelity to the Benedictine Rule, and provisions were made for reform. They were particularly severe on the fact that most abbots had a separate establishment and lived apart from their monks, 'which was neither a part of the Rule nor the founder's intention'. In a ballad addressed to the king and the knights of the Garter, Hoccleve wrote of the king:

> *To holy chirche a verray sustenour*
> *and piler of our feith, and werreyour*
> *Ageyn the heresies bittir galle.*

161 Much Wenlock priory, Shropshire. 15th century
The ease and comfort of late medieval monasticism is nowhere more clearly glimpsed than here. To the
12th-century infirmary (LEFT) has been added an infirmary chapel and a separate lodging for the prior.

There is a sense in which Henry's policy in France was marked by a similar return to first principles. In the early months of his reign his ambassadors, sent to discuss terms with the French court, were instructed to ask not just for what had been granted in 'the great peace' of Brétigny (1360), but also for Normandy and Anjou. The king wanted all the rights of his ancestors, and the least for which he was ever prepared to settle was both Aquitaine and Normandy in full sovereignty. When this was denied he had no alternative, so it was claimed, but to go to war. The first of three major French expeditions, and the one that brought him his most famous victory, sailed on 11 August 1415. There were reportedly 1500 ships mustered, and between 10,000 and 12,000 men. They landed at Harfleur, on the north of the Seine estuary, close to the modern port of Le Havre. This was taken after a long seige, during which the army suffered severely from dysentry. The king, ignoring advice that he should then return home, took little more than half his original force, and moved westwards, making for his base at Calais. He was faced by the problem of finding a suitable crossing on the Seine, and by a French army which considerably outnumbered his own. He found a suitable crossing at Béthancourt. The French let pass the opportunity to pin him down there, and it was in more

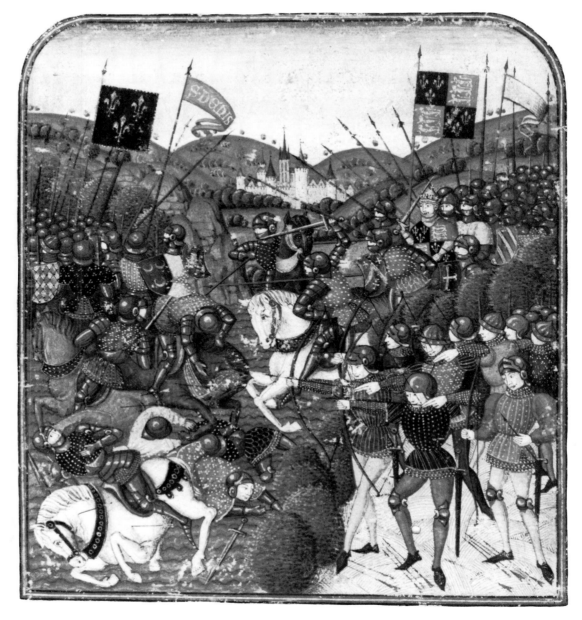

162 (LEFT) John duke of Bedford kneels before St George. London, British Library, Add. MS 18850, fo. 256v (The Bedford Hours) The volume, which is Flemish work, was the gift of Duke Philip the Good of Burgundy to Anne his sister on her marriage to the duke of Bedford in May 1423. St George was especially venerated by Henry V, who was Bedford's brother. The saint is shown here wearing the ermine-lined sovereign's Garter robe over full armour, and attended by a squire; the panels depict scenes from the martyrdom of St George.

163 The Battle of Agincourt. London, Victorian and Albert Museum, E. 1169–1921, late 15th century A leaf from a manuscript of Froissart's *Chroniques*, showing the French and English armies fighting under their banners.

favourable wooded country that they blocked his way at Agincourt, where battle was fought on the morning of 25 October 1415. The result has always been interpreted as showing the superior discipline and control of the English forces; the French, whose separate contingents marked the political divisions of their country, failed to establish a unified command, and may have lost as many as 5000 dead. The English inflated the figures, as they minimised their own casualties.

On his return to England a month after the battle the king was treated as a hero. London, always a sensitive and often a hostile neighbour to the royal court, was completely captivated by this victory. It welcomed the king with a pageant, which one of the royal chaplains (in his

Gesta Henrici Quinti, 'The Deeds of Henry V') described in detail. Some 20,000 horse, he claimed went out to welcome the king; the mayor and aldermen in scarlet, those below them in gowns, and all of them 'according to their crafts, wore richly fashioned badges'. (They too had their liveries, and the London merchant associations are livery companies to this day.) The king, carefully clothed in purple, the colour of the passion, was escorted through the streets of the city which had been specially decorated with the images of English and biblical kingship. There were the arms of St George, St Edward, St Edmund and England, 'and under an awning was a company of prophets with venerable white hair' who released small birds as the king passed by, 'of which some descended on the

The Lollards

ON 23 MARCH 1430 John Belward of Earsham (Norfolk), after a year or more in the bishop of Norwich's prison, formally denied the charges of heresy against him and, with the aid of six oath-helpers, purged himself of the accusation. Though his denials and oaths were accepted, the bishop was probably justified in his suspicions, for John Belward was the head of a notably unorthodox family. One of his sons, also called John, was tried and acquitted of heresy at the same time as his father. Another son, Nicholas, possessed a New Testament in an unauthorised translation – bought in London for the huge sum of £2 16s. 8d. – and was reputed to be a teacher of heresy. A third brother, Richard, certainly was such a teacher; six years earlier he had been accused of keeping an

heretical school, supplied with books from London by a sympathetic parchment-maker.

John Belward and his family were, it seems clear, 'Lollards' – the common name for dissenters from established ecclesiastical orthodoxy in later medieval England. We know from the evidence of other Lollard suspects what the Belwards believed, and taught in their schools: that no priest had the power to create the body of Christ in the sacrament of the altar, which was itself nothing but a cake of wheaten flour; that the true catholic church was the souls of the faithful, so that prayers said in woods and fields were as acceptable to God as devotions made in church; that no one was obliged to pay tithes or oblations to the clergy; that prayers for the dead were useless, for this

world was itself the place of purgatory.

There is much in the lives and beliefs of the Belward family characteristic of Lollardy. Much of its tenacity was drawn from the close-knit nature of Lollard communities. The family circle and the household – including servants as well as kinsmen – was the commonest heretical grouping, and it was from the enduring strength of the yeoman household that Lollardy drew much of its durability, just as Catharism in the Languedoc depended for its survival on the *ostal*, the family house. It was, thought Bishop Reginald Pecock, chiefly 'in their houses' that the heretics would 'vaunt and advance themselves when they were in merriment . . . to argue and dispute against clerks'. Such heretical households were by no means widespread in

1 The Bible in English. Oxford, Bodleian Library, MS Bodley 959 fo. 352r, late 14th century
The Early Version of the Lollard Bible, a literal translation usually associated with Wyclif's follower, Nicholas Hereford.

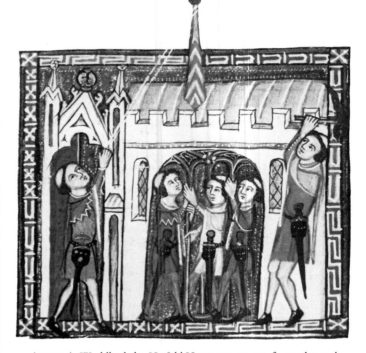

2 (ABOVE) Worldly clerks. Hatfield House, MS CP 290, fo. 13r, late 14th century
Criticism of the clergy was not confined to heterodox circles. This manuscript shows dissolute clerks destroying the church of God.

4 (RIGHT) The Trinity. Peterborough Cathedral, roof boss from the porch on the west front, late 14th century
Such concrete representations were a special target for the Lollards' abuse. 'For first men err in making of images when they make images of the Godhead, as of the Trinity, painting the Father as an old man, and the Son as a young man . . .'

3 Friars and Devils. Cambridge, Corpus Christi College, MS 180, fo. 11, late 14th century
Lollard criticism of the mendicant orders had good intellectual precedent in Wyclif's own writings and in Robert Fitzralph's *De Pauperie Salvatoris*.

medieval England – the number of abjurations in the whole of the period 1380–1520 falls well below 1000 – but they were heavily concentrated in particular areas. Such towns as Leicester, Bristol and Northampton supported a continuous Lollard presence for well over a century, while rural centres such as Tenterden, Amersham and the Waveney valley, where the Belwards lived, proved highly resistant to ecclesiastical efforts at the eradication of dissent. Movement between these centres, from Maidstone to Coventry, from Newbury to Colchester, was relatively easy for 'known men'.

This movement was facilitated by the degree of organization Lollardy achieved. Much heretical teaching and instruction took place informally, 'in secret places, in nooks and corners', even 'in the fields keeping beasts', but there was a more formal side to Lollard teaching as well. The evidence of heretical manuscripts, which were often carefully prepared and expensively produced, points to the existence of well-organized Lollard centres in the late-fourteenth century, sponsored and protected, in some cases, by a powerful member of the local gentry. These centres did not survive the more concerted persecution Lollardy suffered after 1407 but Lollard schools, in which the itinerant evangelists of the movement, men such as William Swinderby, Thomas Drayton and William White, taught and catechized the faithful certainly continued to exist. It was said that a man must be occupied in the schools for a year before he knew the true faith. This emphasis on education reveals, in turn, the considerable importance the Lollards ascribed to literacy and, in particular, to reading the Bible in the vernacular. 'God grant to us all grace to know well and keep well holy writ, and suffer joyfully some pains for it at the last' asked the translator of the Wycliffite Bible, writing around 1396. That 'holy scripture containeth all profitable truth' remained one of the Lollards most commonly-held convictions, and much time was devoted to studying and committing to memory the copies of it supplied, chiefly from London, by couriers like 'old father Hacker' of Coleman St.

The content of Lollard doctrine was greatly affected by the importance ascribed to the vernacular Bible. Indeed, Lollard beliefs were less a set of formalized doctrines than a series of attitudes, based upon the twin foundations of Scriptural fundamentalism and a common-sense rationalism, that refused to lend credence to the miracles of the saints and the sacrifice of the mass. In consequence, it is easiest to characterize their beliefs in negative terms: Lollards were anti-sacramental, anti-authoritarian and, above all, anti-sacerdotal, vehement in their attacks on the immorality of the religious orders and in their denial of any clerical right to tithes and offerings. Against the social and sacramental rights the Chuch offered for the salvation of all, the Lollards pitted the superior sanctity of the godly family and the gathered community of the Gospel.

SIMON WALKER

5 A debate on Images. London. British Library, Royal MS 10.E.IV, fo. 209v
Lollard attacks on the presence of images in church evoked a strong response from orthodox writers; here, an artist painting a statue of the Virgin and Child argues with the Devil.

king's breast, some settled on his shoulders, and some cir-
cled around in twisting flight'. Old men must have been
at a premium, for others were needed to stand in for the
twelve apostles and the sainted kings of the English suc-
cession, with 'crowns on their heads and the emblems of
their sanctity for all to see'. Maidens were also in demand.
Queen Eleanor's cross on Cheapside was entirely sub-
merged by props, and made into a miniature castle with
its own gate-house. These too bore a weight of imagery,
the arms of St George, the king and the great nobility,
and from its shadow there issued

*a choir of most beautiful young maidens, adorned in pure white raiment
and virgin attire, singing together with timbrel and dance, as if for David
coming from the slaying of Goliath (who might appropriately be repre-
sented by the arrogant French) this song of congratulation, following
their texts: 'Welcome Henry ye Fifte, Kynge of England and France'.*

The spectators were to be left in no doubt of God's
favour, or that Henry V was a king in the true line of suc-
cession. The parliament that convened at Westminster on
4 November 1415 granted the king the wool tax for life,
almost a unique sign of confidence. It followed a great
victory, but it rested as much on observation of the king's
care in financial matters, a recognition that money granted
would be properly spent. Henry V ran a major war on
what was in effect a cash and not a credit basis: little of
the revenue coming in, only 7 per cent in his first two
years, was committed to the payment of annuities or to
past creditors. All this was admirable, but there remained
formidable obstacles standing in the way of Henry's
translating into real power the title given to him by the
maidens in London, 'carefully following their texts'. He
sought to ground an interest in English rule on the soil

164 The siege of Caen, 1418.
London, British Library,
Cotton MS Julius E.IV, fo. 19r,
late 1480s
The town is about to fall, here
attacked by land and sea,
though spearmen within the
walls and crossbowmen put up
some defence. At top left the
earl of Warwick, whose life is
told in this manuscript, gives
instructions to a gunner, who
stands poised to fire a breach-
loading cannon.

165 Arms of Henry v. Westminster Abbey, c.1440s
In his will drawn up in 1415 Henry v ordered the construction above his tomb of a chantry chapel, a detail from the screenwork of which is shown here.

of France. Harfleur gave him a second bridgehead, in addition to Calais. On his second campaign, commencing in the late summer of 1417, he took the chief towns of lower Normandy, Caen and Bayeux, fanning westwards as invaders had done before and would do again (the same strategy was followed by the Allied high command in 1944), before turning east to take Rouen, which surrendered after a siege of six months early in 1419.

All this was made possible by the continuing feud among the rulers of France, which Henry's success only exacerbated. The English king's territorial power in France made him now a 'third force' in French politics, along with the Burgundians and Armagnacs. The struggle was now very clearly for the French succession, and the heir of Charles vi, the Dauphin Charles, was the effective leader of the 'Armagnac' party. In September 1419, in the course of one of many diplomatic negotiations, John the Fearless duke of Burgundy was ambushed and assassinated at Montereau. A century later a Carthusian friar showed Francis I of France what was reputedly the skull of John the Fearless, marked prominently with a gash: 'my lord, that is the hole through which the English entered France'. There is more to this than in most stories of like kind. The English had already entered France, but what they had was nothing compared with what they were now promised. The dauphin was clearly implicated in the assassination, and his disinheritance was a matter on which Henry v and the Burgundians could readily agree. The treaty of Troyes, concluded in May 1420, made Henry v

the French king's heir, and he was given control over the government of France with immediate effect. All this was granted with the marriage of Katherine the French king's daughter. Motives of revenge and resignation were mixed in this agreement. The English had by this time taken Pontoise, and with it gained control of the Vexin, and the famous fortress of Château Gaillard. The men of Paris, all but surrounded by English and Burgundian forces, shouted 'Yes' when the terms of the agreement were put to them. The English king and his French bride were married in June 1420, and an heir, the future Henry vi was born, in December 1421.

The Final Stages of the French War

Henry v did not long survive the birth of the heir of so many expectations. At the siege of Meaux, an important junction to the west of Paris, he fell victim to dysentry, the illness that had carried off so many of his troops. He died during the night of 31 August–1 September 1422. When the French king died less than two months later the infant Henry vi was credited with the rule of both kingdoms. His rule in France depended on the support of the Burgundians, and was opposed by the dauphin, who was now (to his supporters, but not to the English) Charles vii (1422–61). At first 'le roi de Bourges', for he controlled little outside the valleys of the Loire and Cher, with his financial administration at Bourges and his own *parlement* at Poitiers, Charles came finally to the rule of the whole of his kingdom. By the time of his death the English had been entirely driven out of France, and were embarked on a period of civil war, which this loss helped to precipitate.

For the French the national struggle for liberation from the English is encapsulated in the career of Joan of Arc. When she first appeared before Charles vii at Chinon early in 1429 and told him of her visions the war was at a crucial stage. Orleans was under siege, and the English were attacking the heartlands of the French monarchy. Joan supplied a sense of mission: St Louis and Charlemagne were on their knees asking God to favour him, she told Charles when she first appeared. The siege of Orleans was lifted. The English had lost an important military commander there, the earl of Salisbury, and they had lost impetus also. Their lines were too extended, and their manpower could be raised only by weakening the garrisons of Normandy. For a few short months Joan could do little wrong, but then on 24 May 1430 she was captured outside Compiègne. Her captors were Burgundian, and 'the maid of the Armagnacs', as a Parisian observer saw her, became a pawn in the larger conflict. She was sold

to the English, and placed on trial as a heretic. She was found guilty of witchcraft by the Inquisition, on charges that were trivial and by processes that were wholly suspect, and burnt at Rouen on 30 May 1431. (She was canonisd in 1920.) It was the legitimacy of Charles VII's kingship that had really been on trial.

During the 1420s the war had gone well for the English. After the death of Henry V his two brothers had divided power in England and Normandy between them. The 1422 parliament granted Humphrey duke of Gloucester the title of protector and defender of the realm, and recognised him as the king's principal councillor. It was an authority only grudgingly given by the lords, and was to apply for only so long as his elder brother, John duke of Bedford, was out of the kingdom. To John came the more difficult task and with it the more impressive title: he was made military governor of Normandy and (when Philip the Good duke of Burgundy declined the title) also recognised as regent of France. The duke of Bedford was married to Anne of Burgundy, the sister of the duke, in April 1423. It was very likely that at the time of his marriage he was presented with the famous Bedford hours. It is a work closely identified with this time – the emphasising of certain passages on treachery has been taken to refer to the assassination of John the Fearless – and it places both duke and duchess firmly in the history of their own houses (see Pl. 162). It was Bedford who carried forward the war in France. Lancastrian Normandy became an occupied land. The towns captured were garrisoned; lands and offices were given out; and many men came from England as settlers. There were enough of these to create what may be termed a 'Norman lobby' in England in the second quarter of the fifteenth century, men with a financial interest in the retention of Normandy, which made the war more difficult to resolve.

As this phase of the war entered its second decade both parties appealed to history. Charles VII was crowned at Rheims, at the insistence of Joan of Arc, in July 1429. Bedford reacted immediately; and Henry VI was crowned at Westminster in November of the same year. It must have been a strain for an eight-year-old boy, the crown so heavy it had to be supported, while 'the bishops of Chester and Rochester sang a litany over him; and the archbishop of Canterbury read many collects over him', not once but several times. Afterwards there was a magnificent feast, the main dishes bearing suitable texts. Among them it is tempting to see the young king's favourite food in 'bakemeats and frytoure cryspe' and 'gely' (though this last had be be 'wrytyn and notyd, *Te Deum Laudamus*'). The king was then sent to be crowned in Paris also. He was first sent to France in April 1430 and remained at Rouen

for more than a year; thence he sailed along the Seine to Paris, only recently and temporarily made secure, for his coronation in December 1431. Behind the 'dual coronation' must be seen a public opinion in England that was committed to the maintenance of English lordship in France. It symbolised the 'dual monarchy' set up by the treaty of Troyes in 1420. The message of Joan of Arc touched even the pockets of the English commons in parliament, who granted a double subsidy in 1430 and further subsidies in 1432 and 1433. With this support John Lord Talbot and Richard duke of York, appointed lieutenant of France in 1436, were able to recover several sections of upper Normandy that had recently been lost. The quality of English war leadership remained high.

In the maintenance of the dual monarchy of France and England, however, a key feature was the alliance with Burgundy. But in the month that Henry VI was crowned in Paris the duke of Burgundy concluded a six-year truce with the French king, which before it ended had been superseded by a much more firm alliance. This was the work of the treaty of Arras, concluded in August 1435, at the end of what has been termed 'Europe's first real peace congress'. It was summoned, under the presidency of two cardinals, in the hope of making a 'general peace' between England, France and Burgundy (in which it failed), and with the object of making a 'particular peace' between France and Burgundy. The French paid substantial bribes to the chief Burgundian negotiators, but more important was the confirmation of territories, from Péronne in the north down through Bar-sur-Aube to Mâcon, previously held without warrant. No one engaged in international trade would have been unaware of the economic importance of towns such as these. The memory of Montereau was excised. As seen from Arras these grants of land were more significant than the loss of support in England. The more careful of the duke of Burgundy's councillors saw danger in this agreement, and hoped that the 'general peace' could still be agreed. One of them, Hugh de Lannoy, governor of Holland, wrote in September 1436:

As regards the king and kingdom of England, the king is young, too young to rule; they have spent excessive sums of money on the French wars for the last twenty years; they have lost a considerable number of captains, nobility and others during those wars; and you, my most redoubted lord, have left their alliance, so that their own English people now have to sustain the whole war and pay for it ... it is probable that, everything considered, they are tired of war and will gladly embrace a more reasonable policy, the more so now than ever before, since the king will be fifteen on St Nicholas's day (6 December).

In the eyes of this wily observer, all was still to play for. A lot would depend on the personality and the leadership of the new king.

Henry VI and the Loss of France

Henry VI was king of England from 1422 to 1461, when he was deposed. What is termed his 'personal rule' dates from 1437 to 1453. Before 1437 authority lay with a council of men associated with his father's triumphs; one of them, the earl of Warwick, was his tutor, appointed to this office in Henry V's will. The two leading figures in the Council were Duke Humphrey, Henry V's brother, and Henry Beaufort bishop of Winchester, who had succeeded William of Wykeham in 1404 and became a cardinal in 1426. (The Beauforts were the descendants of John of Gaunt and his mistress Katherine Swinford. They were legitimised in 1407 and became one of the most influential magnate families of the fifteenth century.) Duke Humphrey and Cardinal Beaufort were continually at odds during Henry VI's minority. In 1425, for instance, Beaufort garrisoned the Tower of London against Gloucester's supporters within the City; violence was felt to be likely, and

Bedford had to be brought back from France to mediate. In fact there was no violence. The disagreements were over policy, in particular the conduct of the war, with Beaufort active as a peacemaker. He took 800 men to the Congress of Arrass in 1435, all in fine scarlet livery, with the word 'honour' embroidered on their sleeves. 'Peace with honour' remained an elusive concept. The council cannot be blamed for its failure here, but it was culpable in not disciplining some of its members: in 1428, for example, a dispute between the duke of Norfolk and the earl of Huntingdon in East Anglia was the cause of serious rioting, and gradually came to draw in other members of the council.

After 1437 these disagreements were for the young king to mediate. As to the personality of Henry VI there is a good deal of disagreement. It is not in dispute that in 1453 he went mad (p. 252); it is more difficult to assess his competence as a king before this time. A good though contentious source is the life of the king written after his death by John Blacman. Blacman was a fellow of Eton College

166 Banners and badges from John Writhe's Garter Armorial. London, British Library, Add. MS 37340, fo. 1v Seen here are antelopes and swans, chained and gorged with coronets, the emblems of Henry V and Henry VI. The original manuscript was late 15th century; this is a copy made c.1640 for Sir Christopher Hatton.

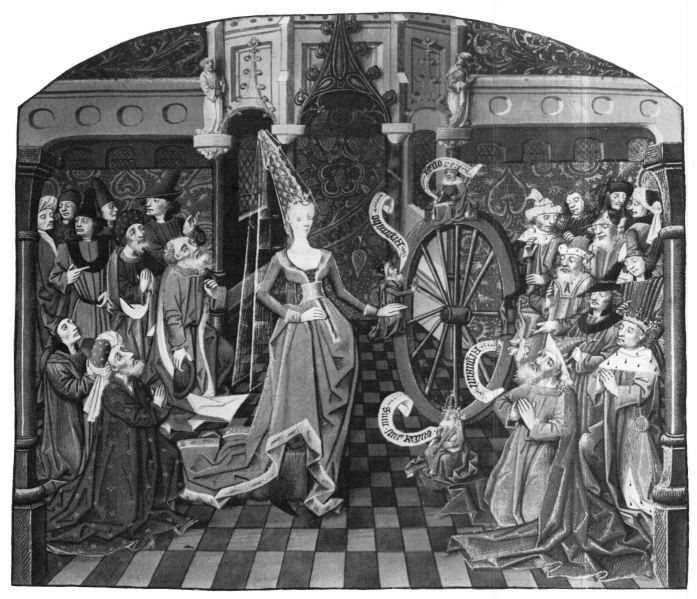

167 Fortune with her wheel ruling life at court. London, British Library, Harley MS 4373, fo. 14r, 15th century
A manuscript of classical texts, but the image here of the insecurity of life at the top was one with which the contemporary courtier could readily identify.

between 1443 and 1454, and so knew Henry VI well at a time when his influence on policy was most pronounced. It is clear that he can be understood at Windsor and Eton as nowhere else. Eton College was the first public grammar school for boys founded in medieval England. At first intended for twenty-five poor scholars, the complement was raised to seventy in 1448–9, necessitating a much more grandiose building plan for the school, which lay beneath the royal castle at Windsor. Blacman describes the king as calling 'his boys' to him when they visited the castle, and exhorting them: 'Be you good boys, gentle and teach-able, and servants of the Lord.' The king was most con-cerned that they should not be corrupted by his court, indeed his evident lack of sympathy for the manners and the morals of his court is manifest in almost every section

of Blacman's memoir. 'At Christmas time a lord brought a dance or show of young ladies with bare bosoms who were to dance in that guise before the king.' This advanced décolletage was then at the height of fashion, but the king was not amused, any more than he was at Bath in 1448, when he saw men 'wholly naked' taking the cure; the fol-lowing year the bishop told bathers to cover up. This lack of sympathy with the court was not just a matter of external observances. The king disliked public business taking him away from his devotions. 'There came all at once', says Blacman, 'a knock on the king's door from a certain mighty duke of the realm, and the king said: "They do so interrupt me that by day or night I can hardly snatch a moment to be refreshed by the reading of any holy teach-ing."' As these attitudes became translated into policy, and

248

became widely known, they were to cause problems for Henry's kingship.

A king with this attitude to public business and court ceremonial will inevitably come to depend on a few trusted men if business is to be done at all. During Henry VI's personal rule there appeared an inner circle of councillors, who came to dispose of virtually all patronage in the council's gift. Clerks were inevitably prominent among them: Bishop Stafford of Bath (who had ordered the bathing cover up), Bishop Ayscough of Salisbury, and Adam Moleyns, keeper of the privy seal and appointed bishop of Chichester in 1445. Of the laymen who had been intimates of the king the greatest was the earl of Suffolk. Suffolk was great-grandson of the Hull merchant William de la Pole. He was closely identified with the Beaufort party, and hence with a desire for peace with the French. The king was very generous to men such as these, as Blacman also testifies: 'to the confusion of avarice he was bountiful in his gifts, as his former servants bore witness'. This was attempting to make a virtue of what the king's subjects saw to be a vice.

In 1449 parliament passed an act of resumption, to apply to all grants made by the king since his accession in 1422, but Henry vitiated this by adding (as he was permitted to do) no fewer than 148 clauses of exemption. This generosity was one cause of disaffection, but potentially more damaging was the exclusion of other senior magnates from the royal court. The divisions between the court party and others were fought out in the English countryside, often literally. In Norfolk men of the royal household acting under Suffolk's protection sought to take over political control of the shire. In 1449 a justice was sent to investigate complaints, but the two men chiefly complained of – Sir Thomas Tuddenham and John Heydon – brought 400 men to the court at Walsingham, and none were allowed to speak against them. All this is well set out in the Paston Letters, which elsewhere refer to the 'great hevyng and shovyng be my lord of Suffolk and all his counsell'. This heaving and shoving threatened the equilibrium of the county communities of England. The matter was made worse by the king's readiness to issue pardons for crimes: he did not wish, again according to Blacman, that 'any person, however injurious to him, should ever be punished'. As well as specific pardons, six general pardons were issued in the course of his reign, by which for a payment of 16s. 4d. any crime might be pardoned. A total of 3319 letters were issued after the pardon of 1446. They often followed the mediation of one of the local magnates, and if, as many were, they were pardons for offences against the livery laws, these letters to the commons were as red rags to a bull.

One area in which the king did become involved, not inappropriately, was in his own marriage, which was intended as a step towards the making of peace in France. The earl of Suffolk was also much involved. The bride whom he chose for the king, and persuaded the council to accept, was Margaret the daughter of René of Anjou. The dowry was not large – the proffered islands of Majorca and Minorca were not then an attractive prize, and the Angevin title to them was tenuous – and it was the English who held out the promise of real concessions, chief among them that the county of Maine would be surrendered as a token of good faith. The marriage took place on 23 April 1445, and soon thereafter, in July, an embassy arrived from the French. The atmosphere of the meeting was cordial, well described in a journal kept by one of the French party. Formal speeches were made, and then the king:

came to the said ambassadors, and putting his hand to his hat and raising it from his head, he said two or three times, 'Saint Jehan, grant mercis'; 'Saint Jehan, grant mercis'; and patted each one of them on the back, and gave very many indications of joy, and caused them to be informed by the said earl of Suffolk that he did not consider them as strangers.

This is a pleasant vignette, and interesting not least in the statement that the earl of Suffolk served as interpreter. The English king, though he claimed the French crown, had no French. Before the end of the year the promise was made that Maine would indeed be surrendered. This promise was made by the king on his own initiative, before any concessions could be obtained in return. It was highly unpopular, both to English opinion and to the troops on the spot. Le Mans was eventually surrendered in March 1448, Adam Moleyns and Sir Robert Roos coming over from England to effect the transfer.

The peace move had by this time already claimed its first major casualty. Duke Humphrey of Gloucester, Henry V's son, could be relied upon to oppose the surrender of Maine. He was first frozen out, at the 1445 discussions, and then charged with treason. He was summoned to Bury St Edmunds, an area where his lordship was weak and that of his opponents strong, was arrested, and died in custody (possibly of a stroke) in February 1447. He would continue to haunt the earl of Suffolk from beyond the grave. Before the year was out Suffolk – alarmed at evidence of his own unpopularity – sought permission to declare publicly that he had not been party to the surrender of Maine, and in 1449, probably to placate his critics, he broke the truce in north-west France in a way that was ill-advised. The English attacked Fougères, and they sought to transfer the allegiance of the duke of Brittany to their side; it suited the French to say that the latter was 'twenty times greater an enterprise and breach of truce than

the said taking of Fougères'. There was nothing very serious in the breaking of truces, it was all part of the game; this breach was wrong, however, because no strategy lay behind it. During the truce the French had rearmed; they had built up a field-army of over 30,000 men, including a regiment of siege artillery. The English army was perhaps only a third of this size, and its leader, Edmund Beaufort 2nd duke of Somerset, did not manage to coordinate an effective defence of the duchy. One by one the English garrisons fell to the French, Rouen in October 1449, Harfleur, 'a great jewel to all England', on 1 January 1450. A relief army was defeated at Formigny near Bayeux in April of the same year.

It was clear in 1450 that France was lost. A more consistent policy, with popular support, might have saved it. But with a king alienated from many of his chief men, with a small clique pursuing an unpopular policy, and with the worst manifestations of livery and maintenance in the countryside, both support and consistency were lacking. The commons showed their disapproval of all these things by being reluctant to grant taxation – after 1435 it fell to half the level of the early 1430s – and this made the military situation even more difficult. A few men paid the price of failure, chief among them the earl of Suffolk. When parliament met in November 1449 he sought to pre-empt criticism, and make some counter to the charges which he knew to be inevitable, because of 'the odious and horrible language that renneth through your realme'. Yet in the recess Adam Moleyns was murdered by sailors at Portsmouth, and was reputed to have confessed that he shared Suffolk's guilt in these 'odious' crimes. The charges were put when parliament reassembled in January 1450, and served as grounds for impeachment. It was charged that Suffolk was in league with the French and had planned an invasion, that the delivery of Maine was his sole decision (in fact it was the king's), and that he planned to depose the king and set his own son in his place, marrying him to Margaret Beaufort, 'pretendyng her to be next enheritable to the corone of this youre realms'. (Margaret Beaufort was indeed to transmit a title to the crown, but not in this way.) He was also charged with acquiring 'many grete possessions by mayntenaunce', and on this charge, refusing to hear those of treason, the king sentenced him to be banished for five years. He did not, though, even manage to get across the Channel; his ship was intercepted by the *Nicholas of the Tower*; the crew offered their own version of due process, and he was beheaded. The sailors are supposed to have stated that the crown was a symbol of the community of the realm, and the king had no absolute claim on it.

This was a new theory, and prophetic. It was much

more clearly established that the commons in revolt was an outward sign of inward disruption in government. Later, in 1450, came the rebellion that goes under the name of its leader Jack Cade. This followed in a number of respects the pattern that had been set in the Peasants' Revolt of 1381. It drew its strength from the home counties, and it came to focus upon London. It was primarily a Kentish revolt; the problems of maintenance in the county provided it with a starting point and 65 per cent of the over 2000 men pardoned at its end came from there. The rebels marched on London and encamped on Blackheath. The king's councillors advised him to stay away, for it was they, 'the false traytours about his hyghnesse', who were the objects of attack. It was reported from Blackheath that many in the retinues of the magnates, brought there to put down the insurgents, refused to attack because they had sympathy with their claims. This was put in a later source:

We say that our sovereign lord may understand this: his false council has lost his law; his merchaundise is lost; his common people are destroyed; France is lost. The king himself is so placed that he may not pay for his own meat and drink.

Cade's followers saw themselves as petitioners, not as rebels, loyal to the king: 'these fawtes amendid we schall go hoom'. The 'fawtes' of Henry VI's government up to that point could not have been more accurately described.

The Beginnings of the Wars of the Roses

Jack Cade took as his stage name, as it were, the name of John Mortimer. This was an interesting conceit, one that goes to the heart of the political difficulties of the 1450s. In taking this name, Cade laid claim to kinship with the line of Lionel duke of Clarence, the second of Edward III's sons, whose senior member was then Richard duke of York. This man was the son of Richard earl of Cambridge executed after his involvement in the Southampton plot against Henry V in 1415, but to the rebels in 1450 he was 'the hye and myghty prince' and 'the trewe blode of the realme'. He had been brought up, because of his background, in a strict Lancastrian household, and had named his first son Henry in the most loyal way. York was one of the great men alienated from the court in the 1440s; he was not paid monies that were owed to him

168 Knight in shining armour. 1475. From Germany. London, the Wallace Collection
The full harness of plate armour from head to foot developed from the beginning of the 15th century. The best armour was imported from Milan and southern Germany.

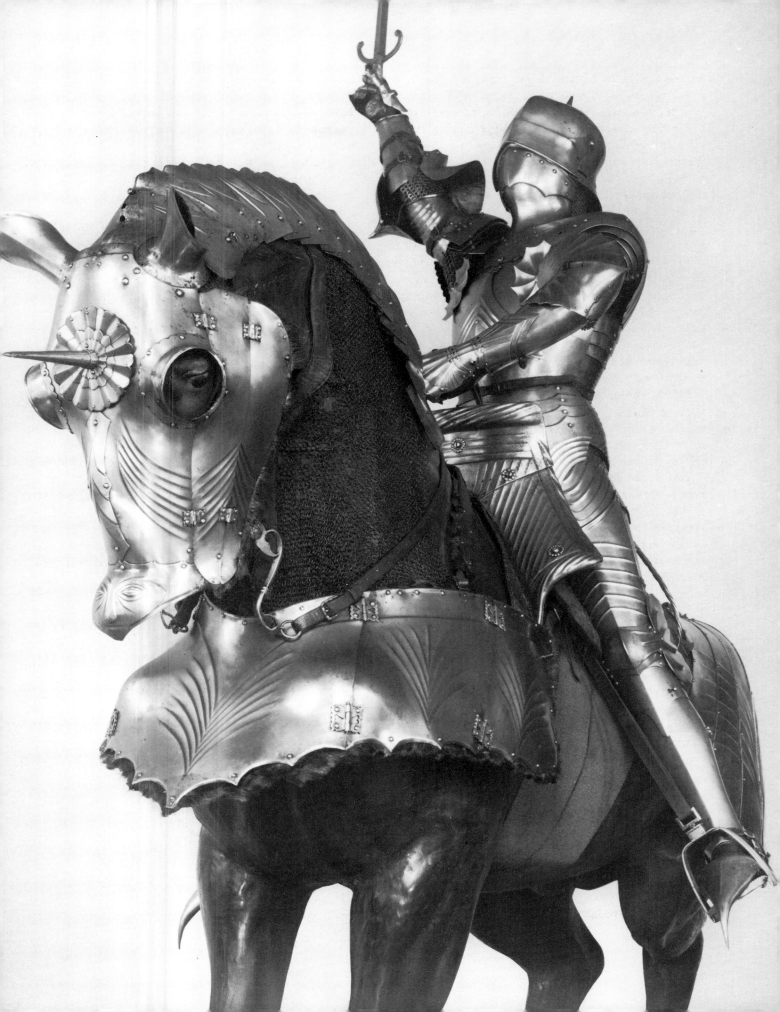

for war service in Normandy; and in 1447 he was sent in virtual exile to Ireland. With the death of Gloucester in that same year York became the next heir, in the Lancastrian succession, to the crown of England, and he maintained Gloucester's opposition to the peace policy in France. Cardinal Beaufort also died in 1447, and the heir to his policies and position at court was his nephew Edmund Beaufort 2nd duke of Somerset. There was little landed substance behind this title – Somerset's hereditary lands of around £300 were supplemented by grants of around £2000 from the royal chamber, which alone allowed him to maintain his estate. Somerset was a courtier or he was nothing. York was heir to two earldoms, and had the wealth and local power which came with them. The struggle between York and Somerset is the key to politics in the early 1450s.

York was always a good publicist. He needed to be, because with the financial need to sustain France in the course of being removed, and with many of the agents held responsible for its loss now dead, there was less chance of opposition appearing in parliament. In 1451 the king was taken on tour, and justice was done on the rebels of the previous year: 'men calle hyt in Kent the harvyste of hedys'. Somerset was at the king's side, and in 1451 he was appointed governor of Calais, a position of increasing influence at this time. York took his quarrel against Somerset to the country. On 3 February 1452 he addressed a letter to the citizens of Shrewsbury, signing himself 'your good friend'. (In just such a way an MP might write to the chairman of his constituency party, and copy his letter to the newspapers.) In his letter York harped again on Somerset's responsibility for the loss of France – the 'derogation, loss of merchandise, lieson of honour, and villany reported generally for the lose of the same' – and the evils of maintenance within England. Yet he could only sustain his campaign by mustering his own forces, and inciting a general insurrection, which he insisted was against his enemy and not against the king. The leaders of the towns of Canterbury, Maidstone, Colchester, Sandwich, Oxford, Winchelsea and Sudbury all sent to the council copies of York's circular letters. Many more must have been sent, but the sample may show that York hoped again for support from the men of Kent. In this he was disappointed. At Dartford in March 1452 his forces faced those of the king. The royal council was not yet polarised, and insisted on peace being made. Yet it was peace on terms that left Somerset's position all the stronger for York's challenge. In the following year the situation was to change.

In August 1453 Henry VI went mad. He was taken ill at Clarendon Palace, and after two months was transferred to Windsor. For a year and a half the king of England was totally unaware of his surroundings, needing to be fed, and to be nursed night and day. Five physicians treated the king for his mysterious illness, but like the doctors in one of Belloc's *Cautionary Tales* found there was little they could do.

> '*They answered, as they took their fees,*
> *There is no cure for this disease.*'

It is now thought likely to have been a case of katatonic schizophrenia. While the king was thus out of commission the queen was delivered of an heir, Edward, on 13 October 1453. What earlier would have a blessing now came heavily disguised. The birth of an heir, to a king who had always been inconsequential and had now become insane, in the short term only complicated the problem of the succession. For a time the queen became the effective head of her husband's government. She asked to be made regent, for which there were precedents in France but not in England. When the next parliament met, in February 1454, York was made 'protector' of England, a title which consolidated a position he had already gained as head of the king's council.

The first protectorate of the duke of York lasted until December 1454, when the king recoverd. In this brief time, the popular model of kingship was more thoroughly acted out than it had been at any time in the previous thirty years. Efforts were made to reform the royal finances, and to defend Calais. Somerset was imprisoned, but not harmed, and York became governor of Calais in his place. York ensured that this transfer, and other conciliar decisions of similar importance, bore the signatures of those approving the decision. As well as showing a careful and impartial stewardship of the king's resources, York made sure that the king's public responsibilities for the keeping of order was discharged by those acting in his name. Of the many private feuds which weak and partial government had allowed to flourish the most important, which now drew itself to the council's attention, was that in the north of England, between the Percys and the Nevilles. On 8 October 1453 the council sent letters to the earl of Northumberland and the earl of Salisbury, stating that each of them had the reputation of being 'a sad, a sober, and a well-ruled man', and ordering them to disband their retinues. No notice was taken of this injunction. The two families mustered their supporters in Yorkshire. With the Percy earl of Northumberland were his sons Lords Poynings and Egremont, and Lord Clifford; with the Neville earl of Salisbury were his son Richard (already earl of Warwick, 'the kingmaker') and other lords. A truce was called, but in the following year other lords were drawn in, and northern England seemed destined for civil war.

York and the council took direct action to prevent this. He marched north to the city of York, which had become involved in the disturbances, and there sat at the head of a commission of justices, to try those indicted for the disturbances of the previous eighteen months. It was the Percys who suffered. Northumberland was charged, and the case postponed; Egremont was captured later in the year, and imprisoned. York as protector had pacified northern England, but at a necessary cost of taking sides. The Nevilles were from now on his consistent allies.

The gains of York's protectorate were then rapidly undone when at Christmas 1454 the king recovered his senses, such as they were. Early in the new year York was removed from his office, and Somerset was released from prison and took up his previous place at court. It was business as before; but the stakes were becoming higher. At

169 Poor relief. Early 15th century. York,
All Saints Church, North Street,
north aisle
One of the seven corporal acts of mercy, here
realised in an urban setting.

court now were the Percys, firmly allied with Somerset. As leaders of the council they summoned a great meeting in Leicester on 21 May. The stated business was to provide for the king's safety, and as York and the Nevilles quite reasonably remarked, this 'of common presumption implieth a mistrust to some persons'. They had no doubt who was meant, and withdrew north. After collecting troops, they came south, and intercepted the king and the court party at St Albans, when they were only a day's journey out of London. Neither army was large, York having perhaps 3000 men while Somerset on behalf of the king led around 2000. Negotiations for peace failed, York being adamant on the surrender of Somerset for trial, and on 22 May 1455 the first battle of the wars of the roses was fought. This, the first battle of St Albans (for armies would meet again on this road), was a small engagement, but highly significant in terms of those killed: Somerset, Northumberland and Clifford headed the list. The king was present, not so much above the battle as unaware of it: the manifestos in which the Yorkists set out their position were not shown to him. After the battle he was escorted to London, and York become protector for a second time. A parliament that met in July 1455 pardoned York and his followers for taking up arms against the king, and men were told to put the battle out of their minds, 'and nothing doon there never after this time to be spoken of'.

This was an impossible prescription. It might have been feasible with firm leadership, but this was not forthcoming. During the late 1450s the king was the shadow of regality. For Ralph Griffiths, who has written the chief modern study of the reign, this was 'a period of administrative difficulty, governmental paralysis, and intensified political faction'. Insecure in his own capital city, Henry was removed therefrom by the queen, and Coventry in the heartland of Lancastrian territory became his main base.

For much of the period there was near anarchy in London. Italian merchants trading in the city were attacked, and offered no protection. A certain crude mercantilism, the feeling that the Italians were draining the country of currency lay behind these attacks. In fact this was not so; the Italians provided skills in banking and exchange that were important for the effective working of the English economy. The whole mercantile community, as well as the London commons, became alienated from Lancastrian rule. The interests of the merchants centred on the success of the Calais garrison. In York's second protectorate this was granted to the earl of Warwick, and he was able to to regain control of it when that protectorate in turn was dissolved in 1456. The commander of Calais controlled the one permanent garrison

170 Merchant brass. c.1490. Northleach
church, Gloucestershire
The brass shows John Taylor, his wife,
and (out of sight) their fifteen children.

met York and the Nevilles. The Yorkist troops were deserted by their generals, who declined to fight against the king, and fled abroad – York to Ireland where he was a major landowner and the king's lieutenant, and Warwick and Salisbury to Calais, taking York's son Edward with them. A parliament was then summoned to Coventry, to convene on 20 November 1459, and acts of attainder were passed against the duke of York and a long list of his supporters. All were declared guilty of treason, liable to death and to the disinheritance of their heirs. If the rights of those heirs were to be protected, there, fore, their fathers must fight for them. For the great medieval lord, with the blood of great ancestors coursing in his veins, no call could be more imperative than that. In June 1460 the Yorkist lords then at Calais crossed the Channel and were admitted to London. They found the royal army at Northampton, and in a short battle there on 10 July, the king was captured and two of his chief supporters, the duke of Buckingham and the earl of Shrewsbury were kil, led. Parliament met in London in October to repeal the attainders. York, who had played no part in the battle, came over from Ireland, and claimed the throne. This was more than all but a handful of the lords had looked for, and York was offered no encouragement. Undeterred, on 16 October he sent the lords a genealogical statement of his claim, showing the line of descent from Edward III's second son. Genealogical rolls giving the descent of the kings of England were much in fashion at this time, and all this was well enough known. The lords shrank from the consequences of, in effect, putting the clock back seventy years, placing in question all that had been done since the Lancastrians came to power in 1399. York was there, however; he had the king in his power; and his claim would not go away. In the event a compromise was reached by which Henry VI would retain the crown, but his heir would be the duke of York, and the crown would descend to York's heirs after him.

The justices of England, asked to adjudicate on York's claim in the parliament of October 1460, stated that the matter was 'beyond their learning'. They cannot be faulted for saying this. The arrangements there made disinherited Henry VI's son Edward (aged seven), and also the Beau, fort line, the duke of Somerset, his sister the countess of Richmond, and her son Henry Tudor. Their claims would have to be fought for in their turn, and they had a powerful protagonist in Queen Margaret of Anjou, who was still at large. She raised an army in Yorkshire, which had always been 'her' territory, and York impetuously pur, sued her there. At Wakefield on 30 December 1460 the duke of York, heir to England, was killed; his head was given a paper crown, and placed upon the walls of York.

of English troops at this time, and he had the means to pay them through control of the wool staple established there for that purpose. Calais became a weapon in the Yorkists' hands, and it was the Londoners who financed the Yorkist revolution.

The revolution came during a period of civil war in England, which lasted from 1459 and 1461. Henry's queen Margaret must bear the chief responsibility for the drift to renewed warfare. If any one event made war inevitable, it was the summoning of a great council to meet at Coventry on 24 June 1459. The Yorkists saw this threat to their position and failed to appear. Orders went out for their arrest, and the two sides armed for conflict. The first major confrontation here was at Ludford Bridge in Shropshire, when the king at the head of his own army

The queen then marched south, and won a second victory at St Albans on 16 February 1461. This again was not a major engagement, and the Yorkist leader the earl of Warwick was able to escape, but it was important because the queen 'recaptured' her husband Henry VI. Had the queen now been more resolute the Yorkist takeover might never have happened. Her army, however, stopped short of a London that was highly fearful of it. One of the London chroniclers states that now:

alle this seson was grete wacch kepte in the cyte of London for it was reported that the Quene with the northyrn men wold come down to the cyte and robbe and despoyle the cyte and destroye it uttirly and alle the sowth cuntre.

The queen's failure to capture London gave York's son and heir his opportunity. He came, along with Warwick, from the security of his base in the Cotswolds, and was admitted to London on 27 February 1461. Edward duke of York was now 'elected' king by the Londoners. With this recognition he pursued his enemies north, and defeated them at Towton on 29 March 1461. This may fairly rank as one of the decisive engagements in English history. The Lancastrian army there defeated was enormous, one authority giving its size as 22,000 men. The queen, with her husband and their son, fled to sanctuary in Scotland. The duke of York returned to London for his coronation as Edward IV.

171 Genealogy of the earls of Warwick. London, British Library, Add. MS 48976, c.1483
Henry VI as a child in the arms of his tutor Richard Beauchamp, earl of Warwick, from an illustrated history of the earls of Warwick by their family historian, John Rous.

Edward IV

Edward IV started well enough. In his first parliament in November 1461 he made a speech from the throne, the first ever recorded, for normally the chancellor spoke on the king's behalf. He thanked the commons for their support, and promised to be their 'very rightwise and loving liege lord'. He promised to tour the country and do justice in person, in response to criticisms of the state of public order. From this parliament survives the first *Lords' Journal*, which shows that the king was present and active on each day that the lords met. The king's subjects would find him to be as good as his word. A number of the Paston letters give something of the flavour of Edward IV's personal government. Before the 1461 parliament had met, the Pastons were at court pursuing their claim to the manor of Dedham. They applied to the treasurer, who spoke with the king and reported his reply as follows: 'he said he would be your good lord therein, as he would to the poorest man in England'. The king knew the Pastons and their kind; 'there used to recur to him the names and estates of nearly all the persons dispersed through the shires of this kingdom'. Henry III was the only other medieval English king of whom this was said, but Henry never used his excellent memory to work the stump in the way that Edward did. His charm can be seen at work in 1475, when the French king introduced the historian Philip de Commynges. Edward said that he remembered him well, and proved it, for he retailed 'where he had seen me, and that previously I had put myself to much trouble in serving the king at Calais'. The historian was impressed by this, even though elsewhere he was critical of the English king. It helped also that Edward looked every inch a king. This had helped him in London when he came to power. It continued to be an asset. Commynges on another occasion states, 'I do not recall ever having seen such a fine-looking man as he was when my lord of Warwick forced him to flee from England'. Edward looked the part, and he acted the part, but he was not allowed to live it out.

The king promised good lordship in the 1461 parliament, but this did not apply to the more prominent Lancastrians. A total of 113 separate acts of attainder were passed, confiscating property worth as much as £30,000 a year. This was a fine opportunity for the king both to strengthen his own finances and to broaden the base of his support, but the opening was entirely wasted. The greatest gifts went to the Nevilles, to whom he undoubtedly owed his throne. Warwick 'the kingmaker' was made chamberlain, warden of the Cinque Ports and captain of Calais. His brother, John Lord Montague, was granted

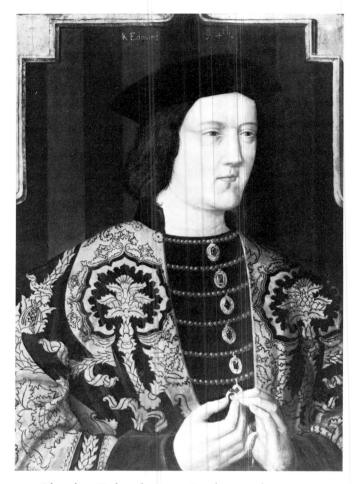

172 Edward IV. Early 16th century. London, Royal Collection
The work is by an unknown artist, thought to be Flemish, but based on a portrait dated to before 1472.

the earldom of Northumberland and most of the Percy lands in Yorkshire in 1464. This was a reward for continuing loyalty, for in the north during the early 1460s several strongholds of Lancastrian support remained. Three times the great Northumbrian castles of Alnwick, Bamburgh and Dunstanburgh fell into the hands of supporters of the old dynasty, with the aid of the French and of the Scots. The battle of Hexham on 15 May 1464 saw the end of that threat while Henry VI, still its most potent symbol, was captured the following year and sent to the Tower of London. Queen Margaret was now in France. With this relaxation of pressure came the relaxation also of the tight alliance, forged in adversity, between Edward IV and the earl of Warwick. That they grew apart was for two main reasons; first because of the king's marriage, and second because of differences in foreign policy.

A marriage into one of the royal houses of Europe would have helped established that of York as their equal. But

ELIZABETH·REGINA·REGIS·EDWARDI·QVARTI

173 Elizabeth Woodville. Mid-16th century. Longleat House
The long galleries of Tudor country houses offered scope for the
display of panel portraits of this type. This is one of a series at
Longleat. Though they were in a sense mass-produced, care was
taken to copy a good likeness from early examples. This is based on
a portrait now in the Royal Collection and closely resembles a
contemporary portrait at Queens' College, Cambridge.

those houses proved to be reluctant to commit themselves
to a new line; and Edward IV, urgent to beget an heir,
lost patience with diplomacy. On 1 May 1464 he married
Elizabeth Woodville at Grafton Regis in Northampton-
shire. Elizabeth was a widow: her first husband Sir John
Grey had died at St Albans, fighting on the Lancastrian
side. Edward cut against many conventions here. A king's
marriage was a matter of state, requiring counsel; no coun-
sel was taken, and the marriage was kept secret for nearly
six months, during which time negotiations for other
matches continued. Those who conducted those negotia-
tions, among them Warwick, the king's chief counsellor,
were made to look foolish. The new queen came supplied
with a host of relations, all of whom had to be found prefer-
ment and marriages appropriate to their new estate. The
Woodvilles cornered the marriage market, and at a time
when Warwick himself had two daughters who were near-
ing marriageable age. They were seen as a clan, and they

never became popular; not surprisingly they were most
unpopular among those whose equals they had only
recently become, the greater nobility. When the king died
prematurely the first concern of the council was reportedly
that control of the young heir should not be left to 'the
uncles and brothers of the queen's blood'. It was a marriage
that proved fertile – ten children were born between 1466
and 1480 – but in making it the king had sowed also
the seeds of dissension.

Edward IV also disagreed with Warwick over the con-
duct of diplomacy, and how best to seek to recover former
English lands in France. Warwick favoured an alliance
with the French King Louis XI against Burgundy,
Edward the more traditional alliance with Burgundy
against France. The two chief men in England conducted
two separate foreign policies between 1464 and 1468, in
which year the matter was resolved with a formal
Burgundian alliance and the marriage of Edward's sister
Margaret to Charles the Bold duke of Burgundy. There
were signs closer to home also that the Neville influence
was on the wane: George Neville archbishop of York was
dismissed as chancellor in 1467, and in 1469 matters came
to a head. What is remarkable about the crisis which now
followed was that Warwick evidently thought that
Edward's kingship was sufficiently weak for it to be chal-
lenged. Neither Yorkist nor Lancastrian had yet a genuine
control over local government. Many lords saw the
penalties of failure at court to be much greater than the
rewards of success: 'to be great about princes is dangerous',
John Blount Lord Mountjoy wrote to his son. They stood
aside, and with the small numbers involved small shifts
in advantage took on the character of seismic changes. In
1469 there was a rising in the north for which Warwick
was responsible; while Edward marched north to meet the
threat Warwick raised an army at Calais, gained London
(which Edward had not troubled to conciliate), and cap-
tured the king. It seems to have been the intention to replace
Edward as king by his brother George duke of Clarence.
Support for this was lacking, however, and a temporary
truce was agreed. A further rising in Lincolnshire led to
further skirmishings. Warwick's support collapsed, and
he was forced to flee abroad. There he patched up an
alliance with his old enemy Margaret of Anjou, and with
the support of the French king he returned to England
in October 1470. It was Henry VI's title which he was
now forced to support. This was the so-called Readeption;
for six months after October 1470 the government of Eng-
land was conducted in Henry VI's name. Edward found
himself totally without popular support, and was forced
into exile. 'It is a difficult matter to go out through the
door, and then to enter by the windows', said one foreign

Priests and People

PROTESTANT PROPAGANDA long taught that 'true religion' scarcely existed in fourteenth-century England, since the Bible was a closed book to laity and clergy. Yet the late middle ages saw anxious discussion over lay religious education and censorship. Protestants sought precedents for the Reformed church in the Lollard followers of John Wyclif (condemned in 1382). Yet reforming views voicing dissatisfaction with the clergy and the need for scriptural translation (views discredited by Lollard extremism) were widely held. Many shades of opinion lay between conservative orthodoxy and radical heresy.

The period saw growing interest among increasingly well-educated, devout laity in doctrinal enquiry (traditionally reserved for trained university theologians). Some, like the poet, Wil-

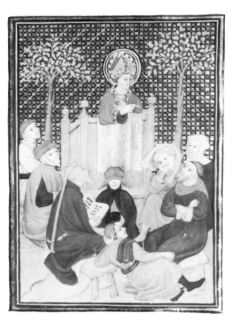

1 (ABOVE) A fashionable sermon audience. London, British Library MS Harley 2897, fo. 160ᵛ, c.1419. Burgundian breviary
Some of the congregation illustrate the custom of reading books of devotion during the sermons and at Mass.

liam Langland, disliked dinner-time disputation, finding it unseemly to 'gnaw God with the gorge when their guts grow full', but some clerics (especially friars) encouraged the custom. Margery Kempe, the mayor's daughter of King's Lynn, tells us, in the remarkable spiritual autobiography of her career as a professed mystic, that a Franciscan of the town, 'Mayster Aleyn', 'informed her in questions of Scripture'. Another friar (anonymous) likewise spoke of priests' responsibility to 'answer to doubts and questions that men ask of God's law'.

Lay interest in Scripture was partly met by two later fourteenth-century Wycliffite Bible translations. Without their heretical preface, they are not doctrinally tendentious and many must have survived in orthodox ownership. Over 235 copies survive, a vast number for a vernacular text, and many more may

have been destroyed. Clerical opinion over the wisdom of Bible translation was divided, as shown by a debate held in Oxford in 1401, in which one of the supporters of translation was Richard Ullerston, better known to history as an opponent of the Lollards.

In 1407, however, the Archbishop of Canterbury, Thomas Arundel (1353–1414), promulgated decrees designed to arrest the spread of Lollardy. Lay ownership of Bible translations was forbidden without a bishop's licence; licensing of preachers was more strictly enforced; the content of sermons was controlled to inhibit anti-clerical comment before the people and to restrict hired curates (who had much responsibility for parish administration) to the rudiments of faith and morals. The effects were resented by more than heretics. Thomas Gascoigne,

3 The Dreamer has a vision of the spirit of his dead daughter and questions divine justice. London, British Library MS Cotton Nero A. x, fo. 37r
The poem *Pearl*, from the second half of the fourteenth century, testifies to the growing lay interest in speculative theology.

2 Portrait of a donor, Margaret FitzEllis, Waterperry, Oxfordshire, 1460s
Moralists disapproved of this form of self-advertisement: friars especially were accused of promoting such an incentive to generosity, just as Langland's friar invites Meed to present a window in which she will be portrayed.

4 (LEFT) A friar
confesses Meed
('money-payment') in
a scene from *Piers
Plowman*. Oxford,
Bodleian Library MS
Douce 104, fo. 11ᵛ,
1427
In return for an easy
absolution, Meed is to
help with the convent's
building programme.
Langland shared the
view that friars too
often sold the
sacraments.

5 Thomas Arundel,
Archbishop of
Canterbury (died
1414). Oxford,
Bodleian Library MS
Laud misc. 165, fo. 5ʳ,
late fourteenth century
He presents a copy of
the Franciscan,
William Nottingham's
commentary on the
Gospels to the monks
of Christ Church,
Canterbury.

chancellor of Oxford University, thought the muteness which afflicted Arundel in his final illness a divine judgement. Even the laity's scriptural questions might be suspected: Margery's 'Mayster Aleyn' was for a time forbidden to teach her. Even in the early sixteenth century, a pious London grocer, Richard Hill, included in his commonplace book a poem on prelates who kept the Gospel from the people. Lay desire for private Bible study could not be contained by Arundel's licensing of the translation, by the Carthusian Nicholas Love, of meditations on the Life of Christ ascribed to Bonaventure. Desire by pious householders to turn home into a little church saw them reading religious books aloud to their families at mealtimes, and reading scriptural commentaries and other devout works in church, even during sermons. Nonetheless, the feeling outlasted the Reformation that the most sacred

mysteries should be reserved from the laity. Simple faith sufficed for salvation: shepherds and shoemakers, said Langland, 'pierce with a Paternoster the palace of heaven'.

Interest in private study and prayer derived partly from dissatisfaction with the temporal church, dissatisfaction which Arundel's legislation made difficult to express without creating suspicion of heresy. Friars especially were seen as having forfeited the respect earned by the ardour of their founders: writers of the late middle ages were able to draw upon extensive traditions of anti-mendicant satire. Langland was not the first to see friars as the false prophets, foretold by the New Testament, who would appear at the end of the world. Because friars had become Wyclif's bitterest opponents, Lollards voiced most rancorous hatred of them, but they were not alone. Long-standing rivalry existed between friars

and secular priests over who was best fitted to preach to and confess parishioners, and war intensified when, from the late fourteenth century onwards, some seculars began to make more active provision for regular preaching.

Friars came (not always justly) to be identified as chief agents of the suppression of the vernacular scriptures. Satirists declared this to be in their interests since widespread knowledge of the Bible would reveal them as latter-day Pharisees. So, in a fifteenth-century mockery, a 'friar' exclaims:

*I trow the devil brought it about
To write the Gospel in English.*

He concluded with a prophecy:

*Men shall find unnethe [scarcely] a friar
In England within a while.*

H. L. SPENCER

174 The miracles of the Virgin. *c.*1480. Eton College Chapel
The panels were whitewashed over in 1560; rediscovered in
1847 (reported by *The Times*, 17 July 1847 as showing 'a
variety of miracles alleged by the Romish church to have
been performed by the Virgin Mary'); and restored in the 1920s.

commentator, but this is what Edward, by ability and luck, was able to achieve. He landed at Ravenspur in March 1471, and found Yorkshire sullen, for the scars of Towton had not healed; but as he moved south, he was able to pick up support. William Lord Hastings, the most powerful of Edward's Midland creations, joined him with 3000 men. On 11 April, Maundy Thursday, Edward reached London, which gave him custody of Henry VI, and sight for the first time of his son and heir Edward, who had been born the previous November. The king then faced two challenges. The first was from Warwick. (Clarence had kept his options open, and was by now at his brother's side.) On Easter Sunday the two armies met at Barnet, and Warwick was killed. The same day Queen Margaret landed at Weymouth, and Edward turned west to meet the final Lancastrian threat to his throne. The queen had with her her own son Prince Edward, and gained considerable support in the south-west. The two armies fought at Tewkesbury; Prince Edward was killed; and when the king returned to London he ordered the assassination of Henry VI. The first phase of Edward IV's reign was over: 'no one remained in the land of the living who could claim the throne from that family'. So, at least, it then appeared.

Edward resented the aid that France had offered to his enemies during the Readeption. It was the chancellor who spoke to parliament on this matter in 1472. He claimed the king's 'just inheritance' in France; warfare helped keep the poor off the streets and provided younger sons with proper employment; and, anyway, had not the most successful kings of England been those that had engaged in war'. It was a circumstantial argument, if it was an argument at all, but parliament was prepared to listen. The sum of £118,625 was promised, the estimated cost of a year's wages for 13,000 archers. In addition to the normal renders, here taken as an income tax at 10 per cent, the king took benevolences, and turned all his charms to the war effort: a Suffolk widow doubled her contribution from £10 to £20 in return for a kiss from her monarch. This was to be the 'finest, largest, and best appointed force that has ever left England', said Thomas de Portinari, the Medici representative at Bruges (whose portrait by Memling is in the Metropolitan Museum of Art, New York). This force was never to face a major engagement. It landed in France in July 1475, but Edward's allies, the dukes of Burgundy and Brittany, backed away from offering positive support. By the middle of August the two kings were anxious to come to terms. After a meeting at Picquigny near Amiens these were agreed. The English king was to receive £15,000 for his speedy withdrawal, and then, for a seven-year truce, the sum of £10,000 a year. The

French king's son, the dauphin, would marry the first or second-born daughter of the king of England. The leading captains were given pensions and presents as compensation for the lost spoils of war. It was a generous, perhaps even a patronising settlement on the French side. On the English side the commons grumbled, for it was their money that had been spent, and there were no presents for them. Neither side was quite happy. It was a fair agreement.

Edward did his best in 1475 to carry his brothers with him. The instructions sent to his ambassadors in France on 13 August he took care to have witnessed by both Clarence and by Richard, duke of Gloucester, who had each a share in the lands and authority of Richard Neville earl of Warwick. The memory of Clarence's earlier treachery was still vivid, and several foreign commentators felt that he would again try to overthrow his brother. For the next couple of years Clarence, cast as a potential traitor, acted out the part. After his wife died in childbirth he sought a second marriage to the heiress of Charles duke of Burgundy. But the resources of Burgundy coming with an alliance to a descendant of John of Gaunt, 'time honour'd Lancaster', would have offered a patent threat to the first Yorkist king. When the marriage was denied him Clarence reacted petulantly. He was mute in council, and boorish at his brother's board, refusing food and drink lest it be poisoned. At length in the January parliament of 1478 he was accused of a list of treasonable crimes, none of them very specific, but as an 'incorrigible' enemy of his brother he was condemned to death. It is for the manner of his death that he is perhaps best-known. The judgement was carried out secretly in the Tower on 18 February 1478. Almost certainly he was drowned, and it may be that the most colourful story is in fact correct, and that it was in a butt of Malmsey wine that 'false fleeting, perjur'd Clarence' met his end. The Crowland chronicler was surely right in seeing the danger as being that of disaffection. Now the king might reign secure, 'those idols being removed', he said, to whom 'the multitude, ever desirous of change, had been in the habit of turning in times past'.

Reign securely Edward IV now did, more confident of his power, and of his succession. The new chapel of St George in Windsor Castle was his work, and here he was buried. Money was also found for Eton College; the chapel was completed and decorated with wall-paintings in a style much influenced by Flemish work (Pl. 174). This was the dominant influence on the English art of the time. Edward had been in exile in Bruges in 1470–1, and from his host there, Louis de Grunthuysen, he acquired the foundation of a royal library, to which he added works specially commissioned during the last years of his reign (e.g. Pl. 133). Here is the renaissance prince,

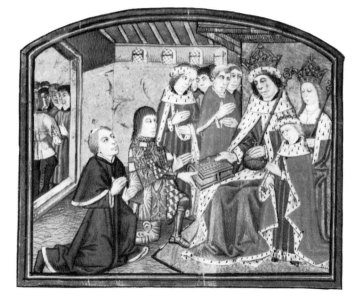

175 An image of Yorkist kingship. London, Lambeth Palace
Library MS 265, fo. 6r, 1477
Anthony Woodville, Earl Rivers, presents a book to Edward IV.
The figure to the earl's right may be Richard of Gloucester, later
Richard III.

if not on the grand scale at least passable enough. At the
Christmas court of 1482 he made a striking impression.
He kept ahead of fashion. 'The sleeves of his cloak hung
in ample folds like those of a monk's frock, lined inside
with the richest furs and rolled on the shoulders.' Taken
in all, he had 'a most distinguished air', and the beauty
of his five daughters was everywhere admired. It seemed
to need only a few years for them to make excellent marri-
ages, and for the succession to pass to Edward's heir, but
this was not to be. The king had a stroke, and died on
9 April 1483; he was forty years old. For a week his body
lay in state in St Stephen's chapel, Westminster. On 18
April the royal cortege set off along the line of the Thames,
resting overnight at Syon Abbey. As it passed Eton the
following day it received a benediction from the Fellows.
On 20 April the king was buried with great ceremony
at Windsor.

Bosworth Field

The succession now fell to Edward V, a boy of twelve
with a mind of his own, whose control was, and had long
been, in the charge of Earl Rivers, the queen's brother.
The dying king had nominated his brother Richard duke
of Gloucester, as protector of England. Gloucester's loyalty
up to this point had seldom been in question. His position
when the king died was difficult, but he was not alone
in that. In particular he seems to have feared that once

Edward V was crowned, his authority as regent would be
abrogated. Gloucester resolved his difficulties, and as he
did so he destroyed a dynasty. He needed control of the
young king, who was intercepted at Stony Stratford, Rivers
and the bodyguard fearing no treachery until it was too
late. When she heard that Edward had been captured the
queen immediately took her family into sanctuary at West-
minster; she had been there before, and doubtless had her
routines worked out. The situation was difficult, but there
remained the hope that reasonable men might come to
terms. The chief of the moderate councillors, fearful of the
Woodvilles and yet loyal to Edward V's succession, was
Lord Hastings. He was summoned to a business meeting
on the morning of 13 June; by lunchtime he was dead,
seized in Gloucester's presence and executed without trial.
That Richard aimed at the throne had long been rumoured
and could not now be denied. It was necessary to summon
parliament, and make some show of an argument that
Edward V should be stood down. The case was thin, but
the duke was determined, and the fate of Hastings made
clear the threat to any who opposed his ambitions. The
best that could be done was to question the validity of
Edward IV's mariage, and thus the legitimacy of his sons,
the younger of whom, Richard, was extracted from sanctu-
ary under threat of violence, and placed with his brother
in the Tower. On 4 July the duke of Gloucester was
crowned king as Richard III. The figures of the princes
in the Tower could be glimpsed occasionally in the dis-
tance, but after a few days they were seen no more.

The Yorkist dynasty was not firmly established, and
Richard, for his own ends, had destroyed much of what
integrity and coherence it had. He met resistance straight
away, and soon a claimant to his own throne was to appear.
Rumours of the fate of the princes in the Tower, if anything
more damaging because they were impossible to resolve,
spread through southern England: 'for this cause he lost
the hearts of his people, and many gentlemen intended his
destruction'. Preparations were made for a general insurrec-
tion in October 1483, the leaders being the duke of Buck-
ingham and the marquis of Dorset, but the capture and
execution of Buckingham the following month was the
prelude to its failure. The rebels had, however, identified
a successor to Richard in the unlikely form of Henry Tudor
earl of Richmond. He was to marry Edward IV's eldest
daughter Elizabeth of York who, after her brother's death
(which no one at the time doubted), had become the heir

176 A vision of paradise. c.1500. March church, Cambridgeshire
A double hammerbeam roof with angels with spread wings in three
tiers, on the corbels supporting the shafts, and at the ends of both
hammerbeams.

177 The tournament. London, British Library, Harley MS 4205, fo. 12r, c.1440s
The figures in this series of drawings of jousting knights are not portraits but models for the display of arms, here those of Payton and Tendring.

of Edward IV. At Rennes cathedral on Chrismas Day 1483 Henry Tudor in exile swore to contract this marriage should he become king. The marriage had suddenly become the dream of those who could not face the reality of Richard III's rule. His fall, which would not long be delayed, marks the nemesis of English involvement with France. For decades, and most recently in 1475, the kings of England had sought to use faction among the great houses of France to undermine the French monarchy. Now the boot was on the other foot. Henry Tudor landed near Milford Haven on 7 August 1485, and a week later crossed the Severn into England at Shrewsbury. The end was mercifully brief. A week after this, at Bosworth field in Leicestershire on 22 August, the two armies met for a first and final engagement. It was Richard's intention that it should be so, though Henry, outnumbered, would have been happy to fight another day. Before the armies were fully engaged, and weight of numbers might have been seen to tell, Richard struck out with his bodyguard to find in person the pretender to his crown. He came close, for Henry's standard-bearer was killed, and by the king himself, but not close enough. At the end of the day Richard's body lay dead on the field. His crown was found, perhaps in the legendary bush, and delivered to the new king. The old king's body was stripped, and sent naked to the Franciscan friary at Leicester. Richard III, the last of England's medieval kings, was the first to be treated as a war criminal.

Bibliography

The series of Bibliographical Handbooks prepared for the Conference of British Studies provides a full survey of the literature. Three volumes cover the period of this study: M. Altschul, *Anglo-Norman England 1066–1154*; B. Wilkinson, *The High Middle Ages in England 1154–1377*; D. J. Guth, *Late-Medieval England 1377–1485* (Cambridge U.P., 1969, 1978, 1976). The best guide to publications thereafter is the *Annual Bulletin of Historical Literature*, published by the Historical Association, London, edited by M. Greengrass.

The following abbreviations have been used in the bibliography:

BIHR Bulletin of the Institute of Historical Research
EHR English Historical Review
NMT Nelson Medieval Texts
OMT Oxford Medieval Texts
TRHS Transactions of the Royal Historical Society

The writing of general surveys is a little out of fashion so far as medieval England is concerned, and first mention should go to three volumes which show (for Scotland and Wales) the continued usefulness and vitality of such work: R. R. Davies, *Conquest, Coexistence, and Change. Wales 1063–1415* (Oxford: Clarendon Pr., 1987); G. W. S. Barrow, *Kingship and Unity. Scotland 1000–1306* (London: Edw. Arnold, 1981); A. Grant, *Independence and Nationhood. Scotland 1306–1469* (ibid., 1984).

The following general surveys of periods of English history are of value: F. Barlow, *The Feudal Kingdom of England 1042–1216*, 3rd edn. (London: Longman, 1972); Marjorie Chibnall, *Anglo-Norman England 1066–1166* (Oxford: Blackwell, 1986); M. Prestwich, *The Three Edwards* [1272–1377] (London: Weidenfeld and Nicolson; New York: St Martin's Pr., 1980); M. H. Keen, *England in the Later Middle Ages* [1272–1485] (London: Methuen, 1973). Surveys of the English economy include: J. L. Bolton, *The Medieval English Economy 1150–1500* (London: J. M. Dent; Totowa N.J.: Rowman and Littlefield, 1980); E. Miller and J. Hatcher, *Medieval England. Rural Society and Economic Change 1086–1348* (London: Longman, 1978); Susan Reynolds, *An Introduction to the History of English Medieval Towns* (Oxford: Clarendon Pr., 1977). A variety of approaches to the study of the English peasantry will be found in: Barbara A. Hanawalt, *The Ties that Bound. Peasant families in Medieval England* (New York: Oxford U.P., 1986); G. C. Homans, *English Villagers of the Thirteenth Century* (Cambridge, Mass.: Harvard U.P., 1941); R. M. Smith (ed.), *Land, Kinship and Life-cycle* (Cambridge U.P., 1984); J. A. Raftis, *Tenure and Mobility: Studies in the Social History of the Medieval English Village* (Toronto: Pontifical Institute of Medieval Studies, 1964).

Useful village studies are: E. Britton, *The Community of the Vill* [Broughton, Huntingdonshire] (Toronto: Macmillan of Canada, 1977); P. D. A. Harvey, *A Medieval Oxfordshire Village. Cuxham 1240–1400* (Oxford U.P., 1965); Marjorie K. McIntosh, *Autonomy and Community. The Royal Manor of Havering* [Essex] *1200–1500* (Cambridge U.P., 1986). Estate studies provide the raw material for social history: F. R. H. Du Boulay, *The Lordship of Canterbury* (London: Nelson, 1966); Barbara Harvey, *Westminster Abbey and its Estates in the Middle Ages* (Oxford: Clarendon Pr., 1977); E. King, *Peterborough Abbey. 1086–1310* (Cambridge U.P., 1973); E. Miller, *The Abbey and Bishopric of Ely* (Cambridge U.P., 1951).

Dom David Knowles's study of the religious orders of medieval England is one of the great works of medieval scholarship: *The Monastic Order in England*, 2nd edn. (1963); the *Religious Orders in England*, 3 vols (1948–61), the series published by Cambridge U.P. See also D. Knowles and J. K. S. St Joseph, *Monastic Sites from the Air* (Cambridge U.P., 1952). On royal buildings in England the essential work of reference is H. M. Colvin (gen. ed.), *The History of the King's Works. Vols I–III. The Middle Ages* (London: HMSO, 1963). Also on buildings see: R. Allen Brown, *English Castles*, 3rd edn. (London, Batsford, 1976); Margaret Wood, *The English Medieval House* (London: J. M. Dent, 1965). On interior decoration see the survey volumes by E. W. Tristram, *English Medieval Wall Painting*, 3 vols (London: Oxford U.P., 1944–50), and *English Wall Painting of the Fourteenth Century* (London: Routledge, 1955).

For art and artefacts the most recent bibliography will be found in the catalogues of the Romanesque exhibition at the Hayward Gallery, London, 1984, and the Gothic exhibition at the Royal Academy, London, 1987/8: *English Romanesque Art 1066–1200*, ed. G. Zarnecki et al. (London: Arts Council, 1984); *Age of Chivalry. Art in Plantagenet England 1200–1400*, ed. J. Alexander and P. Binski (London: Royal Academy, 1987). On manuscripts see the survey of Manuscripts illuminated in the British Isles, gen. ed. J. J. G. Alexander (Oxford: Oxford U.P. – Harvey Miller); C. M. Kauffmann, *Romanesque Manuscripts 1066–1190* (1975); N. Morgan, *Early Gothic Manuscripts*, 2 vols (1982–8); Lucy F. Sandler, *Gothic Manuscripts*, 2 vols (1984).

Visual material of a different kind is presented in M. W. Beresford and J. K. S. St Joseph, *Medieval England. An Aerial Survey*, 2nd edn. (Cambridge U.P., 1979); and for what lies beneath the surface M. W. Beresford and J. G. Hurst (ed.), *Deserted Medieval Villages* (London: Butterworth, 1971; New York, St Martin's Pr., 1972). Archaeological work is surveyed in an indispensable annual journal, *Medieval Archaeology*,

fully indexed every five years. What has become the 'show-piece' deserted medieval settlement in England is in course of publication as *Wharram. A Study of Settlement on the Yorkshire Wolds*, gen. ed. J. G. Hurst and P. A. Rahtz, 4 vols (London: Society for Medieval Archaeology, 1979, 1987; York: York University, 1983, 1986).

The main literary sources that have been used in the text are fully discussed in two volumes by Antonia Gransden, *Historical Writing in England c.550 to c.1307*, and *Historical Writing in England c.1307 to the early Sixteenth Century* (London: Routledge; Ithaca, N.Y.: Cornell U.P., 1974, 1982). The main series of texts in translation is the Oxford Medieval Texts series (a continuation of Nelson Medieval Texts), edited by Diana E. Greenway, Barbara F. Harvey and M. Lapidge. The number of references in the chapter sections which follow will make clear its importance.

Chapter One. 1066–1106

On the prehistory of this period see J. Campbell (ed), *The Anglo-Saxons* (Oxford: Phaidon Pr., 1982); F. Barlow, *Edward the Confessor* (London: Methuen; Berkeley: U. of California Pr., 1970). Surveys of the Conquest are: H. R. Loyn, *The Norman Conquest*, 3rd edn. (London: Hutchinson, 1982); J. Le Patourel, *The Norman Empire* (Oxford: Clarendon Pr., 1976); and the story is told in *The Ecclesiastical History of Orderic Vitalis*, ed. Marjorie Chibnall, 6 vols (Oxford: OMT, 1969–80), a magnificent edition of the primary chronicle of Anglo-Norman history up to 1141. The Anglo-Saxon Chronicle is available in several editions, including *The Peterborough Chronicle 1070–1154*, ed. Cecily Clark, 2nd edn. (Oxford: Clarendon Pr., 1970). On Domesday Book see the geographical survey, H. C. Darby, *Domesday England* (Cambridge U.P., 1977), the historical survey, V. H. Galbraith, *The Making of Domesday Book* (Oxford: Clarendon Pr., 1962), and important work published for the nine hundredth anniversary: J. C. Holt (ed.), *Domesday Studies* (Woodbridge: Boydell and Brewer, 1987); P. H. Sawyer (ed.), *Domesday Book: A Reassessment* (London: Edw. Arnold, 1986); Elizabeth M. Hallam, *Domesday Book Through Nine Centuries* (London: Thames and Hudson, 1986). Studies of church leaders include: Margaret Gibson, *Lanfranc of Bec* (Oxford: Clarendon Pr., 1978); R. W. Southern, *St Anselm and his biographer* (Cambridge U.P., 1963); Sally N. Vaughn, *Anselm of Bec and Robert of Meulan* (Berkeley: U. of California Pr., 1987); C. N. L. Brooke, 'The archdeacon and the Norman Conquest', in *Tradition and Change. Essays in Honour of Marjorie Chibnall* ed. Diana Greenway et al. (Cambridge U.P., 1985), pp. 1–19. Eleanor Searle, 'Women and the legitimization of succession at the Norman Conquest', *Anglo-*

Norman Studies, 3 (1981), pp. 159–70, and J. C. Holt, 'The introduction of knight service in England', ibid. 6 (1984), pp. 89–106, are two articles used from an important series, the proceedings of the annual Battle Abbey conference. Note also: W. E. Kapelle, The Norman Conquest and the North (Chapel Hill: U. of N. Carolina Pr.; London: Croom Helm, 1979); F. Barlow, William Rufus (London: Eyre Methuen, 1983; Berkeley: U. of California Pr., 1983).

Chapter Two. 1106–1154

C. Warren Hollister has in preparation a biography of Henry I. An important collection of his articles is Monarchy, Magnates and Institutions in the Anglo-Norman World (London: Hambledon Pr., 1986). On Henry I: Judith A. Green, The Government of England under Henry I (Cambridge U.P., 1986); E. J. Kealey, Roger of Salisbury. Viceroy of England (Berkeley: U. of California Pr., 1972). On Stephen: R. H. C. Davis, King Stephen (London: Longman, 1967); H. A. Cronne, The Reign of Stephen (London: Weidenfeld and Nicolson, 1970); E. J. King, 'The anarchy of King Stephen's reign', TRHS 5:34 (1984), pp. 133–53. The most accessible chronicles are: Gesta Stephani, ed. K. R. Potter and R. H. C. Davis (Oxford: OMT, 1976), and The Historia Novella of William of Malmesbury, ed. K. R. Potter (London: NMT, 1955; rev. edn. in preparation for OMT). Much of importance for England at this time occurs on or beyond its frontiers: G. W. S. Barrow, The Anglo-Norman Era in Scottish History (Oxford: Clarendon Pr., 1980), and his 1984 Stenton Lecture, David I of Scotland (1124–1153). The Balance of New and Old (Reading: U. of Reading, 1985); R. R. Davies, 'Henry I and Wales', in Studies in Medieval History Presented to R. H. C. Davis, ed. H. Mayr-Harting and R. I. Moore (London: Hambledon Pr., 1985), pp. 132–147; D. Crouch, The Beaumont Twins (Cambridge U.P., 1986). Note also Marjorie Chibnall, The World of Orderic Vitalis (Oxford: Clarendon Pr., 1984).

Chapter Three. 1154–1199

On kings and their policies see: W. L. Warren, Henry II (London: Eyre Methuen; Berkeley: U. of California Pr., 1973); H. E. Mayer, 'Henry II of England and the Holy Land', EHR 97 (1982), pp. 721–39; J. Gillingham, Richard the Lionheart (London: Weidenfeld and Nicolson, 1978); J. W. Baldwin, The Government of Philip Augustus (Berkeley: U. of California Pr., 1986). Other important figures are: A. Kelly, Eleanor of Aquitaine and Four Kings (Cambridge, Mass.: Harvard U.P., 1950); Regine Pernoud, Eleanor of Aquitaine (London: Collins, 1967); F. Barlow, Thomas Becket (London: Weidenfeld and Nicolson; Berkeley: U. of California Pr., 1986); C. R. Cheney, Hubert Walter (London: Nelson, 1967); R. Bartlett, Gerald of Wales 1146–1223 (Oxford: Clarendon Pr., 1982). Amongst a large literature on law and administration see: R. C. Van Caenegem, The Birth of the English Common Law (Cambridge U.P., 1973); S. F. C. Milson, The

Legal Framework of English Feudalism (Cambridge U.P., 1976); T. K. Keefe, Feudal Assessments and the Political Community under Henry II and his Sons (Berkeley: U. of California Pr., 1983); C. R. Young, The Royal Forests of Medieval England (Philadelphia: U. of Pennsylvania Pr.; Leicester U.P., 1979); P. R. Hyams, King, Lords, and Peasants in Medieval England (Oxford: Clarendon Pr., 1980). There is a great abundance of texts, including: The Chronicle of Jocelin of Brakelond, ed. H. E. Butler (London: NMT, 1949); Dialogus de Scaccario, ed. C. Johnson, rev. edn. (Oxford: OMT, 1983); The Chronicle of Battle Abbey, ed. Eleanor Searle (Oxford: OMT, 1980); The letters of John of Salisbury, ed. W. J. Millor and C. N. L. Brooke, 2 vols (Oxford: OMT, 1979, 1986); Walter Map. De Nugis Curialium, ed. M. R. James, rev. edn. (Oxford: OMT, 1983). Note also M. T. Clanchy, From Memory to Written Record. England 1066–1307 (London: Edw. Arnold; Cambridge Mass., Harvard U.P., 1979). On the 'big bang' of the late twelfth century note the different interepretations of: R. C. Palmer, 'The Economic and Cultural Impact of the Origins of Property: 1180–1220', Law and History Review, 3 (1985), pp. 375–96; Pamela Nightingale, '"The King's Profit": Trends in English mint and monetary policy in the 11th and 12th centuries', in Later Medieval Mints. Organisation, Administration and Techniques, ed. N. J. Mayhew and P. Spufford (BAR Int. ser. 389, 1988), pp. 61–75; J. Langdon, Horses, Oxen and Technological Innovation; the use of draught animals in English farming 1066–1500 (Cambridge U.P., 1986).

Chapter Four. 1199–1258

On King John and Magna Carta: J. C. Holt, The Northerners. A Study in the Reign of King John (Oxford: Clarendon Pr., 1961), and his Magna Carta (Cambridge U.P., 1965); C. L. H. Coulson, 'Fortress-Policy in Capetian tradition and Angevin practice: aspects of the conquest of Normandy by Philip II', Anglo-Norman Studies, 6 (1984), pp. 13–38. F. M. Powicke, King Henry III and the Lord Edward (Oxford: Clarendon Pr., 1947) is a classic. More recent work on the politics of Henry III's reign includes R. Stacey, Politics, Policy and Finance under Henry III 1216–1245 (Oxford: Clarendon Pr., 1987), and (among several articles in preparation towards a new biography) D. A. Carpenter, 'King, Magnates, and Society: the Personal Rule of King Henry the Third, 1234–1258', Speculum, 60 (1985), pp. 39–70; J. R. Maddicott, 'Magna Carta and the local community 1215–1259', Past & Present, no. 102 (1984), pp. 25–65. Two important critics of Henry III are studied by R. Vaughan, Matthew Paris (Cambridge U.P., 1958), and R. W. Southern, Robert Grosseteste (Oxford: Clarendon Pr., 1986). Studies of magnates are: N. Denholm-Young, Richard of Cornwall (Oxford: Blackwell, 1947); S. Painter, William Marshal (Baltimore: Johns Hopkins Pr., 1933); J. W. Alexander, Ranulf of Chester (Athens: U. of Georgia Pr., 1983); F. M. Powicke, Stephen Langton (Oxford: Clarendon Pr., 1928). C. R. Cheney, Innocent III and England (Stuttgart: Hiersemann, 1979) is a fine study. The great text of the period in a great

edition, is Bracton. On the Laws and Customs of England, ed. G. E. Woodbine, trans. and revised by S. E Thorne, 4 vols (Cambridge, Mass.: Harvard U.P., 1968–77); vol. 5 in preparation. Note also C. A. F. Meekings, Studies in 13th Century Justice and Administration (London: Hambledon Pr., 1981).

Chapter Five. 1258–1307

Look at Edward I first from outside England: R. R. Davies, 'Colonial Wales', Past & Present, no. 65 (1974), pp. 3–23; G. W. S. Barrow, Robert Bruce and the community of the realm of Scotland (London: Eyre Methuen; New York: Columbia U.P., 1965); E. L. G. Stones and G. G. Simpson, Edward I and the Throne of Scotland 1290–1296, 2 vols (Oxford: Oxford U.P., 1978). Then start at the beginning: C. H. Knowles, 'The resettlement of England after the Barons' War', TRHS 5:32 (1982), pp. 25–41; J. R. Maddicott, 'Edward I and the lessons of baronial reform: local government, 1258–80', in Thirteenth-Century Studies: I, ed. P. R. Coss and S. D. Lloyd (Woodbridge: Boydell and Brewer, 1986), pp. 1–30. Further sources for the civil war are: M. Altschul, A Baronial Family in Medieval England: the Clares, 1217–1314 (Baltimore: Johns Hopkins Pr., 1965); G. Williams, Medieval London from Commune to Capital (London: Athlone Pr., 1963). On parliament and the law note: R. G. Davies and J. H. Denton (eds.), The English Parliament in the Middle Ages (Manchester U.P.; Philadelphia: U. of Pennsylvania Pr. 1981); G. O. Sayles, The King's Parliament of England (London: Edw. Arnold; New York: Norton, 1974); D. W. Sutherland, Quo Warranto Proceedings in the Reign of Edward I, 1278–1294 (Oxford: Clarendon Pr., 1963); Sandra Raban, Mortmain Legislation and the English Church 1279–1500 (Cambridge: U.P., 1982); T.F.T. Plucknett, Legislation of Edward I (Oxford: Clarendon Pr., 1949). Two important studies are M. C. Prestwich, Edward I (London: Eyre Methuen; Berkeley: U. of California Pr., 1988), and J. H. Denton, Robert Winchelsey and the Crown 1294–1313 (Cambridge U.P., 1980). A useful source is The Chronicle of Bury St Edmunds 1212–1301, ed. Antonia Gransden (London: NMT, 1964).

Chapter Six. 1307–1349

On Edward II: Vita Edwardi Secundi, ed. N. Denholm-Young (London: NMT, 1957), J. R. Maddicott, Thomas of Lancaster 1307–1322 (Oxford: Clarendon Pr., 1970); J. R. S. Phillips, Aymer de Valence. Earl of Pembroke 1310–1324 (Oxford: Clarendon Pr., 1972); Natalie Fryde, The Tyranny and Fall of Edward II 1321–1326 (Cambridge U.P., 1979); N. Saul, 'The Despensers and the downfall of Edward II', EHR 99 (1984), pp. 1–33. On politics and finance through the period see G. L. Harriss, King, Parliament, and Public Finance in Medieval England to 1369 (Oxford: Clarendon Pr., 1975). On Edward III, war and chivalry see: M. H. Keen, Chivalry (New Haven: Yale U.P., 1984); H. J. Hewitt, The Organisation of War under Edward III. 1338–62

(Manchester U.P.; New York: Barnes and Noble, 1966); P. Contamine, *War in the Middle Ages*, trans. M. Jones (Oxford: Blackwell, 1984); *Froissart. Chronicles* (Penguin classics edn., 1968); *Scalachronica by Sir Thomas Gray of Heton, knight*, ed. J. Stevenson (Edinburgh: Maitland Club, 1836), and trans. by H. Maxwell (Glasgow: Maclehose, 1907). For the section on the economy see: J. Z. Titow. *English Rural Society 1200–1350* (London: Allen and Unwin; New York: Barnes and Noble, 1969); Z. Razi, *Life, Marriage and Death in a Medieval Parish* (Cambridge U.P., 1980); I. Kershaw, 'The Great Famine and agrarian crisis in England 1315–1322', *Past & Present*, no. 59 (1973), pp. 3–50; R. H. Britnell, 'The proliferation of markets in England, 1200–1349', *Economic History Review*, 2:34 (1981), pp. 209–21; Margery K. James, *Studies in the Medieval Wine Trade* (Oxford: Clarendon Pr., 1971); J. Hatcher, *English Tin Production and Trade before 1550* (Oxford: Clarendon Pr., 1973); E. Miller, 'Medieval York', *Victoria County History of Yorkshire. The City of York* (London: Institute of Historical Research, 1961), pp. 25–116.

Chapter Seven. 1349–1399

On Edward III: W. M. Ormrod, 'Edward III and the recovery of royal authority in England 1340–1360', *History*, 72 (1987), pp. 3–19; G. Holmes, *The Good Parliament* (Oxford: Clarendon Pr., 1985). On royal and magnate lordship two complementary volumes will be: C. Given-Wilson, *The Royal Household and the King's Affinity* (New Haven, Conn.: Yale U.P., 1986); S. K. Walker, *The Lancastrian Affinity 1361–1399* (Oxford: Clarendon Pr., forthcoming). On the events of 1381 see: R. H. Hilton and T. H. Aston

(eds.), *The English Rising of 1381* (Cambridge U.P., 1984); E. B. Fryde, *The Great Revolt of 1381* (London: Historical Association, G.S. pamphlet 100, 1981). On Richard II see: *The Westminster Chronicle*, ed. L. C. Hector and Barbara F. Harvey (Oxford: OMT, 1982); Caroline M. Barron, 'The tyranny of Richard II', in BIHR 41 (1968), pp. 1–18; A. Tuck, *Richard II and the English Nobility* (London: Edw. Arnold, 1973); F. R. H. Du Boulay and Caroline M. Barron (ed.), *The Reign of Richard II. Essays in Honour of May McKisack* (London: Athlone Pr., 1971). On diplomacy, J. J. N. Palmer, *England, France and Christendom, 1377–99* (London: Routledge; Chapel Hill: U. of N. Carolina Pr., 1972). On the village and the economy works have been listed earlier; see also J. Hatcher, *Plague, Population and the English Economy 1348–1530* (London: Macmillan, 1977), and C. Dyer, 'English Diet in the later middle ages', in *Social Relations and Ideas. Essays in honour of R. H. Hilton*, ed. T. H. Aston et al. (Cambridge U.P., 1983).

Chapter Eight. 1399–1485

On Henry IV and Henry V see: K. B. McFarlane, *Lancastrian Kings and Lollard Knights* (Oxford: Clarendon Pr., 1972); J. L. Kirby, *Henry IV of England* (London: Constable; Hamden Conn., Archon, 1970); G. L. Harriss (ed.), *Henry V. The Practice of Kingship* (Oxford: Clarendon Pr., 1985); *Gesta Henrici Quinti*, ed. F. Taylor and J. S. Roskell (Oxford: OMT, 1975). On Henry VI: R. A. Griffiths, *The Reign of Henry VI* (London: Ernest Benn; Berkeley: U. of California Pr., 1981); B. P. Wolffe, *Henry VI* (London: Eyre Methuen; Berkeley: U. of California Pr., 1981); R. Lovatt, 'John Blacman:

biographer of Henry VI', in *The Writing of History in the Middle Ages*, ed. R. H. C. Davis and J. M. Wallace-Hadrill (Oxford: Clarendon Pr., 1981), pp. 415–44; Blacman's memoir of Henry VI was edited by M. R. James (Cambridge U.P., 1919); Caroline Barron, 'London and the crown 1451–61', in *The Crown and Local Communities in England and France in the Fifteenth Century*, ed. J. R. L. Highfield and R. Jeffs (Gloucester: Alan Sutton; New York: Humanities Pr., 1981); R. L. Storey, *The End of the House of Lancaster*, new edn. (Gloucester: Alan Sutton, 1986). On the Yorkists: C. Ross, *Edward IV* (1974), and *Richard III* (1981), both volumes London: Eyre Methuen and Berkeley: U. of California Pr.; D. A. L. Morgan, 'The king's affinity in the polity of Yorkist England', TRHS 5:23 (1975), pp. 1–25; *The Usurpation of Richard III*, ed. C. A. J. Armstrong, 2nd edn. (Oxford: Clarendon Pr., 1969). On the magnates in this period either individually or as a group see: K. B. McFarlane, *The Nobility of Later Medieval England* (Oxford: Clarendon Pr., 1973); Carole Rawcliff, *The Staffords, Earls of Stafford and Dukes of Buckingham, 1394–1521* (Cambridge U.P., 1978); A. J. Pollard, *John Talbot and the War in France 1427–1453* (London: Royal Historical Society, 1983); M. A. Hicks, *False, Fleeting, Perjur'd Clarence. George Duke of Clarence, 1449–78* (Gloucester: Alan Sutton; New York: Humanities Pr., 1980). Three further useful collections are: A. R. Myers, *Crown, Household and Parliament in the Fifteenth Century* (London: Hambledon Pr., 1985); S. B. Chrimes (ed.), *Fifteenth Century England 1399–1509* (Manchester U.P.; New York: Barnes and Noble, 1972); J. L. Lander, *Crown and Nobility, 1450–1509* (London: Edw. Arnold; Toronto: McGill-Queens U.P., 1976).

DATE DUE

SEP 04 2014	

DEMCO, INC. 38-2931